MASTERPLANNING FUTURES

In the past, spatial masterplans for cities have been fixed blueprints realized as physical form through conventional top down processes. These frequently disregarded existing social and cultural structures, while the old modernist planning model zoned space for home and work. At a time of urban growth, these models are now being replaced by more adaptable, mixed use plans dealing holistically with the physical, social and economic revival of districts, cities and regions. Through today's public participative approaches and using technologically enabled tools, contemporary masterplanning instruments embody fresh principles, giving cities a greater resilience and capacity for social integration and change in the future.

Lucy Bullivant analyses the ideals and processes of international masterplans, and their role in the evolution of many different types of urban contexts in both the developed and developing world. Among the book's key themes are landscape-driven schemes, social equity through the reevaluation of spatial planning, and the evolution of strategies responding to a range of ecological issues and the demands of social growth.

Drawing on first-hand accounts and illustrated throughout with colour photographs, plans and visualizations, the book includes twenty essays introduced by an extensive overview of the field and its objectives. These investigate plans including one-north Singapore, Masdar City in Abu Dhabi, Xochimilco in Mexico City and Seattle Waterfront, illuminating their distinct yet complementary integrated strategies. This is a key book for those interested in today's multiscalar masterplanning and conceptually advanced methodologies and principles being applied to meet the challenges and opportunities of the urbanizing world.

The author's research was enabled by grants from the Commission for Architecture and the Built Environment (CABE), the SfA (the Netherlands Architecture Fund), the Danish Embassy and support from the Alfred Herrhausen Society.

Lucy Bullivant Hon FRIBA is an architecture curator, guest lecturer and internationally published author and critic. She has a Master's degree in Cultural History (RCA, London) and was Heinz Curator of Architecture, Royal Academy of Arts, London, in the early 1990s before curating a number of highly successful exhibitions for institutions including Vitra Design Museum, the Milan Triennale and the British Council. She is the author of *New Arcadians*, *Responsive Environments*, *4dsocial*, *4dspace* and *Anglo Files: UK architecture's rising generation*. Lucy is an international correspondent to Domus, The Plan, Volume and Indesign.

MASTERPLANNING FUTURES

Lucy Bullivant

Routledge
Taylor & Francis Group

LONDON AND NEW YORK

First published 2012
by Routledge
2 Park Square, Milton Park, Abingdon, Oxon OX14 4RN

Simultaneously published in the USA and Canada
by Routledge
711 Third Avenue, New York, NY 10017

Routledge is an imprint of the Taylor & Francis Group, an informa business

British Library Cataloguing in Publication Data
A catalogue record for this book is available from the British Library

Library of Congress Cataloging in Publication Data
Bullivant, Lucy.
 Masterplanning futures / Lucy Bullivant.
 p. cm.
 Includes index.
 1. Urban renewal. 2. City planning. 3. Urban ecology (Sociology) 4. Dwellings—Design and construction. 5. Architecture—Technological innovations. I. Title.
 HT170.B85 2012
 307.3'416—dc23 2011041721

ISBN: 978-0-415-55446-6 (hbk)
ISBN: 978-0-415-55447-3 (pbk)

Typeset in Avenir
by Keystroke, Station Road, Codsall, Wolverhampton

Printed and bound in India by Replika Press Pvt. Ltd.

Contents

Preface		vii
About the author		ix
Acknowledgements		xi
INTRODUCTION		1

1 POST-INDUSTRIAL URBAN REGENERATION — **25**

Ørestad, Carlsberg, Loop City, Nordhavnen, COPENHAGEN, Denmark — 27

HafenCity, HAMBURG, Germany — 45

2 CITY CENTRE AND WATERFRONT NEIGHBOURHOODS — **57**

Musheireb, DOHA, Qatar — 59

Waterfront SEATTLE, USA — 69

3 SCIENCE AND TECHNOLOGY DISTRICTS — **81**

one-north, SINGAPORE — 83

4 POST-DISASTER URBAN REGENERATION — **91**

PRES Sustainable Reconstruction Plan, CONSTITUCIÓN, Chile — 93

Make It Right, NEW ORLEANS, USA — 104

5 SOCIAL EQUITY — **115**

MEDELLÍN, Colombia — 117

Lion Park Urban Design Framework, extension to Cosmo City, JOHANNESBURG, South Africa — 129

Urban Think Tank, an interview — 141

CONTENTS

6 'ECO-CITIES' **157**

Masdar City, ABU DHABI, UAE 159

Montecorvo Eco City, LOGROÑO, Spain 174

**7 LANDSCAPE AND LANDSCAPE
 INFRASTRUCTURE-DRIVEN URBAN PLANS 185**

Milan Urban Development Plan, MILAN, Italy 187

MRIO, Manzanares River, MADRID, Spain 202

Xochimilco, MEXICO CITY, Mexico 211

Sociópolis, VALENCIA, Spain 217

8 THE WATER CITY **225**

Saemangeum Island City, SAEMANGEUM,
South Korea 227

9 URBAN GROWTH **237**

Almere Structure Vision, ALMERE,
the Netherlands 239

LONGGANG, Pearl River Delta, and Qianhai Port
City, SHENZHEN, China 250

Smart Cities: Rethinking the City Centre,
BRISBANE, Queensland, Australia 264

EPILOGUE **275**

Illustrations Credit Information 280

Index 297

Preface

Throughout history, many people have sought to plan city habitation for work, leisure and the protection of people, from the earliest gridded towns – Miletus of Hippodamus of Greece (fifth century BC) to Baron Haussmann's remodelling of Paris as a modern city (nineteenth century) or today's Masdar City in Abu Dhabi, or city-wide plan setting an agenda for the future, PlanNYC, for example. Many plans have failed, been overcome by excessive growth, destroyed by war or social unrest, or never found the support or agency they needed to be realised.

The world's population of nearly 7 billion has doubled since I was born, with more growth in my lifetime than in the previous 2 million years humans have existed. Projections are for it to reach 8 billion in the next 14 years, and 9 billion by 2043.[1] On the other hand in many countries population growth is decelerating so many of the world's cities have aging pouplations. Eco systems are strained and the world and humanity are facing many threats, and their need for the infrastructure of modernity to provide the best possible solutions for everyone remains ever present. Many architects and urban designers today are proactively grappling with new challenges and are trying with more ingenuity to create new spatial conditions responding to the many opportunities and problems of urban growth and post-Fordist evolution of society, and improve by renewal what already exists.

The central theme of this book is the ways in which masterplanning and its variants are changing and will be of value in the near future. It analyses 24 current plans, in 22 cities, in 17 countries, on 6 different continents, chosen for their innate value to these debates, while my home city of London and other UK and world cities are the subject of my ongoing studies for further publications in the future.

Few publications have analysed masterplanning as a mediatory design process across continents responding

1 Source: Population Media Centre, Vermont, USA, www.population media.org.

to the demands of the present and the future. This is a collection of stories about new and topical solutions – each with their own distinct capacity for differentiated, progressive design and organisational and public consultation principles. The thematic clusters in which they are gathered are overlapping and interdependent. The issue is not which is better, or are they the best, but the legitimacy of each as contemporary responses to the globally present conditions in which they are grounded.

A happy and prosperous life is a universal desire and the conceptual planning and design of habitations[2] play

a very important role in enabling patterns of existence to generate the pre-conditions for this. The survival and well-being of the world's population may depend on the work of architects, urban designers, their collaborators and the decisions of their clients and politicians who support them and the future-oriented principles underlying urban plans.

Lucy Bullivant
London
August 2011

2 Habitate is a verb used by Jan van Ettinger, *Towards a Habitable World: Tasks, Problems, Methods and Acceleration* (Rotterdam: Elsevier, for the Boucentrum, 1960). Van Ettinger was the founder of the IHS (Institute for Housing Studies and Urban Development Studies), concerned with the developing world through its mission, Making Cities Work, and now based at the Erasmus University, Rotterdam.

About the author

Lucy Bullivant Hon FRIBA is an architecture curator, author, critic, guest lecturer and consultant. She trained as an art historian at Leeds University and has a Master's degree in Cultural History from the Royal College of Art. Formerly Heinz Curator of Architectural Programmes at the Royal Academy of Arts, London, Lucy has curated many exhibitions including 'Kid size: the material world of childhood' (Vitra Design Museum, Germany); 'The near and the far, fixed and in flux' (Triennale di Milano) and 'Space Invaders: young UK architects' (the British Council). She regularly judges architectural competitions and was Renaissance Advocate to Yorkshire Forward, Leeds, 2007–2010.

Lucy has written regularly about architecture and urban design and the social impacts of emerging strategies for Domus, The Plan, Volume and Indesign for over twenty years. Her publications include *The New Arcadians* (Merrell, 2012), *Responsive Environments* (V&A Contemporary, 2006), and *Anglo Files: UK Architecture's Rising Generation* (Thames & Hudson, published as *British Built*, Princeton Architectural Press, 2005). She is Guest Editor of *4dsocial: spatial interactive environments* (AD Architectural Design, 2007), *4dspace: Interactive Architecture* (AD, 2005), *Home Front: new public housing design* (AD, 2003).

She has curated forums including 'Responsive Environments', Strelka Institute, Moscow, 2011; 'Give Me More Green In Between', Museum of Docklands, London, 2010, for the London Festival of Architecture; 'Softspace', Tate Modern, 2007, '4dspace', ICA and the Architectural Association, London; Archis London events,1988–2001; and 'Spaced Out II', ICA (1997). Lucy has chaired events and lectured at international institutions including IAAC, Barcelona; Strelka Institute, Moscow; Swedish Institute of Architects, Stockholm; National Council for Architecture, Helsinki; Malaysian Institute of Architects, Kuala Lumpur; UCLA, Los Angeles; V&A (as chair of the 'Talking Architecture' series) and other UK venues. www.lucybullivant.net

Acknowledgements

I would like to extend grateful thanks to David Adjaye, Chrissa Amuah, Ama Amponsah, Adjaye Associates, London; Alejandro Aravena, Victor Oddó, Elemental, Santiago; Javier Arpa, a + t, AA-lava; Joanna Banham, V&A Museum, London; Dr Matthew Barac, Department of the Built Environment, South Bank University, London; Larry Barth, Landscape Urbanism, Architectural Association, London; Florian Beigel and Philip Christou, ARU, London; Giacomo Biraghi, Business Integration Partners s.p.a., Milan; Tom Bolton, Centre for Cities, London; Tom Bolton, Centre for Cities, London; Ole Bouman, Netherlands Architecture Institute, Rotterdam; Angela Brady, President, Dr Tim Hollins, Head of Programmes (RIBA Trust), Mike Althorpe, Public Programmes Manager, RIBA, London: Alfredo Brillembourg and Hubert Klumpner, Urban Think Tank, Caracas and Zurich; Alison Brooks, ABA, London; George Brugmans, Director, Rotterdam International Biennale (IABR); Jan Bunge, treibhaus landschaftsarchitektur, Berlin; Ricky Burdett, Adam Kaasa, Urban Age, LSE Cities, London; Professor Peter Carl, Faculty of Architecture and Spatial Design, London Metropolitan University; Helen Castle, Wiley, London; Eros Chen, Shanghai; Kees Christiaanse, KCAP, Rotterdam; Christian and Signe Cold, Entasis, Copenhagen; James Corner, Lisa Switkin and Justine Heilner, James Corner Field Operations, NYC; Michael Cox, Kim Richards, Cox Rayner, Brisbane; Manuel Cuadra, Secretary General, CICA, Kassel; Ali Curran, CHL Consulting, Dun Laoghaire, Ireland; Judy Dobias, Neil Byrne, Camron PR, London; Tim Duggan, Make It Right, New Orleans; Alejandro Echeverri, Laura Gallego, Urbam, Medellín; Chris Egret and David West, Egret West, London; Alex Eley, mae, London; Marina Engel, British School at Rome; Leslie Fairweather, former Editor of Architectural Review, London; Paul Finch, Deputy Chair, Design Council and founder of the World Architecture Festival, London; Chris Foges, Architecture Today, London; Alberto Francini, Andrea Boschetti, Flavia Grima, Metrogramma S.r.l., Milan; Ginés Garrido, Myriam López-Rodero, Burgos & Garrido, Madrid; Katya Girshina, Alexander Ostrogovsky, Strelka Institute for Media, Architecture and Design, Moscow; Adrian Geuze, Matthew Skjonsberg, Edzo Bindels, Joost Koningen, Christian Dobrick, Allard Terwel, West 8, Rotterdam; Francisco Gonzalez de Canales and Nuria Alvarez Lombardero, London; Joseph Grima, Elena Sommariva, Domus, Milan; Vicente Guallart,

ACKNOWLEDGEMENTS

Daniela Frogheri, Guallart Architects, Barcelona; Zaha Hadid, Patrik Schumacher, Manuela Gatto, Dillon Lin, Bozana Komljenovic, Roger Howie, Davide Giordano, Zaha Hadid Architects, London; Michael Hart, Michael Hart Architects and Designers, Johannesburg; Alex Haw, Department of Architecture, Royal College of Art, London; Jeremy Hunt, Art & Architecture magazine, London; Bjarke Ingels, BIG, Copenhagen and NYC; Rita Justesen, Head of Planning, By & Havn, Copenhagen; Juulia Kauste, Finnish Museum of Architecture, Helsinki; Holger Kehn, Eva Castro, Groundlab, Alfredo Ramirez, London and Beijing; Andreas Kipar, LAND, Milan; Rem Koolhaas, Reinier De Graaf, Eveline van Engelen, Louise Jallilian, OMA; Tom Kovac, Spatial Information Architecture Laboratory, RMIT, Melbourne; Paul Karakusevic, Karakusevic Carson Architects, London; Adrian Lahoud, Urban Design, University of Technology, Sydney; Chris Lee, Serie, London; Iris Lenz, ifa-Galerie, Stuttgart; Francisco Javier León de la Riva, Mayor of Valladollid; Nicola Leonardi and Carlotta Zucchini, The Plan, Bologna; Caroline Mallinder, Routledge; Wolf Mangelsdorf, Buro Happold, London; Prathima Manohar, Urban Vision, Mumbai; Carlo Masseroli, Councillor for Land Use and Territorial Planning, Milan; Bjarne Mastenbroek, SeARCH, Amsterdam; William McLean, School of Architecture and the Built Environment, University of Westminster, London; Jay Merrick, London; Virginia Miller, BeuermanMillerFitzgerald, New Orleans; Michel Mossessian, mossessian & partners, London; Elizabeth and Richard Motley, Integreatplus (formerly of Yorkshire Forward and Integreat), Leeds; Geoff Mulgan, NESTA, London; Peter Murray, Director, New London Architecture, London and the London Festival of Architecture; Solveig Nielsen, Project Manager, DAC/ Danish Architecture Centre, Copenhagen; Paul McGillick, Editor, and Raj Nandan, Publisher, Indesign, Sydney; Charlotte Newman, Manager, Architectural Association Bookshop, London; Enrique Norten, Barb Steffen, Humberto Arreola, TEN Arquitectos, NYC and Mexico City; Arjen Oosterman, Lilet Breddels, Volume, Amsterdam; Henk Ovink, Ministry for Infrastructure and the Environment, the Hague; John Palmer, Director of Communications, Sheffield Hallam University; Dominic Papa, S333, London; Claudio Pasquero and Marco Poletto, ecoLogicStudio, London; Enrique Peñalosa, Bogota, Columbia; Stefano Mirti, Id-Lab, Milan; Claudia Pasquero and Marco Poletto, ecoLogic Studio, London;

Steve Pearce, City of Seattle Department of Transportation; Renzo Piano, Renzo Piano Building Workshop, Genoa; Mandi Pretorius, Department of Architecture, University of Cape Town; Kristen Richards, Editor, Oculus/AIA New York City Chapter, ArchNewsNow.com, NYC; Winy Maas, Jacob van Rijs, Jan Knikker, MVRDV, Rotterdam; Manu Rubio, EMVS, Madrid; Enric Ruis-Geli and Olga Subiros, Cloud 9, Barcelona; Anne Save de Beaurecueil and Franklin Lee SUBdV, São Paulo; Richard Sennett, NYC; Himanshu Sharma, Delhi; Shideh Shaygan, Swedish Institute of Architects, Stockholm; Theresa Simon, Theresa Simon & Partners, London; Diane and Raj Singh, Delhi; Cathy Slessor, Architectural Review, London; Brett Steele, Director, Architectural Association, London; Shuyun Sun, Hella Pick, Institute for Strategic Dialogue, London; Fay Sweet, Jonathan Harris, AECOM, London; ·Vladimir Urlapkin, Development Solutions, Moscow; Tiina Vapola, Finnish Architecture Policy Programme/National Council for Architecture, Helsinki; Gleb Vitkov, Moscow; Marlene Wagner, buildCollective, Vienna; Ute Weiland, Alfred Herrhausen Society, Berlin; Ken Yeang, Llewelyn Davies Yeang, London; Alejandro Zaera-Polo, Manuel Tavora, AZPA, London and Barcelona.

I am also indebted to a number of people and bodies who enabled me financially to carry out my research and development for this book:

Sir John Sorrell and Richard Simmons, formerly Chairman and Chief Executive respectively of CABE, London, since 2011 has been known as Design Council CABE after the consolidation of the two bodies. For their financial support, understanding why this project was necessary and worthy of support, encouraging me with their brief to explore the international dimensions of masterplanning as a contemporary practice, to help further extend knowledge and awareness of how topical issues of holistic adaptive planning are being dealt with abroad, prior to any separate and similarly investigative study of the high quality masterplanning skills of UK-based architects applied at home.

The Stimuleringsfonds voor Architectuur – the Netherlands Architecture Fund – whose financial support allowed me to research of the Dutch aspects of the book.

The Creative Industries Unit of the Queensland Government's Department of Employment, Economic Development and Innovation, which initiated the HEAT – Queensland's new wave

of ecological architects – through the kindness of Lindy Johnson, Director, Creative Industries, and colleagues Scott Duffield and Julie McGlone, for hosting an extensive research trip to Queensland – Brisbane, the Gold Coast and the Sunshine Coast – to investigate ecological architecture and urban design in the region in 2009.

The Danish Embassy, London for enabling a further visit to Copenhagen in 2009 to explore some of the multiple masterplans on the go in the city.

The Alfred Herrhausen Society, Deutsche Bank, Berlin, specifically, Ute Weiland, Deputy Director, and Wolfgang Nowak, Managing Director, for their kindness in extending invitations to the Urban Age series of international conferences staged annually by AHS/LSE Cities since 2004, enabling visits to Mexico City, Mumbai, São Paulo, Istanbul, Chicago and Hong Kong. Many thanks to Ricky Burdett, Professor of Urban Studies, Director, LSE Cities and Professor Richard Sennett, the Centennial Professor of Sociology, LSE and University Professor of the Humanities at New York University and the LSE Cities team for the inspirational Urban Age project.

The Institute of Strategic Research, London, for enabling, through Director of Arts and Culture Hella Pick's excellent programme, a research trip to China, to Chengdu, in 2011.

Louise Fox, Associate Editor – Landscape, Siobhán Greaney, Production Editor and Alex Hollingsworth, Senior Publisher, Routledge/Taylor & Francis Group, for their support, constructive comments and patience, and Susan Dunsmore, freelance copy editor for her help.

For their persistent encouragement and belief in me: Patricia, my mother and Dargan, my father, whose everlasting love and my architectural genes helped me reach the finish line. Likewise all my friends in London and around the world, for making free with their insights, wisdom, passion, rigour, commitment, resilience, courage, hospitality, generosity, good humour and solidarity.

CABE is now part of the Design Council

Introduction

The bespoke city

At a time of huge global migration, across nations, from rural to urban areas, the city epitomises the critical arena of cross-cultural life within the emerging geopolitical landscape of the world.[1] As nerve centres and places of coexistence within a global network, the physical landscapes of cities have become vital to the continuation of an inclusive, democratic society.

Issues of cities' formal organisation, infrastructural patterns, density, intensities of programme, distributions and scale are very important socially, economically and politically. But amidst deepening social divides, globally, millions of government policies and urban policy instruments are failing to keep up with changing social patterns. Given the power of urban growth forces the network society beyond the scope of architecture and urban planning, any urbanistic intervention – if it is to be an intelligent and bespoke response that is also progressive – needs to be based on a precise analysis of what is going on in terms of geo-political and social transformations, and why. What could be done and how could it feasibly be delivered? This book examines some of the myriad of questions asked by architects and their clients in different global milieux, to help define the context of a reasoned and enlightened set of principles for wider urban regeneration and growth strategies.

The resurgence of masterplanning

Macro urban planning has been out of fashion for the past 20 or 30 years, but it reappeared on the global scene during the height of the last construction boom, from 2000–7, and is essential if societies are going to mitigate and adapt to urban growth and climate change. During that period more development in terms of square metres was realised than in the whole post-war period.[2]

1 Architect Alejandro Zaera-Polo writes about the physical space of the city as a trans-cultural vehicle as a sessionist on the theme 'Where will people congregate?', Singapore Sessions, Singapore Economic Development Board, 2009, available at: www.sedb.com.
2 Architect Reinier de Graaf, 'On Hold', British School at Rome, Italy, exhibition catalogue curated by de Graaf, May 2011.

The architectural icon came to signify the universal panacea to the challenges faced by all cities. But, in reality, this media-friendly emblem and supposed magnet of people and activities is not in itself capable of helping cultures find new extrapolations of their existence, even though achieving a satisfying relationship between building structures and their masterplans remains acutely important for quality of life. What are plans for? They are metaphors, fabrications that are judged on how specific, how credible, how contingent they are – how far they might be the source of the means to defy the disappointing, inadequate or anachronistic reality of many earlier speculations that were realised. On that basis, it is hard to expect too much of them, but vital to expect the best from them – the best for all, and that is a cultural, ethical matter.

In what were conditions of market prosperity and huge demand, when city living rose in popularity for all levels of society in both the developed and the developing world, the rise of the icon was accompanied by a boom in urban design and in masterplanning. This new surge of urbanistic interest has had intoxicating cultural motives, because of the speculative scope of new ideas for the city to trigger change. It has also bid up land prices and raised interest in leveraging public assets, with mixed outcomes.

In the wake of the global economic crisis, a lot of planning opportunities were put on hold, some temporarily, some permanently. This has created a space for reflection on strategies by architects and clients. What is the ideal, or the most appropriate conceptual framework to deal with cities' challenges in the twenty-first century? Is it a masterplan? If so, what kind of plan or plans makes best sense in a specific context? What new spatial and urban typologies are already emerging from new conditions – political, social, cultural and ecological? To what extent can informal projects play a role in innovative solutions? Do we consign the word and the principle to the scrapheap of

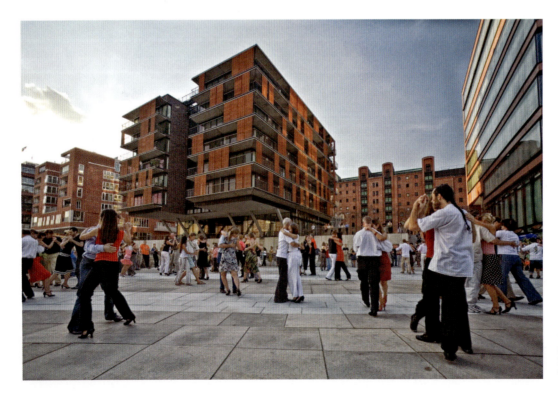

1 HafenCity, Hamburg, masterplan by KCAP. Dancing on Magellan Terrace at Sandtor Quay.

history and call it adaptive or future planning? This book argues that what we understand as a masterplan has changed and diversified, with many different valid approaches to processes, but still maintains overriding ideals that match today's post-Fordist era of complexity and changing attitudes towards, and patterns that drive the identities of cities and the use of land. Evaluating these is tough, but necessary.

Masterplanning: definitions

Traditionally, a masterplan was a top-down blueprint, a convergence of form and values that has very often become just a superficial zoning exercise but nonetheless a powerful determining tool of socio-spatial relations. A myriad of factors beyond the scope of this book led to 'laissez-faire', piecemeal approaches to the city, or masterplanning being reduced to physical planning and zoning, compartmentalised into splinter groups, repairing what was dysfunctional, rather than projecting into a possible future.

While this limited approach is still common,[3] the contemporary masterplan is now very often loaded down with expectations of its virtue as a commercial planning tool. So people retreat from the dictatorial suggestions of 'masterplanning' (with planning by the 'servants' denied), and many see the noun, 'masterplan', as a mere oxymoron – any plan, as history has shown, is so often overwhelmed and conquered by other plans. But the definition has broadened, and a masterplan is now in many people's eyes interchangeable with the word 'vision', its framework plan based on a deeply researched envisioning exercise drawing on the views, wishes and even votes of the public, because urban design is now a collective affair. These days, a masterplan is also an activity that occurs very early in any process of urban change, well before major costs for change are incurred in the delivery process. So there is huge scope, and an advantage in timeliness to hitting the mark at this speculative stage.

The abstractness of the plan as impediment

'No abstract Master Plan stands between him and what he has to do, only "the human facts" and the logistics of the situation', wrote architect Alison Smithson in the *Team 10 Primer* in 1962,[4] referring to the architect and his role. Half a century later, can we confidently say that 'abstraction in masterplans' has decreased, and in cases where it is present, potentially suffers the fate of being challenged or thrown out by its constituencies for being distanced from human needs? The contemporary conceptual masterplan does – far more than ever before – strive to relate to 'the human facts', as a vast myriad of interconnected phenomena, as far as it is possible, based on findings from multidisciplinary research. But, in harnessing new technologies, it can now do far more with its latent relational qualities. It frequently embodies a shrewd sense of logistics – flexible processes, relational data from research and public consultation, and the benefits of input from multidisciplinary team members, incremental scenarios for phasing, and often opportunities to evolve newer forms of public–private mechanisms for funding and of delivery. That is both advantageous, but at every step the path is also strewn with challenges to define and then develop design tools to spatialise goals and help achieve the common good in a way that is durable.

Whether tending to a top-down or more bottom-up attitude, masterplanners are more likely nowadays not to prescribe a rigid blueprint, but will create a performative set of tools with the aim of incubating the future. As integrated sets of principles, they add utopias, not one single utopia, to a city or region's

3 Russia is one country where a conceptual urban masterplan, and the idea of fostering consensus among various city stakeholders, are rare. The city of Perm is an exception and the masterplan commissioned from KCAP (see HafenCity Hamburg, p. 45) breaks with old models such as the *microrayons* of prefab housing outside the city and scattered infill development, treating the city as a resource, and introducing a block strategy, along with others, with an easy-to-navigate spatial framework, as well as new decision-making processes. Interview with Sergey Gordeev, a Senator in Perm and President of the Russian Avant-Garde Foundation, *Project Russia* magazine, Moscow, 56, Feb. 2010.

4 Alison Smithson (ed.) *Team 10 Primer* (Cambridge, MA: MIT Press, 1975, first edition, 1962, revised edition, 1968).

public laboratory of possibilities, because any plan needs to be accompanied by a lot of open debate, a good degree of open-endedness, and must relate closely to an individual context. Furthermore, it must respond generously to the innate presence of difference of all kinds found in all cities and regions. For example, traditionally, the arsenal of approaches adopted by conventional architectural practice possessed limited scope for responses to ecological crisis, and the beginnings of localised, biodiverse adaptations to those practices is one major indicator of change in masterplan thinking.

In identity, masterplanning has become an interdependent set of principles, an integrated gestalt of a mechanism for directing change in cities, not one single tool but a synergistic and interactive set of design tools applied to key urban issues, including degrees of density and the effect of their relationship, mixed use and its application, cultural identities and their interaction, ecological and economic sustainability and their satisfactory dovetailing, cluster policies, anti-flooding policies, transport infrastructure, and families of housing models. Inevitably, a post-zoning model – a more intelligent, rather than a wasteful use of land – is at the heart of a good masterplan. No one element can afford to be compartmentalised, but must play its role as part of a conceptual network of interrelationships and elements that encourage social conditions to emerge or to be reinforced. The social engineering capacity of a masterplan is nowadays invariably applied to accrue commercial benefits; but to make a part of a city the setting for future society, considerable flexibility and adaptability – and transparency – have to be built into the process, allied to sophisticated economic mechanisms, as the story of Milan's UDP (see p. 187) demonstrates.

The imperative to create urban design tools as part of a masterplan can be manifested as a framework plan, a set of adaptive principles, as retrofitting or inventing place in the

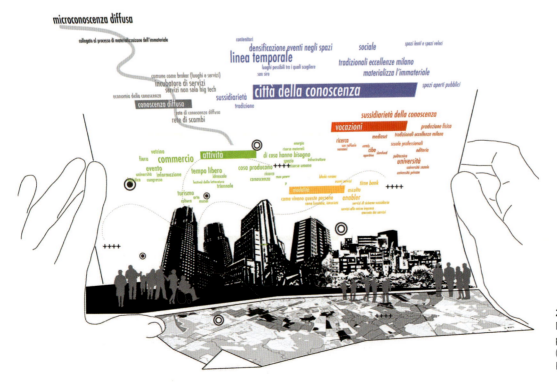

2 Milan Urban Development Plan: Services plan for the Milan PGT (architects Metrogramma), Id-Lab.

context of a *tabula rasa*. It can reinforce walkability, perme-ability, social inclusion, can introduce a new balance between the hard built environment and the soft landscape, or retrofit the rigid zones of modernist planning with a warped grid, layer grids, mend them in a new way, or put emphasis on another kind of connectivity entirely.

A masterplan's scope is today being stretched. In terms of scale, it can be as small as a neighbourhood or as large as 55 hectares, for example, the international competition-winning

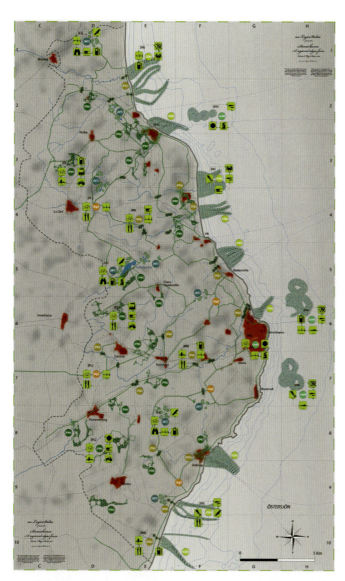

3 Masterplan for Algae Farm for the Swedish Municipality of Simrishamn, ecoLogicStudio, demonstrates the interactive potentials for algae-related urban activities via a 'co-action' plan map with six prototypes sited in a devised network.

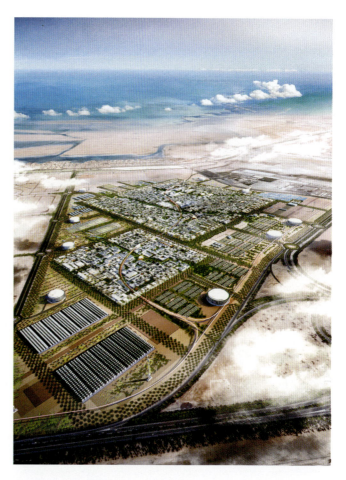

4 Aerial view of Masdar City, Abu Dhabi, masterplan by Foster + Partners, rendering.

mixed-use Kartal-Pendik masterplan by Zaha Hadid Architects (ZHA), on the Asian side of Istanbul, which has six million square metres of gross buildable area for all the programmatic elements of a city, or city-wide. The proliferating numbers of Urban Development Plans with regional implications and advantages for cities demonstrate the return of macro-scale thinking. The lucidity of thinking overlays or responds to a set of coherent social, economic and ecological strategies: Milan (see p. 189) adjusting to a post-industrial era, Abu Dhabi (see p. 159), anticipating an era beyond the end of dependency on an oil-based economy, and Brisbane (see p. 264), and one-north Singapore (see p. 53), like the other two cities mentioned, making plans that interconnect the knowledge industries in a multidisciplinary way in tandem with inner city living.

Tactics vary. In the city, a drawing out through means greater than the remediation of zones of existing or evolving assets is coming to the fore. When, in 2008, French President at the time Nicolas Sarkozy launched a competition for ten proposals by international architecture and urbanism teams to envision the future of Paris, the French capital and its vast agglomeration under the heading of 'Grand Paris',[5] architect Jean Nouvel took all the small intervention plans and mapped them all together on one map of the city. Yves Lion's team amassed all the derelict urban sites, twice the surface area of historic inner Paris. Instead of a masterplan, Nouvel looked at what everyone else had been doing; Lion looked at land in the city, damaged through neglect, that could be humanised and stitched together, supra-urbanistically, whereas Steen Eiler Rasmussen's Finger Plan for Copenhagen of 1947 was about connecting the suburbs to the centre of the city, BIG's Loop City proposal links a ring of highly differentiated urban nodes, including work clusters in a centreless metropolitan region envisaged as a focus for dense, sustainable and recreational development of the region (see p. 42).

A masterplan's timescale for development can be set at 1–2 years, or over 15–20 years, with cumulative activities arriving at a wholly new urban condition and diversified means of financing it by, say, 2030, in the case of Abu Dhabi. Why not plan a new

5 'Grand Paris', the ten urban design proposals invited by President Sarkozy were exhibited at the Cité de l'Architecture, Paris, 30 April–22 November 2009, available at: http://www.citechaillot.fr.

5, 6, 7 Loop City masterplan concept to revitalize Copenhagen's suburbs linked to the cross border region between Sweden and Denmark, renderings, BIG/Glessner Group.

relationship between cities and regions in both the developing and developed world for the next hundred years? In the here and now, fast track planning, taking place in China, for example, in many cases has no time to develop incrementally, and adopts many out-of-date Western planning models, while sticking to old regulatory frameworks, making it hard for urbanisation to be reinvented on the basis of local geographies, topographies and ecologies, with full attention to cultural narratives and social

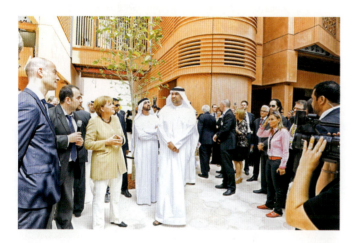

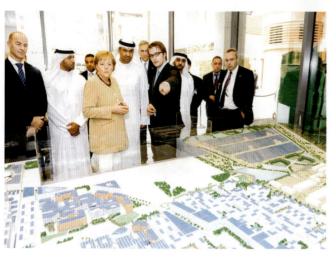

8, 9 Angela Merkel, the Chancellor of Germany, visiting Masdar City, Abu Dhabi, 2010. Masterplan and buildings by Foster + Partners.

inclusion.. However, this new approach is emerging in many schemes, and also can involve groups of architects proposing schemes for the plan and collaborating on new physical strategies, such as for the centre of Guiyang[6] (see China essay p. 250). Now that plans have this mixed strategy and come with accompanying imperatives to reform administrative structures, as in the case of Milan (see p. 187), energy systems (for example, Masdar City, see p. 159), and in the Paris region (the 'Grand Paris' project), as well as the need to find funding, a phased system is essential.

The city as organic process

In the twentieth century the identity of the modernist master-plan as a composition of separate functional zones began to fragment. Traditional categories of space – residential, commercial and industrial – were breaking down, and distinctions between the home and workplace were being blurred. A new relationship between the whole and its parts, permanent and transient, emerged in plans, supremely Kenzo Tange's 1960 plan for Tokyo, made after incisive research into demographics and economics, which imposed a new physical order to accommodate expansion and internal regeneration via a linear series of interlocking loops expanding the city across the Bay. Incorporating concepts of mobility, urban structure, linear civic axis and the city as organic process, the plan was considered beneficially different from earlier approaches, and abandoned the concept of modernist zones in favour of an open complex linked by a communication network. Metabolist in spirit, as a denotation of human vitality, it demonstrated the scope of what Team 10 called the 'aesthetics of change to replace the traditional Cartesian aesthetic in design'.[7]

Two years after Tange's plan, Jane Jacobs advocated that instead of urban designers substituting art for life, they should forge strategies to illuminate and explain the order of cities

6 The Huaxi masterplan for Guiyang City in the south-west of China, from 2008, led by MAD with Serie Architects, Atelier Manferdini, BIG, Dieguez Fridman, Emergent, Houliang, JDS, Mass Studies, Michel Rojkind and Sou Fujimoto.

7 Smithson, *Team 10 Primer*, op. cit.

and their complex systems of functionality. She quite rightly proposed this as a speculative scientific endeavour: '[A] city's very structure consists of mixture of uses, and we get closest to its structural secrets when we deal with the conditions that generate diversity.'[8] Fifty years later, I would postulate that the contemporary masterplan can only be of use if it engages with urban order expressed as dynamic interdependencies between evolving conditions and systems, becoming a mediatory instrument operating between fixed and flexible outcomes.

Attitudes to the informal

In 1958, the rush to claim the remaining uninhabited modernist housing blocks of 23 de Enero in Caracas, for example, part of the concrete centrepiece of the New National Ideal, the city's renewal programme which aimed to rid it of slums, led to an adjacent aggregation of makeshift ranchos created from the detritus of urban growth on the surrounding land. As writer Joshua Bauchner commented in 'The City that Built Itself',[9] '[The Pérez Jiménez] dictatorship's greatest symbol of regimen and progress was taken over and folded back into the Caracas it was to have replaced.' In his 1966 history of Caraqueño architecture, Carlos Raul Villanueva, the primary architect of 23 de Enero, described the growing metropolis as 'no longer properly a city but a formation of different molecules'.

The superblocks of his housing for TABO, the city's public housing office, were intended to synthesise different social groups into 'an organic community' as part of a masterplan. But political discontent, a burgeoning population and government debt railroaded the housing project. Underlining the fact that frequently the power of the collective will to build usurps imposed planning, the occupants of its hybrid evolutionary identity have continuously effected the superblocks' own renovation, and nowadays the federal government funds community councils, so that they are empowered to make their

10 Medellín, Colombia, Parque Explora, inauguration, Alejandro Echeverri, Alcaldía de Medellín.

own decisions about improvements and social programmes. It is in this vein that the rehabilitation of the *barrios* in Medellín as part of the recent masterplan there (see p. 119) has taken place.

Is the enduring masterplan an oxymoron?

Master architects such as Le Corbusier, Frank Lloyd Wright, Ludwig Mies van der Rohe, Oscar Niemeyer, Louis Kahn and Philip Johnson aspired to wear both hats – architecture and urbanism – but only in a few exceptional cases did they succeed in realising their largest-scale schemes. Revisiting plans reveals factors that were deemed less important as well as others that could not have been foreseen. In the 1950s, the city of Brasília was built, but while its individual buildings by Oscar Niemeyer are liked, its barren public spaces, with little respite from the heat, are not.

Before Le Corbusier was given the masterplanning job for Chandigarh in the Punjab region of India, the first planned city in India, two American architects, Albert Mayer and Mathew Novicki, were engaged to do the job and created a leaf-shaped

8 Jane Jacobs, *The Death and Life of Great American Cities* (London: Jonathan Cape, 1962).
9 'The City that Built Itself', Joshua Bauchner, Triple Canopy, available at: http://canopycanopycanopy.com (accessed 4 May 2009).

plan to avoid the sterility of the geometric grid, but after Novicki died in a car crash, Le Corbusier went on, in the 1950s, to devise his distinctive low-density, heavily planted city plan, drawing on their seminal ideas, and many Garden City models. By 1999, the periphery of the city, fast becoming a global hub of IT services, has seen a lot of planned and unplanned urbanisation, resulting in traffic congestion and environmental pollution, and nearby Mohali was conceived in the late 1960s on similar, sector-based lines to Chandigarh, but many of the sectors have yet to be developed, and Chandigarh needs a better response to its edges, as well as a better relationship with its region, as a team from TU Berlin who carried out research in the city in 2006, concluded in their Update Chandigarh study.[10]

Unfortunately, or fortunately – depending on the plan in question – masterplanners do not have a crystal ball, and have frequently been unable to predict or tool the future. In London, for example, after the Second World War, the masterplans proposed by the Scottish planner Patrick Abercrombie for the decentralisation of London were made, but rapid population growth undermined their principle, and his ideal of decentralisation was achieved not by policy, but by market forces.

While the words 'utopian' and 'masterplan' have been intertwined, some consider that utopia as a plural, microtopian concept has more weight, in line with a full scrutiny of the 'is' before the 'ought', to paraphrase Denise Scott-Brown. The value of one single line of utopian resistance in relation to the landscape-driven masterplan approach advocated by the book is epitomised by OMA's 1987 plan for Melun Sénart in France, one of the last Villes Nouvelles around Paris, is to preserve the void, a vast landscape, with beautiful forests, 'taking urbanism's position of weakness as its premise', with a strategy of 'where not to build'. Accordingly, the voided out 'islands' govern the plan, with the constructed landscape unfolding as it may. Here lie the seeds of today's landscape-driven urbanism, an approach with undeniable potency.

No Town

'No Town', a term invented by the landscape architects Gross.Max, is the urban condition with either no sense of place or topography, or which has lost it, and which has incrementally developed housing estates, out-of-town supermarkets and business parks progressively eating away at land. What, then, is a legitimate contemporary urbanistic response 'to the trauma of the loss of the urban, through deindustrialisation, depopulation and related processes' described by Richard J. Williams in his book, *The Anxious City* (2004)?[11]

Planning today remains nothing less than a political issue and will, moreover, in spite of the amount of codification by planners, encompass the phenomenological and the near transgressive. Instead of old-style notions of utopia as an imposed overall morphological effect, there is perhaps in some quarters greater willingness to engage with the complexities of growth. Through a form of magic realism, perhaps a district can be steered in certain directions by taking a balanced, rigorous approach towards assumptions and an acceptance of today's needs. But also an awareness born of failure that unilateral actions do not work; that of the two modes of operation, an organic approach and a highly planned approach, there are advantages to be gleaned from both. At the outset in terms of identity, there has to be a sense that one priority should not leave out another priority – the masterplan must bring a menu to the party, not a single dish. Masterplan at your peril without the organisational nous to steer the process through today's labyrinths of uncertainty.

What goes around, comes around

Berlin's Potsdamer Platz, redeveloped to a masterplan by Renzo Piano (1996–2000), is nowadays criticised not only for the mediocrity of its architecture but also for its failure to blend into the surrounding older neighbourhoods. Those in thrall to the Bilbao effect fell back on the power of the icon; other

10 Lucy Bullivant, *Sun, Space and Verdure: The Making of the Indian City of Chandigarh* (Tokyo: A+U, 2010), pp. 445, 7. Update Chandigarh was a study of the city undertaken by TU Berlin students Jan Bunge, Deniz Dizici, Daniel Stimburg and Laura Vahl.

11 Richard J. Williams, *The Anxious City: British Urbanism in the Late 20th Century* (London: Routledge, 2004).

authorities realised new chunks of the city like Canary Wharf in London by suspending planning legislation and denying communities a say.

One priority that has to remain high is to tap into the memory banks of a city. This is not to reproduce the past, but in order to have the sensibility to contribute to urban evolution through a deep awareness of different social patterns and their contestatory identities and interaction through time. That requires community consultation and social research. Whether in estates or on the peripheries, the enclaves of the disen-franchised, 'The Third Space', as Homi Bhabha termed it, calls for regeneration to go beyond classic gentrification, and deal with social difference in alternative ways. For example, breaking with the traditions of microrayons on the edges of cities as built in places like Kabul, Minsk and Perm in Russia.

Now the post-industrial economy encourages the design of intense relational spaces in a mix of functions and an elastic range of uses, cogently discussed by architect and theorist Andrea Branzi in Weak and Diffuse Modernity (2006).[12] Can there still be the reverse logic as OMA applied in an earlier decade? Today there are propositions, like Milan's Urban Development Plan (see p. 187), in which density is not abstractly allocated but is polycentric in strategy, being related to compacted urban fabric around epicentres, emphasising the differentiated nature of the city. Is this maybe a recuperative network logic instead?

The imperative to collage the city discussed 27 years ago in Colin Rowe and Fred Koetter's Collage City[13] is rightly against an old-style grand utopia. But while rigid enclaves are not the answer, collaging either a range of 'utopias', whether miniature as the authors advocated, or at a macro scale, in line with global commercial development practice, if done without a considered assessment of optimum form, the best urban interests of the programme, and their satisfying interdependency, can put projects seriously out of kilter with the needs of today's neigh-bourhoods and districts.

ARU's masterplan for Saemangeum in South Korea (see p. 227) is most pertinent to the discussion of the value of collaging done well. Weaving of built form and landscapes, creating a permeable network of public spaces instead of privately defined courtyards, brings a myriad of advantages, among them facilitating multiple futures for a community's members, all of whom benefit. The Yards Development Workshop, led by architects Marshall Brown and Letitia James, has taken this approach with the UNITY Plan[14] for Brooklyn's Vanderbilt Yards, 8 acres of former railway yards land with residential blocks next to neighbourhoods for which property values are skyrocketing.

Part of an embattled urban scenario that has now been made into Battle for Brooklyn (2011), an award-winning docu-mentary film, the UNITY plan grew out of a community charrette in 2004. It counters Atlantic Yards, the generic, polarising, mega-development for the site by Forest City Ratner, sup-ported by the Mayor and city officials, which has been stalled by over two years of litigation, and would entail eminent domain[15] to be realised. Instead, UNITY proposes new streets creating pedestrian connections and more lot frontages, and creates smaller sites that could be developed either simultaneously or gradually. This generative approach formally distributes density and integrates scales with diverse blocks, allowing for multiple developers. Subdividing the Yards facilitates a much faster completion, in a way that is less vulnerable to fluctuations in the economy, and minimises disruptions to neighbouring com-munities.

The UNITY plan is accompanied by an integrated, step-by-step proposal for design and development based on principles

12 Andrea Branzi, Weak and Diffuse Modernity: The World of Projects at the Beginning of the 21st Century (Milan: Skira editore, 2006).

13 Colin Rowe and Fred Koetter, Collage City (Cambridge, MA: MIT Press, 1976).

14 UNITY: Understanding, Imagining and Transforming the Yards, plan for Brooklyn's Vanderbilt Yards, available at: http://www.unityplan. org/news.html.

15 Eminent domain, a term used in the USA (compulsory purchase/ acquisition in the UK, Australia, and expropriation in South Africa and Canada) is a legal term meaning the government's right to seize private property, usually with compensation, for public good, a concept that if defined by an elite, as in the case of The Yards, that can get ransacked by careless development benefitting small sectors of the community and sometimes no-one at all. See Battle for Brooklyn, and the Eminent Domain Abuse, a review of the 2011 film by Michael Galinsky and Suki Hawley, Bruce E. Levine, Truthout, http://www.truth-out.org.

of transparency, inclusive housing policy, and community input compatible with the aims of the environmentally sustainable PlaNYC 2030,[16] with a community oversight committee that becomes constituted as a local authority along the lines of the Hudson River Trust Authority.

The film sends out a powerful universal message about a community's sense of ownership, and has resonated deeply with citizens of other US cities, including the LA Neighbours United community organisation. In such a scenario, the conceptual masterplan of UNITY, whose future still has potential and is now undergoing environmental view, and is supported by a coalition of community organisations, possesses the principles and the evolutionary capacity to overcome blighted urban space, certain prejudices, vested interests and methods to create a potentially highly valuable community environment – a landscape of difference.

Why have a masterplan?

The idea that, in reconstructing historic urban form, a certain authenticity in social life will be present is unfounded, when radical changes in society continue to confront people with the need to make their own histories in a reflexive way.[17] However, at the heart of the guiding principles of urban projects is a striving for authenticity in any plans in relation to the existing city, not about making a stage set, but a place, for example, a waterfront, for all. That calls for aspirations and direction from architects, rather than fixed designs. It calls for a multi-team commitment to the complexity of, and evaluation necessary as part of, the process, as the feasibility of a plan is established over time by the stakeholders. It calls for a commitment to understanding the urban critical mass as an ecosystem in which physical coexistence can be fostered through design, but moreover commitment to the making of social space able to generate a sense of ownership and connectivity.

16 PlaNYC, launched in 2007 by the Mayor of New York City, Michael Bloomberg.

17 Ulrich Beck, Anthony Giddens and Scott Lash, *Reflexive Modernization: Politics, Tradition and Aesthetics in the Modern Social Order* (Cambridge: Polity Press, 1994).

Gated paradise?

Masterplanning today is deployed to reinforce the socially segregating patterns of gated communities existing globally, mostly on the outskirts of cities or in rural areas. Conceived and built by developers as 'satellite towns' or campuses, they have little historic or physical context, being not really part of an urban edge but possessing their own enclave condition. Malibu Town in the IT hub of Gurgaon, or Eden Park in Chennai in India are examples, the latter township also near to the local IT campus. Some are only partly inhabited, and the freedom to enjoy non-traditional design in the 'gated paradise' (of their marketing literature) is very rare. The country-wide average population of a township is 50–150 families from the high end housing segment. Local psychologists point to the lack of social interaction and opportunities for people to practise tolerance at a wider level, with around-the-clock security seemingly a poor trade-off for the negative psychological consequences of growing up away from the world beyond closed gates. Although developers such as Hiranandani[18] may express interest in alternative township models, there is little sign so far of variants to conventional formulae, although the spiritual ideals of Auroville in southern India make it an exception.

Democratic, process-oriented urbanism

However, the ground has shifted and there is now more integrated planning globally encompassing physical, economic and social issues, and signs of the evolution of a more flexible, democratic and process-oriented urbanism. Virtually all the plans discussed in this book have been accompanied by extensive public consultation processes, some involving the Internet. Facilitation methods are even more vital now in order that public and private spheres can be mediated in such a way that enable concrete development proposals to be advanced. In 2008 Archis Interventions, the not-for-profit arm of the Archis Foundation in Amsterdam, a cultural think-and-do tank also renowned for its magazine on contemporary culture/urbanism, *Volume*,

18 Interview by the author, Mumbai, 2006.

established the See-Network. Focused on south-eastern Europe, it works with local initiatives by architects, planners, urbanists, sociologists, artists and other professionals to exchange knowledge and best practice in contexts in which initiatives are often advanced in isolation, embedding them in supra-regional networks. 'The task of creating a sustainable urban environment cannot be left entirely to local authorities and international organizations: civil society stakeholders also have a crucial role to play,' state the directors of the See-Network, Lilet Breddels, Arjen Oosterman, Kai Vöckler and Srdjan Jovanovi Weiss.[19]

Specific objectives and priorities have arisen: deal with post-industrial territories, limit urban sprawl, retrofit modernist planning, improve the design quality of urban environments, improve connectivity and permeability, adjust single density to a range of densities, stitch together urban fabrics, protect against flooding, with responsible growth as communities hybridise and post-traumatic reconstruction being two of the most pressing issues of the twenty-first century. Which prompts the question, why wait for a masterplan? Urban theorist and social commentator Mike Davis proposes in *Planet of Slums* (2007) ongoing advice for urban districts, not 'episodic interventions'.

It is therefore not surprising that urban design frameworks have emerged as a superior model, providing broad principles for an area as part of a detailed, three-dimensional vision for sustainable spatial development. These incorporate considerations of community well-being, identity, and attachment of its members to each other and to their physical neighbourhood, to overcome social divisions, build on existing and mutually enhancing resources, integrate minorities and to encourage new residency, more jobs, enrich the genius loci and develop future strategic actions.

Retooling the instruments

Nonetheless, top-down masterplanning, traditionally associated with some kind of physical and even social 'cleansing' in favour of large-scale areas owned by commercial bodies, self-contained and generic, has burgeoned as a tool of property

developer-driven urban regeneration, sadly paying only the most scant lip service to public consultation. While this imperative is still very strongly in evidence today, a combination of the global economic crisis, climate change imperatives, a rise in public sector-driven urban planning activity and a corresponding widening in regeneration goals, has shifted emphasis towards strategies that reassess, reappraise and adjust, addressing quality of life with a full sense of cities' dynamism in a way that sees them as entire ecologies without applying a technocratic mindset about sustainability, but committed to remediation in the widest sense. As such, plans need to embody the principles that integrate economic, physical, social, and collaborative, environmental, circulatory, interactive, safety, time-based and interrelational dimensions of the identity of a place. They also need to engage in counteracting the detrimental effects of the privatisation of public space.

Building social equity

But, if at one end of the scale, masterplanning is seen as the mechanism for commercial accumulation, invariably entailing gentrification and top-down activity, the other end of the scale is becoming increasingly bottom-up, and concerned with social mobilisation and the building of social equity. This book looks at models in which first-rate architecture and urban design are key to their success, and where everyone profits. It has been in Latin American cities that the specific theme of building social equity has been strived for most energetically. In mega-cities, such as São Paulo, the planner Jorge Wilheim regards rehabilitation of the urban environment as going hand-in-hand with strengthening the social and political power of citizens who lack it, bridging social justice and quality of life with efficiency and pragmatism.

Enrique Peñalosa, Mayor of Bogotá, the capital of Colombia, from 1997–2000, developed a model for urban improvement of the city, based on the equal rights of all people to transportation, education and public spaces, introducing the bus-based transit system, TransMilenio, and combating the stigma associated with bicycles as 'vehicles of the poor'. 'I was almost impeached,' he has stated, referring to his virtual War on Cars for the city of 6.5 million inhabitants with no subway system, 'for

19 http://www.seenetwork.org.

getting cars off sidewalks which car-owning upper classes had illegally appropriated for parking.'[20]

Now Peñalosa is writing a book on a new urban development model for the Third World, covering fields such as transportation, land use and housing for the poor, pollution abatement and public space. 'High quality public pedestrian space is evidence of a true democracy at work', giving everyone a sense of belonging and creating a more socially integrated community. Wholly committed to the democratic contact with nature which parks provide, he was aware that for a long time in Colombia people did not regard sidewalks as 'relatives of parks – not passing lanes for cars'. For society to be as egalitarian as possible, 'quality of life distribution is more important than income distribution', and accordingly, 'public space is for living, doing business, kissing and playing. Its value can't be measured with economics or mathematics. It must be felt with the soul.'

Peñalosa disagrees with the New Urbanists that the answer is simply to return to the model of the 1990 city centre. 'I believe that a radically more pedestrian city, with both more pedestrian streets and parks can be created in a dense urban environment.' The New Urbanism movement, which emerged in the late 1980s in the USA as one alternative to urban sprawl, has proposed and realised a number of walkably-proportioned towns with civic monuments, and its influence has taken hold in the USA and in India. However, urban plans lack readings of individual places based on history, culture and geography as part of their baseline studies. The physical design principles supposed to lead to a stronger sense of community than conventional suburban or alternative tactics for neighbourhood design, may well not be sufficient in themselves to foster a sense of community in multicultural contexts. The research evidence is as yet limited in this respect.

Social theorist David Harvey has commented on New Urbanism that it presumes that 'spatial order can control history and process'. Future urbanism needs to incubate new possibilities, not from an atomised understanding of forms, but far more from an understanding of processes of urbanisation and their impact on how social-spatial and temporal-spatial relations can work.

Landscape and social infrastructure-driven masterplanning

Embracing post-Fordism and countering the 'disorientating, generic neutrality and monotony of modernism' requires 'new, more variegated, complex, and densely integrated patterns of spatial ordering that are inherently multivalent and adaptive', argues architect, author and teacher, Patrik Schumacher, Partner at Zaha Hadid Architects, whose exploration of the parametricist paradigm for the build-up of a complex order for the one-north Singapore business plan (see p. 83) brings 'variation and correlation'.[21] These key design processes are 'akin to the laws of nature', with everything 'potentially made to network and resonate with everything else', and possess scope also to optimise the architectural forms within a masterplan with regard to ecological performance criteria,

This book argues for the vital need for ecologically advanced landscape design to be part of masterplanning, focusing on processes and systems. Most masterplans today are developed in phases for economic reasons. Their comprehensiveness can give people a feeling that they are nonetheless imposed rather than being allowed to evolve over time, opening things up more to chance. Structures can be of huge value to masterplanning – structures that are morphologies with flexibility built into their design, and living social infrastructures, part of larger ecological systems, a set of relations about which the best 'eco-city' plans aim to clarify.

In contexts where urbanisation has taken place, but needs opening up, landscape urbanism[22] is an interdependent approach that enables mixed programmes rather than compartmentalisation of functions. James Corner, founder of james corner field operations, winner of the design competition for the Seattle Waterfront (see p. 69), calls it 'a systems-based way of understanding an environment' and its 'flows, energies and dynamics', and such a sensibility at the level of applied methodologies, not just architectural graphics, also plays a key

20 Available at: http://www.pps.org/articles/epenalosa-2/

21 Patrik Schumacher, 'The parametric city', in *Zaha Hadid: Recent Projects* (Tokyo: A.D.A. Edita, 2010).
22 The term was coined by Charles Waldheim, Chairman of Harvard GSD's Department of Landscape Architecture.

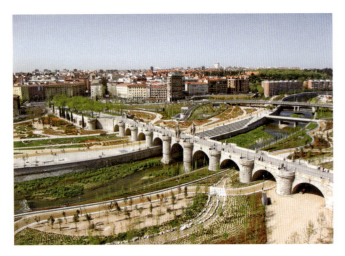

11 Manzanares River, Madrid: River Garden and Toledo Bridge. Masterplan by West 8 & MRIO Arquitectos.

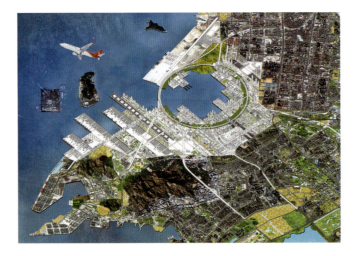

13 Concept of masterplan for Qianhai Port City in Shenzhen, China, OMA.

12 MRIO, Manzanares River, Madrid: Avenida de Portugal, Madrileños on cherry islands. Masterplan West 8 & MRIO Arquitectos.

role, advanced by LAND and others, in plans for Milan (see p. 187), Singapore (see p. 83) and by GroundLab for Longgang in China (see p. 250).

Regardless of whether a project adheres to the landscape architecture-driven 'landscape urbanism' of james corner field operations or LAND, for example, or to the more expressively 'parametricist' paradigms of ZHA or GroundLab, the fact remains that many cities are hugely negligent when it comes to cultivating biodiversity and applying advanced tactics of landscape design. Working together, West 8 and Burgos & Garrido do this for the MRIO plan (see p. 202) along the Manzanares River in Madrid, to enhance through a variety of connected spaces the recreational quality of the neighbourhood for everyone, and these tactics need to be a central part of any serious attempt to respond to the challenges of urbanisation in the future.

It's eco-logical, surely

'If something is to be "sustainable", it implies flexibility,' says Reinier de Graaf, director of AMO and partner of OMA (see

Qianhai Port City, Shenzhen, p. 250). 'Hard infrastructure, especially when fossil-fuel based, relies on a single source to produce a single product. A truly sustainable masterplan takes advantage of climatic conditions and utilizes natural assets to provide a reliable system of energy provision.'[23]

It is easy to deride the motives behind the 'eco-city' as so much 'greenwashing' by the instigators. There are no grand precedents of 'eco-cities' as yet, as the viability of custom-built projects has not yet been fully established, which makes them hard to evaluate, and assess by comparison with the urban retrofitting of existing districts. But in the twenty-first century all cities need to become eco-cities – the term can no longer be seen as an optional category of urban identity, or add-on. All urbanism needs to be ecological in its principles and processes. Joan Clos, Under-Secretary-General and Executive Director of UN-Habitat, recently argued that 'with increasing urbanization, understanding the impacts of climate change on the urban environment will become even more important'. However, and this is essential for contemporary masterplanning's credibility when it comes to urban differentiation, each solution needs to be individual: 'no single mitigation or adaptation policy is equally well suited to all cities'.[24]

A synergetic learning-development framework

A well-managed framework for learning, including study tours to demonstration projects, and a focus on issues of best practice, charrettes and workshops with a mix of professionals from public and private sectors and with the different public constituencies are a vital ingredient of the adaptive planning process. A synergistic learning-development framework helps wider investment in emerging rather than anachronistic processes; it motivates local authorities (especially in countries which are not federal states where regional government plays a

major role, for example, Spain or Germany), builds leadership and participatory capacities, articulating urban issues that may have scarcely been touched on before in a semi-public setting, and encourages awareness of how public and private sector cultures, each with their enshrined practices, can collaborate and strive for common goals.

Scientific speculation

'The very nature of a masterplan is to be able to incorporate change,' says architect and urban designer Alejandro Zaera-Polo, founder of AZPA.[25] His practice, Foreign Office Architects (FOA), was a member of the masterplanning team for the London 2012 Olympic Park since the winning of the Games and during the development phase, and has been responsible for the D38 Zona Franca Office Complex masterplan[26] on the outskirts of Barcelona, now partly built, which well exemplifies what he means. 'Designed to grow as an accretion of modular units, in a similar way to a gothic or Mediterranean village,' as Zaera-Polo describes it, the masterplan derives from a series of rules, regulations and building systems rather than fixed massing. The parameters of the six virtual volumes, each with a restricted height, a position on plan with views of the main road, produce consistency between the buildings in a 'continuous and differentiated fabric, rather than relying on the qualities of individual buildings. The typologies are flexible enough to host larger and smaller entities to respond to changes in the market,' he explains. 'We called them virtual envelopes, so that things can grow to their limit but no more.' With only 50 per cent of the footprint allowed to touch the ground, this formula generates an urban fabric with a base of sheltered public spaces integrated with the buildings.

'A masterplan is about establishing rules, otherwise you are reacting ad hoc,' he adds. 'You need to be quite scientific. A city is like a machine. It's quite easy to analyse the mechanisms.' But

23 Interview with Reinier de Graaf, by Lucy Bullivant, Domus, July 2011.
24 United Nations Human Settlements Programme, *Cities and Climate Change: Global Report on Human Settlements 2011* (London: Earthscan, 2011).

25 Interview with the author, 2011, AZPA, www.azpa.com, is a legacy company of Foreign Office Architects (FOA), 2005–2011.
26 D38 Zona Franca Office Complex masterplan by FOA and Arata Isozaki Architects (2009).

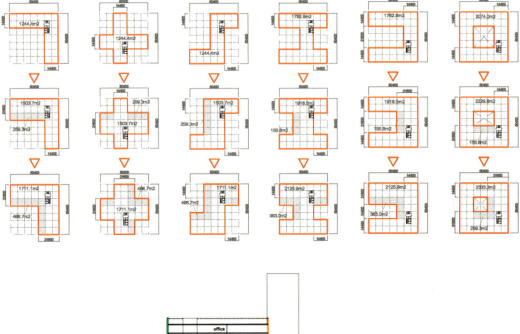

14 D-38 Zona Franca office complex, Barcelona, masterplan, Foreign Office Architects & Arata Isozaki Architects, 2009. With buildings capable of hosting a variety of workspace types, FOA realised building 2 in the first phase. Diagram.

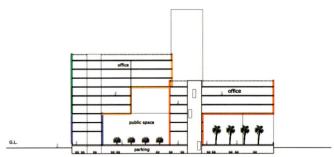

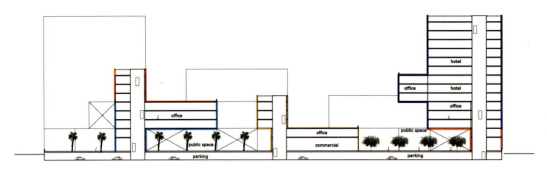

15 D-38 Zona Franca office complex, Barcelona, masterplan, Foreign Office Architects & Arata Isozaki Architects. Sections.

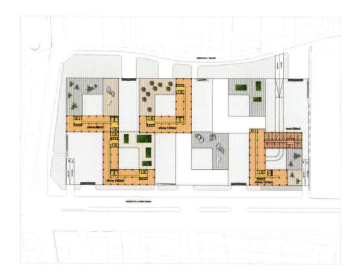
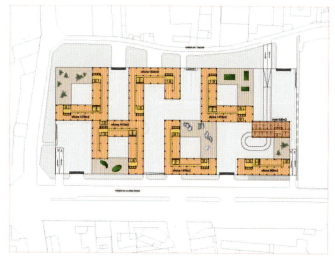

16, 17 D-38 Zona Franca office complex, Barcelona, masterplan, Foreign Office Architects & Arata Isozaki Architects. Plans.

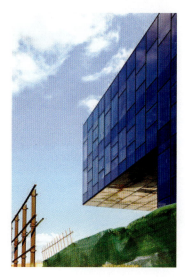

18, 19 D-38 Zona Franca office complex, Barcelona, masterplan, Foreign Office Architects & Arata Isozaki Architects.

this 'brings a big dilemma' because city planners 'want everything to be as restrictive as possible'. However, with flexibility and the capacity for change as essential features of any masterplan, 'that dichotomy is what produces the challenges'. Zaera-Polo regards the 'level of investigation more speculative architects can do' as essential to masterplanning. It is 'a discipline that requires rigorous intuition and knowledge of parameters so it can be done in a less idiosyncratic manner than in the past'. When it comes to the issue of flexibility, a word often used with regard to a masterplan but seldom adequately explained, he explains, 'On one side, it is prescriptive, applying tested models; on the other side, a good masterplan needs to allow room for evolution and chance, and be speculative.'

Resistance to the generic city

Urban Think Tank (U-TT; Hubert Klumpner and Alfredo Brillembourg, Professors of Urban Design at ETH, Zurich; see p. 141)[27] have been engaged in retrofitting the informal settlements of *favelas* in cities including Caracas in Venezuela and São Paulo in Brazil for over a decade. They believe that contemporary urban conditions must be read and deciphered as part of a process of identifying operational tools, because of the reality that an entire set of interconnected, implemented instruments has shaped urban environments. Only by understanding which urban plans, instruments, visions, political decisions, economic reasoning, cultural inputs and social

27 Urban Think Tank, www.u-tt.com.

organisations have operated in urban settlements at specific moments of change in the past do they believe the architect can transcribe them as operational tools.

This approach is of course not just about the physical environment, but about 'the imaginary city that exists along with its potentials and problems and with the conflicts that have evolved over time', the omnipresence of diversity and instability impacting on the city's complex adaptive systems, along with political interests, economic pressures, cultural inclinations, the imaginative input of architects and planners, and informal processes at work. This process of building awareness is also one which public consultation can help foster through discussions of memories of urban space with residents.

As part of their approach, U-TT subscribes to the practice of urban retrofitting. By identifying fields of actions, tools and 'handling concepts', they can find ways to operate to improve the quality of life in urban localities. It is a strategy which focuses on the rearticulation, reprogramming and recodifying of the references identified. Social networks reaching across the city can also be demonstrated which constitute 'circuits of resistance

to the generic city that can provide it with micro-environments', as U-TT collaborator Marcos Leite Rosa terms it, with regard to their work in São Paulo between 2008 and 2010.

Scalable templates

The New Urbanists have tended to emulate historic models of density, but an architect such as Teddy Cruz, founder in 2000 of estudio teddy cruz,[28] who mostly focuses on the micro-scale of the neighbourhood as the urban laboratory of the twenty-first century on both sides of the San Diego/Tijuana border, prefers to create instrumental concepts and scalable templates adaptable to changing uses of space, drawing on existing physical and urban conditions and on patterns of occupation and interaction that can rework the limits defined by rigid zoning and planning laws. He believes that instead of proceeding in

28 Estudio Teddy Cruz, La Jolla, USA, www.estudioteddycruz.com.

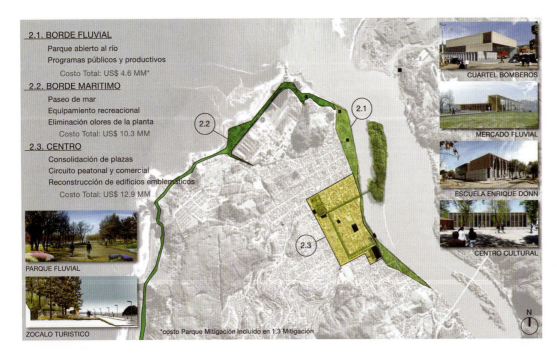

20 Constitución, Chile, PRES sustainable reconstruction masterplan by Elemental, public space and public buildings plan, riverside, coastal and downtown plans.

terms of buildings per acre, what is important is the idea of helping to generate economic, social and cultural transactions per acre.

Open source networks

The 'disurbanism' of natural disasters is more likely to hit the poor and disenfranchised, as the slums of its victims are invariably built on wetlands and land unsuitable for human habitation. The capacity of architects to swiftly engage and envision such situations holistically can be mandated by the authorities, as in the case of Elemental's involvement as masterplanners of Constitución in Chile (see p. 93). Cameron Sinclair, founder of Architecture for Humanity (1999), recounts in *Design Like You Give a Damn: Architectural Responses to Humanitarian Crises*[29] the frustrating experience of developing a strategy for a sustainable town plan in Kirinda on the south coast of Sri Lanka, in the aftermath of an earthquake and tsunami of 9.3 magnitude. Frustrating because government surveyors deemed a non-go zone changeable, marked by a line that determined whose homes would remain and whose would be torn down. After ten months of residents sleeping in tents, the line was changed once again. Sinclair's goal is to create an open-source network of innovative solutions which, while protecting the rights of the designer, could make a huge impact on alleviating many global housing crises.

Let it be unfinished

How can you make masterplans in an era in which fewer public spaces encouraging dwelling, as opposed to making a transit, exist? One proposal, the Urban Room, architect Michel Mossessian's concept (see Musheireb essay, p. 59), contains public space but also emphasises connections between spaces creating a porous boundary between public and private,

21 Constitución, Chile: PRES sustainable reconstruction masterplan by Elemental. Community workshop in progress at the PRES Open House.

22 Constitución, Chile: day of the popular vote for the mitigation park and other projects. Elemental's PRES sustainable reconstruction masterplan got 92 per cent approval.

29 Cameron Sinclair, *Design Like You Give a Damn: Architectural Responses to Humanitarian Crises* (London: Thames & Hudson, 2006).

transcending morphology with lighting, landscape design and art – Chicago's Millennium Park being an excellent recent example, and employing ways to streamline pedestrian flows. It makes people the foreground; encourages a sense of public ownership; accommodates evolving societal needs and rhythms in a convivial fashion. Some architects also stage events; others propose initiatives which generate funds and jobs for local residents.

The involvement of local residents and universities in the design process – as was the case for the masterplan for Medellín, Colombia, through talks, competitions and charrettes, sets up strong collaboration with the community in defining the public realm. But how fixed should it be? Yona Friedman, the architect, urban planner and designer, in his 1959 manifesto of mobile architecture, 'Utopies Réalisables',[30] said that planning rules could be created and recreated according to the needs of residents. 'Ideally the Urban Room should provide a space for people to make their own meanings. With this vision, it can become a dynamic place, driven by the new encounters and relationships it can foster,' says Mossessian, quoting the sociologist Richard Sennett: 'the attempt to find a finished form is always self-destructive'.

Evolutionary masterplanning design

'The built environment is an evolutionary process, like the emergence of life,' says Patrik Schumacher.[31] While the urban scale implementation of parametricism is still at a relatively early stage, ZHA's winning of a series of international masterplanning competitions – one-north, Kartal-Pendik, the mixed use Soho City project in Beijing and for Bilbao – demonstrates its perceived worth. If 'political and private buy-in' can be achieved, Schumacher feels, with appropriate planning guidelines put in place, the 'worthwhile collective value' of a 'coherently differentiated cityscape' gives the urban field a 'unique character and

order that all players benefit from'.[32] He also sees its validity as 'a framing agenda' within the contemporary context of metropolises of 20 million people upwards.

Whether S, M, L, or XL, who is instituting it?

However, now that governments across the world have cut public sector provision, people see a lack of central action in implementing plans that face the future but in fact, taken as a whole, governments are in fact very proactive in urban plans and in trialling new solutions, many of which may end up being adopted by other cities. The power of market forces has been greatly reduced since the global economic crisis started to bite in September 2008, but plans embodying a myriad of commercial goals have nonetheless revolutionised the appearance of parts of cities. Some have assisted social inclusion, and improved on older customs of public sector-driven low density. What adapted role are they likely to play now? The free market alone, in boom conditions or during times of crisis, is limited in its capacity to create the new conditions needed to move away from a reliance on cheap energy: energy-efficient transport infrastructure, retrofitting buildings and increasing urban density to promote walkable urban environments. This has been recognised by many governments.

Whether a plan emanates from the public or private sector or a stakeholder partnership between both is significant: governments working within statutory planning frameworks are more likely to be risk-averse because of the consequences of public mistakes, while in the private sector, if businesses do not risk making mistakes, they are not really advancing. Wide-ranging objectives, a mix of local priorities, and elements of national and central government policies have to be melded together with a high degree of reconciliation and clarity about advantages and what can be traded off. Ultimately whoever the client body and whatever their mix of aims, masterplanning has

30 Ibid,
31 Lecture, 'Proto/e/cologics: speculative materialism in architecture', Rovinj, Croatia, 6–7 August 2011, staged by the Mediterranean Laboratory for Architecture & Urban Strategies (MLAUS).

32 Patrik Schumacher, 'A new global style for architecture and urban design', *Digital Cities*, 79(4), AD, July/August 2009. Guest Editor: Neil Leach.

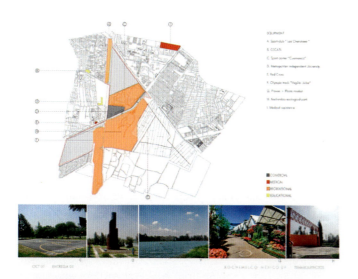

23 Xochimilco masterplan, Mexico City, TEN Arquitectos. The different facilities on the site including relocated sports facilities and flower market.

to include robust mechanisms to deal with issues of practical viability and management of rapid change. But to what extent should physical solutions fit in with environmental and policy constraints? In many masterplanning proposals, compelling reasons can be traced to adjust environmental planning and policy instruments.

Opening up a robust conversation

A masterplan can be a door opener in so many ways. Apart from whether it is implemented or not, 'it can be seen as an incitement to produce other things, speeches, reports, more plans and so on', says Adrian Lahoud, urban designer and Course Director of postgraduate Urban Design at the University of Technology Sydney.[33]

'In a way, the masterplan is only a provocation to produce more plans. Its 'use value' is its capacity to structure an ongoing conversation on a project, even if that means the original document will not be fully implemented. In this sense, the plan is always useful because it provides a focus for a forum of stakeholders, and it is able to raise questions and problems that might not otherwise be raised through other forms'.

He feels that understanding the masterplan as existing within a series and a network of other drawings and plans enables the burden of its success to shift from one of 'has it been implemented or not?' to 'has it structured a robust conversation among the different stakeholders?'[34]

Crowdsourcing ideas

The USA and many other governments, including France and Australia, have incubators for social innovation, and the European Union is shifting its emphasis in its research and development funding priorities towards new services based on citizens' ideas as well as those of experts. The ethos underlying social innovation in adaptive planning needs to be about collaboration: doing things with others, 'rather than just to them or for them: hence the great interest in new ways of using the web to "crowd-source" ideas, or the many experiments involving users in designing services' like urban farms, hospices and new urban bicycle schemes, as author Geoff Mulgan has stated.[35] Crowdsourcing can, for example, nurture positive behaviour change, and deeply inform how cities allocate their resources or structure environmental and transport policies, for example. Projects of this kind, using emergent distributed technologies as a newer, digital layer of a city, achieve acceptance and a sense of public ownership through trialling and prototyping.

33 Adrian Lahoud is Guest Editor, with Charles Rice and Anthony Burke, of *Post-Traumatic Urbanism*, AD Architectural Design, 80(5), 2010.

34 Interview with the author, 2011.

35 Geoff Mulgan, co-founder of Demos, the public policy research think tank, and now Chief Executive of the National Endowment for Science Technology and the Arts (NESTA), London, 'What makes you happy?', The Observer, 3 April 2011.

For Mulgan, it was Ebenezer Howard, founder of the Garden City movement, triggered by his 1898 publication, *Garden Cities of Tomorrow*, who influenced other planners such as Frederick Law Olmsted II and even Walt Disney (his design for EPCOT, or Experimental Prototype Community of Tomorrow), who created one of the most brilliant innovations in urban planning. Not suggesting that they are the answer now, he nonetheless bemoans the fact that nowadays, 'innovation in how we live our lives, in social solutions and social ideas, is organized in a much more haphazard way, resembling far more the science of the 1890s than that of the 21st century'. So far, 'We have not yet made the transition to scale and system that science made in the early 20th century,' he adds, and 'it is nobody's job to spot the most important emerging innovations, nobody's job to finance them and nobody's job to grow them to scale.'

Spatio-temporal spread models

Simulating complex systems through dynamic, advanced design techniques such as parametric scripting and agent-based modeling[36] is now much more widely used to emphasise differentiation and endow urban space with a sense of fluidity like natural systems. Just one example of many innovative urbanism further education courses – the subject of a whole book in its own right – is the Urban Environmental Management programme at Wageningen University, in the Netherlands. Planning and Design of Urban Space,[37] part of its Environmental Technology programme, focuses on creating ecologies through adaptation of environmental technology within the complexity of urban systems, devising approaches, tools, and methodologies for designing urban spaces and then achieving that vision through mechanisms that manipulate the city, for example, solar envelopes, quality programmes and spatial plans.

Mapping multi-scalar urban ecologies via Geographic Information Systems, or GIS (see Urban Think Tank interview, p. 141), generating time-based urban morphologies and 3D virtual spatial simulation modelling are innovations of immense value for conceptual masterplanning. Spatio-temporal spread models that can simulate anything from human migration, weather, to human ideas, as a convergence with different types of data, including social, create a better speculative understanding of

36 Using scripting in Mel-script or Rhino-script and parametric modelling with tools such as GC and DP.
37 http://www.mue.wur.nl/UK/.

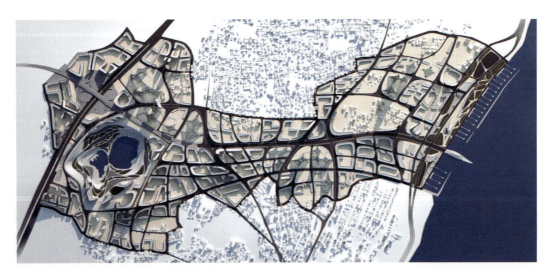

24 Plan for Kartel-Pendik mixed-use masterplan by Zaha Hadid Architects on the Asian side of Istanbul.

the city. Integrative innovations affording a whole new capacity for what could be called dynamic 'area atlases' are being researched by bodies such as the Centre for Advanced Spatial Analysis (CASA), University College London,[38] and in the field of sustainable planning, MVRDV recently proposed a demo version of a software and webtool,[39] which quantifies the 'behaviour and performance of a city' and makes it comparable to others, connecting qualitative to quantitative parameters. It could be used as a public and planning tool to support sustainable planning and is being conceived in collaboration with The Why Factory at Delft University of Technology.[40]

Digital-physical thresholds

The digital has not only rendered urban plans more publicly transparent as phenomena, trailed by bloggers, but moreover through the existence of proliferating mechanisms offering manipulable lenses through which to view and investigate the world. For example, Google Earth[41] and Green Map[42] systems are used by environmentally committed community agencies around the world to document green spaces, biking paths, endangered habitats and more, bringing a hyperlinked dynamism, enabling wider comprehension of place and of the forces impacting upon it. Worldmappers[43] allows fed-in data about numerous global economic factors, from population growth to energy use, to produce maps that reveal disparities between the developed and developing worlds. Stamen's Walking-Papers.org, a site with free geographic data, wiki-style open street maps users can edit and update online, personalising locations, has been used for humanitarian relief efforts, such as for Haiti, and in disenfranchised areas with a real

lack of on-the-ground information to help lobby for changes to urban infrastructure.

From parcelling up land to enabling frameworks

While masterplanning as a practice continues to be carried out widely as a service, merely reacting in a very limited way by parcelling up land for future profit, the immensity in the range of global needs requires a high-performance architecture-led physics of cities. This does not mean prioritising one thing – highways, for example – over another or compartmentalising, but having a priority strategy that deals with a diversity of conditions in and affecting urban space. That recognition has brought about a growing shift to harness multidisciplinary skills and public consultation to create menus for cities that function in a number of interconnected ways and anticipate growth. The city first appeared when the human mass confronted their differences. The contemporary masterplan must be, if it is going to hold any weight at all in the future, a reconciliatory, humane, questioning and progressive response to that reality – an enabling framework incubating new possibilities for all.

38 CASA runs the Digital Urban blog, available at: http://www.digitalurban.org/.
39 Proposed in 2009 as part of 'Paris plus petit', MVRDV's invited proposal envisioning the future of Paris, commissioned by Nicolas Sarkozy, the French President.
40 The Why Factory, Delft, the Netherlands, www.thewhyfactory.com/.
41 Google Earth, www.earth.google.co.uk/.
42 Green Map, www.greenmap.org
43 Worldmapper, www.worldmapper.org.

1

Post-industrial urban regeneration

Ørestad, Carlsberg, Loop City, Nordhavnen, Copenhagen, Denmark

In the book *New Architecture in Copenhagen, Copenhagen X 2009/2010*,[1] the Danish capital is represented by no fewer than 17 current masterplans, ranging from the 200-hectare container port and harbour test site of Nordhavnen, a kind of small, CO_2-neutral Venice in the northern docks, to which the developers By & Havn are taking the public on four sailing trips a week in order to discuss the issues arising from the proposed extension, to the southern Ørestad, the largest urban development project in the city (realised by developers By & Havn, NCC and others), to the old meatpacking district, Kødbyen, for which young architects Mutopia devised a plan to include art and meat.

This wealth of masterplans is evolving at a time when the city has a strong identity as a centre of green interests – the COP15 United Nations Climate Change conference was held there in 2009, more than three-quarters of its housing energy comes from district rather than oil-based heating, and it lives by new

1 Nordhavnen, Copenhagen, rendering of site of masterplan by COBE, Sleth and Rambøll, CPH City & Port Development.

1 DAC/Danish Architecture Centre, *New Architecture in Copenhagen, Copenhagen X 2009/2010* (Copenhagen: DAC, 2009).

2 Nordhavnen, Copenhagen, rendering of site of masterplan by COBE, Sleth and Rambøll, CPH City & Port Development.

masterplanned by a team led by Søren Leth of SLETH Modernism,[2] to create a compact mixed-use residential area. With a 'ceiling' of six storeys in most places, it has an 'intelligent grid' with different sizes and types of accommodation, and a 'green loop' incorporating the future Metro, with a bicycle path that will cover the whole district, so that there will never be more than a 400-metre walk to public transport. Historic traces of the harbour will be the starting point in a plan with 50–50 residential and commercial buildings, 70,000m² of retained buildings, and variety of green zones, parks and waterfront promenades. It will have the density of the typical Danish city. Henrik Nowak of Rambøll, one of the consultants, says it will embody 'a sense of the qualities we know from suburbia',[3] yet still be compact and accessible: 'We think it's sensible to live in the centre of the city,' says Leth. 'We would like to pull Copenhagen right out to the water's edge and enjoy qualities of the inner city.'[4]

Jan Christiansen, municipal architect in the city, says the biggest challenge is for Copenhagen to create quarters where different social groups meet. What kind of planning does it take to ensure the liveliness of that mix? In 2007, the architectural practice Entasis won the international competition for the development of the brewing firm Carlsberg's 33-hectare industrial plot in Valby, Copenhagen. The proposal aims to reconcile the classic city's density with credible urban environments, boosting the social sustainability of the area with coexisting cultural buildings and spaces, offices, kindergartens, shops and homes. The plan maximises the diversity of housing possibilities with different target groups.

This project is very interesting as an example of a commercial firm forging the transformation of an entire city district. Indeed, when industry decides to retain control of its inner urban site, and transform it for new uses, does compromise have to follow? It was back in 2008 when Carlsberg moved

laws to reduce carbon dioxide emissions by 20 per cent within 5 years. It famously embraces the bicycle – 35 per cent of all journeys are made using this form of transport. It is also rapidly growing: today it has 500,000 residents, but by 2024 this number is estimated to have increased to 580,000, and this anticipated increase has propelled the development of numerous urban districts, new housing and workplaces, and ease of access is a top priority.

One of the most promising plans is for the Nordhavnen district, a peninsula on the Øresund coast, 4 km from the city centre, whose first phase of development began in 2011. Used by dockers and fishermen for more than 100 years, it is now Scandinavia's largest metropolitan development project, being

2 Following the open international ideas competition for Nordhavnen's layout, the entry 'Nordhavnen –Urban Delta' was chosen, and COBE, SLETH Modernism, Polyform and Rambøll were appointed in connection with the masterplan.

3 Henrik Nowak, Rambøll, 'Nordhavnen: The Green City, interview', available at: www.nordhavnen.dk.

4 Søren Leth, SLETH, 'The Compact City, interview', available at: www.nordhavnen.dk.

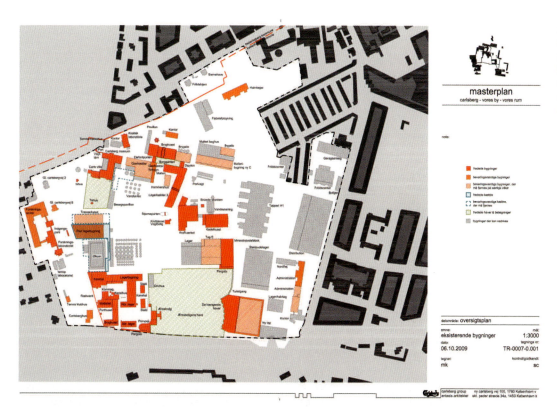

3 Carlsberg masterplan, Copenhagen: map showing listed buildings, gardens, basements and buildings on the Carlsberg site, to be demolished (in grey), Entasis.

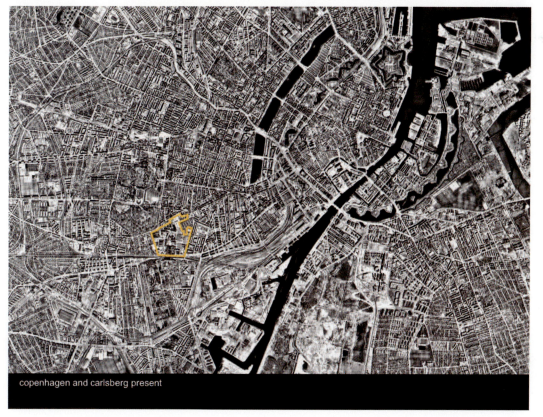

4 The Carlsberg site in the context of Copenhagen, Entasis.

production from its 33-hectare Valby site in the centre of Copenhagen – in use since 1847 when it was farm land – to Fredericia on the Jutland peninsula, leaving the site, which currently has a customs barrier around it, open for redevelopment and public access. However, as Lars Holten Petersen, Properties Director at the firm, said at the time, 'We still have a presence in the area and we want to be connected with it. It's not a hit-and-run project we simply make a ton of money on. It [the scheme for the site] has to be something that the city and its residents will like.'

As soon as it was made known that the firm would be moving out of the city, a broad spectrum of suggestions, ranging from a single nature park to skyscrapers, began to trickle in from the public. Gehl Architects were also asked by Carlsberg to propose ways in which the district could develop, building on the site's historic identity. On the basis of this initial investigation, in 2006, the firm launched an international ideas competition.

In the early days, Carlsberg was a patriarchal company that took care of its workers. Now, its symbolic multinational identity and shift in location call for urban responsibility. Petersen makes the analogy with the responsibility of raising a child. You cannot predetermine everything: as they grow, they want to do things themselves and handle them alone. With urban areas, 'You can give them a base and a framework, but at some point they take over and develop on their own terms.' He predicts 5–10 years of development to create Carlsberg's new urban centre, but the firm aims to avoid the site becoming isolated like the Forbidden City in Beijing, instead giving a boost to neighbouring areas like Vesterbro, Søndermarken and the traditional residential district of Valby Circle. Underground parking will avoid Vesterbro's congestion, and Petersen also wants underground roads.

'We actually think we can build an urban environment that is denser than Vesterbro but seems much more open, friendly and accessible,' he adds, explaining that the district isn't just reserved for people with a certain income level or 'people of a certain persuasion'. 'We want this new urban area to be festive, folksy and fun.' Ørestad is not Carlsberg's model. Instead, Christiania, the Freetown, is closer to their aims. 'In our conceptual framework, an urban district is a confrontation in the positive sense of the word.'

Carlsberg invited participants to enter the open competition to ensure that 'top names outside Denmark with an analytical

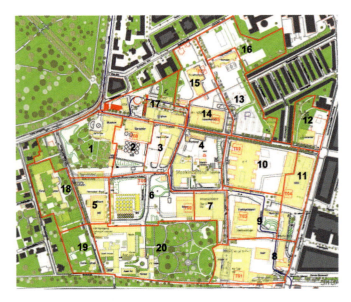

5 The Carlsberg masterplan, Copenhagen, showing the separate building 'sections'. The numbers originally represented a chronology, number 1 being the first. However, the order has changed as the planning of the first building section stopped two years ago due to the financial crisis, and number 8 by the station seems to be the first one to be planned, with a couple of competitions taking place there, Entasis.

approach to urban planning participate'. The Danish architectural practice, Entasis, founded by Christian and Signe Cold in 1996, were entrusted with the job of masterplanning the site to create a vibrant and sustainable part of the city with housing, shops and offices (a total of 800,000m²: 45 per cent housing, 45 per cent shops and 10 per cent sports and cultural facilities). They created a network of public spaces – gardens, squares, axes, streets, alleys, passages and public buildings in 17 defined areas, 12 of which were given a functional and aesthetic code.

Entasis believes that a successful definition of Carlsberg's urban spaces in turn helps encode architectural and functional form, not the other way round. Their masterplan is not a tool to create a historic city or to museumify the site, but, they say, aims to produce a robust, modern, 24/7 and CO_2-neutral district with contrasts in building heights, in existing and new elements, and in labyrinthine and axial experiences of it.

6 Chart of the existing Carlsberg site in Copenhagen, showing what is presently going on in the buildings.

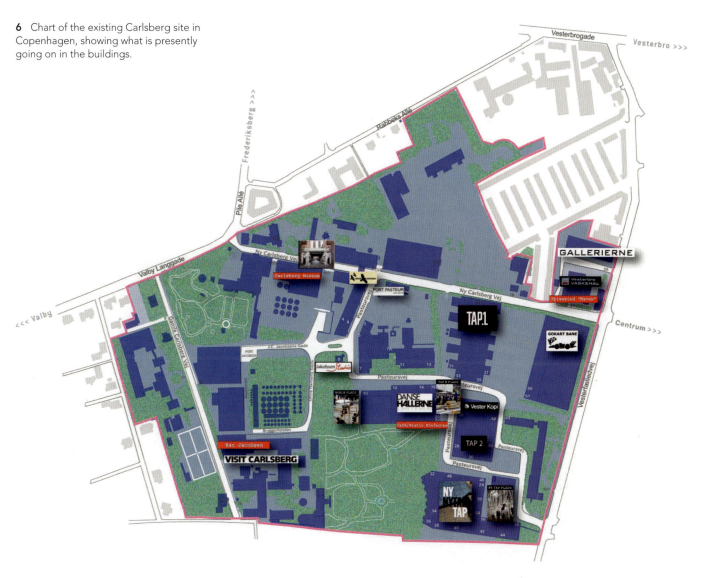

Area 17, the first to be developed, has seven buildings set around the oasis of Industrikulturens Plads, three of which are preserved structures, and four new ones. Some listed buildings could not be developed, while some other structures were ripe for reuse. Along the south border of the site on either side of a brewery building from 1901 are 17.3 by Arstiderne, an office building, and 17.4, a silo renovated by Vilhem Lauritzen, with office space. 17.1 and 17.2 are new buildings by Danish architects Vandkunsten and Henning Larsen – residential/ground floor businesses such as cafés, shops, clinics – on either side of The Grey House, an Italianate villa from 1875.

Drawing inspiration from the classical, dense city centre, the new mixed-use plan also includes nine slim towers 50–120 metres high. There is a commitment to shared space, not

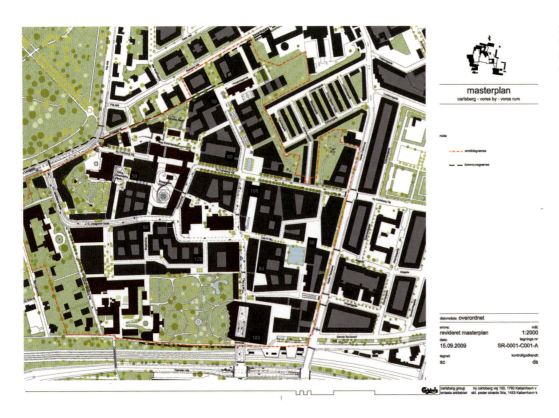

7 Masterplan by Entasis of the future Carlsberg site, Copenhagen, the basis for the local plan.

through uniformity but by the proximity of short narrow streets, alleyways, and mix of large and small squares. Carlsberg's extensive network of underground corridors and cellars lend an aura to the reuse of this exceptional site. However, no amount of subterranean fun would make up for a disappointing design at ground level, and it seems Entasis's plan grasps exceedingly well the challenge of making a new piece of city out of an industrial site.

Carlsberg created a public forum, and people sent in hundreds of ideas. Early on, Gehl's proposal showed how the district could develop, with five key words: identity, activity, structure, sustainability and development. Carlsberg wants the new district to build on what was there before, open it up and

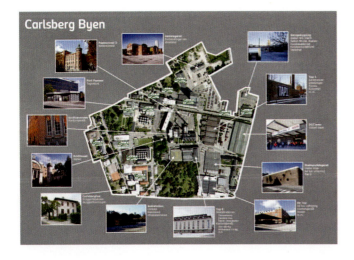

8 Photocollage made by Carlsberg showing the different existing buildings on its site in Copenhagen, Carlsberg A/S Ejendomme.

give a boost to the neighbourhood around it, the Vesterbro and Sondermarken districts, Vestre Cemetery and the more traditional districts of the Valby Circle. Since 2010, the project has been in a quiet and non- productive phase, while Carlsberg was looking for a financial partner. A couple of announced international design competitions may be a sign that activities will resume soon, and still retain the mix of functions envisaged.

By contrast, Ørestad is an emerging 5km-long strip of mixed-use community along the Metro connecting the inner city and bordered by Amager Common, an enormous piece of field land. Now with 5400 residents and a total of 20,000 expected within 20 years, it epitomises Scandinavian architecture and urban planning's contemporary focus on social and cultural demands, and the further renewal of democratic society as a model first addressed by 'Velaerdsstatens Arkitektur' (welfare architecture) in the 1950s. This social 'pact' was renewed in the 1970s in the wake of the globalised economy impacting on what had become an economically poor city that its citizens increasingly rejected as a place to live in favour of the suburbs. Industry moved out in the 1980s and left Copenhagen a diminished former centre of growth. Traditional working-class

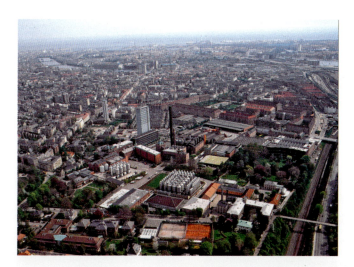

9 Aerial view of the Carlsberg site, Copenhagen, as it is today.

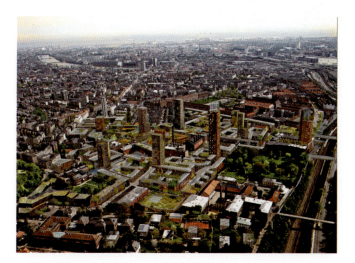

10 Aerial view of the Carlsberg site, Copenhagen, a visualization of the masterplan, Entasis.

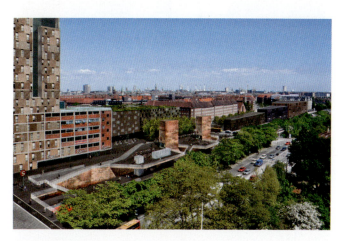

11 View of the future station at the Carlsberg site, Copenhagen. The roof of the platform is a giant cardiogram. The station project is not shown on the masterplan as it was not yet politically approved at this point (May 2011), Entasis.

12 Visualization of 'the basement square' at the Carlsberg site, Copenhagen: a small square is planned around an existing listed basement, originally used for storing beer, Entasis.

13 Visualization of a shopping colonnade at the Carlsberg site, Copenhagen, showing views of the existing former power plant in the background, Entasis.

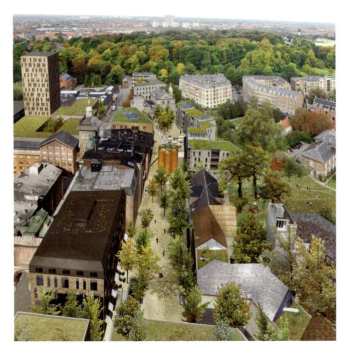

14 Visualization of the future plaza behind the listed brewery with the buildings at the Carlsberg site, Copenhagen – Frederiksberg and Søndermarken – in the background. Most of the new buildings have green roofs, Entasis.

housing was not up to standard for renewal. Something had to be done.

The issue of Copenhagen's renewal was raised with the government leading to a decision in 1989 to boost the city and build a bridge between Copenhagen and Sweden (then not part of the EU), in a government-driven programme to support better infrastructure. A competition for a scheme to connect a new district to the inner city, the bridge and the airport was launched, and a development company was set up. As recently as the 1970s there were trolley buses to the area, but no Metro, which was agreed on by the government in 1992 in tandem with the decision to go ahead with Ørestad, as part of a decision to improve the city to allow it to compete with other major European cities. The financing of the Metro was inspired by the

English New Town principle: the infrastructure is paid for through the increased value of land. By building Ørestad, Copenhagen would not only finance the Metro, but also create a new urban district to help lever the city out of its crisis of low economic growth and high unemployment.

As a vision, Ørestad was in part inspired by Dutch canal city plans, which are 'an example of the urbanity that was wanted, not as a design guide of the structure,' says Rita Justesen, Head of Planning for By & Havn, the developers.[5] The designated site for the skinny, 310-hectare, 600 metres wide, piece of city was on field land stretching 5km from the city centre, some of it a former military training area on the island of Amager to the south-east of Copenhagen. Owned by the Municipality and the state, it had a natural preservation area to its north.

In the Spring of 1994, the mandatory open competition for the masterplan – an ideas competition – was launched and four winners were chosen for the plan, Erik Bystrup; Aaro Artto and colleagues (Finland); Matthew Priestman Architects/Tower 151 Architects (the UK) and Jan Henrisen and colleagues (Danish). Competitions for plans for an educational campus on the first part of the site, and later in 2000 an IT University and Science Park, a new complex for the Danish Broadcasting Corporation, a new Hotel Pro Forma, the Tietgenkollegiet Hall of Residence (2002) and a new secondary school (2003), were also held. Allied with these educational and media functions, 'from the start it was the government's intention that Ørestad should be mostly a business area', explains Justesen. 'Later it was decided to develop a city quarter with approximately 25,000 inhabitants, 30,000 students and 60,000 workspaces.'

The masterplan vision had a number of priorities to do with connectivity, linking to the old city via the anticipated Metro and within walking distance of four of its stations to the field land. From everywhere, in fact, the elevated sections of the Metro can be seen, mounted on pillars in order to allow other activities in the free areas under the railway. The fourth priority committed to giving each of the four intended districts at Ørestad a distinct character.

In 1995, after the ideas competition, the young Finnish practice Arkki, collaborating with Danish architects KHR as Arkki

15 Ørestad, the 1995 masterplan diagram of the light rail systems in red, with the station catchment areas within a radius of 600m. Station 5 is Ørestad Station with interchange to the railway to the airport and to Sweden. Photo: CPH City & Port Development.

5 Interview with the author, 2009.

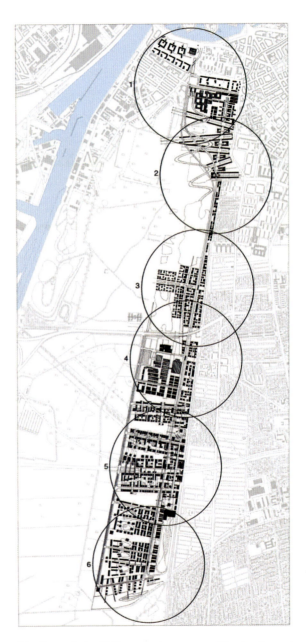

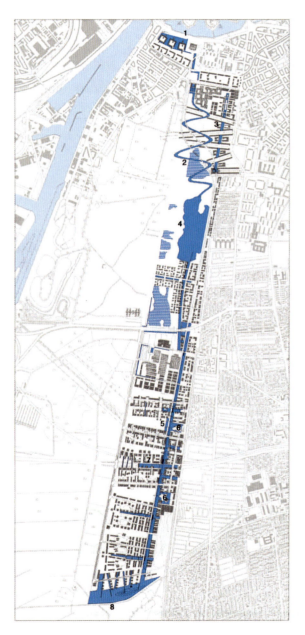

16 Ørestad, the 1995 masterplan presented by the Ørestad Development Corporation follows the general concept of the Finnish first prize entry in the ideas competition. It shows catchment areas for the Metro stations by 600m circles: Islands Brygge, University District, Sundby, Bella Center, Ørestad and Vestamager. The schematically drawn up building patterns were used as a guideline in the first competitions until the masterplan was revised as a result of these, CPH City & Port Development.

17 Ørestad, the water element (lake, preserved wetlands and canal) in blue, CPH City & Port Development.

ApS, presented a unified plan to the City of Copenhagen. The following year, the city agreed on a zoning plan which determined the boundaries of the future Ørestad. Its districts share a high density of tall buildings, and contrast with the large horizontal landscape of the nearby Faelled district. Strips of green space, long connecting streets, with water as the orientating and structuring element – the scheme Arkki ApS came up with seemed quite Dutch, as By & Havn had anticipated. The Metro builders announced they would take the line underground along the first fifth of the site, and then overground. Ten years of masterplan refinement followed the competition win. During the 1990s, Ørestad came in for public criticism, mostly because it was relatively long in planning, during which time society changed. The very phased nature of the scheme appeared to be one liability. As the investors came in, the clients tried to be strategic and keep the nascent

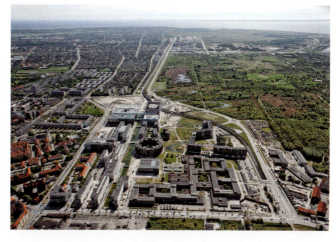

19 Ørestad, Aerial photo of Ørestad North with the KUA educational and research campus in the foreground, Photo: Ole Malling, CPH City & Port Development.

population motivated, largely by maintaining a broader variety of housing. Appropriate residential solutions were especially vital to fuel the academic institutions locating at Ørestad North.

In the end, what has emerged are four districts, each with their own Metro stop close to hand: Ørestad North, the most developed part which has the iconic DR Concert Hall by Jean Nouvel commenced in 2000; DR Byen, the new headquarters of the Danish Broadcasting Corporation; the IT University designed by Henning Larsen; an extension of the existing University of Copenhagen at Amager (KHR Architects), boosting its role in knowledge industry with new facilities sited here; and Tietgenkollegiet, halls of residence by Lundgaard and Tranberg and apartment buildings. Its clustering of amenities makes the main streets easily readable to the pedestrian as a work-oriented enclave.

One Metro stop further takes the visitor to the Amager Faelled district, to date developed only on the eastern side, and the location of Amager Hospital, Småland day-care centre, and residential areas of Solstriben and Ørestad Friskole. The western part borders on the substantial greenfield site running the length of Ørestad, and will be the last to be developed. At Ørestad City, construction work began in Autumn 2007, and by

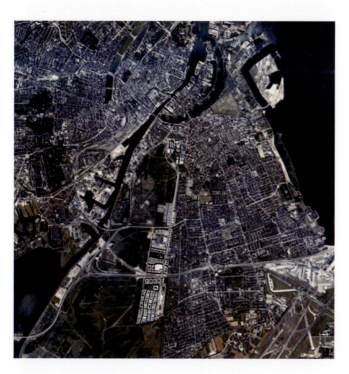

18 Aerial photo of Ørestad in its context south Copenhagen. Photo: CPH City & Port Development.

summer 2009 its apartment buildings were occupied by families and some businesses at ground level. There is a regional train station as well as a park surrounded by housing. Delineated by Center Boulevard to the west, Arne Jacobsens Allé to the north, Ørestads Boulevard to the east and the motorway to the south, the magnet at its most southern point is Fields, a big shopping centre minutes from the Metro station. Ørestad South, bordering on the Kalvebod Faelled district, has been under construction since 2007/8, intended to become the most populated district, with capacity for 10,000 people to take up residence, and another 15,000 to work in its businesses, residential areas, shops, schools and other public services. Here Ørestad Urban Gardens, which began as a mobile scheme but is now permanent, have created 60 organic allotments of 16m², in which members can grow anything so long as it is organic. The plots lie along a 10-metre-wide green band part of the Plug 'n Play area for leisure and sporting activities.

German architect Daniel Libeskind prepared the master-plan for Ørestad City for NCC Property Development, Ørestadsselstabet I/S and Steen & Strøm A/S, scheduled for completion by 2012–13. He envisaged a unique district of buildings and public spaces well considered in design in which people would enjoy circulating and lingering. It has been designated Ørestad's 'downtown', suggesting an interesting international environment. He was inspired by the medieval city

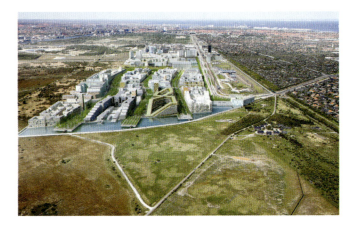

21 Ørestad, aerial visualization of Ørestad South with the mixed-use 8 House (completed in 2010) by BIG on the outer edge of the development overlooking the common. Photo: CPH City & Port Development.

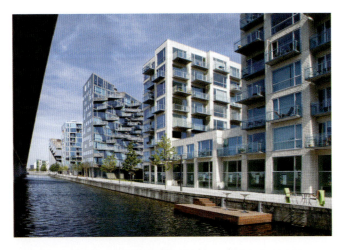

20 Ørestad City, with VM Houses by PLOT (completed in 2005) in the background. Photo: Lena Skytthe, CPH City & Port Development.

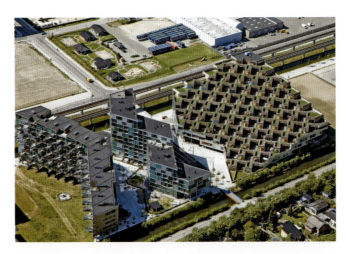

22 Ørestad, Aerial view of VM Houses (completed by PLOT in 2005) and the mixed-use Bjerget MTN (completed in 2008) at Ørestad City. Photo: Ole Malling/By & Havn I/S.

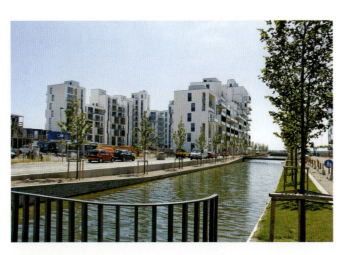

23 Ørestad, housing by Vilhelm Lauritze at Ørestad South with views over western Amager. Photo: Lene Skytthe/CPH City & Port Development.

centre of Copenhagen only 10 minutes away, with its winding streets, intimate urban spaces and tranquil courtyard gardens. The central square below his two towers is the same shape and size as the central area of Kongens Nytorv square. Like the rest of Ørestad, this is a pedestrian- and cyclist-friendly scheme, with vehicular traffic placed underground. The central street running alongside the shopping centre is a gallery protected from the weather by large glass canopies. The programme includes shops, cafés, restaurants, cinemas and a major cultural facility, workspaces and business facilities for a projected 5–7000 people who will work in the area, high-rise residential buildings, two large hotels – Cab Inn, the largest hotel in Denmark here with about 700 rooms – and two towers of about 20 storeys with 37,000m² of residential and office facilities, all buildings designed by Libeskind.

Currently two complexes play a significant relationship in response to the masterplan. On the east side of the north–south route next to the elevated Metro tracks at Ørestad City is the 32

24 and 25 Ørestad, housing development bordering the canal running down the spine of the district. Photos: Lene Skytthe/By & Havn.

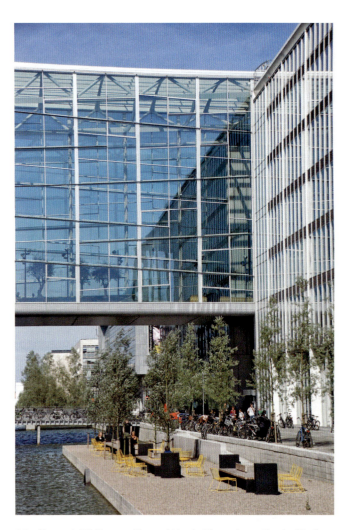

26 Ørestad, DR Byen at Ørestad North. Photo: Lene Skytthe/By & Havn.

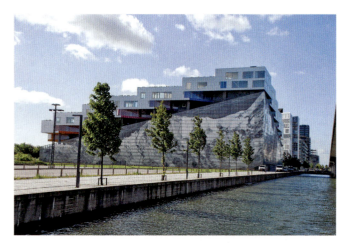

27 Ørestad, the mixed-use Bjerget MTN development at Ørestad City completed in 2008 by BIG. Photo: Lene Skytthe/By & Havn.

metre-high, 10-storey Bjerget MTN (mountain) designed by Bjarke Ingels of BIG, only one-third of it housing, in what appears as a suburban neighbourhood of homes – all with roof gardens – above a 'concrete hillside' podium of parking, a scheme awarded the prize of 'world's best housing' at the 2008 World Architecture Festival. 'How can the relaxed atmosphere typical of suburbs be united with the social intensity expe-

rienced in an urban setting of dense buildings and city life?' asked Ingels, in the context of a masterplan that 'dictates a city consisting largely of square perimeter blocks, the generic ingredient in 90% of Copenhagen's urban tissue'.

Shaped like a V and an M when viewed from above, the V and M Houses with 225 duplex and triplex units and more than 80 unique types, designed by PLOT (Bjarke Ingels and Julien De Smedt, who split to form separate practices in 2006) were the first residential buildings to be constructed at Ørestad in 2005. Their multilevel nature interlocks them in a Tetris game-style of composition in wood, glass and aluminium. V-House's south-facing balconies combine minimum shade with maximum cantilever overlooking the common. Envisaging residents as 'pioneers of a new town'[6] surrounded by construction sites, BIG's angling of balconies creates visual connections to neighbouring apartments in a vertical radius of 10 metres. The other distortion of a square block, M House, was conceived as 'a Unité d'Habitation version 2.0' (after Le Corbusier), zigzagged, and all the corridors have good views and daylight in both directions. As with MTN, both were sold out very quickly.

6 Ibid.

28 Ørestad, The tiled portrait of BIG's client Per Høpfner at one of the entrances to VM House, PLOT, Ørestad City, CPH City & Port Development. Photo: Lucy Bullivant.

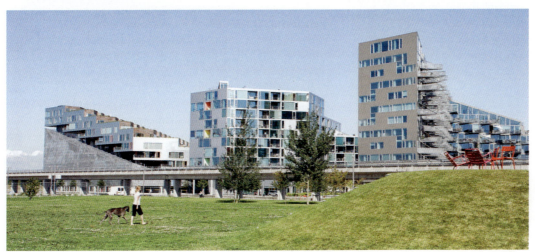

29 Ørestad, the VM Houses (PLOT) and MTN development, BIG, seen from the common on the west side of the district. Photo: Lene Skytthe/By & Havn.

In 2010, BIG completed 8 House at the southern end of Ørestad, which called for an east–west route through the housing to a nearby square.[7] Within the general context of the masterplan, BIG avoids a Modernist formula, with the form rising in an individualised 'layer cake' from row houses with front gardens, traditional apartments to penthouses with roof gardens. The architects opened up the block and twisted it into a figure of eight, creating two new plazas and an extended pavement, lifting up the north-east side and pushing down on the south-west side, to ensure the widest views of the surrounding protected landscape and suburbs, 'as well as eliminating the vis-à-vis between blocks'.[8] This distortion creates 12 storeys towards the public areas of the district to the west and reduces down to four floors on the east side facing the suburbs, creating a ramped 'mountain walk' for pedestrians and cyclists right around the figure of eight.

This kind of design differentiation can be induced from a masterplan that did not necessarily anticipate that challenge if the regulations allow it. Certainly it fits in with Ørestad's intended spirit, if not the straightforwardness of its masterplan. From the beginning, Ørestad was meant to be an intense new live–work neighbourhood, operating 24 hours a day, and not a typical dormitory town. Justesen says: 'Ørestad is not what we understand as suburbia. When it is realised, it will include day care centres, schools, a gymnasium, shops and mixed use. It is close to the city centre, to the airport and to the motorway system and at the same time you have the quality of the green common.'[9]

There is not yet such an intensity in all parts of the district, which has much to do with the crisis affecting the numbers of commercial units at street level and the fact that only a quarter of the projected population is as yet resident there. But, if not yet possessing the density of older districts, it does have novel features, such as the beautiful north–south canals, forming recreational lines, which function as rainwater reservoirs and contribute to Ørestad's sustainable profile. A 2006 Gallup profile showed that as many as 71 per cent of the inhabitants of Ørestad were under 40 years of age compared to 48 per cent in the rest of Copenhagen. More than two-thirds have a higher education, while the figure is 39 per cent for the rest of the city. Ørestad has more families with young children than the rest of Copenhagen; 28 per cent of the interviewees have children who live at home, the figure for the rest of Copenhagen being 25 per cent. Moreover, the under-30s in Ørestad constitute a larger group than in the rest of Copenhagen (33 per cent compared to 23 per cent).[10] Ørestad possesses too much distance between its buildings, but the green spaces are being more heavily used, and this will hopefully develop further as the district is still evolving, and this demographic of residents are reported to be very happy about the quality of their new apartments and green surroundings and close proximity to the centre of the city.

Ørestad is just 5km by motorway or railway from the new 17km bridge which opened in 2000 linking Denmark and Sweden, enabling Copenhagen and Malmö to become one large metropolitan area. The aim is to make not just Copenhagen but the entire Øresund region (which includes the Copenhagen Metropolitan Area and Skåne, the southernmost region of Sweden), which has 3.5 million inhabitants, into one of the most dynamic growth centres in Northern Europe. This makes sense as Copenhagen is the pivotal point where Central and Northern Europe meet, and the largest metropolitan area in Scandinavia, with excellent access to the Scandinavian and Baltic markets, a highly developed infrastructure, a large concentration of knowledge and a high growth rate.

Another scheme that aims directly at fulfilling this vision is BIG and Kollision's excellent Loop City animation.[11] This brave stab at a 50-year plan shows how the 1947 'Finger Plan' of Steen Eiler Rasmussen for the city's expansion, which connected the suburbs and the centre, can be used as a basis for linking Copenhagen with the Øresund region. Built on over many

7 Bjarke Ingels, *Yes Is More: An Archicomic on Architectural Evolution* (BIG ApS, 2008), published on the occasion of the 'Yes is More' exhibition, Close Up: BIG, at the Danish Architecture Centre, Copenhagen, 21 February–31 May 2009.
8 Ibid.
9 Ibid.

10 According to By & Havn.
11 BIG and Kollision, '1947–2047: From Fingerplan to Loop City', shown in Q & A: Urban Questions _Copenhagen Answers, the official Danish contribution to the 12th Venice Architecture Biennale, 2010.

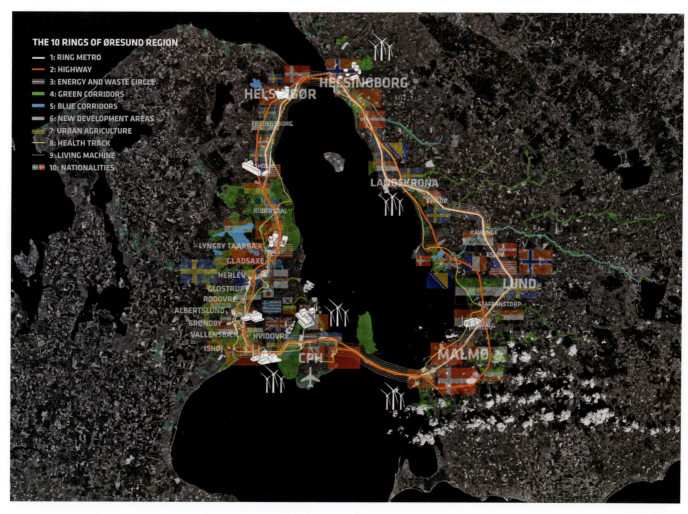

THE 10 RINGS OF ØRESUND REGION

- 1: RING METRO
- 2: HIGHWAY
- 3: ENERGY AND WASTE CIRCLE
- 4: GREEN CORRIDORS
- 5: BLUE CORRIDORS
- 6: NEW DEVELOPMENT AREAS
- 7: URBAN AGRICULTURE
- 8: HEALTH TRACK
- 9: LIVING MACHINE
- 10: NATIONALITIES

30 Loop City masterplan concept to revitalize Copenhagen's suburbs suburbs linked to the cross border region between Sweden and Denmark, BIG and Kollision.

years, the plan had, by the 1990s, resulted in urban sprawl, eating up land and causing traffic jams. Initiatives to convince people to stay in the centre of the city led to a number of plans, but Loop City proposes in addition a ring of industrial areas in the suburbs between the fingers with a new light rail Metro. BIG argue for 'a smarter grid' and a second green revolution after the end of oil, and in the face of many challenges – exploding

waste per capita, water shortages, falling biodiversity, huge increase in the number of older people, obesity, robotics transforming industry. In asking, 'Could we dedicate this massive urban development to addressing the new challenges, not as individual cities with separate tasks?', they instead propose ten parallel strategies in an infrastructure spine that honours flows – of people, energy, waste, water, fauna and flora.

In this way, the Metro is defined as an artery of dense urbanity, with the Loop as a spine of sustainable infrastructures and a continuous green band. The Loop's 11km of linear city is equivalent in size to the dense inner city of Copenhagen, and BIG propose extending it with the Metro to Helsingborg in the north, creating an entire transcultural loop of the Pan-Scandinavian region as a centreless metropolitan area comparable in size to San Francisco Bay.

Ørestad lacks street life, dispersed shops and facilities and a sufficiently wide range of housing, but Leth, in fully addressing these issues at Nordhavnen, nonetheless defends its urbanism as new and different.[12] As for Carlsberg, when the historical roots of sites are so specifically identified as industrial, or as potentially unbuildable (marshland) or green field, a leap of faith is required by all concerned that a valid *genius loci* can percolate. Strengths inherent or adopted can overcome weaknesses and, in the case of Ørestad, its close proximity to the city centre facilitated by the Metro partly compensates for the lack of street level dynamism, a problem a future plan such as Loop City does address through its very densely integrated nature.

For the moment, Copenhagen city dwellers have an expanding array of living options, each spearheaded by multiple urban masterplans competing for their attention. At 'What makes a liveable city?', the title of the Danish Architecture Centre's 2011 exhibition of no fewer than 100 plans for the city, exploring the huge changes that have taken place in Copenhagen in the past decade, visitors were invited to make an e-magazine to be used as a personal guidebook, which is an encouraging form of citizen input to the professional debate. On this occasion, the Mayor, Frank Jensen, threw out a further cue for visionary masterplanning principles when he remarked that 'In the future we will need green growth and green welfare, and this calls for close cooperation between architects, planners, companies, citizens and everyone who contributes to the life of the city.'[13] This is a vital layer of any liveable city, and needs to be dovetailed with all the multiple plans encompassing various income levels that give citizens a real choice. The Danes' recent experience with their urban experiments has raised standards and only inclusive plans will make the grade in future.

12 Søren Leth, quoted in Oliver Lowenstein, 'A green reckoning: Copenhagen's eco-blueprint divides opinion', *The Financial Times*, 12–13 December 2009.

13 'What Makes a Liveable City: New Architecture and Urban Development in Copenhagen', exhibition, Danish Architecture Centre, Copenhagen, 10 June–23 October 2011.

HafenCity, Hamburg, Germany

While the new development of HafenCity in Hamburg, an island that sits in the course of the River Elbe, intersected by harbour basins, has visible signs of its history as a port, and many buildings there are being renovated, at 157 hectares this waterfront scheme represents a major paradigm shift for Hamburg City, forecast to increase its population of 1.78 million[1] by 40 per cent.

The idea of a new inner city district was conceived soon after the fall of the Berlin Wall and the Iron Curtain, as Hamburg changed identity to being the metropolitan hub of a continent evolving more cohesively once again. Connections with Northern Europe were improved and the Baltic Sea grew in significance. An urban planning ideas competition for a draft masterplan with the intention of doubling the population of Hamburg's city centre was staged in April 1999, after initial studies in 1997 and 1998 by the authorities and GHS.[2] The winner, announced in October 1999, was Hamburgplan by a Dutch-German team of KCAP with ASTOC. The masterplan was approved by the Hamburg Senate in February 2000, and presented to the public via a number of exhibitions and events. At its heart was the concept of 'a finely tuned mix of uses', as Jürgen Bruns-Berentelg, CEO of HafenCity Hamburg GmbH – the public company owned by the city of Hamburg – puts it.[3] The masterplan was kept to scale, and its flexibility, by comparison with the existing city centre and the historic Speicherstadt district, has proved a good basis for ongoing planning and development, one that embraces the differing interests of end users and helps to create a versatile, diverse piece of city with retained port structures. One that has the capacity to be flexible and to adjust to changing needs in the future.

Intense interaction between existing buildings and the water, involving raising buildings to protect against flood, and public ground floor uses were key concepts, along with the goal to make HafenCity emblematic of a business, social, cultural and urban economic breakthrough, impacting greatly

1 Some 4.3 million people live in Hamburg Metropolitan Region (Source: HafenCity, Hamburg, 2011).
2 Gesellschaft für Hafen und Stadtortentwicklung.
3 He is also a real estate economist.

on Hamburg's city centre for the next century. It was also conceived of as a model for the European inner city of the twenty-first century, with 10.5km of new waterfront with promenades and squares, which, including the parks, total over 27 hectares. Development plans up to the 2020s for various neighbourhoods were integral to the plan. The three eastern neighbourhoods, Oberhafen, Baakenhafen and Elbbrücken, that had a more suburban character in the first masterplan draft,

were redesigned in a more compact way, now better integrated into the surrounding areas, and thus developed a stronger identity of their own.

When completed, the entire district will be home to 12,000 people, 40,000 workers (as of 2008 around 200,000 businesses were operating from the district) and up to 80,000 visitors.

Kees Christiaanse, founder and partner of KCAP, dislikes the idea of 'dead office cities', and sees the advantages of

3 HafenCity, Hamburg, KCAP: render overview.

combining living, working and leisure spaces. For him, the masterplan strives for 'the symbiosis of the city and HafenCity'. As in the case of Westfield's involvement as retail developers with London's 2012 Olympics legacy masterplan site, there are strong corporate drivers. HafenCity gains an advantage in its claim to create a new piece of mixed use city through the presence of their workplaces. Spearheading the identity of the business sector at HafenCity are firms such as the multinational Unilever (1,150 employees in a new headquarters building by Behnisch Architekten, won in competition with a remit to adhere to the masterplan, and incorporating an apartment block as part of the development, along with ground floor retail and a spa), the Spiegel Group, brought together in a new building by Henning Larsen Architects, on the Ericusspitze, with partial use of the ground floor for public purposes. This sits next to the Ericus-Contor, also designed by Larsen, on the eastern end of Brooktorkai, a district that staged its own urban design competition, which was won by a local practice Gerkan, Marg und Partner. It has buildings that have been certified with the gold standard of HafenCity's eco label, including the Marco Polo building, including some of the district's most exclusive apartments, also by Behnisch, who regarded the quality of the public spaces as clearly a major priority for the planners.

4 Masterplanning competition model of HafenCity, Hamburg, KCAP.

Together Christiaanse and his clients designated Oberhafen as a place for the arts, retaining some of the old warehouses and industrial spaces for lease to art associations, Baakenhafen was to be developed primarily as a residential and leisure quarter, while Elbbrücken will be a mix of residential and

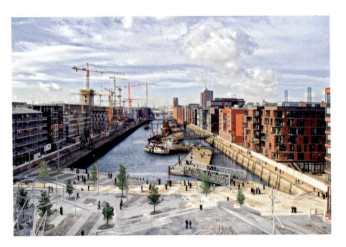

5 HafenCity, Hamburg, KCAP: Bird's eye view of the Magellan Terrace at Sandtor Quay with ship dock.

6 HafenCity, Hamburg, KCAP: Bay at Sandtor Quay.

business. Large and small squares encourage spatial integration, and the green, open character of the district, including a new green riverbank zone and bridge linking to the Entenwerder peninsula, will be intensified. 'The most varied patterns and structures of use converge here, and public spaces play a pivotal role in the HafenCity concept,' says Dr Marcus Menzl of HafenCity Hamburg GmbH.

That includes a high percentage of publicly accessible ground floor premises, mixes of functions in the same urban block and the opportunity for joint building ventures with HafenCity GmbH as managers. Planning principles dictate a varied mix of uses, urban topologies and architectures, as well as consistent heights. This is why the plan devises ten different neighbourhoods, some defined in relation to topography, for example, the canals, harbour basins or the River Elbe forming the borders of neighbourhoods, or, in other cases, roads. In some cases the character of the neighbourhoods is more strongly influenced by the typical port atmosphere, and they possess structures determined by their historic uses, despite new building development, more so than in a maritime context such as Kop van Zuid in Rotterdam.

Typologies vary hugely between neighbourhoods, from 3500–4500m² in Sandtorkai to 30,000–40,000m² in large

7 HafenCity, Hamburg, KCAP: Boardwalk at Sandtor Quay.

8 HafenCity, Hamburg, KCAP: Boardwalk at Sandtor Quay.

Copenhagen, which allows a shopping centre to define one of its districts. In this way, the plan is best enabled to develop step by step in line with market demand over a period of more than two decades. However, coherent urban entities were completed quite early on, commencing in the north and west at the interface with the city centre, and now moving towards the south and west of HafenCity.

Herzog & de Meuron's Elbphilharmonie concert hall, on the rooftop of the nineteenth-century warehouse Kaispeicher A, housing the International Maritime Museum, on the roof top of the seventeenth-century Kaispecher warehouse (handled by a public–private partnership) was topped out in May 2010 after a two-year delay, constituting a new landmark at the 1.5km-long site between the city centre, which is less than a kilometre away, and the River Elbe, on the site of the former harbour. It is a key monument for the scheme with a public plaza, a five-star hotel, 60 luxury apartments and parking, on Kaiserhöft, the site of a previously failed concept for a Media City Port at Am Sandtorkai, at one end of the 1.1km site. It is located in Sandtorkai/Dalmannkai (north/west of HafenCity), the first of the ten neighbourhoods to be completed, and is arranged around the traditional ship harbour, with a mix of residential and

buildings in the Überseequartier, echoing merchants' trading places of the past.

Fortunately transitions between districts are seamless, and the quality of open spaces has been enhanced as the result of competitions which were won by international practitioners, for example, Am Sandtorkai, Dalmankai, Am Sandtorpark and Strandkai – Magellan Terraces, two plazas by the water's edge – won by EMBT and open spaces at Überseequartier and Elbtorquartier, won by BB + GG arquitectes.

Another asset is that no neighbourhood is solely devoted to homes, offices, retail or leisure, contrasting with Ørestad in

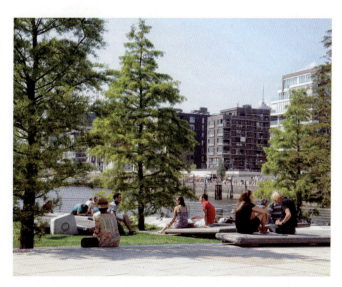

9 HafenCity, Hamburg, KCAP: Marco Polo Terrace at Sandtor Quay.

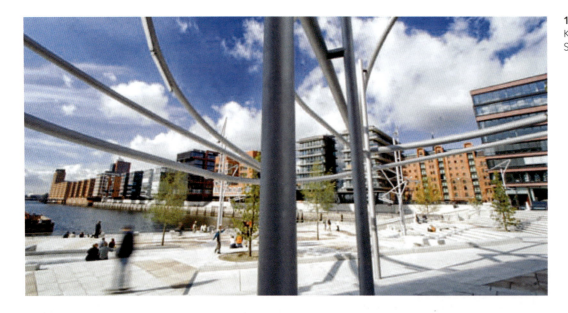

10 HafenCity, Hamburg, KCAP: Magellan Terrace at Sandtor Quay.

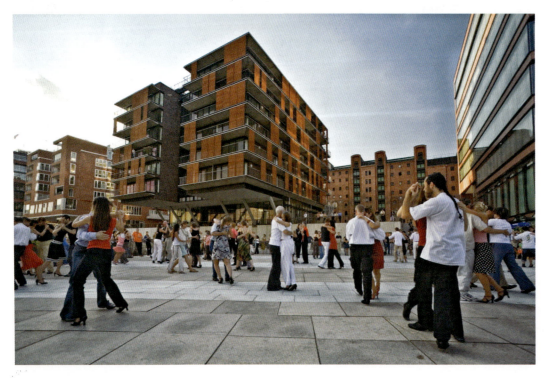

11 HafenCity, Hamburg, KCAP: Dancing on Magellan Terrace at Sandtor Quay.

business uses and animated by ground floor shops, cafés, restaurants and bars.

After a decade, huge advances have been made, although not all the goals have been attained. A 23,000m² science centre and aquarium, designed by OMA, was planned as one of a series of buildings; funds are still being raised for this. The Busanbrücke bridge across the Magdeburger Hafen has also reopened (previously known as the Magdeburger, and renamed to honour the partnership with the port of Busan in South Korea), linking HafenCity's emerging central expanse of water around Magdeburger Hafen. It joins new and old, HafenCity's western and central neighbourhoods with its eastern sector; Überseequartier, the heart of HafenCity, to Kaispeicher B.

Spatial attractors are a strong feature of HafenCity, and Busanbrücke can feasibly be termed a place as well as a bridge. Catalan architect Beth Galì has paved it in various types of natural stone laid in a striped pattern, which integrates the bridge into the open space. Here visitors can sit and take in views of the warehouse, the Elbarkaden bridge, the German headquarters of Greenpeace and designport, the design centre which aims to serve as the first central hub for the 2000 designers and design offices in the city. On the other side of the bridge, buildings on the northern part of Überseequartier rise up – such as the Waterfront Towers, designed by Erick van Egeraat, with arcade passages along Osakaallee, where the old Hafenamt port authority building is sited. This area, plus the southern part of Überseequartier, constitutes the urban heart of HafenCity, to be used by more than 40,000 people per day.

There is no specific cluster policy apparent at HafenCity. Businesses from all sectors appear to be locating there, attracted by the potential offered by an evolving symbiosis between district and business community. A further branch of the community is the knowledge quarter east of Magdeburger Hafen, which includes HafenCity University (1600 students), Kühne Logistics University, the Greenpeace headquarters and those of its Greenpeace eco-energy supplier Greenpeace Energy eG, designport and the International Maritime Museum.

In the Am Sandtorpark/Grasbrook neighbourhood is the Katherinenschule, with a primary school, day care centre and nursery that also functions as the district's community centre. To its south is Strandkai with prominent waterfront sites, including

Richard Meier's Hamburg-America-Center. To the east, Am Lohsepark quarter is emerging, with an elongated park, a green lung for HafenCity, faced by buildings. Lohsepark, which was where the Hanover railway station once sat, will become a

12 HafenCity, Hamburg, KCAP: Lunch terrace and basketball courts on the Vasco Da Gama Square at Dalmann Quay.

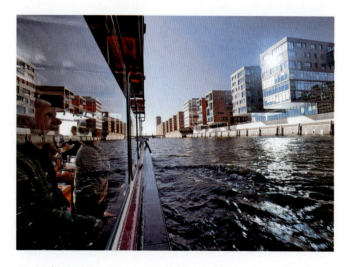

13 HafenCity, Hamburg, KCAP: Water view from tourist boat of Sandtor Quay.

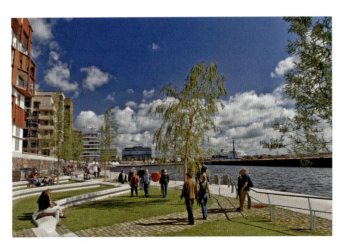

14 HafenCity, Hamburg, KCAP: Dalmann Quay boardwalk.

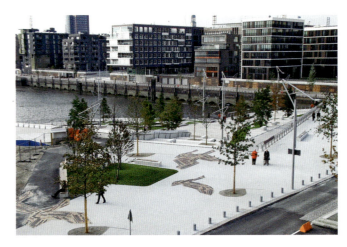

16 HafenCity, Hamburg, KCAP: Marco Polo Square at Sandtor Quay.

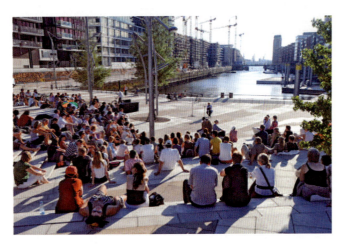

15 HafenCity, Hamburg, KCAP: Small concert on the Magellan Terrace at Sandtor Quay.

memorial to the deportation of German Jews, Sinto and Roma before and during the Second World War.

The avoidance of compartmentalisation, with areas with offices separate from living spaces, as can be seen in many German cities rebuilt after the Second World War, is a major

priority, according to Bruns-Berentelg. The close proximity of galleries, museums and the university to commercial and residential buildings to create a sense of community is an asset, and the juxtapositioning of luxury penthouses with cheaper apartments should fend off concerns that HafenCity could become a haven of retired rich people. In terms of atmosphere, there is perhaps a similarity with the Eastern Docklands of Amsterdam, a smaller-scale scheme developed a decade ago.

An unusual step for a public body such as HafenCity Hamburg GmbH was to commission sociologist Dr Marcus Menzl to analyse uses of space, collecting resident wishes, for example, for a playground and indoor recreation area, which already have been implemented. 'You can't have a totally structured place and then just expect people to fit in', he explained in Der Spiegel.[4] 'But nor will it work if everything is totally open to interpretation': it is vital to find a balance 'between structures and freedoms and opportunities'. It is essential for finetuning of this kind to be factored into the development process sufficiently early on – and at HafenCity research has been ongoing for over five years – to avoid new

4 Cathrin Schaer, 'The challenge of making HafenCity feel neighbourly', Der Spiegel, 26 August 2010.

residents feeling they have no chance to put their stamp on places.

Martin Kohler, a lecturer in urban photography at HafenCity University, and his team were also commissioned to investigate over a period of five months how people are using the new public spaces since these places play such a pivotal role in the project. The reason, he explains, is that they were 'interested in discovering which aesthetic principles have proven successful in practice, and which could be further developed, for example, in the framework of ongoing planning of open space'.[5]

This urban ethnographic research, carried out in a variety of weather conditions, has already been shown in a public exhibition, and studied issues, such as how children made open spaces their own during play, how the street furniture designed specially for the district was actually being used, and how the restaurants were making use of the outdoor areas assigned to them. 'Many places are being used in just the way that the planners anticipated, which reflects a good balance between the specifications and the public – and the quality of the planning,' said Kohler.[6] One example was the concrete slabs on the surfaces of promenade areas subtly suggesting where to go, and these cues were being taken up. Spaces are also being used for purposes not originally anticipated, for example, children and young people climbing the clinker brick walls of the flood-secure plinths.

Bruns-Berentelg sees the masterplan not 'merely as an urban design framework, but also as the precursor to an equally important realization strategy'. He feels it can be read 'from the perspective of its desired objectives, not necessarily just from its implied strategic rules'.[7] Not all of the plans have been advanced: HafenCity's local public transport links were scheduled to be integrated into a new city streetcar network, possibly complemented by a people mover system. These plans were discontinued but the new U4 line will provide HafenCity with a local transport service comparable to other city centres. One feature which has advanced are plans for a new HafenCity

University, an architectural academy on a prominent waterfront location at Magdeburger Hafen. The plan proposed setting up schools, and in fact took advantage of the need for an existing elementary school at St Katharinen to be rebuilt as a school and

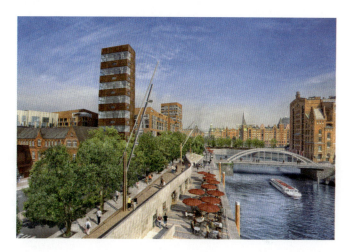

17 HafenCity, Hamburg, KCAP: Bird's eye view of Osaka Street at Überseequartier with proposed new buildings.

18 HafenCity, Hamburg, KCAP: Boulevard along Grasbrookhafen at Dalmann Quay.

5 HafenCity Hamburg GmbH, 'Research Assignment: Open Space', 2010.
6 Ibid.
7 HafenCity Masterplan document, 2006.

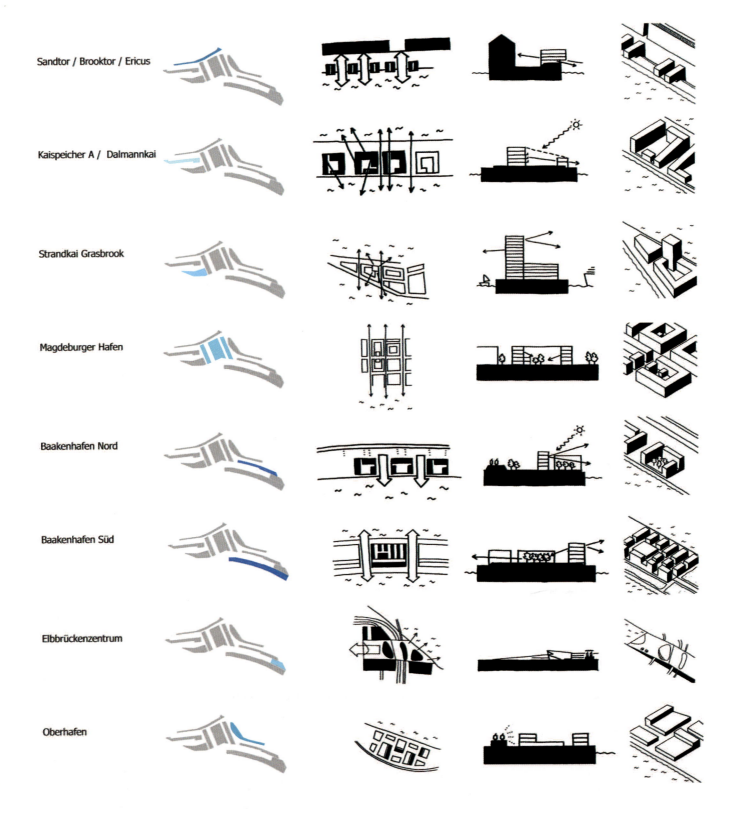

Sandtor / Brooktor / Ericus

Kaispeicher A / Dalmannkai

Strandkai Grasbrook

Magdeburger Hafen

Baakenhafen Nord

Baakenhafen Süd

Elbbrückenzentrum

Oberhafen

19 HafenCity, Hamburg, KCAP: massing principles of the masterplan.

20 HafenCity, Hamburg, KCAP: diagram showing spatial relations.

21 HafenCity, Hamburg, KCAP: diagram showing mass vs void.

22 HafenCity, Hamburg, KCAP: diagram showing pinnacles triangle.

23 Diagram of historical area of Hamburg with HafenCity extension, KCAP.

community centre. This, feels Bruns-Berentelg, breaks with the tradition of having children attend schools close to home, replacing it with a school close to the parents' work, helping to promote family-oriented living and women's employment opportunities.

As of June 2011, 45 of the projects are complete, with 35 under construction or planned. Aiming for completion of the plan in 2025, Bruns-Berentelg's intention that HafenCity should lay successful foundations for a benchmark project in Europe, at least, is driven by strong plans for public space and its extensive claims to sustainability. The brownfield development here amounts to a major effort in making the city sustainable in itself since Hamburg is no longer growing around its periphery as it was during the 1980s and 1990s, so that greenfield development can be avoided to a great extent.

The principles underlying the plan are about confrontation in the most positive sense of the word. They intensify city living in such a way that various milieux can blend into one another, while promoting accessibility and a stimulating differentiation in the use of space largely off limits to people in the past, due to the determining character of industrial heritage.

Christiaanse believes that it is all-important for clients to establish a results-based methodology for masterplans. It seems

that the ideal of a mix of housing tenures and types for all pockets will avoid the luxury residential monoculture that has characterised and ghettoised London's Docklands. 'We are doing something very ambitious here. Yes, we are building buildings. But we are also producing social and cultural environments for the next century,' says Bruns-Berentelg. 'After all, a city is not only a commercial product, but also a public good.'[8]

8 Der Spiegel, 26 August 2010.

2

City centre and waterfront neighbourhoods

Musheireb, Doha, Qatar

Doha is Qatar's largest city, founded in 1825, and the cultural and commercial hub of the country, undergoing extreme growth, development and modernisation. In the 1930s, when Doha's oil and gas were discovered, it was a small fishing village. Since then, it has grown into a sprawling city, its population more than doubling in the past decade to over 400,000 people. After the Second World War it became a frenetic construction site, not as extreme as Dubai has been, but that led to an absence of public realm or parking space, and some pretty empty volumes.

In 2011, more than 50 towers were being constructed, and 39 new hotels, transforming its low skyline of adobe courtyard houses, domes and minarets. Greater prosperity and the rise in private car use have led to the expansion of the suburbs and the city centre has lost much of its charm and community spirit. The planned antidote is Musheireb, which means 'water

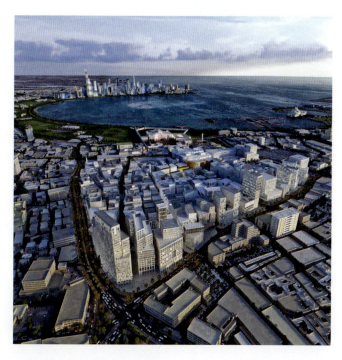

1 Musheireb, rendering of aerial view at night showing Musheireb in the context of Doha, with the commercial district, West Bay, in the background.

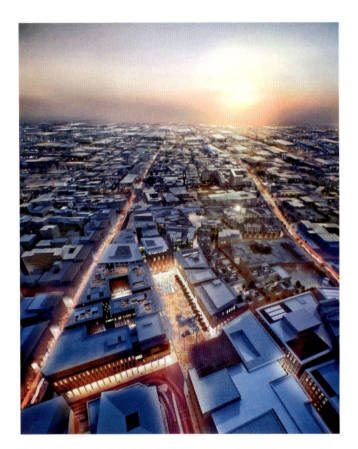

2 Aerial view, Musheireb, Doha.

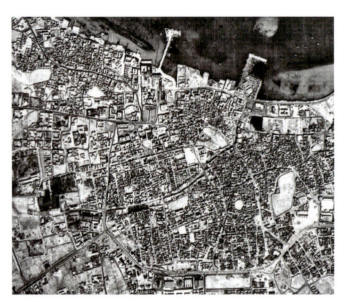

3 Musheireb, Doha, aerial view in 1959.

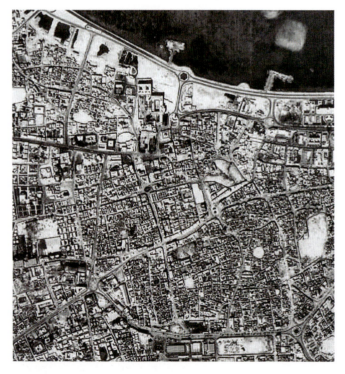

4 Musheireb, Doha, aerial view in 1973.

channel' in Arabic, the inaugural project of Musheireb Properties (formerly Dohaland), a subsidiary of the Qatar Foundation for Education, Science and Community Development, founded in March 2009, with a mandate to create innovative urban developments.

The plan is for a 35-hectare piece of land between the souk and the presidential palace, Musheireb Place, following the lines of the old *wadi* watering hole, and the Al Kahraba North neighbourhood, which will be primarily residential. It could have developed on linear lines, as in Dubai, but the decision was made instead to do a corniche, and have a very concentric plan. This reverses the pattern of development and growth in Doha in recent decades which has tended towards isolated land uses with urban sprawl, and improves connectivity across the wider city area.

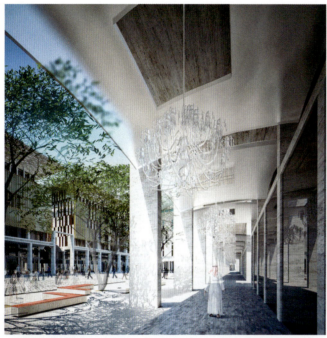

5 Musheireb, Doha, Al Barahat arcade and colonnade, rendering, mossessian & partners.

Mushereib's inspiration is drawn from Qatar's Vision 2030 guidelines[1] set by the Emir, His Highness Sheikh Hamad Bin Khalifa Al Thani and Her Highness Sheikha Moza Bint Nasser Al Missned. This underlines the transformation of Qatar into a country sustaining its own development, on the understanding that the oil and gas that gave it the world's second highest per capita income are finite resources. Accordingly, their Qatar Foundation, established in 1995, with its own landscaped campus masterplanned by Arata Isozaki, has fostered schemes such as Education City, a 2500-acre campus on the outskirts of the city, and the Qatar Science and Technology Park, flagship projects to help the city realise its knowledge-based economy.

'Communities in Qatar have always been close-knit: people lived and worked together in harmony with the climate, with the land and with each other,' said Her Highness in 2010. Today's

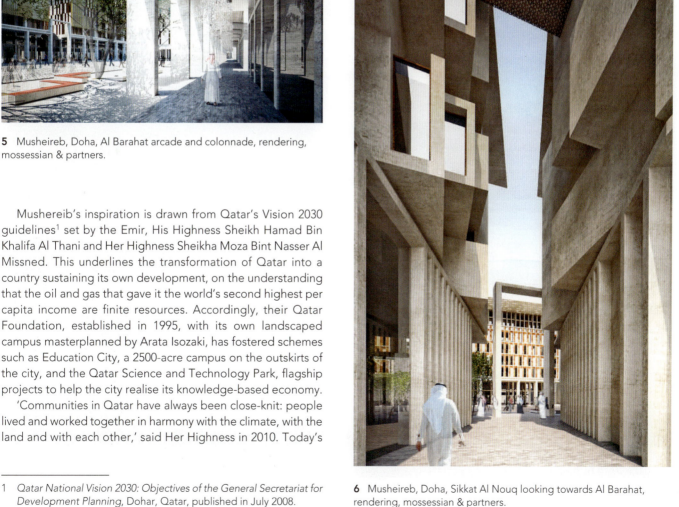

1 *Qatar National Vision 2030: Objectives of the General Secretariat for Development Planning*, Dohar, Qatar, published in July 2008.

6 Musheireb, Doha, Sikkat Al Nouq looking towards Al Barahat, rendering, mossessian & partners.

7 Musheireb, Doha, Barahat Al-naseem Square as an 'urban *majlis*', rendering, mossessian & partners.

8 Musheireb, Doha, Office building on the corner of Abdullah Bin Thani and New Ukaz Street, rendering, mossessian & partners.

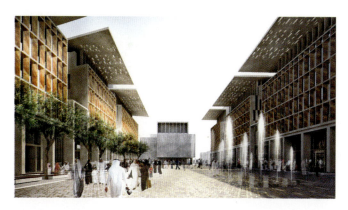

9 Musheireb, Doha. Mixed-use development around Al Baharat, Musheireb, looking east, rendering, mossessian & partners.

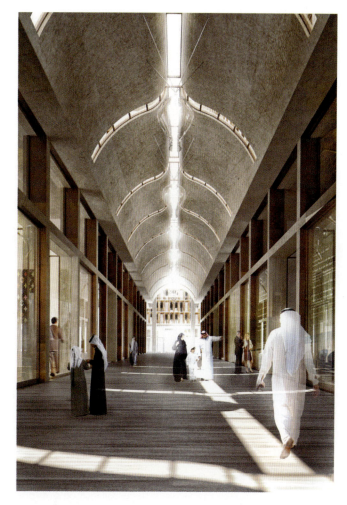

10 Musheireb, Doha. Reemas Street Arcade, rendering, mossessian & partners.

high rises and disconnected architecture, and congested streets – resulting from globalisation – have adversely affected that cultural way of life in the country. 'We had our own ways of dealing with the environment which was sustainable and human in scale, often building our homes together as a family,' she said, referring to the old neighbourhoods – known as *fireejs* – of Qatar and across the Gulf Region, which encompassed the culture, traditions and values of a unified society and through their design expressed concepts such as extended families, kinship ties, societal activism, local economy, collective identity and a high degree of environmental awareness.[2] Believing in a 'meeting' rather than a melting of cultures, Her Highness's approach embraces an anti-global approach in order to reinforce a cultural sense of Doha.

The *fireejs* are linked to a new urban square at the centre of Musheireb, Doha's new focal and gathering point. Occupied on the west end by a luxury hotel, and on the east by a cultural forum, it will be lined a heterogeneous mix of offices and residential buildings, shops, restaurants and cafés, protected by shaded walkways. Retaining those patterns, not through literal

copying, but a new interpretation, the *fireejs* have a mix of up to six townhouses, each with a private *sahan* or courtyard, and apartments, clustered around communal gardens. Public areas are being designed to serve as meeting places for both private and public realms of life, expressing a traditional urban form and principles of climatic design and community living interpreted for contemporary living. 'It's a model for a younger

2 The focus on fostering closer communities and social interaction is also a crucial issue for the Gulf Cooperation Council (GCC), founded in 1981, which has a strong security agenda.

11 Musheireb, Doha. Adjaye Associates, commercial, office and residential buildings, rendering.

of research by international architects, masterplanners and engineers. This governs the design of the buildings and the *fireejs*, and provides the framework for new developments in line with Qatar's architectural heritage and sustainability. The first building embodying this aesthetic is the Knowledge Enrichment Centre off Doha's corniche.

The second phase of the plan, Heart of Doha, as it is known, is being advanced by AECOM and Arup as the masterplanning team, with a team of architects and masterplanners including mossessian & partners, Adjaye Associates, John McAslan + Partners, Allies & Morrison Architects, as building architects. The masterplan does not create a grid but retains much of Doha's historic street pattern including Kahraba Street and the line of the old Wadi. 'Understanding the past provided an invaluable intellectual reference for the masterplan,' say AECOM.[4] A new Western-style grid of urban blocks is overlaid with the curving lines of historic streets, and intersected by an intricate lattice of discontinuous lanes and small urban spaces that converts the hot wind into cooler breezes. To respond to

generation society,' says Michel Mossessian of mossessian & partners,[3] architect of Al Barahat Square, part of the masterplan.

What Musheireb – a $5.5bn project due for completion in 2016 – tries to do is balance contemporary innovation and local heritage and culture, regenerating and reviving the historical downtown area. It will reverse the city's tendency towards decentralisation by attracting residents to compact, easily walkable urban neighbourhoods through a bespoke design language rooted in Qatari culture with colonnades, living roofs and water features. The mixed-use scheme will include over one hundred buildings with residential, commercial, retail and leisure facilities, and most vehicles will be parked underground.

'In Qatar, we may have modern structures with good-looking façades but many of them are not designed for our environment,' said His Highness. 'They do not belong to our history or our architectural language.' Musheireb strives to 'bring back our identity, with a modern architectural language'. A 'Seven Steps' design programme has been developed over three years

12 Musheireb, Doha. Adjaye Associates, commercial, office and residential buildings, rendering.

3 Interview with the author, 2011.

4 Heart of Doha, AECOM, planning document, 2011.

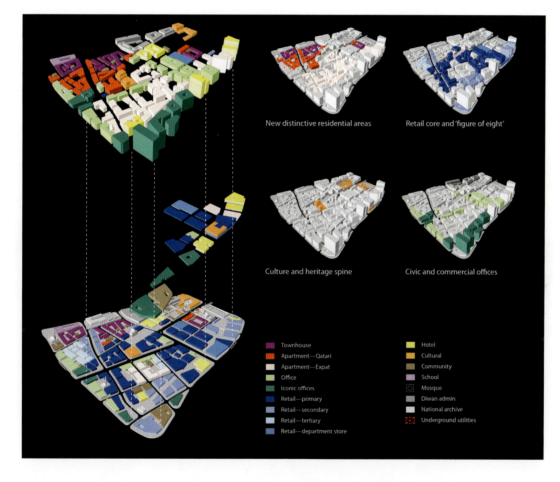

New distinctive residential areas

Retail core and 'figure of eight'

Culture and heritage spine

Civic and commercial offices

Townhouse		Hotel	
Apartment—Qatari		Cultural	
Apartment—Expat		Community	
Office		School	
Iconic offices		Mosque	
Retail—primary		Diwan admin	
Retail—secondary		National archive	
Retail—tertiary		Underground utilities	
Retail—department store			

the intense heat, the plan maximises shade by using the prevailing wind direction.

Professor Tim Makower, partner of Allies & Morrison and Muheireb Properties Co-Chair at Qatar University since 2010, who has also worked on the Diwan Amiri Quarter (Diwan Annex, Amiri Guard and the National Archive, and a heritage quarter, including the Eid Prayer Ground and four heritage houses) in Doha, recently commented[5] that 'the tendency in contemporary urbanism is for the spaces between buildings to be too large, on account of the motorcar'. The plan gives primacy to public space through its network of outdoor rooms and linear routes 'carved' out of solid urban fabric.

Musheireb's compactness combats this by binding space together, ensuring a walkable, shaded environment, drawing references from Islamic street patterns and vernacular building types. Makower also feels that the overall design fully addresses the ethos of the collective – the whole being greater, and more important, than the sum of its parts – as individual buildings are seen as part of a group, and, as with a choir, the success of the individual voices is seen in terms of the overall harmony

5 The Aga Khan Award for Architecture, 'Voices from Doha', lecture at the Knowledge Enrichment Centre, Doha, 16 January 2011.

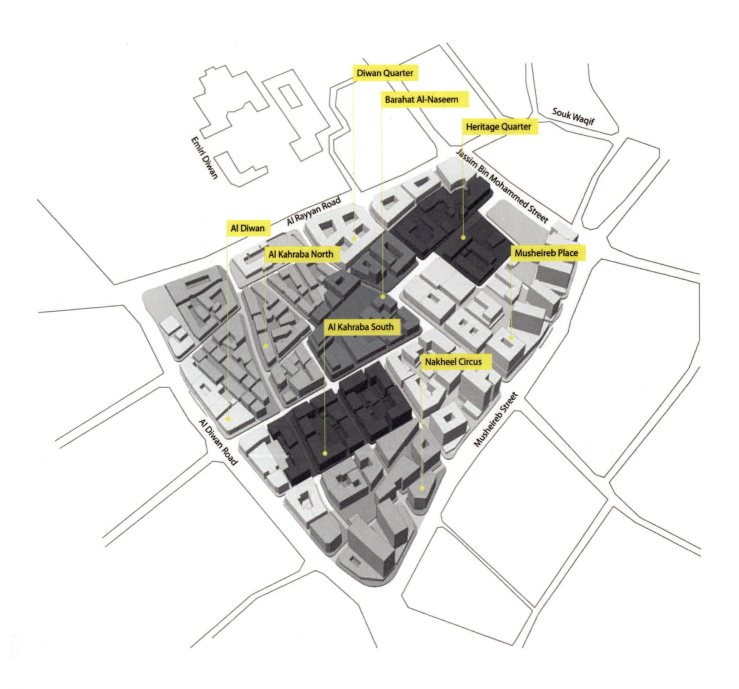

14 Musheireb, Doha. Diagram of the different character areas of the masterplan, AECOM.

15 Musheireb, Doha. Masterplan diagrams, from left to right: historic urban grain and the *wadi* route as a reference framework for the masterplan; the lattice creates intimate *sikkats*; the street grid captures north/south winds and caters for road traffic, AECOM.

achieved. It has been commented that it draws heavily on tradition, but in fact it is a hybridity which strengthens its paradigm. 'Language grows out of places, and binds people to places and to each other. In a similar way, architectural language – vocabulary, grammar, accents – is an essential part of striking a successful balance between local identity and internationalism.'[6]

The centrepiece of Musheireb is Barahat Al-Naseem Square, a 65,000m² civic space designed by Michel Mossessian, surrounded by nine mixed-use residential, commercial and retail buildings. This public forum connects to its surrounding buildings drawing on traditional spatial hierarchies and passive strategies for thermal comfort, and is clad in gold paving. It acts as an 'urban room' for the development, an original, urbanised version of the domestic *majlis*, the large, formal, decorated and carpeted social space with seats on the periphery in traditional Arab houses. These served as a means for communication, interaction and integration between different residential communities.

The very concept of a public square, a civic meeting place – such as Place Pompidou in Paris, Piazza San Marco in Venice, Grand Place in Brussels or Piazza Navona in Rome – is a first for Qatar and the wider area. 'They don't have squares, except in the Middle Ages,' explains Mossessian.[7] The connecting courtyard he designed as a vertical *majlis* clad in mother-of-pearl with lighting that changes through the seasons, to recreate the richness and warmth of traditional interiors and act

as a beacon to draw people in. A pedestrian *sikkat* links the urban room to the southern plaza and further along to the retail colonnade along Al Diwan Street.

'Sculpting the void' – the space between buildings – is as important as the buildings themselves. Accordingly, the square is not a statement of power, he feels, but 'about the collective' and a sense of shared ownership. In this context, the buildings function as a membrane or porous threshold between totally public and totally private space, with deep roof overhangs and decorating screens layering the façades.

For his design, Mossessian took all the ingredients of Qatari tradition, including the modularity and repetition of buildings, and has translated them into a contemporary vernacular in a way that is reminiscent of a number of world locations: the ground pattern was developed with an artist; there are Byzantine-style chandeliers in Murano glass; constellations of LED lighting in the paving; Islamic pools of water; divans by another artist, and a 'forest' of petrified trees.

'Many attempts at reconciling the global with the local, one of the most important challenges of this age of globalisation, have been made but it has too often resulted in one tradition being subsumed under another,' says Mossessian.[8] He continues:

Western cultures have a tendency to think of space as a neutral category in which autonomous objects (sculptures and buildings) are placed. It is considered an absence

6 Ibid.
7 Interview with the author, 2011.

8 Heart of Dohar: residential, retail, offices, mossessian & partners, May 2010.

instead of a presence and is thus produced with little consideration for the people who inhabit it. But space is never neutral; it is something produced and given meaning through the intersection of social, economic and environmental factors.

Mossessian's practice is one of four, including David Adjaye (apartment buildings) and John McAslan + Partners (a cultural forum), Mangera Yvars (a mosque) and Allies & Morrison (the national archive) who won a competition for the central part of the scheme, phase 1b, that will include a shopping mall, hotels, offices, apartments and shops, and will reinforce the district's connection to the Souk Waqif.

John McAslan + Partners is also developing a design for a new 450-pupil primary school within the masterplan, to act as the gateway to the new heart of the city centre. It reinterprets the traditional courtyard typology with classrooms arranged in clusters around the perimeter of a series of courtyards and gardens to become open air extensions of the teaching spaces. Construction began in January 2010 with phase 1b due for completion by 2012, a multi-use cultural forum, offices, hotel and serviced apartments, shopping district, townhouses, a school and a mosque.

There will be five phases in all, and Her Highness has also renovated all Doha's nearby fishermen's villages, so she has also been dealing with Doha's existing community space. Rather than a military grid system, the plan is more linguistic, marking the space more like calligraphy. Comparisons with Foster & Partners' Masdar City currently under construction in Abu Dhabi (see p. 159) are inevitable, but unlike Masdar City, Musheireb lacks public transport until the discussed subway line is completed. Another Gulf project, the New Gourna town outside Cairo, developed on a desert site by Hassan Fathy, was never completed due to lack of sufficient interest by inhabitants, even though the housing quality was very advanced. At Musheireb, it seems the attractions of moving back to the city will be more successful.

The district's plan creates a new sequence of mixed-use, densely planned neighbourhoods, but makes revitalised public space the key to its success, allied to the new language addressing the tensions between history and modernity, unity and diversity, public and private.[9] With the exception of public parks, the city currently has few urban spaces that encourage people to temporarily dwell – sitting and watching, seeing and being seen – as opposed to the everyday habit of merely transiting the city. If architecture is to be a genuine driver of social and environmental change, collective identities and a sense of belonging, it needs to promote public space of this kind.

9 Heart of Doha:, AECOM, ibid.

Waterfront Seattle, USA

How can a masterplan best celebrate the past, present and future of a context? Undertaking a profound reading of the site in question and responding to the wishes of its public gives a project the best foundation on which to build in this respect, but it also needs to be sustainable and adaptable in the future. Spanning 26 blocks from the city's stadia in the south to the Broad Street site of Olympic Sculpture Park, the waterfront in Seattle, now the subject of a far-reaching Framework Plan and Concept Design led by james corner field operations, is a site of intense maritime activity that offers a multitude of challenges to respond to in a sensitive and synergistic way.

The whole area had been a busy working maritime setting since 1885, but after a container port was constructed to its south, it shifted to its current recreational character, with some docks left and the historic pier structures preserved. Today, the visitor can experience parks, piers, promenades, public spaces, arcades, restaurants, a Ferry Terminal at Colman Dock, cruise ship terminals, a short stay marina at Bell Harbor, and take in the Aquarium and Olympic Sculpture Park, and nearby in downtown, Pike Place Market.

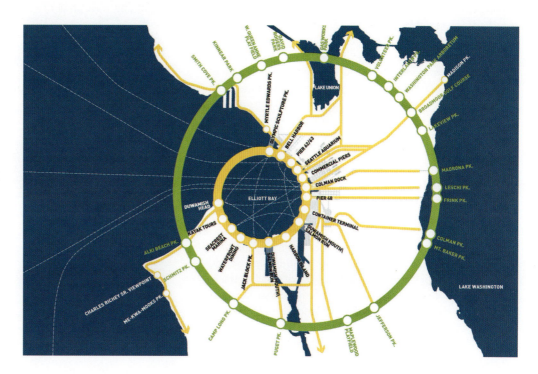

1 The Bay Ring: recentring Seattle around the Bay, james corner field operations.

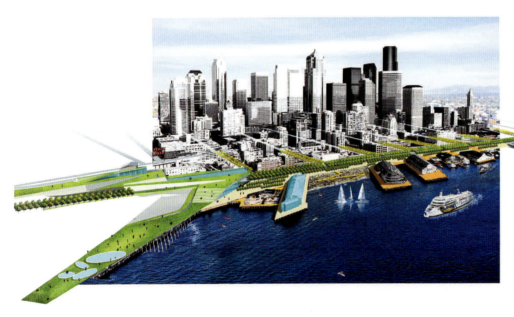

2 Overlook Fold, connecting Victor Steinbrueck Park and Pike Place Market to the Aquarium, Pier 62/63 and the waterfront; view looking east, james corner field operations.

Dominated by touristic activity, in its southern portion the waterfront is separated from inland Seattle by the Alaskan Way Viaduct, which continues northward through downtown and creates an unpleasant and noisy barrier between the various neighbourhoods and Elliott Bay. Dating from 1953, and damaged in a 2001 earthquake, it currently runs along the waterfront in the city's industrial district and downtown areas. Travelling north, a visitor experiences the land rising away from the water, creating a stronger distinction between the water- front and the city's uplands.

The Waterfront Seattle project, which will transform Seattle's Central Waterfront into a series of new public spaces of up to 27 acres in total, is seen by the City as a huge opportunity to reorient its connection to the coastline, Elliott Bay, through the proposed removal of the Viaduct,[1] reclaiming the waterfront as a public asset. Instead, traffic will be given a 3.2km-long underground tunnel,[2] and the aging central Alaskan Way seawall will be replaced. The exact amount of open space will not be known precisely until the Framework Plan, Concept Design and funding strategy are completed by mid-2012.

There has been long and heated debate in the City over the issues arising from removing the Viaduct, which is unsafe, and

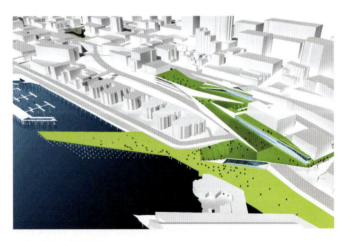

3 Seattle connects to a new green waterfront, looking east from the Bay, james corner field operations.

1 A double-decked elevated section of State Route 99.
2 A project planned by the state of Washington, King County, the city of Seattle and the Port of Seattle.

creating a bored tunnel, but in making the decision to do so and inviting a framework plan, the City is building on ten years of public planning and taking a major scale transformative step. The plan introduces an integrated set of improvements to the 26 city blocks from King Street to Broad Street, a new set of public and cultural spaces along the waterfront in the Alaskan Way area of the removed Viaduct (due for demolition in 2016) and in Belltown, facilitating new means of access to the water and creating a new street connection between the waterfront, which will be equipped for all modes of transport for people and goods,[3] between the waterfront and Belltown, connecting Alaskan Way to Elliott and Western Avenues. Redesigning the 'concert pier' 62/63 and Waterfront Park have also been seen as vital in the process of transformation. A high priority is the creation of an unsurpassed permeability between the waterfront back to the rest of the city through improved connections, including east–west routes for pedestrians, for example, green streets, hillclimb assists, pedestrian bridges and other topographical measures establishing relationships with upland environments. These measures substantially enhance access to downtown, the city's stadia and other amenities.

Work on the project began a few years before the planning process began in 2003, centring on a visioning charrette in February 2004 involving 300 people, the largest of its kind in the city's history. The 20 teams involved at that point had to choose whether they were designing around a cut and cover tunnel on the waterfront, a surface street-only option or an elevated viaduct. Most teams chose the tunnel, but some chose the surface option, but none opted to design with an elevated structure as part of the picture. In 2008, the City and State went back to the drawing board after an indecisive, citywide vote in which neither of the proffered options received a majority. That process looked at eight options: three variations of surface and transit alternatives, two elevated options (one with a park over the traffic below), and three tunnel options. Ultimately the deep bored tunnel was selected at the end of that process. After the charrette, work was done to develop guiding principles and the concept plan, led by the Department of Planning and Development (DPD) with Council support. In 2010, the Council set aside the funds to develop the Framework Plan and Conceptual Design (Phase 1) over an 18–24 month process, committing to removing the viaduct, decommissioning the Battery Street Tunnel and creating the new street. The Concept Design takes place in parallel with the Framework Plan development and brings the core project to approximately 10 per cent design, and will also evolve a strategy for public art and prepare the project for environmental review and permits.

Phase 2 is planned for mid-2012–late 2015, when it is intended to reach 100 per cent design, including securing of necessary permits. Phase 3 begins with the demolition of the existing viaduct and lasts six months or so following the opening of the tunnel at the end of 2015, after which new streets and public spaces in the right of way are scheduled for completion by the end of 2018. Other elements of the plan may be completed in later phases, to be determined by mid-2012, with Phase 1 of the seawall between Washington and Virginia built by the end of 2015 (and Phase 2 of the seawall, Virginia to Broad, an element to be completed in a later phase after 2020).

The seawall project has been conceived in tandem with the Waterfront. As a vertical, relatively smooth concrete surface it fails to support most of the ecological functions originally provided by natural beaches in the region. Local ecosystems experts are studying how the new seawall might incorporate habitat enhancements beneficial to fish and other aquatic organisms in response to the City's commitment to this policy. The whole current and future ecosystem at the waterfront has been considered. There are four existing resident populations nearby: at Belltown and Pioneer Square, along the Central Waterfront between Pioneer Square and Pike Place Market, and in Pike Place Market itself. Businesses trading along the waterfront will not be displaced by the new public space projects, which will complement them and are envisaged as also bringing a large new customer base.

In early 2011, the City,[4] committed to a design process that engages city-wide input, held a number of public events inviting

3 Based on State Route 99 public rights of way.

4 The Seattle Department of Transportation (SDOT) is the contracting department for the project, and is working in close coordination with the Department of Planning & Development (DPD) and the Department of Parks & Recreation. Final decisions on major project elements and funding are to be made by the Mayor and City Council.

citizens to comment on the opportunities and constraints of the project and explain how they envision the waterfront, and disseminated information through a website,[5] Facebook and Twitter. The Central Waterfront Stakeholder group, a broad array of business, residential, neighbourhood, governmental, labour, environmental, pedestrian, cycling and design interests, was formed to ensure that the concerns of all these parties were addressed through the design and planning process. A Central Waterfront Committee of community leaders oversees the project design, financing, public engagement and long-term operations and maintenance, making recommendations to the Mayor and City Council.

On 21 September 2011, it was announced that the design team james corner field operations had been selected from a shortlist of four from the 30 teams who responded to the City's Central Waterfront Request for Qualifications in Urban Design/Public Space Design. The team includes collaborators SHoP Architects, Tomato, artist Mark Dion and a number of local firms including Mithun and The Berger Partnership.[6] Previous projects completed by james corner field operations include the High Line in New York City, Fresh Kills Landfill, Staten Island, NY, and the North Delaware Riverfront Masterplan, Philadelphia. The practice's track record and adherence to landscape urbanism, embracing horizontal, polycentric, interconnected expansive organisations in society, have made a great impact on the necessary re-evaluation of the idea of a masterplan. James Corner, founder of james corner field operations, speaks of ecology not as descriptive of a remote 'nature, but as more integrative "soft systems" – fluid, pliant, adaptive fields that are responsive and evolving'.[7]

The practice's history of leading community meetings and success in public consultation to overcome a lack of dialogue with citizens, is also a fundamental part of landscape-driven masterplanning, and, from the City's point of view, one of the reasons for the choice of the team was the fact that the firm 'truly understands how to create dramatic public spaces where people want to gather', according to Christopher Williams, Acting Superintendent of Seattle Parks and Recreation. Responding to the mutually supportive nature of their proposals, Diane Sugimura, Director of the Seattle Department of Planning and Development, has remarked that 'their goal is to create a new "heart" to the city'. These impulses are allied to a fully tested reputation for visionary design and innovative thinking, context-based design and effective public engagement, international experience and local expertise that a complex masterplanning project of this magnitude must have to help mobilise its vision.

The team began work in October 2010. At the launch of the open meeting hosted by the Mayor of Seattle, held on 17 February 2011, and attended by 1100 members of the public, to discuss what the Council has stressed are initial high-level design ideas generated for the City of Seattle, James Corner addressed the assembly. Representing james corner field operations as the design project leader, he spoke about the team's initial, locally research-based ideas for the city's Waterfront project, sharing the practice's readings and sense of the big picture of Seattle.

As the ideas generated are the beginning of a longer design process, it was vital to consider its opportunities and constraints, and in turn offer insights through workshops and Seattle Waterfront blog comments to help enrich the architects' understanding of their reading and understanding of value. 'I have waited 45 years for us to tear down that viaduct and build this world class destination waterfront' was a sentiment commonly expressed. However, there was also tension in opposing views about the value of the viaduct that the project has taken on board. Steve Pearce, Waterfront Seattle Project Manager, pointed out that, aside from those who wanted to save the viaduct as a highway, some residents have expressed a desire to preserve part of it as an elevated viewing platform and promenade. Pearce emphasised, 'These design objectives were important for us to consider in the emerging design.'[8]

5 http://waterfrontseattle.org.

6 The design team consists of james corner field operations, SHoP Architects, Mithun, The Berger Partnership, Fluidity, Tomato, HR&A Advisors, Herrera, Jason Toft, ETM Associates, Mark Dion and Creative Time.

7 Field Operations: Soft Systems of Landscape, Ecology, Infrastructure, Architecture, Urban Development and Living Patterns, Lucy Bullivant, A+U, 424, June 2001.

8 Interview with the author, 2011.

The design team's approach was about making the waterfront more open and more beautiful, and to achieve that, cosidered it 'essential that the plan for the Seattle Waterfront was grounded in the specificity of its place and context'. Corner explained, it had to be 'immersed in what is peculiar and unique' about the city, while being 'representative of its context in the world', adding that, 'the city has the psychological position of being on the West Coast, but also part of the Pacific Rim, for example'. He described it as 'a gateway where the world comes to Seattle and goes out to the world: its significance is not just about locality and hot dogs', but as 'a global city, and a threshold between east and west, bays and oceans but also mountains and the forest'. He did not see the waterfront 'as something static but a place of continual movement and dynamism', showing a visual reading of tourists' and locals' digital photo activity over a single day.

Corner suggested that the identity of Seattle's waterfront was 'the in-between, looking to the city but also west across Elliott Bay and Puget Sound, part of the Seattle psyche – a theatrical water body'. Moreover, being 'a significant habitat for marine life', the improvement of the water quality is important. Instead of downtown being the centre, Elliott Bay could become 'the site of the gateway, experientially and ideologically'. To convey to the audience the team's sense of the waterfront as 'a synthetic representation of many different groups, as a centering device in the ongoing cultural process of the city', he showed diagrams of the networks of Seattle neighbours, each with their own interests, such as the entrepreneurs; the business owners; commuters (car, bicycle, pedestrians); the green advocates; the shippers and the builders, concerned with moving goods; the tribes – Native American peoples; the visitors (tourists, people attending conventions); the creatives; the sports teams, all of whom interact – as one would expect from civic life – in ways that include both 'agreement and contestation'.

'Waterfront' has for too long connoted 'something brutally manufactured', said Corner, going on to analyse what happened along the water in the city. With its escarpment growing at a low level and becoming much bigger, Seattle is 'a city of hills', he said. Historically, at its waterfront, 'a lot of earth hills towards the water have been removed', in 'a flattening of the topography to enable a Herculean construction with piles and decking, creating a seawall that constitutes an abrupt division between the water and the city', and manufacturing 'engineered escarpments'. Accordingly, Seattle's 'grid responds to that nineteenth-century construction, and most of the mobility is north–south, not east–west, apart from boat transits'. In this context, he re-imagined the linear waterfront corridor after the viaduct has been removed, with frontages to the buildings that could 'transition into a front-facing vista, and a significant amount of public space'. It was vital that 'water bays in between the piers become part of the landscape project', with a new road connecting north and south Seattle, integrated with the park and with pedestrians, and subject to various traffic control methods.

Since Autumn 2010, prior to Corner's first presentation of the Waterfront scheme to the city, james corner field operations had been looking at alternative configurations and potential enhancements of the public realm along the seawall in its existing location. 'Big and brash – we call it Dutch in the design world,' he remarked. During their research in Seattle, the architects met a lot of people and registered the complexity of the situation. They viewed the southern port area to the new bored tunnel located south of Dearborn Street, the stadium, Pioneer Square with its strong block structure, the wedge of docks separating the Square from downtown, the downtown escarpments 'staking out central downtown', and then to the east another wedge culminating in a park and a market; Belltown Cut, an 'aggressive gash' made for a freight train line, north Belltown and the Olympic Sculpture Park.

In response, the team's formulated ideas were for a 'finer grain notion of neighborhoods envisaged as differentiated, with six episodic characteristics built into the urban fabric behind, with a connecting road', possibly to be designed with public space and waterfront access.

Dealing with the waterfront in segments, as is being done with the Hudson River Park in Manhattan (different architects were commissioned for the seven individual segments there), in turn, part of the East River waterfront esplanade, is vital, and does not prevent a unified, holistic approach. At Seattle, they could see the waterfront 'not just as a property line' but as 'something much more networked and integrated,' said Corner, an integrated entity overlaid with attractions like the Aquarium, commercial piers and other cultural resources – an urban

district, long since marked by stadia and the cranes of industry, that is new, fresh, vibrant and integrated.

The team envisions possibilities for new public space around the stadia and has identified specific issues to be solved, for example, the port and stadia, after the viaduct comes down, could be connected to the waterfront via a new pedestrian connection out of Railroad Way, with building frontages opened up with new uses, while vehicular traffic goes into the new tunnel.

At this initial public overview, Corner characterised Pioneer Square, the founding centre of the city, as a tight grid with a great sense of history, brick buildings, galleries, studios with, at Pier 48, the opportunity for a new park, and scope for 'a wonderful walking district'. The Pier could become a better connected public place, while here the streets are mostly easy grade of access to the waterfront. At Colman Dock, a commuter facility as well as an extension of the State highway system, with large volumes of people pulsing through the area all during the day, the frontage is long. Consequently pedestrians do not see the water for some time, and there are access problems, but Colman Dock is vital to the water and its ferry life, so the challenge was how to analyse its potential as a gateway. The commercial Piers, 55 and 56, touristic enclaves with places to eat

and public spaces, had different opportunities and constraints, and the priority there was to heighten their public vibrancy and recognise their landmark designation. There were challenges in access, and piers with structural problems, but Corner envisaged a pedestrian-centric locus. There are also many scenic views much loved by locals from the viaduct, holding out an opportunity to capture those views as part of a new public connection to the market from the water.

A proposal for a park-like, east–west street in Belltown – Bell Street – would connect the waterfront by means of the pedestrian bridges already built by the Council to connect Pike Place Market and Belltown from the waterfront, north of Pine Street. Corner remarked that at the North End, there are good connections for neighbours to walk to the waterfront, and 'a nice atmosphere', but its totality is severed by the railway line, making it 'challenging to figure out what to do with the space'. The North End, with Piers 70 and 69 and Sculpture Park, creates a precedent, in his view, an example of what can be done with topography and connections from upland neighbourhoods and the water via beaches and step get downs, with their dramatic vistas.

It was vital to understand the city structurally, with 'one big theatre of performers and ideologies', Corner explained. The

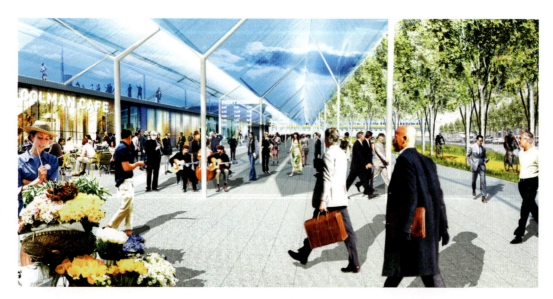

4 Colman Dock Gallery, looking north, james corner field operations.

team's focus was on how the design can have genuine agency and reconcile some of the many issues raised. With 3.7 million of metropolitan population, and 615,000 residents in Seattle City itself, with some living across the waterfront, it constituted, he said, a great opportunity for stimulating waterfront redevelopment. Given the sheer number of tourists – 800,000 people come to the Aquarium alone per year, and Pike Place Market attracts over 10 million people per year – they were also looking at 'why they would come?' reasons and setting expectations for the central waterfront. As a 9-acre public space in the public right of way, it was not comparable with Brooklyn Bridge Park with its much bigger piers, the Hudson River Park, and it was also different from the East River waterfront in New York City, which is the same size but more open, or Fishermans Wharf in San Francisco. The Seattle Waterfront is small, said Corner, but so, for example, is the Manhattan's High Line project, he pointed out, which was led by the practice. The Seattle Waterfront is only 30 feet wide and 7 acres in total, but offered the potential to be quite intense, and they wanted to understand how to build something in Seattle that is based on what is around it.

The calming effects of landscape infrastructure are vital, Corner pointed out, adding that the biggest draw at the High Line was to take advantage of the vistas. Design, he underlined, is 'not just about physical beauty but also about setting the stage for programmes and uses', so it requires integrated activities, and this was a key area where the team invited the public to propose and discuss activity options, and to vote. At Seattle, it is envisaged that the waterfront habitat will accommodate the different rhythms of jogging; cycling, bike 'n blade; children's play; sunbathing, swimming, climbing, touching the water, beachcombing, registering the different tides throughout the year, and sunbathing. It will act as a threshold for sailing, wading and canoeing, kayaking, fishing, and as a platform for different scales of events: picnics, festivals, concerts and performances. It would feature retail activities, from ephemeral markets as well as fixed units, eating and drinking, with the public there because they are commuting to get from A to B by bike, bus, ferry, as well as coming to be part of the life of the waterfront, to experience its habitat.

After the February 2011 public meeting, the design team considered all the feedback from citizens on graffiti boards to the question 'What makes a great waterfront?', relaying these to a further meeting on 19 May 2011. There was a lot of consensus that people wanted opportunities for views, to touch the water, to have parks and open spaces and public facilities;

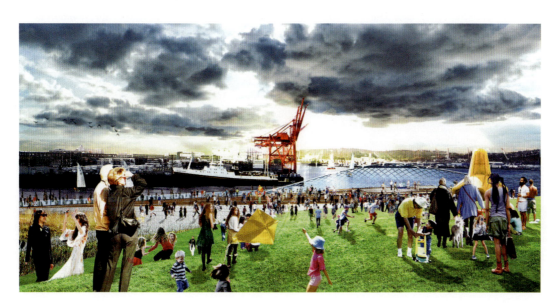

5 Festivals, events and concerts at Pier 48, looking south towards the Port of Seattle, james corner field operations.

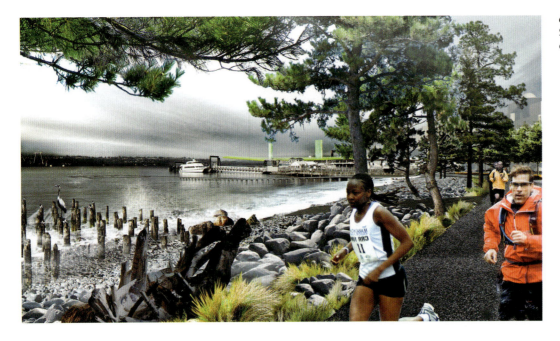

6 The Beach at Pioneer Square, looking north, james corner field operations.

but overwhelmingly they did not want view-blocking structures, large-scale private commercial development, too much hardscape, oversized roads and parking lots, or tourism-oriented facilities that do not feel authentic in this context. The top places were Piers 62/63, 48, the Olympic Sculpture Park and other locations where people could enjoy being on the Bay. They were given the opportunity to mark their choice of places to create better access to the water, and also responded to graphics of possible attractions: parks, places to stroll, walk, sit, concerts, events, a good variety of places to eat for locals, pathways for running, walking and biking.

The team met with individuals behind many existing planning initiatives around the site, as part of the process of engaging all the different interests. They made and presented a model of the existing waterfront with removable pieces and new pieces were made, and the teams continued over some months to walk the streets, as part of an ongoing process of listening and learning, as well as devising provocative ideas to put on the table that would be evaluated by the public in a further round of consultation.

At the public meeting on 19 May 2011, after months of further

team work, Corner explained that the complexity of the project demanded a trio of concepts to be devised. These work at three scales: city, urban framework, and waterfront. At the city scale, the idea of recentring Seattle around Elliott Bay responds to the extraordinary natural asset and animation of the Bay as a centrepiece of the city, re-envisioned as an integrated example of twenty-first-century urbanism. It epitomised the promise of public space as a well-organised, congruent mix of working waterfront – visible industry – with recreational, commercial and transportation uses. He introduced the concept of the Bay Ring of spokes that could be joined up with more parks and attractions and have art installations created around it, offering new habitat restoration, and act as a catalyst of sustainability in a myriad of ways, from a salmon-friendly environment to generating zero waste. A second concept, a green ring, is a device to bring together the green assets of the Olmstead Park and Boulevard system, many of which already have a relationship to the water.

At the urban framework scale, the challenge, Corner explained, is to connect the city to the waterfront, building on the analytical work done earlier by the team on the eight different areas of the Waterfront district, from the iconic

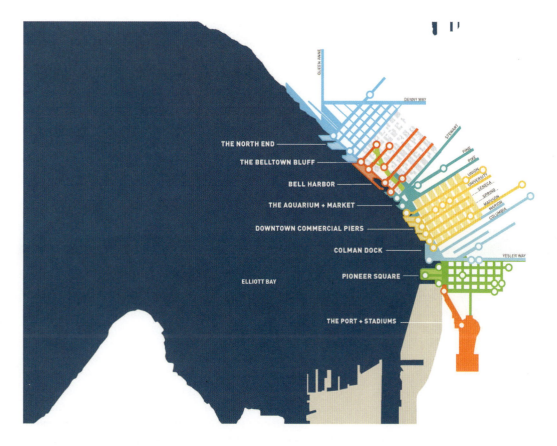

7 The Urban Framework Plan: connecting the city to its waterfront, james corner field operations.

Stadium in the south to Belltown's North End and the Olympic Sculpture Park in the north, and on how to draw existing energy down to the water by bringing out their unique characteristics there. Many of the 29 east–west streets connecting the city to the waterfront, a lot with great views out to the Bay, already have visitor destinations, for example, an art museum or an aquarium. The team identified scope to amplify their potential and integrate a balance of city and waterfront facilities by adding to this network. They also studied the inherent challenges of many of the streets, in terms of access, changes in level, bridges or decks, and devised an inventory, using analytic sections, as a means for better connectivity.

The team proposed a multi-modal access strategy addressing regional and local movement and strengthening the public realm for pedestrians and cyclists, which is a sound idea,

because the existing waterfront has its problems: it is not pedestrian-friendly, as it is hard to access, or feel safe in, it is poorly serviced, and offers parking challenges. The idea of concentrating transit in a hierarchy of three avenues, with the possibility of a streetcar on First Avenue upland from the water, and a lighter system of transit along the waterfront, is tied into ideas of green pedestrian links connecting the city to the waterfront, which could be part of existing and future parking facilities. A number of elevators, stairs, a hillclimb system and new bridges that could upgrade connections are another set of instruments to bring people to a waterfront where the pedestrian is given priority.

Action to revitalise the west-facing façades of development along the city edge was viable, and the new Alaskan Way road could be lined with trees, have pedestrianised intersections,

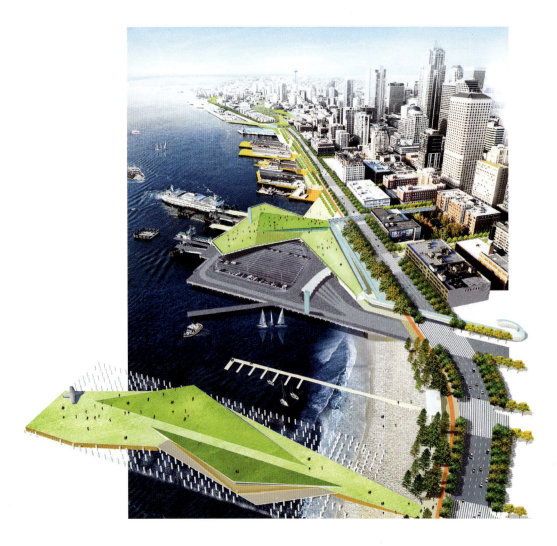

8 Aerial overview of conceptual ideas for the new waterfront, looking north, james corner field operations.

with coordinated pedestrian and cyclist transit. 'Nimbler' transport systems, such as small buses, are being considered for the waterfront with a continuous bicycle path alongside the new road. Can a streetcar be part of the vision? On First Avenue there is more demand and more traffic, so the economics would be better there, but being tight on space at the waterfront, the public realm is quite constrained, so the team prefer to have a smaller form of transit using the street. The team know that an in-depth study of the performance of the street, based on lessons from other cities, is necessary, taking into consideration the fact that at peak time there is a high demand for traffic, but offpeak a much lower demand, so flexibility and accommodating certain uses are vital.

The third parameter is the scale of the waterfront. The team devised Tidelines, an organisational framework to develop waterfront-related features based on water flows. This idea emerged from conversations with locals who wanted the waterfront to demonstrate a commitment to natural systems, and are interested in better water quality and stormwater management (some projects are already afoot in the city to deal with this), and Corner feels it should be done in a more systematic and large-scale way with working landscapes.

The historic context of the dynamic tide landscape has been built over, and the new design, coordinated with the engineers in the team, considers a more varied relationship to the water and the tides, applying a thicker, more dynamic threshold between the land and the water. A topographical diagram functions as a good way to help organise the waterfront and generate different sectional diagrams for terraces, stepping the land down at various gradients or roof structures. Stormwater management is a key part of the plan, collecting rainfall and filtering it through terraces out into the Bay, with the waterfront perceived as a productive stormwater device. It would work within what the team envision as a constructed landscape of planted terraces where people could have a tactile relationship with the elements, with canopies.

Elements of the site indicated the varying challenges of the escarpments, for example, buildings with programmes underneath, with a public surface above. A landform park at the Aquarium and Pike Place Market, for example, could provide a spectacular overview platform, a new public plaza and facilitate a flow of people safely down to the waterfront, totally pedestrianised, with seated steps and scope for events, and scope for building underneath the fold. The team suggest testing out thermal pools at Piers 62 and 63, that would need to be rebuilt as they are aging, which sounds like a fun idea. A second fold at the Belltown Balcony, which involves a topographic challenge for access, could offer views south over the Bay through a deck and neighbourhood park, new green streets, with much better connections in terms of views and access.

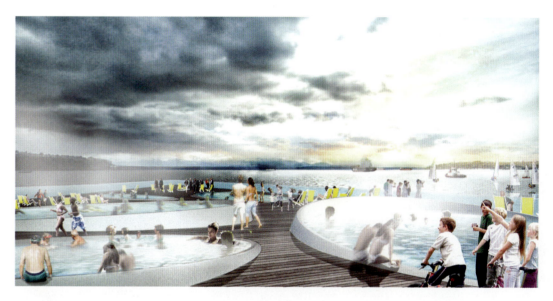

9 Public thermal pools at Pier 62/63, looking west, james corner field operations.

Colman Dock is a noted congregation point, and therefore a key asset that could become much more civic and celebrated, Corner pointed out. It also presents challenges in terms of topography, but the roof could be turned into a park with a tilted sun lawn, and a bridge tying the sports district to the ferry terminal, with a new retail frontage with a folded canopy with solar panels, to diversify uses, and with new clock towers. This is an area that could be better integrated with Pioneer Square and the sports district. More public amenities could wrap the piers, making them more socially vibrant. Pier 48 is state-owned, and the team's proposal is for a park for festivals and large events, redefining it as a soft landscape, cutting it away to include a large beach and sloping it to face north and south, bringing Pioneer Square to the water and ensuring a more regular use of the facilities there.

Having conceptual diagrams at this point has been vital to demonstrate the feasibility of access and social spaces and to enable understanding of the integrated wholeness of the effort, while the arrangement is for the final fabrication and designation to come at the next level of development. When it comes to issues of security, a question asked about all new parks, the team is aware of the need for 'eyes on the park', with a residential presence highly desirable. In answer to another audience question, big picture ideas can also accommodate more places for children, to be developed at the next stage – 'Kids are mandatory on the waterfront,' says Corner. Retaining a portion of the viaduct, an issue that has been raised on a few occasions, is a complicated question, he feels, but he says the new interventions are safer, with better views. Artists will play a fundamental role at the waterfront, with ideas developed collaboratively. The artist Mark Dion and Michael Horsham of Tomato, responsible for a lot of the graphics and 'messaging', are among those with whom the team has had numerous meetings, contributing to the process of development of a public art plan, and new initiatives to give it a high priority.

The culmination of all these multiple devices Corner describes as developing 'a diverse, episodic waterfront respectful of its relationship to adjacent districts', with a radiating effect from water to land and back again. The proposed waterfront has an ecological strategy, adapting it to the advantages of stormwater, alternative energy and biodiversity: accessible, safe, dynamic and beautiful – 'a hard place to leave', as Corner says, adding that masterplanners need to make purposeful ideas visible and compelling, but be aware that the ideas can take different forms as they evolve.

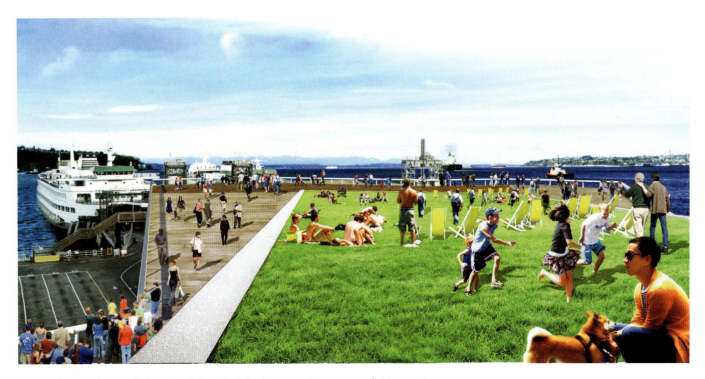

10 Rooftop sun lawn at Colman Dock Ferry Park, looking west, james corner field operations.

A waterfront park should help to transform a city, otherwise why bother? Field Operations' synergistic approach takes full account of all aspects of the public urban environment and how they can best interrelate, and the team has proceeded to gather and respond to public feedback in a considered, interactive way. In such a scenario that involves the complexity of new road tunnels, getting too bogged down with discussions about how many car lanes there should be takes the focus away from what could be facilitated as a result of their realisation – a waterfront that becomes a real civic asset.

It is a complex challenge to create such multifaceted permeability between the city and the water; just as tough to engender a sense of community ownership of public–private-owned public space. Not being scared by the topography and identifying ways to adapt it is part of the challenge for the

Seattle Waterfront. Creating too much open space by the water is not the answer; over-development of the whole corridor also will not work if the quality of the public space is to be fully attended to. Civic leaders undertaking urban development, and aware of the compromises made elsewhere, as they are in Seattle, can now also face the opportunity to love the complexity of the public–private partnership, the entity that is nowadays used to enable epochal projects of this kind, for example, Chicago's Millennium Park. Seattle City Council, spurred on by the Mayor Mike McGill, perhaps the city's equivalent of the US President at the federal level, represents a unified force in having the courage to move the project forward, and has clearly done exactly the right thing by engaging architects and the public in a productive dialogue sufficiently early in the process.

3

Science and technology districts

one-north, Singapore

The twenty-first-century science park hosts the burgeoning knowledge industries of a city or a nation. As a type, it has not traditionally been residential. But the emerging 22@ district in Barcelona is mixed use, including new homes; while many science parks – such as Illinois Science + Technology Park, which has customised research space for synergistic partnerships between different bodies – are not. Now China is building whole live-work development zones focused on innovation in the knowledge industries, for example, in Guangzhou, through its 37km^2 Science City. The reinvention of the science park typology, as part of the densification and intensification of the city, now more commonly integrates living space with a new type of industrial landscape, and is part of an ecologically advanced park environment, for example, Tainan Science Park in Taiwan, Chengdu's Tianfu Life Science Park or Skolkovo Centre for Innovation, a Russian 'Silicon Valley' outside Moscow, being planned.

The 200-hectare one-north mixed-use business park being realised by the JTC Corporation, together with the Science Hub Development Group (SHDG), is part of Singapore's economic and urban development strategy, and targets new economy industries such as biomedical research and development, information and communications technology, and new media production. Although it will not be developed in its entirety until 2021, two of the first five phases have now been completed for the northern section of the site with buildings by a number of architects, and the masterplan, designed by Zaha Hadid Architects, has been evolved to match this agenda.

The masterplan arranges industry-focused hub clusters of research and business collaboration – Biopolis, Fusionopolis in the first phase, and Vista Xchange, Mediapolis and Wessex Estate in the later phases – designed to optimise the accessibility of shared resources and services, and to accommodate and encourage the organic growth of each neighbourhood. As catalysts for urban intensification, they are planned as home to 50,000 new residents and 70,000 workers for implementation over 20 years, with 5 million m^2 of buildings.

'We wanted to start not a science park, but a science home of the future where scientists could work, learn, live and play, in certain hubs,' Yeoh Keat Chuan, Executive Director of

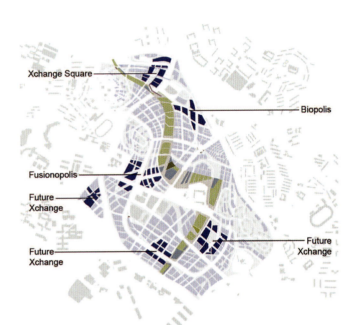

1 Site plan of the various Xchange districts of one-north Singapore, Zaha Hadid Architects.

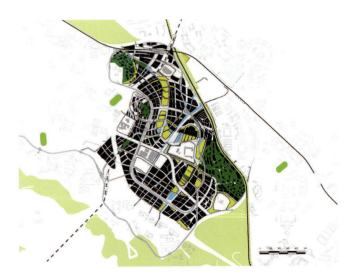

2 Phasing of organic growth diagram, one-north Singapore, Zaha Hadid Architects.

3 Diagram, one-north Singapore, Zaha Hadid Architects.

BioMedical Sciences of the Economic Development Board of Singapore, told *Business Week*.[1] He added:

> By providing homes as well, the scientists never leave their work and we create homes for the future with seamless technologically enabled environments. We see Singapore as a living laboratory. Today we have a city state of 4.5 million people. We think that increasingly in the future many cities in Asia will probably grow – China is talking about megacities of 14–20 million people – and Singapore could be that model of how we address urban solutions, health and wellness issues, lifestyle requirements.

Singapore's long-term development strategy demands strong emphasis on land intensification, and the one-north plan is medium density with close knit massing, but with a range of densities to bring balance and diversity across the site.

1 Pete Engardio, 'Singapore's One North', Business Week, 1 June 2009.

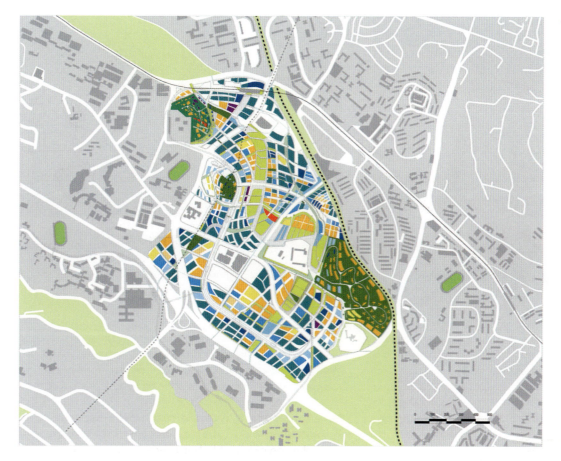

4 Final district programme, one-north Singapore, Zaha Hadid Architects.

The plan represents one of Zaha Hadid Architects (ZHA)' early tried and tested masterplanning schemes. The practice has been designing masterplans, supported by a specialist team including consultant architects like Larry Barth, for many years, and was seen by the client as a modernist outfit capable of the complex aggregated urbanism needed. In 2001, the practice won the international competition for the planning and first phase design of one-north, and the practice made a detailed masterplan for the northern section, defining parcels of land and their goals. 'The client was very brave to take us on,' says Dillon Lin, architect at ZHA, who worked on the project. 'People weren't sure if it would work. There were a lot of bureaucratic hurdles.'[2] JTC is the industrial arm of Singapore

Inc., and its interests were perceived as being outside the post-war frame of thinking in which functions are separated.

Instead of traditional disconnected suburban-style science parks, the plan is one of complex, aggregated parametric urbanism. The architects strived to 'radically depart from the isolation and mono-dimensionality of science parks dotting the world's industrial landscape in recent decades, acknowledging and incorporating the powerful synergies between urban life and today's research-driven industries . . . mixing and layering land uses'. They divided the site into seven neighbourhoods

2 Interview with the author, 2010.

5 Buildings at Biopolis, one-north Singapore.

6 Matrix building, one-north Singapore.

with a mix of densities and their subtle differentiation supports a fluid adaptation to the changing conditions of investment and development.

The site is next to Singapore's Science Parks, close to the National University of Singapore and the National University Hospital, a key location in Singapore's technology corridor. It is also near the Ayer Rajah Expressway, and at an important intersection of existing and forthcoming Metropolitan Rapid Transit lines. The masterplan builds on these advantages to make one-north multi-modal in transport terms and integrated with the larger metropolis.

Biopolis phase 1 is five minutes south of the Buona Vista MRT Station on the east–west line of the subway system and 20 minutes drive from the financial and business district. It is conceived as a world-class biomedical science research and development hub, centred on a complex of seven buildings that were completed in 2004, and several government agencies, research institutes and R&D labs of pharmaceutical and biotech companies are located here. The focus derives from the fact that the biomedical field is a dominant economic force in the twenty-first century, benefitting from electronic and computer breakthroughs, allowing massive amounts of genetic infor-mation to be decoded and processed rapidly. Construction began in 2001, and the first three phases accommodate 5000 scientists from different public research institutes, making it as big as any US biomedical cluster, aside from San Diego's. Its

existence reflects a global urban geographic shift to create research-friendly communities with a clustering of non-polluting firms offering high-paying technical jobs.

One-north transcends purely a bio-medical focus. Just minutes away to the south-east is Fusionopolis, spread over 30 hectares at the nexus of one-north, a synergistic hub for information and communications technology, media, physical sciences and engineering, with office and laboratory space, retail, restaurants and recreational facilities with a 120,000m^2 cluster of buildings designed by Japanese architect Kisho Kurakawa. Phase 2, commenced in 2011, is a business park and R&D centre, with a 50,000m^2 development by Malaysian architect Ken Yeang. The six institutes here are intended to spur cross-disciplinary research not only among themselves, but with Biopolis, treating the two locations as an engine for this. Vista Xchange is a business centre, residential and entertainment hub to the north of one-north, while south of Biopolis is Wessex Estate where creatives live and work and Mediapolis, a district for media R&D.

'It is a vision for convergence, an entire integrated innovation ecosystem', is how Lee Hsien Loong, Singapore's Prime Minister, described it at the official opening of Fusionopolis in 2008.[3] As the client states,

3 17 October 2008.

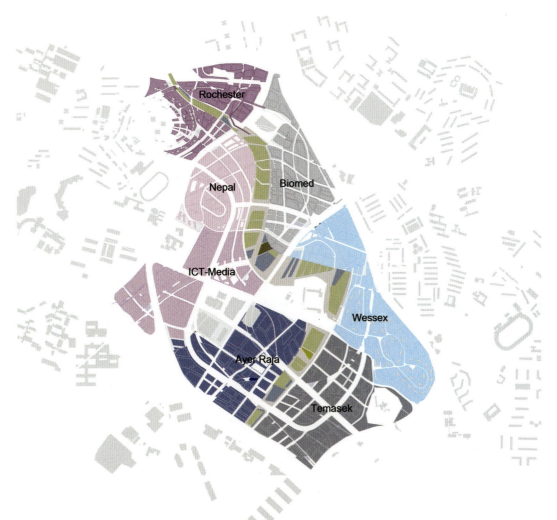

7 Diagram of heritage areas at one-north Singapore, Zaha Hadid Architects.

The development of the three phases will integrate industry clusters and their neighbourhoods, allowing them to grow organically without compromising the site's spatial mix. As innovation in one area fuels ideas in another, new linkages and synergies will develop.[4]

The plan 'changes the ways workspaces are strategised as a field', says Barth who, with architects and masterplanners S333, instrumentalised the scheme to ensure that 'guidelines were interrelated' by a set of tools: fixed sections, porosity, mass, void, dimensional, materials, topological, and developed into drawings, dealing with issues including façades as plans and relationships with streets.[5]

One-north is a bit of a benchmark in the sense that it made the practice's ability to do masterplanning better known, leading to further commissions, but also because it avoids the isolation and mono-dimensionality of previous business parks

on urban industrial urban land which suffered from a compound mentality. ZHA's masterplans animate the ground with a rhythmic flow, adding or scooping out a civic space around every tower and building, accentuating architecturally both global and local spatial properties, achieving an urban porosity. Its Kartal-Pendik masterplan, for example, a mixed-use plan for Istanbul's Asian side, is 'a hybrid between minimising detour networks and deformed grid', explains ZHA Partner Patrik Schumacher, with 'a sense of organic cohesion'. As with one-north, Kartal-Pendik's 'ordered complexity replaces the monotony of older planned developments and the disorientating visual chaos that marks virtually all unregulated contemporary city expansions', he explains.[6]

Mixing and layering land uses to maximise social connections and promote forward thinking was part of the team's rationale. Bringing mixed use into the project is a new idea for science parks that drives new relationships between domestic life and productive activity, moving away from

4 Agency for Science, Technology and Research (A*STAR) oversees 14 biomedical sciences and physical sciences and engineering research institutes, and six consortia and centres, centred at Biopolis and Fusionopolis, as well as their immediate vicinity, www.a-star.edu.sg.
5 Interviews with the author, 2009.

6 Patrik Schumacher, 'Parametricism – a new global style for architecture and urban design', *Digital Cities, AD*, 79(4), July/August 2009. Guest Editor: Neil Leach.

8 Diagram of main roads at one-north Singapore, Zaha Hadid Architects.

9 Axonometrics of the programmes, one-north Singapore, Zaha Hadid Architects.

Modernist approaches. Some colonial buildings have been retained. In an evolution of the generic business park, it has seven urban districts, each with their own business ecology. This differentiation accommodates the logic of organic development, with spatial patterns 'continuously evolving according to local circumstance and changing conditions', say the architects, 'responding equally to local heritage and topography and to the rhythms of business investment'.

The non-contiguous distribution of the three Phase 1 XChanges is key part of this strategy. 'Their distribution accommodates growth while concentrating shared, industry-specific resources and associations,' they add. The masterplan has 'sought a balance between ensuring critical mass in Phase 1 and optimizing the resources and synergies for specific industries'. Each of the three Phase 1 Xchanges responds to a particular business ecology, while also providing the catalyst for the residential, commercial, retail, and leisure development which will hopefully sustain their vitality. The pattern that results distributes sites for business development and simultaneously links them together through 'an urban web of activity'.

The plan emphasises spatial balance and urban amenity, 'reconciling land intensification with quality open space', say the architects. Growth is therefore shaped and organised through the pattern of the districts, each of which is bordered by Buona Vista Park, a 16-hectare, continuous, multi-purpose spine of landscaped spaces running the length of the site giving identity to the area, and existing urban fabric. Intended for informal gatherings and events, the park's sinuous form is a counterpoint

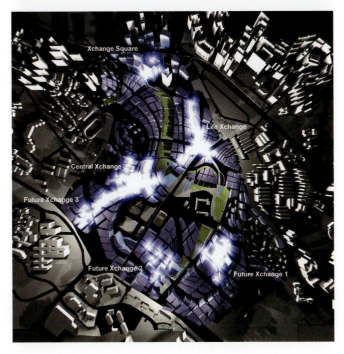

to the sharp outline of buildings, its edges softening paths linking concentrations of business development.

The plan's pattern directs growth along an edge well served by amenities. To enrich the sense of life through ground level links between later building and the original business epicentres, it establishes a network of parks, plazas and linear atria, orienting local activities at ground level, so that high rise development has an active street life. 'Through this hierarchy of spatial controls, the research and business constellations are allowed to grow while maintaining their clear character and amenity.'

Heritage areas at Rochester Park, Nepal Park and Wessex Village counterbalance the intensity of the Xchange districts, with, at Rochester Park, adapted bungalows as a compact collection of shops, restaurants and galleries creating a terrain linking housing and corporate towers. The dual character of calmer and more vibrant urban areas, heritage focal points and new buildings, enables the district to perform well at different scales, with the heritage elements a catalyst for new investment.

10, 11 Bird's eye visualisations of one-north Singapore, Zaha Hadid Architects.

12 Painting of one-north Singapore, Zaha Hadid Architects.

The masterplan is a model for urban intensification under changing conditions. It is made up of the land use plan, open space and landscaping plans, detailed design strategies for each of the Xchanges and urban guidelines for each of the seven districts. It is a system of ground forms designed to suit the shaping of new relationships and intersections, which strategically promotes both spatial control and adaptability. By subtly differentiating seven urban districts, it supports fluid adaptation to changing conditions of investment and development.

While the urban scale implementation of parametricism is still at a relatively early stage, ZHA's winning of a series of international masterplanning competitions – one-north, Kartal-Pendik, the mixed use Soho City project in Beijing and Zorrozaurre for Bilbao – demonstrates its perceived worth. If 'political and private buy-in' can be achieved, Schumacher feels, and with appropriate planning guidelines put in place, the 'worthwhile collective value' of a 'coherently differentiated cityscape' is a 'unique character and coherent ordering of an urban field that all players benefit from'.[7] He also sees its validity as 'a framing agenda' to the contemporary context of metropolises of 20 million people upwards, and stresses that 'the built environment is an evolutionary process, like the emergence of life'.[8]

13 Bird's eye visualisation of one-north Singapore, Zaha Hadid Architects.

One-north Singapore is an unusual science park in that it puts quality of urbanism first and the goal of bringing in industries second. It is 'a science park that isn't a science park', says Lin. The client was interested in what makes cities attract talent – not in having a standard campus, and that grasp of the potential of masterplanning to respond intelligently to contemporary social and industry dynamics and their productive interplay, has made all the difference.

7 Ibid.
8 Patrik Schumacher, lecture, 'Proto/e/cologics: speculative materialism in architecture', Rovinj, Croatia, 6–7 August 2011, staged by the Mediterranean Laboratory for Architecture & Urban Strategies (MLAUS).

4

Post-disaster
urban regeneration

PRES Sustainable Reconstruction Plan, Constitución, Chile

Constitución, Chile's second city, some 350km south of Santiago in the province of Talca, a seaside resort near the mouth of the River Maule in the Pacific Ocean, was hit by a massive 8.8 magnitude earthquake and subsequent tsunami on 27 February 2010, with waves up to 12 metres high, killing at least 550 people and leaving over 2 million people – 80 per cent of the population – homeless. The city has a history marked by earthquakes and still rests on a seismically active area. Most of the city, which currently has about 50,000 inhabitants, was destroyed by an active earthquake in 1939 and was later badly affected by a devastating earthquake in 1960.

Most of the buildings that collapsed – about 70 per cent of the whole city – including many historic structures, were not new but were made of adobe. Reconstruction after the earthquake would take 'three to four years' said Chile's President Michelle Bachelet in March 2010 (4 March 2010, BBC News). Costs were estimated at between $15bn and $30bn, and would require 'credit from the World Bank and other entities'.

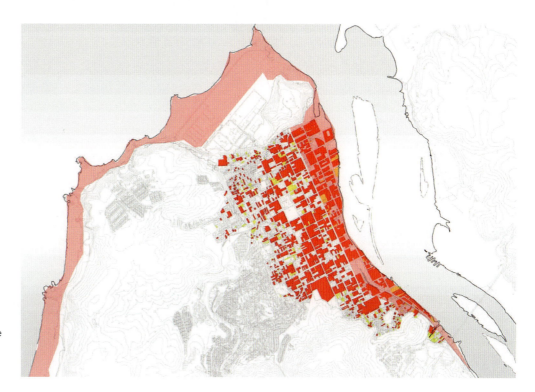

1 Constitución, PRES sustainable reconstruction masterplan: pink shows tsunami damage, red earthquake damage, Elemental.

93

On 19 March 2010, Chile unveiled a $110m reconstruction plan to put the central region back on its feet, focussing on immediate priorities: providing shelter for families made homeless by the earthquake, restoring school attendance and creating jobs in coastal areas that had borne the brunt of the catastrophe (which caused an estimated 15,000 job losses). These measures were complementary to permanent solutions

the Housing Ministry was working on. Arauco, Chile's leading pulp and paper producer, established for over 40 years (the first Chilean company to issue carbon credits), specialising in sustainable forestry, whose plants and resources suffered considerable damage, has played a proactive role in restoring services and providing help. All but one of its 35 manufacturing facilities were destroyed by the quake and its aftermath. When

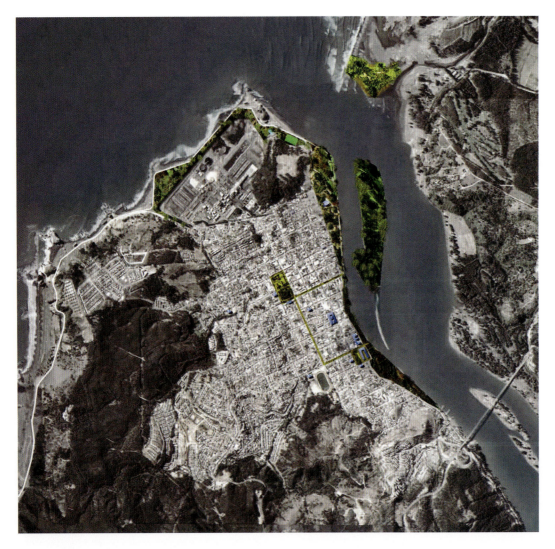

2 Constitución, aerial view of the PRES sustainable reconstruction masterplan, with the location of the park to mitigate the effects of the tsunami, Elemental.

repairing its manufacturing facilities, it offered its factories for use as emergency homes as well as supporting new public projects and donating land for new build homes.

On 31 March 2010, Marcelo Tokman, the former Energy Minister, was ratified as Executive Director of the Reconstruction Plan for the city. The Committee for reconstruction consists of the Municipality, the Ministry of Housing and Arauco. It joined the Housing Ministry and the Municipality in the reconstruction plan, creating a public–private alliance to develop a masterplan for the sustainable reconstruction of Constitución.

In order to realise the masterplan, in an initiative headed by Mayor Hugo Tillería, Arauco organised a consortium of institutions and consultants, including Elemental, the leading Chilean architecture firm with wide experience in the development of social housing. Elemental favours the approach 'do tank' as opposed to 'think tank'. Other committee members include Arup, the London-based architecture and urban development firm, the University of Talca, a nationally renowned institution with expert information on the region, and Fundación Chile, a non-governmental organisation focussed on innovation and technology transfer. The intention from the first was that the reconstruction would be in partnership with the participation of the community and a number of meetings were set up, documented at http://presconstitucion.cl/.

The Sustainable Reconstruction Plan (PRES in Spanish), approved on 30 June 2010, had to be produced in just 100 days, requiring the team to assimilate a huge amount of information. Elemental architect Alejandro Aravena said: 'We had to have, on one hand, design ideas with public consensus, while designing the mechanisms for its implementation. There was no time to plan first, then consult the people, and then think about how to implement it, but we had to do everything at once.'[1]

1 Quoted in Ariel Hendler, 'Aravena remakes Constitución', *Architecture*, 15 November 2010.

MATRIZ DE PROYECTOS

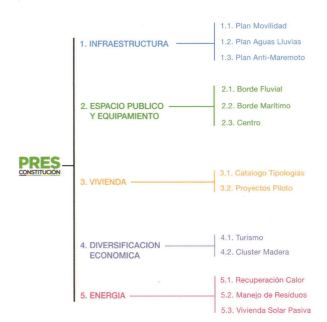

PRES CONSTITUCIÓN

1. INFRAESTRUCTURA
 - 1.1. Plan Movilidad
 - 1.2. Plan Aguas Lluvias
 - 1.3. Plan Anti-Maremoto

2. ESPACIO PUBLICO Y EQUIPAMIENTO
 - 2.1. Borde Fluvial
 - 2.2. Borde Marítimo
 - 2.3. Centro

3. VIVIENDA
 - 3.1. Catalogo Tipologias
 - 3.2. Proyectos Piloto

4. DIVERSIFICACION ECONOMICA
 - 4.1. Turismo
 - 4.2. Cluster Madera

5. ENERGIA
 - 5.1. Recuperación Calor
 - 5.2. Manejo de Residuos
 - 5.3. Vivienda Solar Pasiva

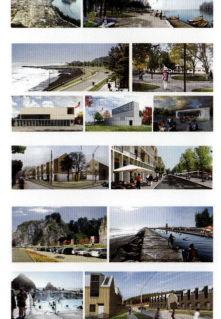

3 Constitución, PRES sustainable reconstruction masterplan project, chart showing coordinated lines of development, Elemental.

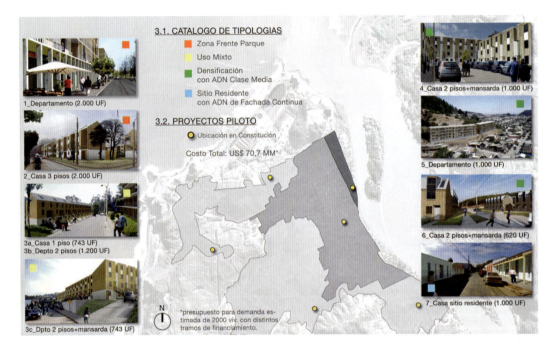

4 Constitución, PRES sustainable reconstruction masterplan, Elemental, housing plan for different contexts, Elemental.

With private money from forestry firms like Arauco, followed by national government funds, a total of $150 million, the team had to act fast and ensure first-rate coordination between all parties. From day one, the focus was on redistributing water; by day ten they were proposing emergency housing with long-term use realised in an incremental way as Elemental had undertaken in its social housing projects elsewhere in Chile. Soon after, they moved onto a major strategy to protect against the tsunami.

The idea was not only recover what was there before the earthquake and tidal wave but also to reconstruct a new city from a comprehensive point of view, so that the people can enjoy a better quality of life in future.

PRES embraces the reconstruction of the city in four areas: infrastructure, public areas and resources, housing, and energy. Chief criteria are technical excellence, political and social feasibility, environmental sustainability, as well as community participation, and the creation of opportunities for raw material, work, industrial capacities and energy. Arauco regards the plan for Constitucíon as 'a unique model . . . which represents a real opportunity to improve the quality of life for people in Constitucíon and put into practice a new way of viewing the city'.

First, PRES makes the town's DNA anti-tsunami, as Elemental put it, by providing a new coastal park that shifts its axis to the waterfront, capitalising on its natural and functional assets and giving it a new river access. The Maule River Park project, as it is known, which was approved by 94 per cent of voters, will mitigate rather than block flood waves, reducing their occurrence (floods occur here every year due to the poor design of the estuaries). As a park with a forest, not a concrete wall (the inefficiency of concrete barriers was proven in Japan and Hawaii), it is a geographical response – this region being the forest zone of Chile – to a geographical threat. Costed out at $10 million to implement, in the case of a tidal wave, it would reduce the height of a flood by 23–28 per cent and reduce the speed of the waves by 34–41 per cent. It includes 19ha of parkland and Aravena points out that 'the standard square metres of green space per person in the city has been $2.2m^2$, whereas the standard recommended by the World Health Organisation is $9m^2$'. Aravena feels that the construction of

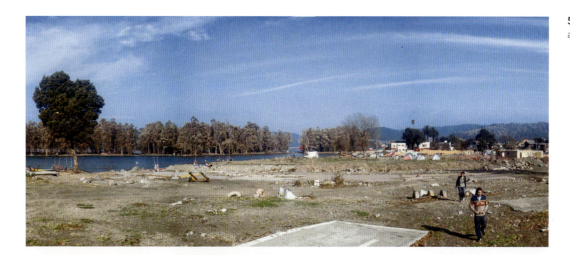

5 Constitución, riverside after the tsunami.

6, 7 Constitución, PRES sustainable reconstruction masterplan, proposal for riverside construction after the tsunami, with trees and mitigation hills, Elemental.

8 Constitución, PRES sustainable reconstruction masterplan, proposal for the riverside, with new docks and a new pedestrian bridge, Elemental.

9 Constitución, riverside after the tsunami.

10 Constitución, PRES sustainable reconstruction masterplan, proposal for the reconstruction, mitigation park and new buildings, Elemental.

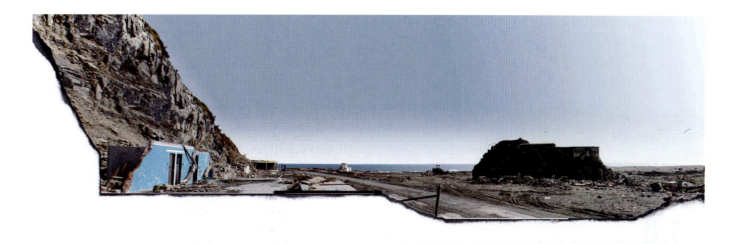

11 Constitución after the tsunami.

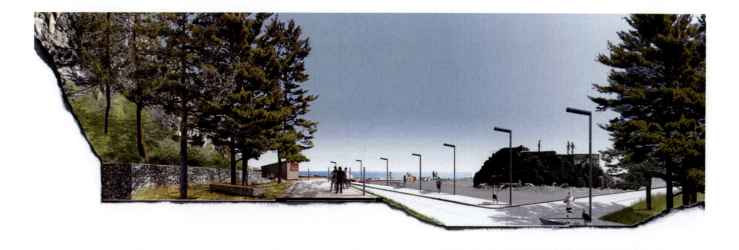

12 Constitución, PRES sustainable reconstruction masterplan, proposal for the reconstruction of the coastline, Elemental.

public spaces in many Chilean cities could be focused on these kinds of coastal woodlands as it 'is an efficient way to correct these inequities (of poor city standards) in a relatively short time'.[2]

Permission was obtained for lightweight buildings on solid first floors along the park's borders. Here will be a protection area near the riverside where no building can be constructed.

In the park the team propose a retardant lagoon and lamination gap for the river's peak hours to protect against flooding. New housing – and existing sun-dried brick houses will be replaced by wooden houses without use of the ground floor for residence – is protected by this new green space, which includes a forest and hillocks. The waterfront in fact became the central attraction and the team built on its public space. Aravena explains that the plan honours the need for people to live close to the coastline, as it is the sea that provides their economic activity; any other alternative is impractical.

2 *Qué*, ibid.

13 Constitución, PRES sustainable reconstruction masterplan, riverside mitigation park, Elemental.

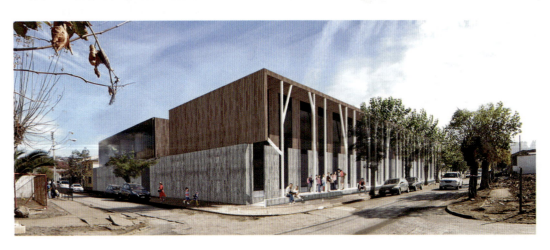

14, 15 Constitución, PRES sustainable reconstruction masterplan, proposal for the Enrique Donn Primary School and the current site, Elemental.

16 Constitución, day of the popular vote for the mitigation park and other projects. PRES got 92 per cent approval.

17 Constitución, community workshop in progress at the PRES Open House.

Overall, 12 public realm interventions, some specified as very high priorities by the community, including a new firefighting headquarters, a bus station, a municipal theatre, a boardwalk and facilities encouraging more tourism, sports facilities, cycle paths, fish markets, a shipbuilders' yard, children's playgrounds and a pedestrian bridge to Orrego Island. The designers used

some of the plot to develop new streets in runoff gutters, and laid out three wide avenues to help evacuation in case of another tragedy. The masterplanning team also proposes to rebuild all the public buildings destroyed by the earthquake or tsunami, including the theatre, the local school, the public library, the San José church and the bus station. The urban fabric of the city did not possess much architectural value but clearly its resources were all but wiped out. The team made a new urban aesthetic with galleries with rows of columns for each building, an approach that had not previously existed there, but which referred to the Chilean tradition of the 'row house'. These are to be constructed mainly in concrete with wooden walls.

Elemental, Arauco and Tironi Asociatos developed a programme of public consultation, which became an inductive process presenting citizens with 'real projects instead of creating an abstract diagnosis of the situation', as Juan Ignacio Cerda, architect at Elemental, explained.[3] Public discussions were staged at the Open House. He stated: 'Because we didn't have time to analyse the situations, we used our professional intuition to propose and test the proposals in hybrid forums of community, politicians, technical, services.' Participation was transparent, multi-channel, multi-scale and binding through a voting process. Some 94 per cent of the citizens voted in favour of the plan, 4230 by visiting the Open House (6300 visits in total were made), and more than 10,700 visits made to the website, with 1200 opinions sent to the ideas mailbox and more than 50 weekly citizen forums, in addition to numerous meetings with public and social authorities, potential regulators and technical experts.

'It's good to have these meetings,' said Clarisa Ayala, the Ministerial Regional Secretary for Housing and Urban Development, 'because they report on the progress of projects and clear doubts that may exist so that we can realise as soon as possible all reconstruction projects.'[4] Some officials were apparently concerned about rebuilding the adobe houses that had been destroyed, but during the consultation process it emerged 'that people did not much identify with them, but rather with nature: the Maule River defined their identity more than the adobe houses,' said Aravena.

3 Interview with the author, March 2011.
4 www.presconstitucion.com.

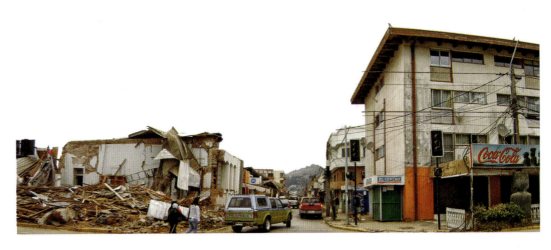

18 Constitución, earthquake damage in the downtown area.

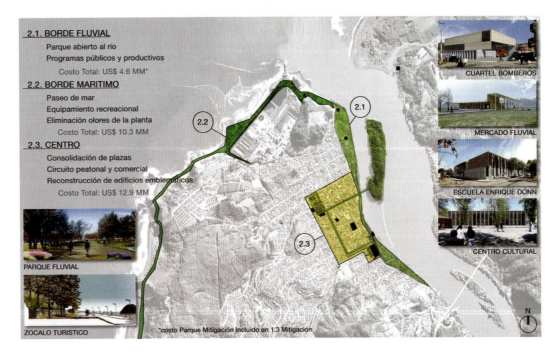

19 Constitución, PRES sustainable reconstruction masterplan, public space and public buildings plan, riverside, coastal and downtown plans, Elemental.

Elemental and their team adapted the plan to the financial resources. They observed that the process of obtaining private monies was faster than the phased process of retrieving public grants. Responding to the crisis, over the last year the government has approved 135,000 reconstruction grants to help the homeless, but, because of complex bureaucracy it has taken until now before construction can begin. Half the 220,000 homes damaged could be repaired, but most remain uninhabitable due to unresolved questions about property rights or liability for the damage. Emergency shelters were provided to 76,000 families on their own land, and one year on, another 4,000 were in shelters in around 100 government camps. Aftershocks, especially one registering 6.8 in the region in February 2011, a year later, are preventing tourists from visiting the nearby resort of Dichato. *Mauchos*, a film directed by Sebastian Moreno, was a social record of the catastrophe and the resilience of the town's inhabitants.

The Housing Minister Magdalena Matte has confirmed that this public–private alliance model can be applied to other affected locations in the country, with the contribution of other private companies. Given the strategic nature of the location, 'the coastal cities [of Chile] should be filled with forests' as mitigation contingency plans for the future, said Aravena.[5] It is also possible, he feels, if Chile develops 'an institutional framework that allows us to anticipate the conflict', that there would be 'potentially the opportunity to export knowledge to those countries that are facing the same conflict, such as Japan and the United States'.[6]

PRES is a highly inclusive, site-specific plan closely geared to the totality of its circumstances: 'We learned to think of the emergency and the contingency as incremental actions: if we are not able to make it fast and good, we can make it fast and improvable,' adds Juan Ignacio Cerda at Elemental.[7] That requires flexibility, because reconstruction is essential to respond to urgent social needs but realistically, he feels, 'there is no urban reconstruction process in the world that lasts shorter than three years', so with the contingency plan they are creating 'permanent and professional solutions that are coordinated, integrated and feasible'. Aravena says this applies equally to the practice's many social housing projects in Chile, saying that 'the most precious resource was coordination'. Moreover, 'we're not asked to just do a design; we're asked to come up with the question that we need to solve.'

5 *Qué*, 'All cities should be filled with coastal forests', 25 February 2011.
6 *Qué*, ibid.
7 Ibid.

Make It Right, Lower 9th Ward, New Orleans, USA

Since Hurricane Katrina in 2005, the most destructive natural disaster in US history, New Orleans – plural in identity, with a river delta setting – has been the subject of many rebuilding and recovery plans. Many of those considered the process of recovery an opportunity to rethink many of the city's practices and institutions. Their scope has been far-reaching, including stormwater management to make the city more resilient and environmentally sound, but also more affordable as a place to live. The city has benefitted not only from the proactivity of its Public Works Department and Plan for the 21st Century: New Orleans 2030, the city's first citywide masterplan whose goal it has been to carry its stories into the future, but also hugely from the role of Make It Right, which has rebuilt the Lower 9th Ward with a new generation of house-building tactics.

Many people look back at the positive influence of historic legislation like Franklin D. Roosevelt's Works Projects

1 Plan for the 21st Century: New Orleans 2030, New Orleans City Planning Commission's citywide Masterplan, by consultant team led by Goody Clancy and other local and national experts.

Administration (WPA) in the 1930s and 1940s, which had a major effect on US cities, roadways and dams, but also on riverfront parks, schools and housing projects. When Federal or central government legislation is forged onto an integrated vision of infrastructure provision, urban plans can have a complementary effect. If the instruments are not adequate, they cannot play this rhizomatic role and will fail to create a sufficiently robust sense of place, and even well-meaning legislation can have negative repercussions. For example, the network of interstate highways built in the 1950s after Dwight D. Eisenhower's 1956 National Interstate and Defense Highways Act introduced heavy Federal subsidy for states to build interstate highways, bringing about major dependency upon cars, and suburban sprawl through its divergent, segregating effects.

In the 1950s, New Orleans saw the building of the Interstate 10 Freeway ousting Claiborne Avenue, an oak tree and azalea garden-lined boulevard, at the centre of a thriving business district in the middle-class Treme neighbourhood, one of the first free African-American communities. It destroyed its affluence, its picturesque vegetation, and its connection with the French Quarter, popular with tourists. Over 500 homes were moved to other districts. At the same time Treme was also hit by other negative factors and Federal policies: desegregation, suburban and shopping mall development, all of which discouraged investment in American cities.

By the 1980s, across the US, minimalist concepts of Federal government reliant upon extensive privatisation were rife, and the presidential eras of Ronald Reagan and George Bush saw a massive shrinking in public spending, including on large public works schemes. In major cities, thematic, developer-led urban planning offered face-lifted urban identities and prosaic infrastructure – roads, bridges, levees – in the case of New Orleans – and sewers, dropped off the radar. Today, roads, subways, housing, public parks and water in the US are all the responsibility of separate government departments.

Plan for the 21st Century: New Orleans 2030, the citywide masterplan and zoning ordinance for New Orleans, led by architects Goody Clancy (with local and national experts), was adopted in August 2010, with input from an extensive grassroots process including educating participants about planning. The elements of its 20-year policy and strategic framework integrate and embody new approaches and

opportunities for early action.[1] 'Committed to the principle of every place and every person', it is 'setting the stage for the stories to come' in its emphasis on liveability.[2] Critically, an ordinance approving the plan bans the council and administration officials from making any zoning or land-use decisions that conflict with the goals, policies and strategies of the huge Masterplan's land use proposals, changing longstanding practice. In 2011, it won a National Planning Achievement Award for a Hard-Won Victory, recognition of its response and effort applied to consultation on the changes inflicted on the city by the disaster and on desires for a new era.

One key recommendation has been to tackle the damage to Treme. The organisers of the Unified New Orleans Plan (UNOP) announced in 2007 a large-scale planning process to coordinate regeneration after Hurricane Katrina, proposed removing 2 miles of the I-10 state highway in order to reconnect neighbourhoods and restore Treme's beautiful avenue with trees, predicting that the city would gain 35–40 city blocks and 20–25 blocks of open space along Claiborne Avenue. Vaughn Fauria, co-chairman of the Claiborne Corridor Improvement Coalition, who called the highway's existence 'a tale of environmental and social injustice', produced a study in 2010 with the Chicago-based Congress for the New Urbanism that explored replacing it with a mixed-use boulevard, restoring walkability, with land free for housing and parks and the opportunity to unite divided neighbourhoods.

The initiative is part of a major shift in other US cities like Seattle (see p. 69), Portland, Oregon, Boston, San Francisco and Milwaukee away from major highways imposed in the name of urban renewal but which construct barriers to vitality. Mayor Mitch Landrieu of New Orleans admitted the scheme 'could be a game changer', and would 'guide strategic integrated investments in housing, transportation and land-use planning to realise the full potential in neighbourhoods along the Claiborne

1 http://www.nolamasterplan.org. More than 5000 people from every walk of life participated in its shaping.
2 Plan for the 21st Century: New Orleans 2030, Chapter A Vision and a Plan for Action, 2010. The award was made in the 2011 American Planning Association's National Planning Excellence, Achievement and Leadership Awards, National Planning Conference, Boston, 11 April 2011.

corridor'.[3] In October 2010, city planners were given a $2 million Federal remediation TIGER II Infrastructure Grant (as was New York, for the removal of the Sheridan Expressway in the Bronx), reflecting a more holistic approach to funding,

After Hurricane Katrina assaulted the Gulf Coast in 2005, breaching the levees in many places, and flooding about 80 per cent of the city, the American Red Cross estimated that a total of 275,000 houses were destroyed statewide, 5300 of these in the 9th Ward alone. After the further chaos caused by the slow Federal response to the disaster, Federal funds poured in, supporting a network of non-profit organisations. Their challenge has been to rebuild while maintaining something of the identity of the city. These small organisations have enabled residents and local business owners to feel part of the rebuilding process, in many cases training local workers in the construction of green buildings. After five years, the clean-up is still in progress in some parts of the city, and gutted houses are still conspicuous in places but multiple activities have made a huge difference to date.

A plan to revitalise the Mississippi River that the city straddles was first mooted in 2004, but the devastation of Hurricane Katrina put paid to its forward momentum. In 2006, the city and the Port of New Orleans resolved to work together to revive the plan, and in February 2007 a multidisciplinary team of architects – Chan Krieger Sieniewicz, Hargreaves Associates, Enrique Norten's TEN Arquitectos and Eskew+Dumez+Ripple – presented Revitalizing the Crescent, a design scheme to open up the river banks for public enjoyment and regenerate dilapidated areas with new parks and public venues funded by private investment.

Commissioned by the NOBC, an agency that develops city-owned properties, the plan was for a 70.5 hectare, 47.25 km-long linear park running along the east bank of the river from Jackson to Poland Avenues past the Lower Garden district, Warehouse and Central Business Districts as well as the French Quarter, Marigny and Bywater neighbourhoods. It includes plazas, cycle paths and new pedestrian routes and vantage

2 Aerial view of the Make It Right site before building, Lower 9th Ward, New Orleans, April 2008.

points over the river. The original industrial wharfs and terminals are still being used for cargo and transportation, and these are incorporated with adaptations in some cases, for example, cutting open a section of one structure and glazing over the other half to permit a visual connection with the river.

The design team also proposed improvements to Holy Cross, an area south of the Industrial Canal which was badly damaged by Hurricane Katrina, going beyond the limits of the brief given to them. Landscape architects Hargreaves Associates' proposal is for 4.85 hectares of land currently occupied by marine businesses, turning it into recreational space and restored river wetlands, while the parklands opposite the central business district would become a more formal, wide terrace of steps down to the river. The forms of TEN's proposed buildings included a hotel in the Warehouse District and a bioenvironmental research centre echoing the curving river. As Allen Eskew of Eskew+Dumez+Ripple comments, 'The plan gives the city a riverfront design that is authentic for our time and does not just reflect the past.'[4] To date, reactions from city residents have been largely favourable, apart from some criticisms of proposed building heights in the Bywater district.

3 Bruce Eggler, '$2 million federal grant will study the Claiborne Avenue revival, possible teardown of elevated I-10', *The Times-Picayune*, 20 October 2010.

4 Allen Eskew, quoted in Shawn Kennedy, 'New Orleans Waterfront Plan takes shape', *Architectural Record*, 19 December 2007.

The New Orleans 2030 masterplan prides itself on its support from 'community consensus' and 'a government committed to implement' it which then, as the theory goes, makes it easier to attract funding and private investment. It could not have anticipated the emergence of Make It Right (MIR), a non-profit initiative launched by actor Brad Pitt in December 2007 to rebuild the Lower 9th Ward, and aimed initially at building 150 environmentally-friendly, affordable homes to replace those flooded. Visiting for the first time after the storm, Pitt was shocked by the sights of the destroyed neighbourhood and to hear that there was no clear plan to address the situation. More residents owned their own home there before the storm than in any other area of the city, but did not get the evacuation buses in time, and a disproportionate number, 1000 people, lost their life in the maelstrom. Pitt said:

> I thought we could make a difference. Starting from scratch has its benefits. Too often we give disaster victims cheap building products, slipshod materials, and then put on top of them the burden of energy bills and medical bills. A new paradigm was needed.[5]

Listening to residents explain the extreme difficulties they were facing, Pitt resolved to help them bring about the rebirth of the district, regarded as the soul of the city. Before the hurricane the area was a strong social hub full of families and well equipped with venues playing live music. Douglas Brinkley, the historian, describes it as 'a virtual storehouse of civil rights history and cultural achievement' on a par with Harlem in New York, and with a Who's Who of the finest musicians ever produced by the States'.

The Lower 9th Ward was targeted after research of numerous factors, including infrastructure, transportation, access to public services, schools and health and safety. The project was in fact located in the most devastated area of the district and directly adjacent to the breach in the Industrial Canal levee, where a barge made the storm's impact even worse, as it crashed through the levee, pushing houses off their foundations. The New Orleans Office of Recovery Management established two of three priority zones to be rebuilt in the Ward, and MIR's target area intersects one of these. It overlaps multiple zoning designations, enabling local stores and commercial services also to return along with homeowners.

A myriad of obstacles made rebuilding much harder for residents, many of whom are retired or disabled and unable to work, including much higher construction, utility and insurance

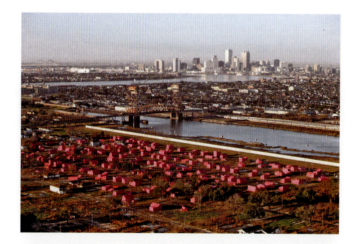

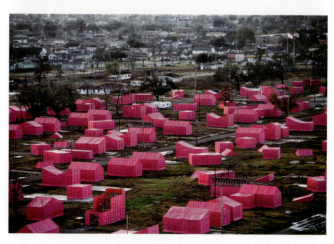

3, 4 The Pink Project, 450 recyclable pink tented structures installed on the Make It Right site in the Lower 9th Ward, New Orleans, by Graft architects, 2008. Photo: Charlie Varley.

5 Interview with Brad Pitt, *The Times-Picayune*, 25 August 2010.

costs and property taxes. MIR says that property tax exemptions and other conditions that made homeownership affordable before the hurricane will not be much help in the future, so it has to build houses that are affordable. It manages the whole process through homeowner counselling to forge a contract with a local community partner, select a design and secure financing.

MIR has 33 full-time staff including engineers, builders, landscape architects, home ownership counsellors and community organisers. Since its inception, it has raised over $27 million from more than 31,000 donors, managed a design process with 21 architectural firms and realised 71 LEED Platinum homes. It draws on input from neighbourhood community leaders, organised in a coalition of not-for-profits. This core team included the US practice of environmental architect William McDonough, drawing on the influence of his approach to design articulated in his book *Cradle to Cradle*,[6] and international practices like Graft, as well as the Cherokee Gives Back Foundation.[7]

Graft were the first to be coopted by Pitt, and in 2008 they launched Pink Project, 450 recyclable structures made of aluminium poles clad in pink fabric sleeves like anti-shrouds laid out on 14 city blocks in the flat land of the Lower 9th Ward. The array – vivid by day, a mass of glowing beacons at night – represented the disruption after Katrina, and this merger of art and architecture, symbolism and functionality, was later realigned over some weeks as a neighbourhood of houses might be, to signify renewal. The recyclable fabric was duly made into tote bags afterwards. It was a highly effective fund-raising effort to build the first 150 homes on the site by the following summer, and an outstanding means to flag up to the media and funding bodies the need for support for the scheme.

Pitt began working with Global Green USA,[8] the environmental non-profit organisation that created the Holy

Cross affordable housing project to the south of the Lower 9th Ward and K-12 schools in the city, and sponsored an architectural competition to generate new ideas about how to build sustainably on the exact spot where the Industrial Canal levee breached in August 2005. There was no masterplan as such. The criteria applied to the choice of the 50 shortlisted

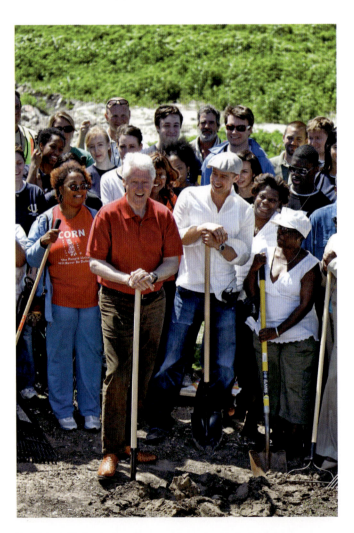

5 Make It Right site breaks ground on plans to build 150 houses, March 2008, former US President Bill Clinton, Make It Right founder Brad Pitt and residents, Lower 9th Ward, New Orleans.

6 Michael Braungart and William McDonough, *Cradle to Cradle: Remaking the Way We Make Things* (New York: Vintage, 2009).

7 A firm that specialises in remediation and sustainable redevelopment of environmentally impaired properties.

8 Founded by Diane Meyer Simon in 1993, headquartered in Southern California and with offices in New Orleans, Washington, DC, and New York.

were prior interest or involvement in New Orleans, preferably post-Katrina and/or experience with disaster relief, familiarity with sustainability, experience with residential and multi-family housing and in dealing with structures that have to successfully address water-based or low-lying environment(s), proof of skilled innovation on low budget projects, and experience and deep respect for design quality.

A host of architects were selected to participate in this first phase of the project. To ensure that they reflected different perspectives as the best way to achieve a community charac-terised by vitality and diversity, they were assembled in three groupings: (1) local, from the New Orleans area; (2) national, from all over the USA; and (3) international. The list included Pugh + Scarpa, Kieran Timberlake Associates, Elemental, Kappe Architects/Planners, Atelier Hitoshi Abe, Bild, Eskew+Dumez+ Ripple, MVRDV, Graft, Concordia, buildingstudio, Trahan Architects, Waggonner & Ball, Constructs, William McDonough + Partner, BNIM, Billes, Adjaye Associates, Shigeru Ban, Morphosis and Gehry Partners. MIR's aim was to use architectural skills to strengthen the community so that it could become a catalyst for further growth locally, and create a model for rebuilding devastated communities around the world. Architects were asked to create green, affordable and durable homes to be built using non-toxic, re-usable materials inspired by 'Cradle to Cradle' thinking, reimagining traditional New Orleans housing types such as the 'shotgun' house which have a bohemian outlook to them, the camelback and Creole town house 'duplex' family home, which usually has a stoop with a balcony.

In 2009, Morphosis Architecture completed Float House, the first floating house permitted in the USA for the site, a new model for flood-safe, affordable and sustainable housing. The team, led by Morphosis founder Thom Mayne, and including graduate students from UCLA Architecture and Urban Design, studied the flooding record, social and cultural history of the city and the ecology of the Mississippi Delta. The environmental implications of rising water levels threatening coastal cities globally required 'radical solutions', said Mayne. 'We developed a highly performative, 1000 square foot house that is technically innovative in terms of its safety factor – as well as its sustainability, mass production and method of assembly.'

The raised 1.21 metre base of the house is conceived as a chassis, and acts as a raft, allowing the house to rise vertically

6, 10 Make It Right, Lower 9th Ward, New Orleans, children playing in front of the house designed by Trey Trahan, photo: Charlie Varley.

7 Make It Right, Lower 9th Ward, New Orleans, resident Gloria Guy and her grandchildren.

on guide posts, securely floating up to 3.65 metres as water levels rise. It is an approach and design that, as a scalable prototype, could and should be replicated all over the world in contexts threatened by increased flooding caused by climate

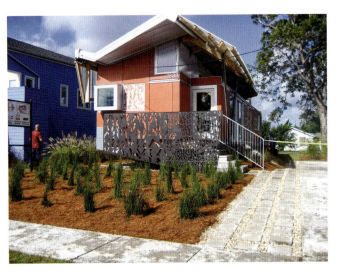

8 Make It Right, Lower 9th Ward, New Orleans, FLOAT House designed to float securely with rising water levels, by Morphosis in association with UCLA Architecture and Urban Design, 2009.

9 Make It Right, Lower 9th Ward, New Orleans, house by Trahan Architects.

change, feels Tom Darden, Executive Director of the Make It Right Foundation. The base of FLOAT House, as with the typical New Orleans 'shotgun' house, preserves the front porch widespread in the community and makes access easier for elderly and disabled residents. It is a prefabricated module made of polystyrene foam coated in glass-fibre reinforced concrete hosting all the equipment needed to supply power, water and fresh air, and the technology developed is already in use in the Netherlands.

All the other houses have porches, aiming to promote sociability and connectedness to the community. Kieran Timberlake's has a continuous street front. Most have deep hip roofs and are on 2.43-metre-high concrete columns, such as Graft's, which has origami-style folds; David Adjaye's house has an inward-sloping roof that catches rainwater and forms part of the porch. Shigeru Ban's is well planned around community spaces and includes cabinets as structural elements. Technical features applied to the houses include geothermal wells, off-the-grid energy solutions, solar panels, chemical-free materials, rain gardens, hurricane bolts for wind resistance and landscape that curbs rainwater runoff. A challenge has been to elevate them above the flood plain and engender a sense of fluid circulation at ground level, by means beyond the stoop. A few are somewhat suburbanite for a context equally in need of building up, and this limits the identity of the surrounding streets.

Having a masterplan might have overcome this drawback, but this is the first phase, and overall the standard is superb and the houses are highly practical, offering creative variants on old types in a much changed environment, for example, Adjaye's boxy house with a roofed patio offering panoramic views over the flat city. The organisation's initiative to involve a global group of architects is a courageous attempt to bring together heterogeneous design languages to help create a new community environment. Whether the layout in the neighbourhood, which is cut off by two drawbridges at each end of the site, is as socially oriented compared with traditional housing in the city, is an open question; other local amenities might have been planned with a more mixed-use strategy.

Nonetheless MIR has fostered many innovations in practice, allowing subcontractors to learn on the job, and partnering with other groups, for example, the Good Work Network, to promote development of contractor and technical skills, helping to build new practices in the industry, push affordability, and

10, 11 Make It Right, Lower 9th Ward, New Orleans, Concordia House, one of the largest, single family houses on the site, built in the first round of houses, with two storeys and indoor and outdoor spaces, shown with resident Gloria Guy, 2008.

sustainable principles such as recycling of found materials as far as possible and extensive community input have been a high priority. The MIR neighbourhood has become the largest, greenest development of single family LEED Platinum homes in America, according to the US Green Building Council.

Once MIR has demonstrated its ability to successfully rebuild its initial target area, its plan is to expand operations to further parts of the Ward, as well as to extend the 9th Ward 'template' for intelligent building to St Bernard Parish. MIR has been considering how to get the prices of houses down, but moreover how the effort can be replicable and standardised so that the model can be extended across the whole of the city.

'We didn't have the luxury of doing a comprehensive masterplan,' explained landscape architect Tim Duggan, who develops the sustainable landscapes for MIR.[9] 'We had to look at the individual residential lots to see how far we could push the envelope of sustainability while still making them socially and economically sustainable.' The scheme is one of 34 pilot projects in the US participating in the SITES Pilot Programme from June 2010–June 2012, the first to demonstrate the 2009 benchmarks of Sustainable Sites, an initiative created to promote sustainable land development and management practices.[10]

Was it right to rebuild in such a vulnerable flood-prone area? That is a tough question, given people's deep ties to the context, but the Lower 9th Ward is above sea level, and the storm surge threat has now been significantly lessened. The MIR flood-proof homes project also has to be seen in the context of larger initiatives to ameliorate the environment that MIR is proactively involved with. MIR was given a bigger opportunity to contribute to the city's Department of Public Work when they were invited to work on extensive, low-impact development strategies involving pervious concrete, rain gardens, rain barrels and sub-surface water storage. The city's landscape gets more than 165cm of rainfall annually and the city had been spending

raise standards. The first families moved into their houses in time for Christmas 2008. Some 71 single family homes have been built to date and have already been awarded a gold green building certification from the National Association of Home Builders, with 150 (including three duplexes) planned. Excellent

9 Interview with Tim Duggan, 21 January 2011, American Society of Landscape Architects, http://asla.org

10 Founded in 2006 by the American Society of Landscape Architects (ASLA) and the Lady Bird Johnson Wildflower Center, with the US Botanical Garden joining in 2006, and the US Green Building Council as a stakeholder.

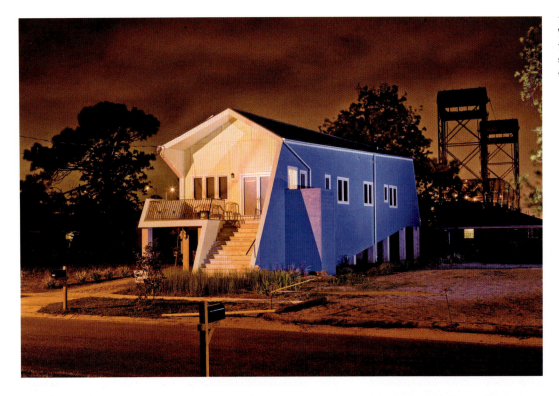

12 Make It Right, Lower 9th Ward, New Orleans, pre-fabricated house with a shallow pitched roof designed by Graft.

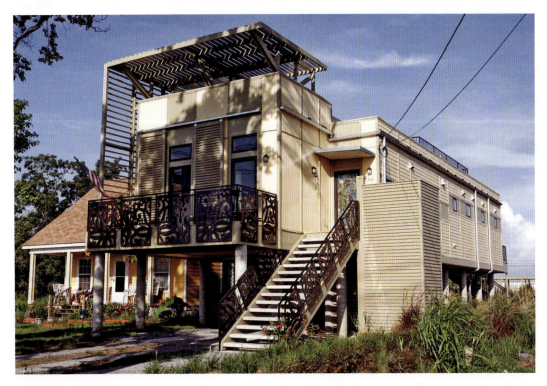

13 Make It Right, Lower 9th Ward, New Orleans, Kieran Timberlake's house design, a flexible system based on customised options, 2008.

millions of dollars pumping water over the levee, so MIR created a series of streetscapes that invested in the public realm instead of simply adding in bigger pipes and pumps.

Building on early studies, MIR set up a design team[11] to create a series of demonstration projects enabling the City to develop new standards in stormwater management. The level of alleviation achieved by the first engineering design showed that it was an economically sustainable model for future development. Duggan said: 'That's one of the most important things that we do on both the houses and the sites – we don't actually take the strategies out of the project, we figure out a way to make them more affordable so they can move forward.'

He continued:

The residents of the Make It Right neighbourhood are actually our biggest proponents. They immediately saw sustainability affecting their pocket books when their new utility bills came in at an average of $28–38, when historically they were $150–160. The ideas that their economic sustainability is connected to their house is one we've tried to communicate, particularly as it relates to their taxes and the infrastructure within their environment.

The city also gave MIR a contract to replace streets, using the site as a test bed for green stormwater management infrastructure explained in MIR's recent 'Sustainable Stormwater proposal (2010): A Kit of Parts Approach', a mandate that could, in time, prove to be historically significant.

As the geographer Richard Campanella comments, in *Time and Place in New Orleans: Past Geographies in the Present Day*:[12]

Whereas a historian might point to the Civil War as the watershed event in the history of New Orleans, a geographer or urban planner may identify a less-famous but equally influential event, at least upon the city's

physical growth; the development of the world-class drainable system that removed standing water and rainfall from the backswamps and eventually opened them up for residential development.

From the very beginning MIR took 'a collaborative, transparent approach', convening the Lower 9th Ward Stakeholders Committee of community and neighbourhood association leaders and local stakeholders. All proposals went through a review process. New scheme ideas are coming to the fore, including urban agriculture, and stormwater management in the wetlands after the locality suffered from the recent BP oil spill, blighting the Gulf of Mexico and the south-eastern coast of the USA.

MIR did not opt for minimal means. An alternative way of proceeding would have been to create as many housing units as possible at top speed. After the San Francisco earthquake of 1906, 5000 portable cottages were built and set out in refugee camps. MIR, as one of the many bodies from the public and private sector doing their best to rebuild the city, did not have that kind of major top-down mandate, and chose a longer-term, micro-scale solution generating a stable neighbourhood atmosphere.

MIR feels that the model of public–private development created in New Orleans could be replicated in a number of cities, for example, Newark, where it has realised a 56-unit mixed-use housing project, with urban agriculture. The issue is a complex one, of whether or not the aggregating benefits of a masterplan devised at the outset at the necessary top speed demanded by a situation in which there 'was nothing to come back to', as one citizen described it, could have added further value in the Lower 9th Ward. Attention to the overall spatial layout of houses and streets, scrutinising options for the identity of the neighbourhood environment and its local amenities as a whole could have been one way in which a masterplanning mindset could have been applied. Indeed, BIM, one of the architects responsible for a house design for MIR, is working with New Orleans architect John C. Williams on a masterplan for the reuse of the Holy Cross School site in the Holy Cross district of the Lower 9th Ward. The many decentralised redevelopment initiatives by neighbourhood associates have provided the opportunity for more organic planning to flourish in the city,

11 With McDonough + Partners, Walter Hood, Siteworks Studios, Diane Jones and BNIM Architects.

12 Richard Campanella, *Time and Place in New Orleans: Past Geographies in the Present Day* (Harmondsworth: Pelican, 2002).

argues Steven Bingler, founder of Concordia, one of the Make It Right architects.[13]

In the aftermath of a devastating disaster made far worse by government neglect of key levee infrastructural protection, when needs are acute in the short term, a catalyst like MIR, creating a unique pilot alongside a long-term, city-wide masterplan, has so far proved to be a vital, long-term mediation of the Lower 9th Ward's citizens' needs and desires for their future welfare. What is good to know is that, in breaking with the antiquated building and ownership practices of the past, MIR is putting an additional focus now on widening its environmental input to regenerative infrastructure and building on its capacity to retain and help rebuild community values.

13 Quoted in Stephanie Grace, 'Do-It-Yourself New Orleans', Architectural Record, 25 April 2011.

5

Social equity

Medellín, Colombia

Closing the wealth gap has not traditionally been one of the ideas at the heart of masterplanning, but the results of being socially instrumental in urban design strategies have been dramatic, especially in Latin America. Empowering public space has been the key to the turnaround in the fortunes of Medellín, Colombia's second largest city with three million people.

Founded in the seventeenth century in the centre of the country at the end of the Andes, and surrounded by mountains, and now flourishing, Medellín had for decades been overwhelmed by drug trafficking and a horrendous murder rate. In the 1950s, a masterplan by architects Paul Lester Wiener and José Luis Sert had to be abandoned due to the city's acute financial and political instability. However, in 1997, Law 388 required all Colombian city councils to draft public space renovation plans and implement them within three years and this Plan de Ordenamiento (POT) proved to be hugely influential.

During this period Colombia's capital, Bogotá, a city of more than seven million people, which had been afflicted by decades of unplanned growth, realised through the dynamic intervention of Mayor Enrique Peñalosa (see Introduction, p. 00) a successful urban renovation plan that transformed the city's social horizons. Medellín, by contrast, has less than half this population and is only 236km². Its central metropolitan area has 2.5 million people and the wider city has 3.5 million inhabitants in total, also serving as the country's industrial and commercial centre (the centre of the vital coffee economy).

Many meetings by members of city institutions were held in the 1990s to discuss ways of improving the city. When Sergio Fajardo became Mayor of Medellín in 2004 (he held this post until 2007), he embarked on engaging architects and planners to realise an extraordinary programme over four years. Driven by the concept of 'the most beautiful for the most humble', his initiative has been to revive the city, creating a 'rupture' with the notion 'that anything you give to the poor is a plus'. Alejandro Echeverri, the Colombian architect and the city's Director of Urban Projects (EDU, or Empresa de Desarrollo Urbano, an urban planning institute in the city government), had already worked for Fajardo for two years with academics, NGOs and other community groups on his government plan as a precursor to a whole series of integral urban projects carried out over the four-year period. Once Fajardo gained office, the EDU became their operations headquarters.

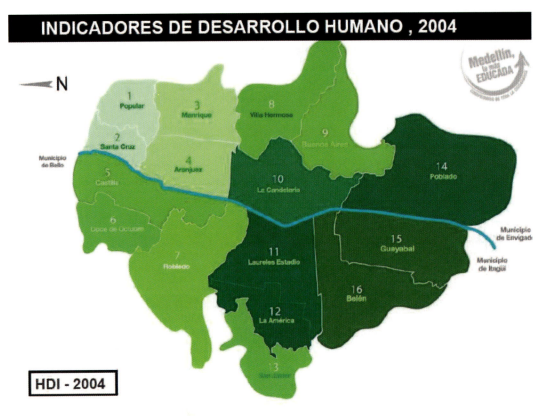

INDICADORES DE DESARROLLO HUMANO , 2004

HDI - 2004

1 Medellín, map from 2004 showing areas of greatest poverty identified in light green with more affluent areas in darker shades of green. The plan intends to bring the poorest areas up to the level of the rest, Alejandro Echeverri, EDU.

The team's 2002 diagram, Indicadores de Desarrollo Humano,[1] shows in varying shades of green the poorer (light green) and richer areas (dark green), and the Fajardo administration's aim was to make the light green darker, improved by massive public investment and a range of physical interventions. In 2006, the Area Metropolitana, the leading regional administrative entity, sanctioned the Metropolitan Directives of Territorial Planning (MDTP). These qualify and redefine guidelines for the preservation and development of natural features and public and private buildings. The MDTP have also served to open up the previously rigid class-ridden boundaries preventing democratised spaces. These objectives have also helped to initiate policies and projects that range from new waterfronts and plazas to social programmes such as public libraries and schools, community centres and housing. At the same time anti-corruption laws were passed for Colombia by President Alvaro Uribe's government, and these included a requirement for design competitions for most large-scale public buildings.

Transformation was envisaged as emerging from new architectural projects over nine years benefitting from a modern urban rail system, the only Colombian city to have one. The Metro, realised in 1995, with trains running every 3 minutes along its main Line A (36 minutes from one end to the other), now connects to the elevated Metrocable. Constructed from 2003 and realised in 2004, enabling access to Santo Domingo (and more recently with another line to Aurora and one from

1 Urbanismo Social en Medellín, del miedo a la esperanza, 2004–2007, Urbam, Centro de Estudios Urbans y Ambientales, Universidad EAFIT, Medellín, Colombia, unpublished dossier, 2007.

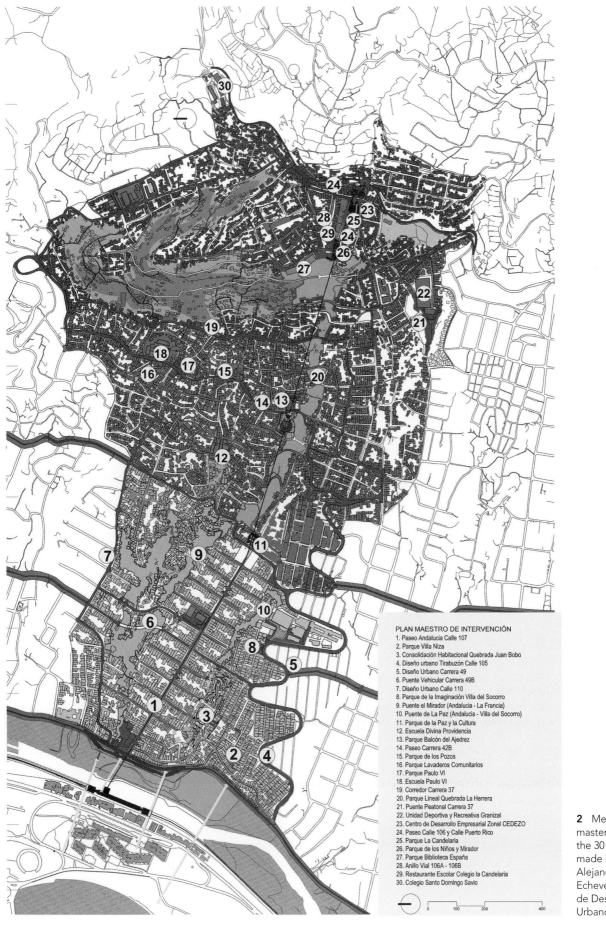

PLAN MAESTRO DE INTERVENCIÓN
1. Paseo Andalucía Calle 107
2. Parque Villa Niza
3. Consolidación Habitacional Quebrada Juan Bobo
4. Diseño urbano Tirabuzón Calle 105
5. Diseño Urbano Carrera 49
6. Puente Vehicular Carrera 49B
7. Diseño Urbano Calle 110
8. Parque de la Imaginación Villa del Socorro
9. Puente el Mirador (Andalucía - La Francia)
10. Puente de La Paz (Andalucía - Villa del Socorro)
11. Parque de la Paz y la Cultura
12. Escuela Divina Providencia
13. Parque Balcón del Ajedrez
14. Paseo Carrera 42B
15. Parque de los Pozos
16. Parque Lavaderos Comunitarios
17. Parque Paulo VI
18. Escuela Paulo VI
19. Corredor Carrera 37
20. Parque Lineal Quebrada La Herrera
21. Puente Peatonal Carrera 37
22. Unidad Deportiva y Recreativa Granizal
23. Centro de Desarrollo Empresarial Zonal CEDEZO
24. Paseo Calle 106 y Calle Puerto Rico
25. Parque La Candelaria
26. Parque de los Niños y Mirador
27. Parque Biblioteca España
28. Anillo Vial 106A - 106B
29. Restaurante Escolar Colegio la Candelaria
30. Colegio Santo Domingo Savio

0 100 200 400

2 Medellín, masterplan showing the 30 interventions made in the city, Alejandro Echeverri/Empresa de Desarrollo Urbano (EDU).

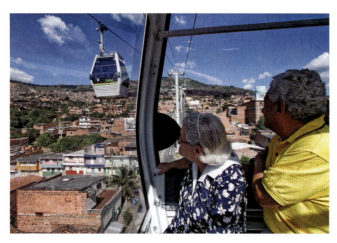

3 Medellín's Metro Cable car, line K, Valle de Aburrá transport system, Metro de Medellín, Empresa de Desarrollo Urbano (EDU).

4 Medellín in 2004 with the brand new Metro Cable car, Valle de Aburrá transport system, Metro de Medellín, Empresa de Desarrollo Urbano (EDU).

5 Medellín's Metro Cable car runs above the street connecting *barrios* for the first time, Valle de Aburrá transport system, Metro de Medellín, Empresa de Desarrollo Urbano (EDU).

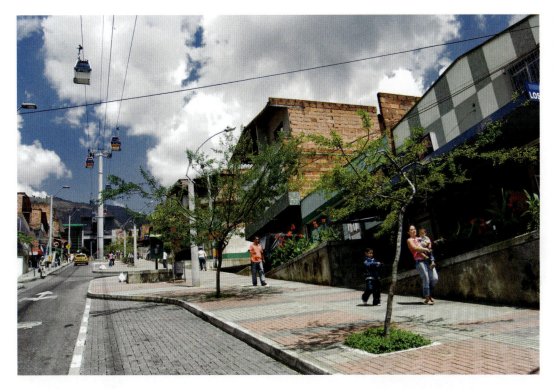

6 Medellín's Metro Cable car above Paseo Calle 107, Valle de Aburrá transport system, Metro de Medellín, Empresa de Desarrollo Urbano (EDU).

Santo Domingo to the Arvi Nature Park), this is a conspicuous icon of the city's revitalisation.

The initiative was allied to the first programme for the city, the PUI, or Integral Urban Project, for the poorest two zones in the north-west, connecting them via the Metrocable to the rest of the city, adding new bridges, streets and 18 new squares and 14 schools. A scheme for ten 'library squares' and an educational infrastructure to dignify the *barrios* has symbolised a new cultural era. The most well known internationally is the Parque Biblioteca España, designed by architect Giancarlo Mazzanti, located on a hilltop in Santo Domingo. The *barrio* was formerly one of the most afflicted by murders and drug dealing. At the end of the twentieth century, it was considered one of the most dangerous places in the whole of Latin America and as late as 2003 people were not allowed to stay on the streets after 5p.m., and locales of this kind were controlled by urban militias.

Mazzanti's library, a trio of sculpted forms like loaves of bread clad in black slate, minutes from the Metrocable stop, was completed in 2007 at a cost of over $4 million with free public access and connected by a network of new roads and footpaths. Three-quarters of the mixed-use space is a library; the rest, children's spaces and workshops. The Quintana Park and library, to the west, were designed by architect Ricardo Caballero, who related it to the topography and natural conditions of the city. Others redefine the symbolic meanings of locations, for example, San Javier Park, in the south, on a small hill by a creek next to a Metro stop, but all are nodes, connected to public space.

Inspired by the revival of neighbourhoods for the 1992 Olympics in Barcelona and the Favela Barrio programme in Brazil, the Urbanización marginal programme in Barcelona, and the PRIMED from 1993 in Medellín, the facilities have mostly been built in tandem with new roads, schools and transit lines

7 Medellín, Parque Biblioteca España, Giancarlo Mazzanti, on top of the Santo Domingo *barrio*, Empresa de Desarrollo Urbano (EDU).

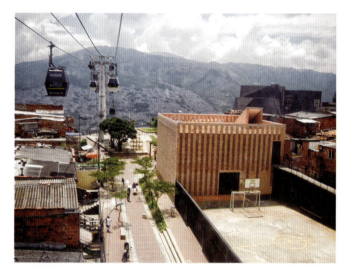

9 Medellín, school behind the Parque Biblioteca España, Giancarlo Mazzanti, on top of the Santo Domingo *barrio*.

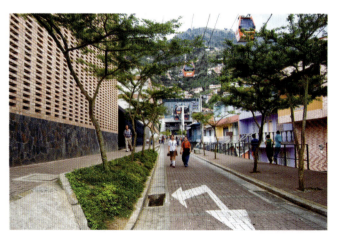

8 Medellín, one of the PUIs (*projectos urbanos integrals*) in the Santo Domingo *barrio*, Alejandro Echeverri, Empresa de Desarrollo Urbano (EDU).

10 Medellín, Parque Biblioteca España, Giancarlo Mazzanti, on top of the Santo Domingo *barrio*.

as the physical elements of a social programme designed to attract families back out on the streets. Fajardo rejected a mere branding exercise. During his term as mayor he assembled professionals and academics who defined the basis for transformation not just of the city but of the whole Aburrá Vallery region. He was at one point advised to bring in international consultants to improve the city's image, but decided against it.

Many workshops were held in the 1990s with the University of Medellín under the Dean, Jorge Pérez Jaramillo, to find ways to improve neighbourhoods, inspired by the new democracy of Spain. 'We began working in the University here in 1991 with the northern projects workshop, a special research group, focussing on the poorest and most violent zones,' explains Echeverri.[2] It was then that they began to discuss in a public way how the city could have a cable car that was connected to a transformed ground. Projects like the Barefoot Plaza, the first of several public plazas realised from 1998, involved the University's architecture faculty.

Moreover, the people living in these slums were consulted about the plans. This has not been a feature of masterplans historically since the poor all too often have been targeted for removal by the plans in question. Echeverri says that the consultation was not a linear process. It opened a space for new possibilities and aimed at a greater sense of ownership. 'Imaginary workshops' to openly identify needs were held on every aspect of the plans, bringing together children, elderly people, mothers, community leaders and former militiamen of the barrios. These and the different processes of participation for the urban projects were begun by EDU in 2004, combining the strategic views of the technical staff and those of citizens. Fajardo promoted the concept of oversight, with over 90 per cent employment of local workers and ongoing community involvement in the work. A foreign visitor arriving in the third year of operation found the taxi driver talking about the library parks, not the local soccer team, and tourism – which did not previously exist in the city – has begun to flourish, with more foreign investment.[3]

The results helped the team understand how to achieve 'urban depth' by defining two scales of intervention: the large infrastructures such as the library parks and cable car transport system, and the best rationale for their 'acupuncture urbanism'. Echeverri defines the overall approach as 'social urbanism' through architectural and urban projects, striving for the best design quality to improve relationship with the surroundings, and include footbridges. There was, he explains, a frontier between the north part of the city where the poor areas start and the Metro in the downtown. Integral interventions related physical and programmatic actions to construct a strategic network in the districts. Each project had a team leader in charge of creating different communication channels with the communities, and the project was developed not independently, but within the Institute owned by the Municipality, and benefitted from a high level of technical support.

There were four programmes to implement different strategies. First, the library parks and quality schools programmes for the barrios, large infrastructure with the highest quality standards and free access. Architects were chosen in national competitions, and in all cases their designs encouraged people downtown to feel that they had been given the best. Downtown, Cisneros Plaza, as it was originally known, was one of the competitions; another scheme was for the new headquarters of Hewlett Packard. The choice of locations for the libraries was guided by the wish, says Echeverri, to 'detonate new centralities in the barrios with integrated public services', all being connected with the public transport system. The investment in 'the physical and social transformation of the skin of the city we have been doing has been five times greater than the cost of the cable car'.

Moreover, the team tried to put the libraries in a 'specific point of tension between the city's topography and its various conditions because the geography is very special'. For example,

2 Interview with the author, Spring 2011.

3 Interview with Alejandro Echeverri, Matthew Devlin, Innovations for Successful Societies, National Academy of Public Administration, Woodrow Wilson or Public International Affairs and the Bobst Center for Peace and Justice, Princeton University, 26 October 2009, www.princeton.ed/successfulsocieties.

11 Medellín, new library parks planned, Alejandro Echeverri/EDU.

San Javier Creek is one of a number of river creeks in the city, a source of natural geographic richness which has gradually disappeared due to uncontrolled urban development. 'Against this negative trend we placed our punctual interventions in order to redraw this geography as a system with great power and beauty,' Echeverri points out.[4]

The same urban principles guided the building of a new network of public 'open' schools attended by 80 per cent of the city's population: ten new ones realised, and 130 renovated between 2006 and 2010. At Alta Vista, for example, they have services not only for students but also for all the family available every weekend and during the evenings. Santa Domingo's Antonio Derka School by architect Carlos Pardo of Obranegra introduces a new sense of urbanity in the area and open space to connect the different neighbourhoods. Fajardo persuaded EMP, the public utility company, to underwrite the new schools, and chose ten architects to design them without the need for any public competitions.

The second, 'projectos urbanos integrales' (PUI) programme against social exclusion and inequality has been the highest impact strategy in the city, applied in three of the lowest income *barrios* which had suffered the worst violence. Urban strategies to 'recover peace' were put in place in three locations, with a manager in charge and a social and technical team, working on community participation and physical improvement. They looked for starting points for time-specific strategies, for example, at Santa Domingo, whose growing informal settlement had expanded over previous decades since the 1950s.

'The open space is one of the keys to build the new urbanity there, especially when you have very bad housing conditions,' says Echeverri, to create spaces for culture, pedestrian streets connecting with parks and bridges that linked the neighbourhoods. Before, people could not cross a number of them after 5pm. To understand better what was needed, the team walked the neighbourhoods with the community and decided to adjust and rebuild with precise interventions and small-scale connections, and use the large infrastructure 'as one of the main tools'. The third strand of activity, the social housing programme for communities in hazardous locations, included some small projects to enable people to stay where they were, to be

4 Alejandro Echeverri, presentation, 'Urban Age South America: securing an urban future conference', São Paulo, 2008.

1. COLEGIOS DE CALIDAD

1. Santo Domingo
2. Plaza de Ferias
3. Llanadas
4. Francisco Miranda
5. Héctor Abad
6. Las Mercedes
7. San Javier
8. La Independencia
9. Altavista
10. San Antonio de Prado

12 Medellín, new schools of quality planned, Empresa de Desarrollo Urbano (EDU).

LOCALIZACIÓN DE LOS PUI

13 Medellín, locations of the 'projectos urbanos integrals' (PUIs) to combat social exclusion in the poorest three barrios, Alejandro Echeverri/EDU.

relocated but without losing their livelihood. New buildings have access to open space and are connected to other facilities.

The fourth programme recovered the central importance of the street, teaching citizens to walk again in a city dominated by cars, with emblematic streets and walkways connecting what is a linear city. The plan for the founding street of Medellín from north–south downtown was based on the aspiration for everyone to be able to meet there, and S+A Arquitectos's design scheme of bright ceramic pavement surfaces now enlivens Avenida Orienta, the major highway through the city. Echeverri's team effected some improvements of old buildings, created the new Parque Explora and renovated the previously threatened Botanical Garden, to its north-east, in which sits the open-air Orquideorama (a previous administration had considered selling the neglected site to a developer), designed by Plan:B Architects and J Paul and Camilo Restrepo. Opening up the Garden's landscapes to the public street, and adding a rotunda theatre café and restaurant, the architects designed a wooden canopy of 14 tree structures shading a huge plaza which collects rainwater to refresh the gardens. Visitors are greeted by an entrance sign: 'Free admission: the Mayor's office has already paid for you'. Echeverri's Parque Explora, an interactive park for science and technology, has also become a prime tourist site. It was intended as a new symbol of the transformation of the 'new north', connecting to an expanded north–south avenue with landscaped walkways where pedestrians and street vendors can mix, 22,000m^2 of interior facilities and 15,000m^2 of public space.

In tandem with the regeneration, in 2005, the city council gave around 40 per cent of the city's annual $900 million budget to social programmes for education, and made micro-loans to small businesses to help make communities more autonomous in how they use their space. Property taxes were increased in 2004 and added a further 23 per cent, with 82 per cent of the budget allocated for investment and the rest for expenses. According to national statistics, in 1991, the number of homicides in Medellín was 381 for every 100,000 inhabitants. By 2007, that number had dropped to 26 and since then tourism has tentatively picked up. Poverty in some of the districts remains marked and in 2010 violent crime began increasing again, but the new buildings nonetheless remain popular with residents who have changed their attitudes to public space.

The planners Sert and Wiener first defined the geographical condition of the city in the 1950s. Today the slums are in the middle of the mountains. Echeverri describes the 'tale of Medellín' as a story of these two cities, the formal consolidated city along the river, and the informal city on the hillsides. 'Our goal is to connect them. We consider design in multiple scales. Architecture adds value in considering the city as a complex design problem for the people we can touch,' he said on receipt of his and Fajardo's Award of the 2009 Curry Stone Design Prize for their implementation of Medellín public works projects. In his award speech, he stated:

> Architecture is done walking the streets. We are just starting our work to recover our city and it will be a long, complex and beautiful journey. We hope in the end that the lowest income children, the majority in our society, will have the same opportunities to get where the other kids are. We, the architects, have an important responsibility in this hope.[5]

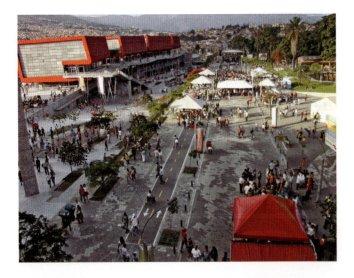

14 Medellín, Parque Explora, inauguration, Alejandro Echeverri, Alcaldía de Medellín.

5 Curry Stone Design Prize, Award Ceremony, IdeaFestival, Louisville, Kentucky, 2009.

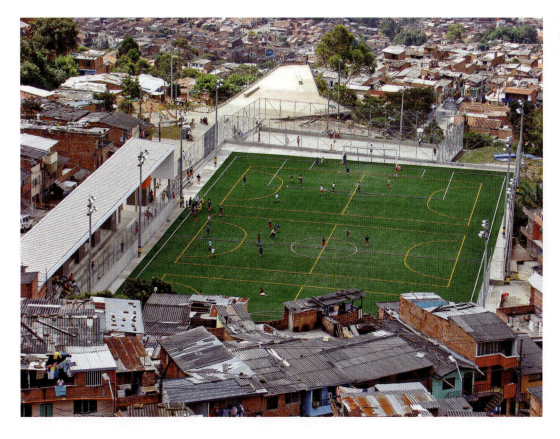

15 Medellín, Granizal sports centre, Empresa de Desarrollo (EDU).

From childhood, Fajardo felt clear about the significance of 'aesthetics as a tool for social transformation, as a message of inclusion', he says, explaining that 'underneath it all is the most important word in all those urban interventions in which architecture plays an important role: dignity'.[6] The team's 'social urbanism' deals with the reality that

> Many people have a solid wall in front of them: at one end is a door to enter into the world of illegality, drug trafficking, for example. Another door leads to informality and homelessness. Our challenge has been to open doors in

that sealed wall, doors so that people can pass through and go on participating in the construction of hope.

Fajardo's successor as Mayor, Alonso Salazar, has seen to it that further new architectural facilities have been built, such as the handsome facilities completed for the 2010 South American Games, including an aquatics centre by Paisajes Emergentes and Mazzanti and Felipe Mesa of Plan:B's sports halls with roof vaults echoing the natural topography of mountains and forests, described by writer Michael Webb as 'a fusion of poetry and function'.[7] Paisajes Emergentes' co-founder Luis Callejas's comment, quoted by Webb, that 'we are not interested in

6 Danielle Maestretti, 'How architecture transformed a violent city', UTNE Reader, 28 January 2010.

7 Michael Webb, Architectural Review, 1368, February 2010.

INVERSIÒN TOTAL:

METROCABLE:
25 Millon Euros

INTERVENCIÒNES FISICAS:
30 Millon Euros

PROYECTOS SOCIALES:
60 Millon Euros

16 Medellín, total investment in the regeneration of the city, EDU.

poetic, pictorial or nostalgic relationships with locations. We look for their emerging qualities to make visible what lies unseen to the public' is an operational philosophy that directly complements the ethos of the Medellín masterplan. Other recent competitions have included one for the extension to the Medellín Museum of Modern Art in the more affluent, 'poblado' southern end of the city, won by Ctrl G and 51-1 Architects for a proposal of stacked boxes whose brick vernacular recalls the materiality of the barrios.

'The political leadership is for us the key for the change in the city,' said Fajardo recently, who continues to work elsewhere in the country on missions similar to his role in Medellín's transformation. Moreover, Medellín's masterplan does not just simply now end. Echeverri and some of his team members have now started Urban Center of Urban and Environmental Studies at EAFIT University in the city and are trying to combine environmental, social and cultural issues with urbanism, thinking how to improve 'some of the politics'. The ethos of better buildings in poor areas has also spread to other Colombian cities, such as Villanueva, and Bogotá, which have built new public schemes. New partnerships between the public administration and other institutions are being forged in Medellín.

Fajardo and Echeverri's ambitious agenda has achieved a hugely meaningful social outcome, building trust with real actions based on an accepted, integrated concept, which has generated positive change of many kinds. It also embodies a new paradigm of how architects, through a socially driven, public sector-mandated urban plan with strong, inspired leadership, can play a proactive, strategic role in urban revitalisation. Honouring the different characteristics of neighbourhoods, the strategy avoided standardisation, instead electing a remedial networked synergy, creating a potent bond between the enabling qualities of libraries, the connecting environment of shared public space and transport infrastructure.

What they have achieved shows how formidable the power of top-down political agency can be to rescue and transform public space when it is steeped in the interests of the poor, who were fully consulted. The Medellín scheme is rightly regarded as one of the world's recent outstanding and influential transformative applications of multidisciplinary architectural skills and intelligence to the ongoing quality of life and profound sense of self-identity of a city.

Lion Park Urban Design Framework, extension to Cosmo City, Johannesburg, South Africa

Urban planning ideas are quite often extrapolated from one region to another without any adjustments to the local culture and climate. South Africa, where English planning was implemented, for example, in Soweto, based on the model of an English Garden City, has experienced this. While a few aspects can be positive, more often remnants of past practices, once standardised, can be difficult to break down, and only serve to hamper progress. Johannesburg, located in the central interior of South Africa, is 120 years old, a city that was originally a mining town, that became rich on its minerals. The mining camp became a metropolis, and now the city's population of five million is likely to grow to 15 million within 15 years. In the past 16 years there has been a lot of change to the urban landscape to overcome South Africa's racially motivated policy of urban containment since the post-apartheid constitutional settlement was achieved by the government in 1994, but the discussion about the role of the sustainable and inclusive masterplan needs to be further advanced.

Before 1994, the city was planned around political ideology with a strong segregation between races formalised in the physical planning of the city, so the challenges after that were to right the wrongs of the past and physically integrate people across colour, wealth and poverty. Some success was achieved but also difficulties in terms of real integration. During the 1980s, architects and urban designers were trained in methodologies to work in a post-apartheid system, but these changes presented great challenges because the aim was to try to change the very strong urban planning landscape in order to create ease of access, access to land, and business opportunities to people who had not been afforded these prior to the government settlement.

Urban design has been carried out in South Africa, therefore, for a number of years as part of the development of existing urban and new urban areas, but as a discussion it was not really included or taken seriously in the restructuring of cities. As a result, the challenges of urban sprawl, and of dormitory townships with huge areas for residential, but not mixed use purposes, which serves to promote poverty through exclusion to capital growth, are omnipresent. Theories of urban design from the late 1950s and the early 1960s of thinkers such as David Crane and Kevin Lynch, and the work of the New Urbanists, were considered influential.[1] These triggers have

1 Cited by Michael Hart in 'Speaking on urban planning in South Africa', available at: http://urbandesignpodcast.com, 20 April 2011.

been key in introducing a thought process about mixed use, helpful ways to integrate people, uses and lifestyles, and more transport-oriented urban design. This is important because large workforces have traditionally lived very far from the centre of Johannesburg and other cities.

Six years ago around 215,000 of Johannesburg's households lived in informal settlements and backyard shacks; today the estimates run to around 1.5 million people. The Council's Housing Department's masterplan was devised to address the backlog and create 600,000 units of sustainable, affordable and safe housing within four years through an incremental approach. Previously there had not been an implementation plan, housing delivery was erratic and mostly carried out on a reactive basis. The masterplan was a mapping out of coordinated and realistic action for each financial year, capable of responding to the city's changing housing needs on a short- and medium-term basis. Ten informal settlements per year were to be formalised (for example, 29 during 2005–2006) and provided with water and sanitation, more roads and named streets, and stormwater infrastructure, hostels upgraded and other suitable land for housing identified. This process was expected to enable *kasi* (township) registers to be opened and title deeds to be issued to people living in the settlements.

Construction of the 1105-hectare mixed use, greenfield Cosmo City, 40km north-west of Johannesburg's CBD (Central Business District) at Randburg, in the Gauteng province, and within the Municipal District of the City, began in 2005 after the developer, Codevco, was appointed in 2000, and a public–private partnership between the local authority, the Provincial Government and the private sector was formed. By 2007, it had completed 12,500 RDP (Redevelopment Programme) housing units, a mix of fully and partially subsidised dwellings, rental apartments and bonded (open market) houses, and the population has now risen to 70,000 people.

Among Cosmo City's residents are people from the original informal settlements of Zevenfontein and River Bend on the site. The intention was for it to be the first fully integrated housing development in South Africa, a heavy responsibility honouring the constitutional right for adequate housing for all South Africans, but moreover accommodating wishes for interaction between all people of all incomes and mixed use that the Reconstruction and Development Programme has struggled to

implement in projects such as Lombardy East and Bara Link in Johannesburg. 'People of different incomes will live together,' said Lindiwe Sisulu, the South African Minister for Housing, talking about the government's Breaking New Ground sustainable human settlement plan. 'Children will attend the same school, will use the same parks and recreation areas, and will grow up together without discrimination of income.'

The satellite or suburb has grown to be one of the most modern areas within the borders of Johannesburg, conveniently located and easily accessible from major business zones within the city. Unlike the typical white suburb, it is not walled or gated, and apparently none of the banks wanted to get involved until the Financial Services Charters obliged them to do so. Cosmo City has 5000 fully subsidised low-income houses, 3000 financed credit-linked houses, 1000 social housing rental units, 3300 bonded houses, 12 schools, 40 churches, clinics and crèches, 43 parks and recreational sites, 30 commercial and retail sites, a 40-hectare industrial park and 350 hectares of environmental conservation area and good infrastructure. However, areas have been built for specific income groups in mind, not social or economic cohesion.

When it comes to Cosmo City itself, the first four parks range in size from 3–6000m², and were designed by Thabo Munyai, South Africa's first black landscape architect, who acted as designer, project manager and project coordinator. Munyai has explained that most parks in Johannesburg are located in the more affluent areas to the east, west and north of the inner city, whereas they are scarce in places like Soweto, Alexandra and Lenasia, where open spaces are neglected and undeveloped, making them vulnerable as places for vandalism and other criminal activity.[2]

Townships have now come to see the value of parks in their neighbourhoods, increasing local labour, and consequently the sense of ownership. Cosmo City's bare stretches of veld (open rural grazing area) where there were no fixed patterns allowed Munyai to use his creativity, and he used aerial photography to identify movement patterns to see how people interacted with open space and how they used it. Consulting the community

2 'Keeping Joburg green is Munyai's passion', *Joburg News*, 14 December 2006, available at: www.joburgnews.co.za.

1 Lion Park, Cosmo City Ext 17, Johannesburg, design framework for an integrated mixed-use housing development, Michael Hart Architects and Urban Designers.

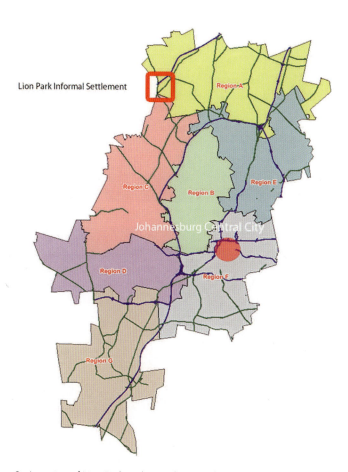

2 Location of Lion Park to the north-west of Johannesburg.

forum and local councilors, he was inspired by some of Pretoria's old parks, and made his equally robust with low fencing with footholds to climb over, spectator stands around the sports fields and bright and funky, rather than staid, signage. There are more than 30 open spaces at Cosmo City, and more parks were planned after this first phase. Now City Parks assesses existing parks to make sure they are fully utilised, and if not, investigates options such as further features.

The Urban Design Framework for Lion Park, an extension of Cosmo City by Johannesburg-based Michael Hart Architects, was made in 2009, a time when there were no roads or infrastructure on the site. The existing 7500 houses had been built by owners from available materials. The local municipality began to plan to redevelop this area in the future, promising their residents improved housing, and Hart and his team were hired to study existing conditions and develop a framework that could be implemented. In assessing weaknesses in urban thinking up to that point, Hart recently explained that while urban planning which focuses on the automobile is not appropriate for South Africa, since car ownership is very low, existing local standards and guidelines ironically dictate automobile-focused planning.[3] There are other issues that are often overlooked, such as the availability of energy and water, and although there are alternative solutions for energy in rural areas, they are too expensive and are rarely implemented.

The culture of South Africa is very diverse and eclectic, with 11 official languages, and emerges from a colonial history with

3 Speaking on urban planning in South Africa, available at: http://urbandesignpodcast.com, 20 April 2011.

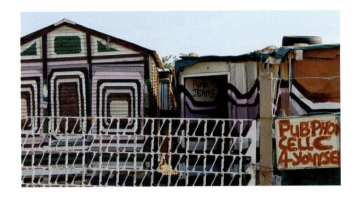

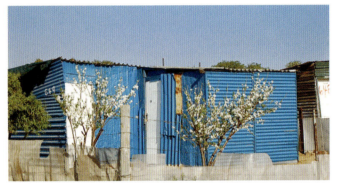

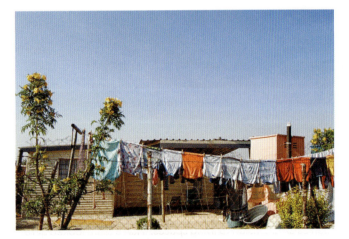

3–7 The existing settlement at Lion Park.

a lot of British planning and culture. Hart sees 'a very interesting progression with a sense of cultural identity starting to emerge in South African cities through honest architecture and use of materials and new skills'. It has one of the best climates in the world, being very temperate. 'The architecture and urban design have not really embraced that fully; it is a matter of time before a true urban design is placed in it.' He comments that the tendency is to look to other countries and cultures to define local guidelines and criteria. Marrying that sensibility with

'the influences of local cultures should bring a different South African identity that will embrace culture, climate

and the way people interact with each other, with big public squares. We need to get away from the classic notion of a piazza and have more local culturally based spaces.'

A lot of cities in South Africa went into a decline in the mid-1980s and mid-1990s when political turmoil opened the opportunity for rebuilding. The Group Areas Act did not allow blacks to live and work in the cities so when it was abolished post-apartheid, everything changed. Hart says:

'A lot of landowners neglected buildings and walked away and people moved in. We lost a lot of good buildings and infrastructure suffered. So now we are designing with a new sense of necessity for a variety of different people – it will take time. The process has started. There are still many no-go zones, but now people are living in the Central Business District of Johannesburg, and new initiatives are opening up, such as cities setting up projects to open up public space.'

Johannesburg has embarked on quite a large public transport programme, instituting a PRT (Personal Rapid Transit). There is an underground tube system: the first leg has been opened from Rosebank and Airport; next comes Pretoria. The desire is to link Cosmo City with the Bus Rapid Transit system (BRT; previously there were trams, which were abolished in the 1950s, and private taxis remained the only means of transport for most people), and to expand the system across the city to allow for the integration and ease of access wanted, bringing people in from outlying areas and visitors. There have been certain hiccoughs: the bus system is not sufficiently suited to citizens' needs, because in Johannesburg there is a very distinct peak rush hour from 7–8a.m. to work and from 4–6p.m. returning from work, but not much need for a continuous service. There are plans to increase densities around transport nodes and bring about public space upgrades in the city centre and in some of the satellite cities.

The UDF – the government's housing project – aims to cater for the backlog of housing needed in informal settlements. There are 280 such settlements in Johannesburg alone, fairly large, and occupied by between 1500–4000 families. During the

time of apartheid people were not given access to land outside their residential townships. Prior to 1994 there was so-called illegal squatting which was then formalised but lacked services, and people lived in shacks made out of scrap metal and other materials. Few bylaws governed their settlement. Over the past 15–20 years the settlements have grown exponentially and become very difficult to upgrade. The informal settlement on the urban edge developed a sense of permanency, with some people living there for more than a decade, who had long since been promised more formal housing. The South African government's capital subsidy for housing gives a house sewage connection but not electricity, which is also a huge opportunity for political manoeuvring, as people have been promised houses.

Therefore, when budgets were allocated to Cosmo City Ext 17 Lion Park, as it was first known, Hart insisted that an urban design input was necessary. 'One of the issues we've been involved with has been the need for the housing development to be design-driven not engineering-driven, and then used to create an infrastructure plan.' The brief was to design a new town: 80–90 per cent of the community would be given free housing. A number of social facilities were required, so the team defined a number of community cores. 'The idea was also to look at how to create densities without creating high-rise developments, so the government subsidy covers a 40m^2 dwelling unit on a stand of 98m^2 so that public spaces were seen as an extension to living spaces.' Hart's team looked at row houses and semi-detached houses as models, and how residential densities for this integrated, compact settlement could be achieved through a variety of housing typologies, reflecting the mobile patterns of existing and new community members in the various forms of tenure.

The original settlement at the Cosmo City site, with its population of 7300 people, consisted of makeshift shacks made from reclaimed materials and shipping containers, crammed into urban blocks, separated by eroded paths, in an ordered grid of sites and roadways. Residents were mostly single-parent households, with an average of two children. Each site was demarcated by fences, walls or vegetation, with some small gardens in the front yards. Food shops, shebeens (bars) and butcheries were sited strategically, and residents grew some vegetables and herded cattle. Among the difficulties was a lack

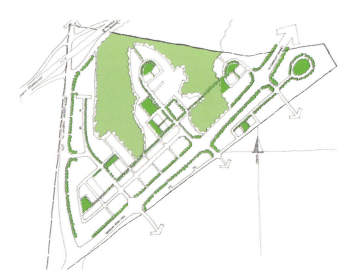

8 Urban Design Criteria: green networks structuring elements, Lion Park, Cosmo City Ext 17, Johannesburg, design framework for an integrated mixed-use housing development, Michael Hart Architects and Urban Designers.

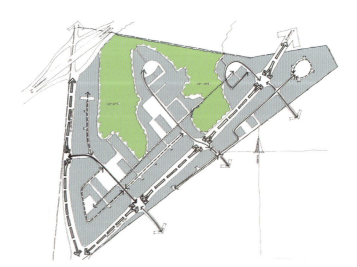

9 Urban Design Criteria: road hierarchy structuring elements, Lion Park, Cosmo City Ext 17, Johannesburg, design framework for an integrated mixed-use housing development, Michael Hart Architects and Urban Designers.

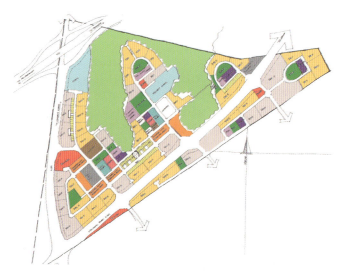

10 Urban Design Criteria: land use layout, Lion Park, Cosmo City Ext 17, Johannesburg, design framework for an integrated mixed-use housing development, Michael Hart Architects and Urban Designers.

of existing service infrastructure, with sanitation but no electricity, and the team's work was delayed for a number of months while the place was declared a township, a slow process due to lack of services.

An integrated set of energy-efficiency principles is part of the conceptualisation of the mixed-use scheme. The current shortage of basic services was also an opportunity to look at alternative energies, the Urban Design Framework[4] states, reassessing reliance on conventional services and methods of management, and the chance to consider reduction, reuse and recycling as vital practices. These are very new ideas in South Africa, but a desperate shortage in supply of services brings the need to create an awareness of alternative energies, moving towards cleaner burning electricity generation as the country suffers from air and ground water pollution. 'The problems are that getting development going is quite a tedious process. Red

4 'Proposed Urban Design Framework for an Integrated Mixed-Use Housing Development, Cosmo City Ext 17 (Lion Park), for the Johannesburg Metropolitan Municipality', Michael Hart Architects and Urban Designers, Johannesburg, 2009.

tape hampered the advance of the settlement.' Hart believes that, 'We need to not only educate our beneficiaries to look at alternative energies, but bring our authorities to look at alternatives, and not to set a standard that cannot be achieved.'

Hart insists that the scheme, like all urban environments, 'must facilitate for lifestyle change, access to facilities, infrastructure, economic development and healthy environments', with SEEDE (Social, Economic, Environmental, Design and Engineering) criteria managed within a parallel process of analysis, review, consultation and implementation. 'Most housing and settlement upgrade projects have been given out to large engineering companies to design and project manage, with the urban design, economic and social components left to chance,' he comments, saying that this is part of the problem. His SEEDE criteria are an inclusive, design-led approach with the back-up of engineering and town planning services, with development a multi-pronged approach. Even today, some projects still do not include architects or urban designers, urban economists, landscape architects or social workers in the team, 'only social survey companies employed to do needs analysis'.

In his Framework, activity nodes and spines have been given priority, with accessible public spaces carved out of the urban fabric and located centrally within each precinct. Green corridors are given definition with public open spaces and community facilities planted along circulation routes. This includes an ecological and wetland assessment, biodiversity report and management plan to make best use of natural resources and avoid degradation. Informal housing on wetlands would be removed and the sites rehabilitated and protected, with adjacent sites used for a variety of uses from housing and parks to sporting activity, and timber boardwalks installed in areas to encourage connection across parts of the wetland. High-density housing (two- and three-storey walk-ups) is located towards site boundaries flanking the main circulation arterials, while lower-density housing is located within defined precincts in a mix of single and duplex units with backyard rooms. By grouping individual RDP house typologies into clusters or linking them as row houses, a larger, more dominant structure rather than a proliferation of McMansion-style, dispersed single standing unit in a low density sprawl, is created.

Hart observed that the client's existing site plan was very car-focused. It was 'a huge challenge to get the planning authorities to understand that car ownership in this area is very low, so standards should not be the same and the amount and width of roads should be changed to create a more pedestrian-friendly environment'. In the process of designing the Framework,

> '[A] lot of ideas were thrown out because we challenged the standards of designing suburbs. These are 20–30 years old but we are still looking at them. The way they were serviced is still being imposed on us; parking regulations are also being imposed. People have aspirations of buying cars, but realistically the numbers to be brought in will be far less than in the average upmarket suburb.'

The plans need to be matched to the real demographics:

> '95–100% black people with a lot of small households and single-bedded households with a single parent and children; a number of unemployed people and a majority of younger people; some older people but they moved out to more rural environments.'

Accordingly, the defined precincts encourage pedestrian movement over automobile use, with a network of 7-metre-wide roads, well lit, with traffic calming and planted to encourage walking and positive social interaction. Hart is influenced by the Dutch Woonerf concept of roadways shared with public spaces – literally, 'living streets' – creating a correspondence with the backdrop of buildings' front entrances and façades, with streets designed as social space for children to play, and as venues for night-time gatherings, extending their identity and improving their safety. Mixed-use nodes encouraging a work–live environment are the core of each precinct, with centrally placed parks with flanking social and community buildings, shared with churches, clinics, community centres and row housing. Here, 'livable' means a sense of ownership, and pride in having such a place to live, to grow and to see businesses prosper, all in one location.

The majority of people in South Africa still live below the breadline, and while addressing the needs of communities is a challenge that has been taken up by a number of bodies and individuals, now the government and private and public sectors

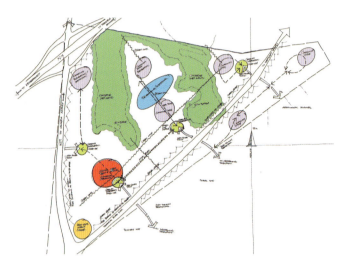

11 Urban Design Criteria: activity nodes and spines structuring elements, Lion Park, Cosmo City Ext 17, Johannesburg, design framework for an integrated mixed-use housing development, Michael Hart Architects and Urban Designers.

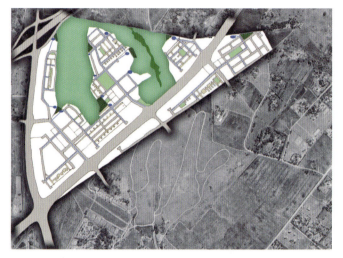

13 Diagrammatic representation of grey water and storm water recycling, Lion Park, Cosmo City Ext 17, Johannesburg, design framework for an integrated mixed-use housing development, Michael Hart Architects and Urban Designers.

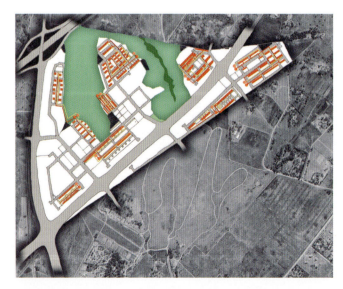

12 Diagrammatic representation of solar collector hot water system, Lion Park, Cosmo City Ext 17, Johannesburg, design framework for an integrated mixed-use housing development, Michael Hart Architects and Urban Designers.

hold many workshops and seminars, but it 'won't be put right overnight', adds Hart. 'We get frustrated as professionals that a lot of the concerns we put forward aren't taken seriously. Social housing in South Africa is very new, for example, the first scheme was built in Johannesburg in 1996.' Before that there was a period of 40–50 years when genuine social housing was non-existent.

In building communities in South Africa, the principle of the most recent period after the ending of apartheid is that everyone will be given shelter and dignity. 'It's taken 13–15 years to grapple with those very basic human needs,' says Hart who explains that it has been 'hard to get the government to accept that the settlement must be upgraded in an incremental way rather than demolishing it and placing it somewhere else', but he feels strongly that

'[It is] better to do that to avoid disturbing the social links forged. We have to look at the communal networks that have been set up between businesses and houses. There are some different factions and political bodies existing, so through social surveys we seldom get all the answers.'

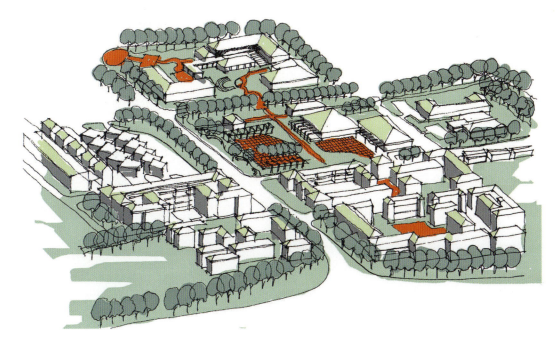

14, 15, Civic node defines place making and making of centres; civic, municipal, transportation, public square and mixed uses, Lion Park, Cosmo City Ext 17, Johannesburg, design framework for an integrated mixed-use housing development, Michael Hart Architects and Urban Designers.

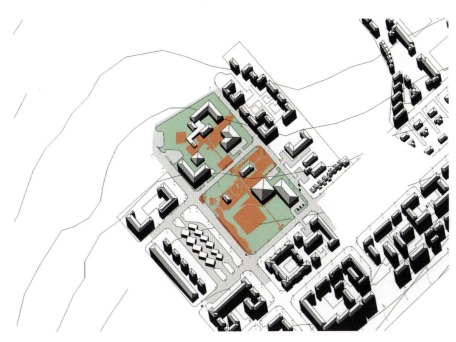

16 Urban Structure: key strategic objectives: diagram of public transport nodes and activity spine, Lion Park, Cosmo City Ext 17, Johannesburg, design framework for an integrated mixed-use housing development, Michael Hart Architects and Urban Designers.

In terms of research, 'We find out what the demographics are but it is difficult to enquire about lifestyles and allegiances, which is unfortunate that we don't have that open discourse opportunity to voice opinions and thoughts.'

In its acknowledgement of the inability of informal settlement dwellers to compete with the formal economy, the Framework proposes commercial, retail and trading facilities, including waste to energy businesses. It puts activity spines and related business hubs close to public transport hubs, and points out the competitive advantages of being located near the Kya Sands Industrial node and Lanseria Airport development. The Framework's Development Objectives strive for integrated livelihoods, with programmes of local education and training, reduction in the transmission of HIV/AIDS, stimulants for economic growth and employment, and a mix of strategies to boost environmental capital, including urban agriculture schemes.

Marlene Wagner, architect, a research fellow at the Technical University of Vienna and co-founder of buildCollective, has studied the formal and informal spatial practices at Cosmo City, and is fascinated by the enormous spatial divergence between the haves and the have-nots within a single metropolis.[5] South Africa historically has practised social exclusion. Wagner studied spatial configurations at Cosmo City, identifying recurring patterns which she could categorise by correlating her interpretation of size, form and function and in turn assign it to typologies. These classifications and typologies generate a number of significant urban patterns between formal and non-formal spatial configurations.

This analysis is required to support government housing legislation and NGOs in their work, to encourage new approaches to dealing with informal settlements and areas with weak formal infrastructure and capacities. 'The focus has to be on reconsideration of zoning regulations, land use and construction standards as well as planning processes for these DIY designed areas', says Wagner, adding that practitioners can only, pragmatically, try out certain instruments and see what they allow us to see and to what extent they remain open to critical self-examination.

Research-led design provides the peripheral vision of a masterplan or set of strategic intervention needs. Cornell University's Sustainable Design (CUSD) group, in partnership with Education Africa, began an impressively documented

5 Marlene Wagner, 'A place under the sun for everyone: basis for planning of integrative urban development and appropriate architecture through the analysis of formal and non-formal space practices in Cosmo City, Johannesburg', buildCollective NPO for Architecture and Development, 2009–10.

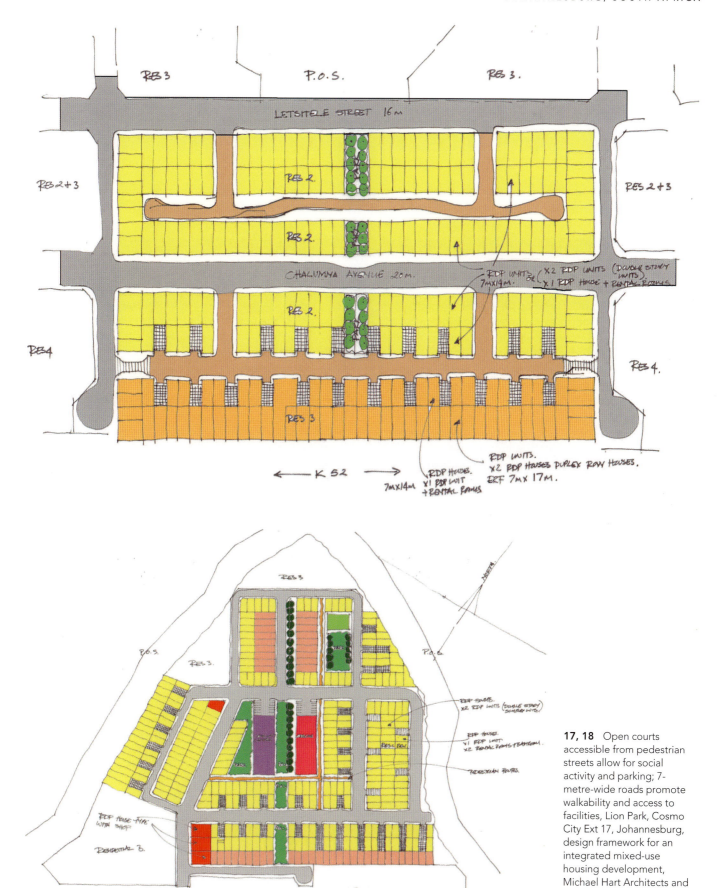

17, 18 Open courts accessible from pedestrian streets allow for social activity and parking; 7-metre-wide roads promote walkability and access to facilities, Lion Park, Cosmo City Ext 17, Johannesburg, design framework for an integrated mixed-use housing development, Michael Hart Architects and Urban Designers.

research project on-site in 2010 at Cosmo City and in South Africa generally to support a new Early Childhood Development Centre to be built at Cosmo City, supported by Basil Read Developments, in 2011.[6] Education Africa is a non-profit organisation focused on countering poverty through education, and has a Social Architecture programme which has created 11 buildings in disadvantaged townships, working with international universities, such as the Jouberton sustainable nursery school, designed and built in the township near Kerksdorp by the Institute of Architecture, of the University of Nottingham, UK, between 2008 and 2009.

Although 1.7 million houses have been delivered in Johannesburg since 1994, the focus is beyond the government's provision of low-cost housing within the context of a post-modernist neighbourhood planning culture. Housing provision otherwise largely remains on the delivery of houses rather than on other forms of tenure and types of accommodation, Moreover, new developer-led residential living environments on the periphery of the formerly white areas, according to Lone Poulsen,[7] cluster schemes full of high walls and security fences, and lack any sense of urban environments or pedestrian-friendly space, thus perpetuating spatial fragmentation and social segregation.

The Lion Park extension to Cosmo City has not yet started due to the lack of bulk services being available. Hart has proposed alternative means of energy, water and septic tanks. He points to the false promises along with the well-intentioned ideals for improving the lot of disempowered communities, and hopes that in the future there will be more sustainable projects in South Africa that take local culture and environmental constraints into consideration.[8] Initially proposed in the late 1990s, Cosmo City was seen as a pioneering, environmentally cohesive prototype redressing urban spatial neglect and a benchmark for a new model of low-cost housing community, taking advantage of its proximity to the city centre, rather than suffering marginalisation and poverty on the metropolitan fringes. It was unique for this at the time of its conception, with its compact spatial planning, and the role given to public parks and landscape design. Although very distinct from the defensible space of gated communities that also continue to mutate globally as atomised living spaces for the wealthy, the scheme needs further expansion fuelled by political will if past planning criteria and segregation strategies are to be disassembled, as in the case of informal settlements in Colombia (see p. 117), São Paulo (see interview with Urban Think Tank on p. 141) and elsewhere, rather than needlessly being built on.

6 Cornell University's Sustainable Design (CUSD) group, available at: http://cornell.edu/ssaa/about-us/, 2010+.

7 Housing Johannesburg, Lone Poulsen, Adjunct Professor, Architecture Programme, School of Architecture and Planning, University of the Witwatersrand, in 'Johannesburg: Challenges of Inclusion?', newspaper accompanying the Urban Age Johannesburg conference, 6–8 July 2006, organised by the Cities Programme at the London School of Economics and Political Science and the Alfred Herrhausen Society, the International Forum of the Deutsche Bank.

8 Interview with the author, 2011.

Urban Think Tank,
an interview

Do we really need masterplanning – a practice traditionally associated with the First World – now and in the future? The architects Urban Think Tank (U-TT), with their track record of interventions in the *barrios* of Caracas and the *favelas* of São Paulo, do not think so. U-TT prefer to discuss the pressing need for urban retrofitting and tools to make all urban centres more resilient. U-TT was founded in Caracas in 1998 by Alfredo Brillembourg and Hubert Klumpner, who since 2010 have held the chair in Architecture and Urban Design at the Swiss Institute of Technology, ETH, in Zurich. Their focus on the cities of developing world, expanding and generating new structures and processes, presents an activist architecture with a socially equitable impact.

Lucy Bullivant (LB): How can specific masterplanning strategies and the kinds of goals applied to plans improve on the tactics applied in the past, largely fixed, modernist blueprints?[1]

U-TT: Before, masterplanning tried to fix zoning environments, distinct areas of work, recreation and living. Business zones recently became a priority and in the development model in the Middle East, closed loop urbanism. Developers need to sell products but it is unilateral and does not take care of the social model. In many countries, China, India among them, new housing is for the more wealthy, while the US model of the mortgage system has proven to be very risky. Given the size of slums globally, there is a huge white spot to deal with the solution.

No one declares these areas as property. We have to relook at slums and upgrade them. Our central issue today is precisely to define these design and planning strategies. Urban designers, and particularly teachers of urban design, are facing a crisis. Our field is playing catch-up with the realisation that we have largely ignored how the majority of human beings live. For decades, the focus has rested comfortably on the Global North. Not only has this limited our field's creative palate, but it has depleted its legitimacy. If designers and architects are to improve cities and impart meaningful strategies to subsequent generations, we must begin evolving creative vision briefs that go beyond this.

The slums of Latin America, Asia and Africa, and the recently impoverished suburbs of North American and European cities,

1 Interview by the author, May 2011.

cast doubt on the traditional notion of city growth and planning as self-contained and rational, born of the logic of the functional organisation of space. Fast-growing cities in the developing world and shrinking cities in the developed world present us with two faces of the same coin joined by the phenomena of informal development.

The conditions and the wealth of cities in the western world are the exception. The rule is what we have documented over the last decade in the cities of the South: urban development without institutional assistance; overstretched infrastructure; lack of resources; and policies of exclusion. Cities, whether deliberately or not, are moving toward a less formal, more flexible order. It is therefore critical that designers recognise that informality provides a large-scale, conceptual framework of cooperation between stakeholders and urban managers. Such cooperation would establish a global agenda of open design framework that accepts cultural, social, and ideological differences. The emphasis of contemporary architectural practice and education must shift from a form-oriented to a process-driven concern.

We (U-TT) praise the productive power and the skills of the inhabitants in slums but we are aware of the fact that there is an urgent need for support. Municipal and national government must provide the financial and the technical expertise to make changes on a larger scale, for instance, with regard to infrastructure and legal framework, possible.

We are in danger of watching another generation merely survive, rather than flourish in cities. The authorities often deliberately ignore potential urban dangers because no easy answers are in sight. The results of negligent policies are too frequently catastrophic. As slum zones are often constructed in the least favourable areas for formal development – such as land with extreme slopes and weak soil resistance or areas subject to seasonal flooding or earthquakes – they are at permanent risk. Entire stretches of neighbourhoods can be lost in a rainstorm. Slum zones need to be recognised as urbanised living quarters, with needs for housing and infrastructure solutions.

Understanding these behavioural processes is critically important to those architects working in the 'developing world'. On the other hand, the so-called 'First World' has the responsibility of creating long-term strategies to assist local stakeholders and professionals to make these cities more resilient. Traditionally, architecture has been defined by a lateral exchange in the northern hemisphere. Since the nineteenth century, Europe and the United States, and later Japan, formed a ring of mutual exchange and intellectual stimulation. More recently, new nodes – China, Brazil, India, Korea, Taiwan, and the Emirates – have been added to that ring and have started to distort the geography of architectural education and provide new spaces for production and dissemination.

LB: So do you believe that masterplanning today is largely based on a skewed vision of cities?

U-TT: Yes, why are we still imagining cities based on grids, when GPS (Global Positioning System) has liberated us from this, for example? Or take Venice as an example, the most visited city in Europe per km². 20 million tourists are expected to have gone there this year. Can't we find a city model that brings people together in some new form of social density? We've got to stop developing green land and must limit the footprint environment of cities, with increased densities. We don't really need masterplanning. We don't need more new towns. What we need is urban retrofitting, an exponential level of urban acupuncture, networked in some way. The new city is to be built on top of the old city. Developers and city planners have to become expert urban surgeons.

LB: If you subscribe to open-ended, open source solutions, how do you protect them from appropriation?

U-TT: In the best case scenario, you find a mayor able to execute the vision. We try to build the most important parts of the value system into the structure. We use the status of the engineer to subvert the vulnerability of the architects' concept, which clients might previously say was too expensive. We build the concept into the structure, for example, a children's school accessed by ramps; the cooling system of the building as part of the structure. It is the same principle as the 'sites and services' first brought to India by the British in the nineteenth century and used in slums. The design principle is a flexible shell with basic services and lets the programme change and adapt to this structure.

LB: You say you begin by not planning. How does this relate to democratic processes?

U-TT: Masterplan is a term that comes from a military context. However, in the developing world where a new participative

democracy is developing, and the top-down plan is increasingly more difficult to implement, it's B, C or D alternatives that are worked out with the community. Plans are unpredictable, too slow. Moreover, we are trying to revive a more socially consequential method, one that develops plans through a democratic process, creating systems but leaving a more open-ended development and scope to reconnect with social experiments. A masterplan such as Masdar City (in Abu Dhabi), for example, until recently, would not have passed any democratic vote. Most plans today are imposed by boards of corporations or sheiks, and in Asia, too fast to be filtered through democratic processes.

Masterplanning in China is playing a role to promote Chinese cities connecting with the global urban system, and supporting infrastructure for the development of the world's factory. However, there are some problems. These big projects have not been successful in creating planning with social and economic community-driven principles, thus they destroy the very beauty of traditional Chinese villages to promote some sort of urban planning learned from the old Soviet urban planning model. They plan a city to create an artificial planned economy, with construction and engineering operations run by state-controlled corporations. We applaud the need for progress but China needs better urban research. The urban models implemented are still weak in the process of public participation. We are hoping for a new era in planning in China, one that transforms to promote a sustainable transition of economic and social growth.

Working within the urban fabric is also deeply embedded in a complex process of democratisation; inhabitants will always be there to judge our success or failure on the capacity of projects to improve living conditions for everyone. Given that cities in the South operate based on appropriating available space, a process of incremental development of the existing resources in order to expand, reproduce and generate new structures, creates perpetual growth and transformation.

LB: Is the true expertise on cities being applied in the right places?

U-TT: A reorientation of planning within the architectural profession is necessary in order for it to incorporate the developing world into our understanding and definition of urban studies. It is necessary that this exchange of ideas is a two-way bridge between the developed and the developing worlds. Successful change comes from collaboration between international experts and local knowledge. It is essential to have input from the best consultants and to remain connected to the most advanced solutions and technologies.

LB: How does UT-T operate and what are your priorities for any given cultural context?

U-TT: Rather than imposing change, Urban Think Tank, as a practising office and educational hub, attempts to provide tools for urban dwellers in order to give them better control over changes within their environment. U-TT has a local office executing projects in Caracas and has placed a strong emphasis on understanding the dynamics and contexts of Latin American cities. This is where we started our research and deepened our experience over more than a decade. Yet, we have found that the lessons we have taken from our work in Latin America can also be implemented in the slums of Mumbai, Kibera, and São Paulo.

We are not interested in a signature masterplan that plays a questionable role in city branding. We see the design of processes as a strategic element and a product to prepare the next generation of designers for the challenges of working in contemporary cities. Processes, not brands, are what will bring together utopia and pragmatism within tangible projects. Change will occur through definitions of new typologies and programmes and the intelligent incorporation of social needs.

Future generations will judge our success by the applicability of our solutions and their capacity to improve living conditions for everyone, everywhere. The notion of a slum-free world is not optimistic but rather pessimistic. If we can embrace slums as components to cities rather than tumours, perhaps we can find more effective ways to learn from their successes and lessen their failures.

LB: What drives the U-TT toolbox approach to cities?

U-TT: With our U-TT toolbox of acupuncture elements, we propose a working method for a new supportive architecture that empowers people at the margins of the Global South's emerging cities and promotes sustainable development in the slum areas. Our agenda in devising and applying the toolbox is two-fold: to shift the emphasis of contemporary architecture and architectural education from form-driven to purpose-oriented; and to eliminate the disconnect between design and

its social impact. Rather than having a purely artistic objective, we call for an architecture that creates buildings from efficient, locally produced, and industrial materials that can be assembled in a kit of parts.

LB: What kind of public consultation does U-TT carry out?

U-TT: Our idea of participative design is not to ask people what they want but to moderate and animate individuals and community groups. We need greater insight into an overview of existing complex infrastructure services. As we developed the design of our Metro Cable project in Caracas, we increasingly relied on the local residents of the San Agustin *barrio*, with the impetus coming from direct conversations and meetings within San Agustin, but, as the design process intensified, we sought more creative modes of tapping the community's vision. This took the form of drawing sessions with neighbourhood children and hosting debates at community meetings about aesthetics and pragmatics. Indeed, as the entire project was framed in the context of a political retort to the city government's proposal to construct more roads through the *barrio*, our design process took on the form of an election campaign.

LB: How does your participative design mediate between different interests to achieve a resilient solution?

U-TT: In this case, we functioned as a mediator and interlocutor, establishing the link between top-down infrastructure and bottom-up community development. The Metro Cable project originated as a viable alternative to traditional, destructive methods of infrastructure development. Indeed, the state-sponsored road strategy was only averted after U-TT organised a public presentation at Caracas Central University, which attracted architects, planners, university activists, and *barrio* leaders in order to protest against the government's plan to build a road through San Agustin. This process demanded careful negotiation between competing requests on behalf of the city, residents, and our own office, resulting in a socially-invested design. As more stakeholders contribute to a project's planning and sign off on the process, the outcome's resilience strengthens. Participative design, in this light, is not only morally sounder, but it is more likely to create a lasting product.

LB: What are the best methods for the designers of tomorrow to employ for understanding the environments in which you work?

U-TT: Traditional methods of urban analysis for scrutinising the city do not yield information or knowledge. Satellite images, for example, are too distant to grasp the essence of slums. Other forms of data, such as ground surveys and census information, have not been conducted with fidelity because slums are in a continuous process of transformation and as soon as a data set

1 Metro Cable, Caracas, Venezuela, view of Homos de Cal Station, Urban Think Tank.

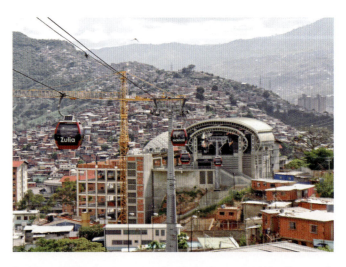

2 Metro Cable, Caracas, view of La Ceiba Station with the Plug-in of the Vertical Gym and Community Centre, Urban Think Tank.

3 Metro Cable, Caracas, Parque Central Station, Urban Think Tank.

4 Metro Cable, Caracas, life around Homos de Cal Station, Urban Think Tank.

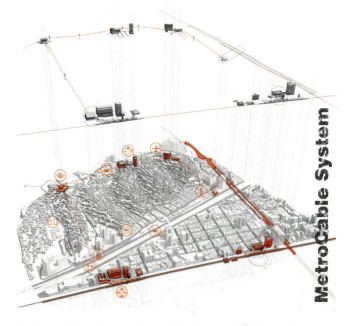

5 Metro Cable, Caracas, Metro Cable System plan, Urban Think Tank.

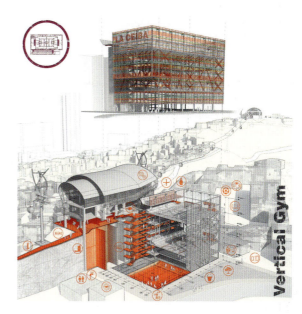

6 Metro Cable, Caracas, Vertical Gym prototype, Urban Think Tank.

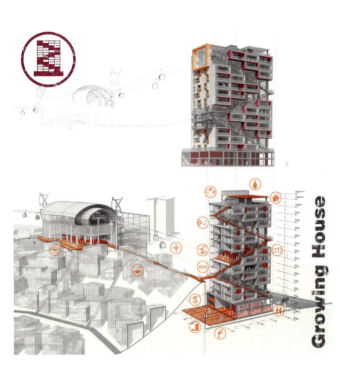

7 Metro Cable, Caracas, Growing House for replacement housing, Urban Think Tank.

is compiled, it needs to be updated. It is impossible to map and colour-code functional zones in a modernist fashion as this provides an inadequate and only two-dimensional image.

Therefore first-hand experience and exploration are the best way to give the next generation of architects a genuine understanding of the twenty-first-century city. The designers of tomorrow must inquire about vernacular changes in lifestyles, perceptions of local government efficacy, and collectively desired improvements to public and private spaces that often dominate community meetings and initiate social demands. Accurate answers to such enquiries rarely lie within official statistic books or in the speeches of politicians, but rather must be 'read' in the oral history that is inscribed on people's memories.

It is equally important to know about the influence of origins, for example, that Tokyo was developed on a marshland slum by

8 Metro Cable, Caracas, Urban Catalysts, Urban Think Tank.

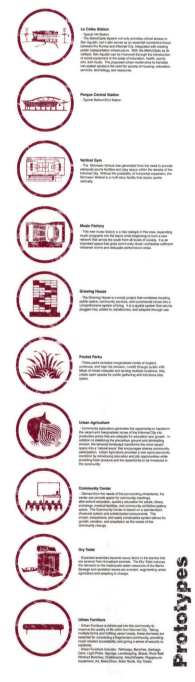

La Ceiba Station
- Typical Hill Station
- The MetroCable System not only provides critical access to San Agustín, but it also serves as an essential connective tissue between the Formal and Informal City, integrated with existing public transportation infrastructure. With the MetroCable as its catalyst, San Agustín can be improved through the introduction of social equipment in the areas of education, health, sports, arts, and music. The proposed urban model aims to translate into spatial solutions the need for access to housing, education, services, technology, and resources.

Parque Central Station
- Typical Bottom/End Station

Vertical Gym
- The Gimnasio Vertical was generated from the need to provide adequate sports facilities and play space within the density of the Informal City. Without the possibility of horizontal expansion, the Gimnasio Vertical is a multi-story facility that stacks sports vertically.

Music Factory
- This new music factory is a vital catalyst in this area, expanding music programs into the barrio within a new network that serves the youth from all levels of society. It is an important space that gives community driven orchestras sufficient rehearsal rooms and adequate performance areas.

Growing House
- The Growing House is a social project that combines housing, public space, community services, and commercial zones into a comprehensive system of living. It is a spatial system that can be plugged into, added to, transformed, and adapted through use.

Pocket Parks
- These parks revitalize marginalized zones of neglect, underuse, and high risk (erosion, runoff) through public infill. Made of mixed materials and serving multiple functions, they create open spaces for public gathering and introduce play space.

Urban Agriculture
- Community agriculture generates the opportunity to transform the vacant and marginalized zones of the Informal City into productive zones that are catalysts for education and growth. In addition to stabilizing the precarious ground and eliminating erosion, the terraced landscape transforms the once vacant space into a 'natural arena' that encourages diverse community participation. Urban Agriculture provides a new socio-economic condition by introducing education and job opportunities while providing fresh produce and the opportunity to be involved in the community.

Community Center
- Derived from the needs of the surrounding inhabitants, the center can provide space for community meetings, after-school education, auxiliary education for adults, library exchange, medical facilities, and community exhibition/gallery space. The Community Center is based on a standardized structural system and prefabricated components. This simple, inexpensive, and easily constructible system allows for growth, variation, and adaptation as the needs of the community change.

Dry Toilet
- Expected amenities become luxury items in the barrios that are severed from formalized services. The Dry Toilet reduces the demand on the inadequate water resources of the Barrio. Sewage and sanitation issues are avoided, augmenting urban agriculture and adapting to change.

Urban Furniture
- Urban Furniture is introduced into the community to improve the quality of life within the Informal City. Taking multiple forms and fulfilling varied needs, these elements are essential for connecting a fragmented community, providing much-needed accessibility, and giving a sense of security to residents.
- Urban Furniture includes: Pathways, Benches, Garbage Cans, Light Posts, Signage, Landscaping, Shade, Rock Wall, Workout Benches, Chalkboards, Amphitheater, Playground equipment, Art, MetroOlivo, Solar Roofs, Dry Toilets.

Prototypes

9 Metro Cable, Caracas, toolbox or icons of the prototypes that will be plugged into the system, Urban Think Tank.

individual upgrading, then retrofitted with the subway, so as a consequence is very labyrinthine and rhizomatic.

Yet it is still very important to develop new ways to plan. The shape of the slum fabric emerges from a bottom-up process; as density increases, slum dwellers build upward and outward. This pattern results in distinctive variations that merge together to form an architectural unity. Because these traditional planning and mapping methods fail to grasp the informal, we became increasingly fascinated in combining mind maps that present and juxtapose functional zones, gang territories, risk zones, multilayered infrastructures, and blurred ownership information. Using GIS (Geographic Information Systems), we assembled our own 3D data bank that allows for a new vocabulary for the informal city.

LB: How important are standardised solutions for cities in the developing world?

U-TT: A central challenge to cities in the developing world is the constant demand for structured, standardised, and consolidated infrastructure. The Metro Cable project, mentioned above, is a new addition to Caracas's public transport system that integrates the San Agustin *barrio* with the formal city. While the city made an automobile-centred proposal to integrate San Agustin with the rest of the city, U-TT saw the opportunity to implement a sensitive form of infrastructure acting as urban acupuncture. By inserting an above-ground cable car system, integrated with new housing, community recreational centres, and spaces for commercial developments, the *barrio* would not lose its existing fabric for mobility, but have a normalised transportation service that complemented and reinforced bonds.

LB: What did you learn from realising the Metro Cable project in Caracas?

U-TT: In essence, the Metro Cable project taught us how the macro must serve the micro. Standardisation, we realised, produces greater flexibility, as it is easier to carry out expansions, changes, and repairs in the future. Infrastructure must be consolidated to effectively infiltrate the informal with capable, maintainable services. Services can share a central access point: garbage collections, water, and electricity are bundled with social functions and a cable car infrastructure.

Social programming clusters, in proximity to infrastructural upgrades, bolster the network and create a densely public hub

that reinforces the built environment through anticipated use. Indeed, the Metro Cable project permitted us to speculate about the neighbourhood's future without locking it into any predetermined future. We acknowledged the touristic possibilities inherent within the cable car platform, while at the same time interweaving the needs of the community, both prosaic and escapist. This is infrastructure performing many roles at once, reflecting the multifaceted community for which it was built.

LB: How did Metro Cable influence a bigger scale change in Caracas, beyond the sheer value of its connectivity, in other spatial and political ways?

U-TT: Normally you could never open a road through the area. We flew over the property boundary. We have blurred the boundaries between public and private, mixing them for the first time. The system will now be reproduced on three or four hills. The scheme provokes the status quo to make that merger.

LB: How do you generate socially advantageous environments from uninhabitable space?

U-TT: U-TT has been developing a proposal for the Grotão *favela* in São Paulo alongside SEHAB, the City of São Paulo Housing Authority, and now in coordination with our research lab at ETH Zurich. Despite its central and urban location, the area is connected by only one road to the larger circulation systems of São Paulo, effectively separating it from the formal city, much like the San Agustin *barrio* of Caracas. Within this separated zone, increased erosion and dangerous mudslides have characterised the site as one of many low-access and high-risk zones. As a result, the unfortunate but necessary removal of damaged housing units has created a void in the otherwise dense fabric.

The new landscape generates the opportunity to transform the vacated space into a productive zone and public space through social design, a process of analysing the conditions of rapid growth and improving marginalised settlements through social infrastructure. In addition to stabilising the precarious ground and eliminating erosion, the terraced landscape of our proposed park transforms Grotão into a 'natural arena' that encourages community participation in recreational and civic gatherings. The park will serve as a foundation for piecemeal development of sports facilities and a music school that will be built vertically on the site and different types of parks within the same plot of land.

Public space, as the New Urbanists reminded us, is not a luxury but a necessity. They reminded us of tenets that early

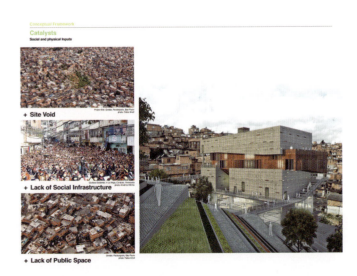

10 Grotão favela, São Paulo, the project is embedded in the challenging situation of a high risk zone, Urban Think Tank.

11 Grotão favela, São Paulo, project catalysts, Urban Think Tank.

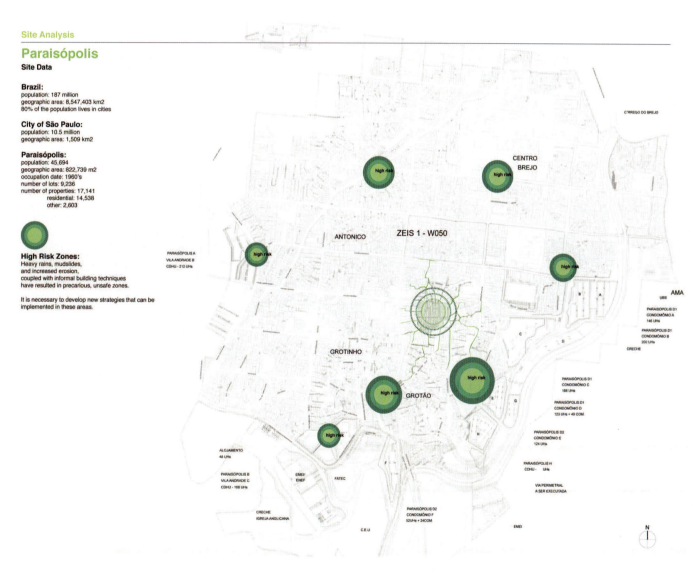

Site Analysis

Paraisópolis

Site Data

Brazil:
population: 187 million
geographic area: 8,547,403 km2
80% of the population lives in cities

City of São Paulo:
population: 10.5 million
geographic area: 1,509 km2

Paraisópolis:
population: 45,694
geographic area: 822,739 m2
occupation date: 1960's
number of lots: 9,236
number of properties: 17,141
 residential: 14,538
 other: 2,603

High Risk Zones:
Heavy rains, mudslides,
and increased erosion,
coupled with informal building techniques
have resulted in precarious, unsafe zones.

It is necessary to develop new strategies that can be
implemented in these areas.

12 Grotão favela, São Paulo, site plan showing high risk zones, Urban Think Tank.

Productive Systems

Water

On-site Water Flows

→ **Solar Water Flow**

→ **Runoff Water Flow**

① Runoff cascades over permeable surfaces, absorbing excess stormwater and increasing water oxygen levels

② Site contours direct the water inward to minimize off-site discharge

③ Runoff is collected into terraced Wetland Water Gardens to trap contaminants and particulates. The system is a natural filter that enhances air quality, lowers ambient temperatures by evapotranspiration, and introduces habitat niches that attract foraging birds

④ Treated overflow from the wetlands is collected into an underground cistern for storage and later reuse

⑤ Stored water is treated to local quality standards with rapid sand filtration and pumped to elevated tanks for reuse

⑥ Water is lifted during dry periods to provide irrigation in planted areas

⑦ Treated water is available for non-potable uses, such as toilet flushing

⑧ Minimal stormwater is discharged to the public sewer system

Water Model

Total catchment area	6012 m2
Runoff coefficient	0.95
Elevation change	100 m
Average daily occupancy	300-400 people
Per person usage	15 liters
Edible garden area	520 m2
Daily garden irrigation	7 mm
Non-garden area	2140 m2
Daily non-garden irrigation	4 mm
Peak water demand	15.5 m3/day
Peak power requirement†	251 watts/cont.
Solar panels required†	11 m2 total area
Total annual water usage	3617 m3
Total annual deficit	550 m3
Approx. cost of water	4.3 USD/m3
Approx. annual savings	**$13,188 USD**

† -- This is for lifting only and does not include power requirements for treatment.

	JAN	FEB	MAR	APR	MAY	JUN	JUL	AUG	SEP	OCT	NOV	DEC
average monthly rainfall (mm)	239	218	160	76	74	56	43	38	81	124	145	201
capture volume (m3)	1364	1248	914	435	421	319	247	218	464	711	837	1146
toilet flushing (m3)	180	180	180	180	180	180	180	180	180	180	180	180
garden irrigation (m3)			26	70	71	80	87	89	67	44		
non--garden irrigation (m3)				94	99	137	164	175	83			
other	10	10	10	15	20	20	20	20	15	10	10	10
total monthly demand (m3)	190	190	216	358	370	417	451	465	345	234	190	190
surplus (m3)	1174	1058	698	77	51	-98	-205	-247	119	476	637	956

13 Grotão favela, São Paulo, water systems and reuse, Urban Think Tank.

Productive Systems

Building Systems

Building and landscape work together to create a comprehensive combination of active and passive systems

① **Natural Ventilation Chimney**
Combination of stack, solar and wind
supported ventilation system

② **Hybrid Photovoltaic Panels**
Electricity during the day
IR-Emission of water during the night

③ **Air Conditioner**

④ **Shading**
Protects against solar exposure along
the east and west facade

⑤ **Slab Cooling**
Tempering the concrete structure with
embedded hydronic piping

⑥ **Hybrid Ventilation**
Natural ventilation in shoulder seasons
AC operation in humid season

⑦ **Cross Ventilation**
Wind from south direction provides
fresh air, warm winds coming from north
direction are blocked by the hill

Cooling Water Cycle

⑧ Heat rejection from Air
Conditioner

⑨ Heat sink during day

⑩ Heat emission during night by
lunar collector on roof

⑪ Chilled water to air
conditioner

25°C < Tamb
hot wind

Tamb <15°C
cool wind

14 Grotão favela, São Paulo, building systems diagram, Urban Think Tank..

Productive Systems

Landscape

Materiality and Urban Agriculture

Circulation Integration
A series of ramps weaves the landscape into the Fábrica de Música

Integration with Context
The terrace pathways connect with the existing context to provide access

Grass
Highly permeable grass is used to retain the steep landscape, absorb excess stormwater and reduce the required construction on site

Grass Pavers
Permeable material to mitigate runoff and erosion

Agriculture
Introduces fresh produce, agricultural education, and micro economies into the favela

Cabbage / Kale
Brassica oleracea
Height: 20-100cm
Origin: Mediterranean
Soil: Rich or dry
Exposure: Medium to full
Water: Regular irrigation
Harvest: 30-45 days
Character: Annual

Carrot
Daucus carota
Height: Up to 1m
Origin: Europe, SW Asia
Soil: Light, sandy
Exposure: Full sun
Water: Regular irrigation
Harvest: 40-80 days

Beet
Beta vulgaris
Height: 100-200cm
Origin: Mediterranean
Soil: Well-drained
Exposure: Partial shade
Water: Regular irrigation
Harvest: 40-80 days
Character: Biennial, Perennial

Onion
Allium cepa
Height: 30-120cm
Origin: Mediterranean
Soil: Fertile, moist soil
Exposure: Full sun
Water: Regular irrigation
Harvest: 90-110 days
Character: Annual

Squash
Cucurbita
Height: 20-120cm
Origin: Central America
Soil: Warm, well-drained
Exposure: Partial to full sun
Water: Regular irrigation
Harvest: 80-100 days
Character: Annual

Lettuce
Lactuca sativa
Height: 10-30cm
Origin: Mediterranean
Soil: Sandy, moist
Exposure: Partial to full sun
Water: Regular irrigation
Harvest: 65-75 days
Character: Annual

Trees

Acai
Euterpe oleracea
Height: 10-20m
Origin: Brazil
Soil: Rich to poorly drained
Exposure: Med/light shade
Water: Normal to moist
Character: Evergreen
Provides shade

Banana
Musacese musa
Height: 3-8m
Origin: Southeast Asia
Soil: Rich, 30-60cm
Exposure: Full sun
Harvest: herbaceous perennial
Character: Provides shade

Tabebuia
Tabebuia aurea
Height: Up to 15m
Origin: Brazil
Soil: Fertile, well-drained
Exposure: Full sun
Character: Semi-deciduous
Provides shade

15 Grotão favela, landscape diagram of elements, Urban Think Tank.

urban planners, like the fifteenth-century Spanish, knew so well: creating plazas and courtyards reinforce social bonds with a myriad of functions and utilities. When designed with complexity and density in mind, the parks and recreational spaces of a slum may accomplish much more than early Modernist planners would have estimated possible.

The Grotão project began as a proposal for the creation of public space, but recently, we have transformed the plan into a full-scale revitalisation project, or, as we term this class of tools, an Urban Generator. The site will become a focal point for productive changes in the community as a whole, that will ripple out and rhizomatically reinforce the area's physical and social

instabilities. What was initially an uninhabitable slope will become a public access point for civic engagement and environmental education.

With both recreational space and a centralised building, or hub, the project will consist of a library, repair station, Internet port, retail shop, kindergarten and public restroom. The hub will also be an ecological prototype for the community, modelling state-of-the-art technologies that demonstrate how to responsibly deal with energy and resources both within and beyond the *favela*. Using a combination of solar cells, water recycling, and gardening habitats, the hub is meant to empower residents and improve the quality of life by combining education with experimentation. As an urban generator, it will catalyse commercial and social cooperatives, with components which are as cheap as possible, function on a small footprint, and are easily reusable.

LB: Does masterplanning as an integrated, multi-disciplinary, design-driven approach to cities and their regions have a positive future, and if so, in what ways?

U-TT: However much planning has been applied to Caracas, the city is plan-proof and inherently chaotic. Elements of various masterplans – commercial and residential developments, infrastructure – remain unfinished and abandoned, that, like meteors, have been dropped at random into the city. So firmly established is the old model of masterplanning that no alternatives have emerged. The city's professional and political leadership remains utterly detached from the reality of the *barrios*, whose self-appointed interpreters and saviours have no idea how to integrate one element of Caracas with another. Any workable plan must therefore establish only a broad framework and structure within which development can take place according to the wishes and needs of the community it serves.

We envision a plan for quick-fix urban design and architecture that functions as a life-support agent for the perpetually changing city. It is, quite simply, activist architecture with the potential to be a visible force for positive change. We promote architecture as an event, which can only be fully realised with the active participation of inhabitants. Architects have to wake up and employ new methods to speed up response times and accept that governments do need our creative and unconventional input to keep all citizens safe – and not just the privileged few.

LB: Have you drawn on patterns of development in one context when working on projects in another context?

U-TT: In our Hoograven Vision design proposal for a district of 14,500 residents in southern Utrecht in the Netherlands, we aimed to achieve sustainable urban transformations encouraging networked social infrastructure and enhancing expressions of appropriation and transformation. Three Hotspots were identified: ArtSpot, LiveSpot and PlaySpot. The ArtSpot with an art and craft school containing student and faculty housing and a commercial corridor aimed to revitalise an existing industrial zone.

The design concept draws on the organic flexibility of housing found in the *medinas* of Moroccan cities. The woven structure design would allow for a variety of residential units, courtyards, and informal spaces that could be adapted over time. The adjacent parkland was transformed into an ArtPark with programming intended to activate the land, connect the art campus to the neighbouring residential area, and create space for diverse recreational activities.

LiveSpot proposes a radical alternative to demolishing outdated social housing, while providing flexible solutions for a variety of household needs. The innovation of a 'jacket' attached to the exterior of existing buildings has the potential to increase insulation, allow for new infrastructure, improve circulation, and hold a kit-of-parts that would enable the expansion of units. Moroccan households tend to be larger, and overcrowding has contributed to the growing inadequacy of existing social housing. Advancing the *medina* concept, U-TT envisaged a souk as the primary spatial mechanism for encouraging local entrepreneurship, designed as an open, mixed-use structure, combining a commercial street with additional social housing apartments adjacent to the existing mosque in the centre of Hoograven.

The third Hoograven HotSpot, PlaySpot, designed to be built along a canal in the south-western area of the district, is intended to re-use existing recreational facilities while adding infrastructure and programming, activating the waterfront with a dynamic sports hub with vertical gym, skatepark, renovated rowing club and pedestrian walkway.

LB: What do you strive to make the large-scale impact of your work?

U-TT: We are interested in applying sustainable living urban models research to macro-micro global systems, situating

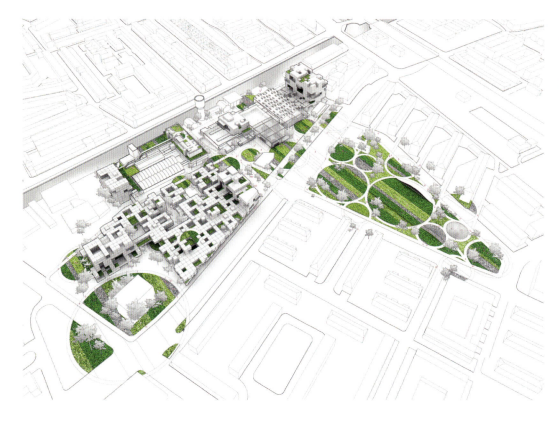

16 Hoograven, Utrecht, the Netherlands, ArtSpot provides a new art and cultural campus for the neighbourhood, Urban Think Tank.

discussion of opportunistic, illicit, ground-level tactics for eco-logically viable human practices. We seek an action group of city designers examining the underside of global urbanisation. Approaching planning this way can change world cities by transforming economies and ecologies, reshaping politics and human settlement. 'Territorial ecologies' are spheres of action sustaining relations and interactions between humans and their environment. We want to shape an explicit understanding of urban ecological terms that can provoke do-able design initiatives and open-ended speculation on alternative urban futures.

The contrived definition of sustainability, micro planning and other buzz words as a pseudo-technical programme is far too limited and limiting. Our approach defines the work of the architect as a kind of filmmaker or story teller, outlining possible scenarios to be implemented locally at a community level.

Without alternating the politics of design, our profession will continue to slide into the powerless area of commercialisation and formalism. No advances in ecologically-minded urban design and architecture can be made without taking into account the continuously changing conditions of sustainability and ecological planning.

LB: Your work is also socially anticipatory as well, isn't it?

U-TT: How you use cities has become a political topic. If you apply the impact of the migration of 300 million people globally moving to cities by 2030 (UN statistic) and mostly in the Global South, where there are the countries with the biggest challenges, we must come up with radically different strategies – we call them hierarchical decentralised infrastructures for a more demo-cratic city – because the existing infrastructure will not work. A masterplan will probably not be able to provide for needs in this context unless it is grown out of a democratic process.

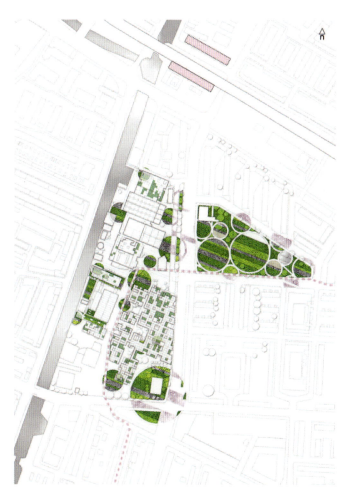

17 Hoograven, Utrecht, the Netherlands, map of the ArtSpot, Urban Think Tank.

LB: How should urban design projects draw on environmental science?

U-TT: Our Metro Cable project originated from our fondness for thinkers like architect Moshe Safdie who do not suggest visions of environmental sustainability without also suggesting radical behavioural shifts. We must look at how the structures we build are integrated into larger ecological systems that have real limits, rather than treating each project as a solitary creature free to devour whatever resources it requires. In doing so, networks of buildings will create and consume communal assets like water, carbon, and space in complementary ways. Environmental science has provided architects with ample information – both broadly and specifically – to help us better design the components to our urban systems. Whether we use ecological knowledge to find metaphorical inspirations for urban systems or use biological tenets to derive new technologies and implement them in efficient manners, we must stop constraining our imaginations to inorganic properties. If sustainability and its ubiquitous marketing synonym, 'green', mean anything, they must signify a greater appreciation for life's inherent complexities.

LB: Is sustainability valid when socially accepted?

U-TT: We insist that any notion of a particular structure or infrastructure's sustainability must be measured in how it is socially accepted. While we designed the system for the Caracas Metro Cable so that residents and visitors do not have to rely solely on petroleum-based modes of transportation (the cable cars will soon create much of their expended energy from solar cells located on their roofs), the system's sustainability will be nullified if people cease to use it. This is an obvious point, but one that often seems too readily dismissed as a mere problem of marketing.

No one holds an authoritative definition of sustainable planning, a phrase with a contested meaning but definitely about resilience, efficiency, and balance. As architects, we must demand that students appreciate the limitless possibilities that can exist within a world that has real limits. This is an idea that has been painted as ugly by economists for too long – it is time that designers reclaim its beauty.

6

'Eco-cities'

Masdar City, Abu Dhabi, UAE

Contemporary masterplanning in the Middle East has a myriad of identities focused on reinforcing a sense of destination. While places like Oman, based on an older economy and with considerable heritage as a hub for sea traffic, is evolving a heritage plan around the port, Dubai's protean identity has spawned plenty of new cities: Dubailand, Dubai Healthcare City, Dubai Media City and Dubai Internet City, among others. Abu Dhabi, the capital of the UAE, by contrast, is home to most of the UAE's oil and natural gas reserves that were first identified in 1958, but it has also realised twentieth-century urban planning principles, and the rising star wishes to continue as a leader in this field. While the global financial crisis has hit other cities, Abu Dhabi has been far less substantially affected, and in what is the richest city in the world in terms of per capita income, the mix of plans focused on development through 2030 is formidable in its variety, with most wedded to the concept of *estidama*, which in Arabic means 'sustainability'.

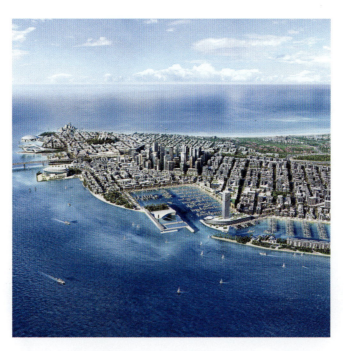

1 Saadiyat Island Cultural District masterplan. Aerial rendering; AECOM.

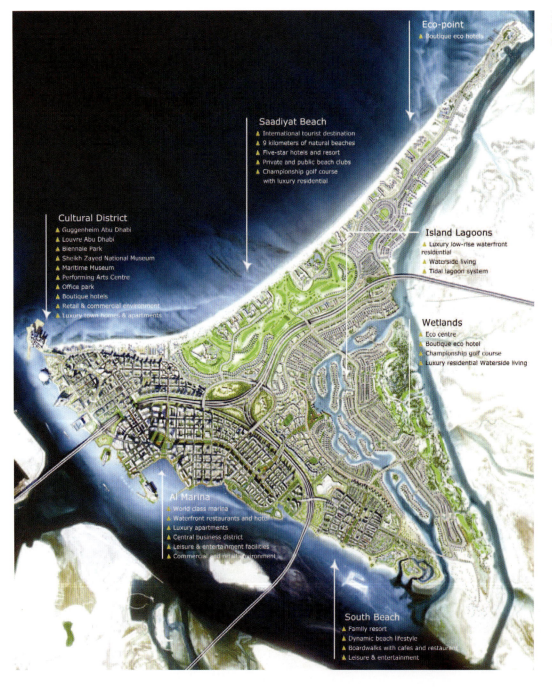

Eco-point
▲ Boutique eco hotels

Saadiyat Beach
▲ International tourist destination
▲ 9 kilometers of natural beaches
▲ Five-star hotels and resort
▲ Private and public beach clubs
▲ Championship golf course
 with luxury residential

Cultural District
▲ Guggenheim Abu Dhabi
▲ Louvre Abu Dhabi
▲ Biennale Park
▲ Sheikh Zayed National Museum
▲ Maritime Museum
▲ Performing Arts Centre
▲ Office park
▲ Boutique hotels
▲ Retail & commercial environment
▲ Luxury town homes & apartments

Island Lagoons
▲ Luxury low-rise waterfront residential
▲ Waterside living
▲ Tidal lagoon system

Wetlands
▲ Eco centre
▲ Boutique eco hotel
▲ Championship golf course
▲ Luxury residential Waterside living

Al Marina
▲ World class marina
▲ Waterfront restaurants and hotel
▲ Luxury apartments
▲ Central business district
▲ Leisure & entertainment facilities
▲ Commercial and retail environment

South Beach
▲ Family resort
▲ Dynamic beach lifestyle
▲ Boardwalks with cafes and restaurant
▲ Leisure & entertainment

2 Saadiyat Island Cultural District masterplan, aerial renderings, AECOM.

Sheikh Zayed bin Sultan Al Nahyan, the founder in 1971 of the UAE, understood that you could change the environment, and launched initiatives to plant a billion trees or more in the emirate. Abu Dhabi is the largest of the seven emirates, with just over a million people living there from around 200 different global ethnic groups, approximately 30 per cent of the entire UAE population. There has been a 7.3 per cent increase in population over the past four years, and the population is estimated to grow to 3.1 million by 2030.[1] Currently connected to the mainland by two bridges, and with more on the way, the island, which was originally a pearl fishing centre, was built in a strict T-shaped grid pattern. In the 1970s, for the residential area at the tip of the island, which is similar in shape to Manhattan, a grid plan was put over it and it was divided into plots. Each Emirati could claim funds for housing his or her family, and this, together with a scheme for commercial buildings with a rent-back system, evolved the area into today's high-density, shaded

square blocks with lots of basic-looking buildings, no architectural design, but definitely the result of planning.

Today the city of Abu Dhabi does not yet have buildings on anything like the scale of Dubai. But 40 million people travel through the UAE each year, and Abu Dhabi is rapidly working to make up for lost time to become one of the fastest growing tourist destinations in the world, and a modern bridge between East and West. Playing host to the inaugural 2009 Formula 1(tm) Etihad Airways Abu Dhabi Grand Prix at its new racetrack on Yas Island, it is also developing Desert Islands, a 'nature-based destination'. Just 500 metres offshore and connected to the city's Mina Zayed district, by an already completed 10-lane bridge, will be the $27 billion Saadiyat Island ('island of happiness'), a natural island being developed by the Tourism Development and Investment Company (TDIC), an independent public joint stock company set up in 2006 to develop Abu Dhabi's touristic assets and led by Chairman Sheikh Al Nahyan. TDIC's role is to develop real estate assets that support the UAE's economic diversification, and secure private investors who will each develop their sites in accordance with the

1 UAE National Bureau of Statistics, 2011.

3 Guggenheim Abu Dhabi, Saadiyat Island Cultural District, Gehry Partners LLP, rendering.

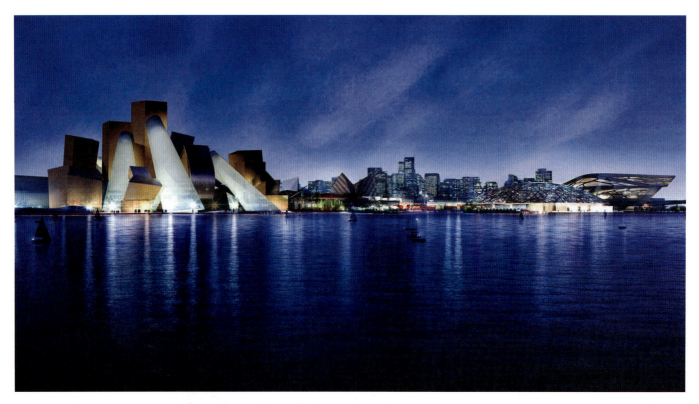

4 Guggenheim Abu Dhabi and Saadiyat Island Cultural District on coastline, Gehry Partners, LLP, rendering.

masterplan and local regulations. The island has 30km of waterfront, and is being developed as an international leisure, culture and tourism destination in three phases up to 2018.

The masterplan designed by AECOM envisages seven distinct districts: the Cultural District, Saadiyat Marina, Saadiyat Beach, South Beach, Saadiyat Park, The Wetlands, and Ecopoint. With more than 3 million m^2 of office space and marinas for 1000 boats, the Island is intended to be home to more than 160,000 people, a scale of population similar to Chang Mai in Thailand, Oxford in the UK, Dijon in France and Hartford in the USA. A key challenge for this culture-led civic infrastructure has been to forge economic, social and environmental sustainability through culture-based tourism, says AECOM, along with job generation and enhancement of local natural ecosystems.

The Cultural District, at 245 hectares the world's largest single mixed-use development in the Arabian Gulf, clusters global cultural brands in a new, multi-layered district. With a grand canal weaving through its heart, it will have the same density as central Paris and aspires to follow the models of other cultural quarters internationally, with facilities for the creative industries (for 30,000 residents), luxury accommodation, live/work artists' studios, theatres, cinemas, bars and restaurants along with the 137,160m^2 Guggenheim Abu Dhabi Museum (architect Frank Gehry), the Louvre Abu Dhabi (Jean Nouvel), a Performing Arts Centre (Zaha Hadid), the Maritime Museum (Tadao Ando) and the Zayed National Museum (Foster + Partners) due for completion in 2017.

Nouvel's design, which has a 180m dome extending over two-thirds of the Cultural District, is inspired by the *mashrabiya*,

a common Arab architectural feature that is an intricately carved wooden window covering that provide, privacy but allows air to flow freely. Its medina of rooms, like a neighbourhood within a city, encompasses about 30 buildings along a promenade, each with a different façade, playing on the interaction between the inside and the outside.

The Cultural District scheme mixes the artistic institutions' globalist aims with the urban policies and cultural investment ambitions of an emerging region in a way some critics regard as compromising. Using global cultural brands as tools in master-planning new pieces of a city is hardly new, and everything hinges on the quality and sustainability of the emerging Island. Formerly geographically defined bodies like the Louvre, born in Enlightenment Europe, will take on a more culturally elastic guise and showcase interrelationships between artistic achievements of different cultures around the world – 'giving a new dimension to the aspiration of a universal museum', as Henri Loyrette, Director, Louvre Museum, said in 2009.[2] The District

will be supported by resorts on the north-facing coast and a marina in the south, with homes at a mix of scales and costs well served by community amenities.

As part of its overall plan for economic diversification, Abu Dhabi's long-term goal is to build its economy in such a way that it is not reliant on fossil fuels. To this end, the government

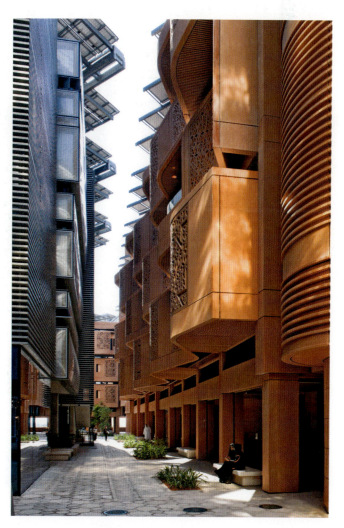

2 Henri Loyrette, Director, Louvre Museum, speaking at 'Museums and Universalism', a public panel discussion, 26 May 2009, Abu Dhabi.

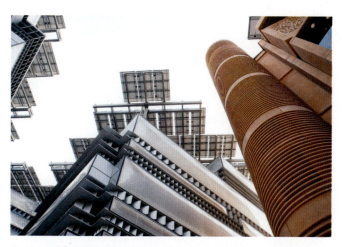

5 View of the Masdar Institute building at Masdar City, Masdar Institute: laboratory building with roof-mounted photovoltaic panels, Foster + Partners.

6 Masdar City, Masdar Institute: street view with laboratory building on the left and student residences on the right, Foster + Partners.

7 Masdar City, colonnades with retractable patterned screens based on Islamic *mashrabiya*, Foster + Partners.

has drafted a long-term urban vision for the Emirate: Plan Abu Dhabi 2030, which sets out the agenda for its systematic, intelligent and organic growth. Masdar,[3] an Abu Dhabi-based global renewable energy company, is backed by Sheikh Al Nahyan, giving traction to Masdar's flagship project, the 6km^2 Masdar City, to be one of the most sustainable urban districts in the world, positioning Abu Dhabi as a global hub for renewable energy and sustainable technologies.

The idea of forging a new identity for an area of Abu Dhabi as the future Silicon Valley of the Middle East for renewable energy was initiated in 2006. At the time, Foster + Partners was working on other projects in the city, including Central Market, a 1.8 million m^2 mixed use development that will be a modern, environmentally friendly souk, and were about to work on the World Trade Centre at Al Raha Beach. The practice was invited to enter a two-stage competition with a three-week work period. They put together an international team, with Transsolar, the German climate engineers; ETA, Italian renewable energy specialists; WSP, British HVAC engineers and sustainability infrastructure specialists, and Gustafson Porter as landscape consultants. The presentation for one of the world's most sustainable cities called for a balance between land and development, and proposed a traditional level of density. This led to Foster + Partners' appointment as masterplanners in early 2007, and a government announcement of billions of dollars to start the project.

The site is located between an expanding airport to the east, Khalifa City, a new neighbourhood of luxury villas to the west, a golf club and Al Raha Beach, an 8km strip of mixed-use beach

3 Masdar means the 'source' in Arabic.

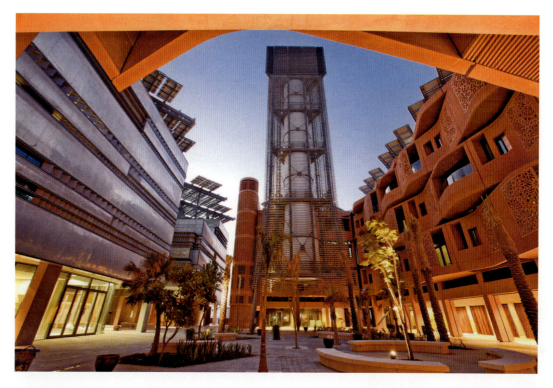

8 Masdar City, The Oasis, one of two squares in the first phase of development, with the 45-metre-high wind tower in the centre showing citizens' levels of energy consumption, laboratory building to the left and student residences to the right, Foster + Partners.

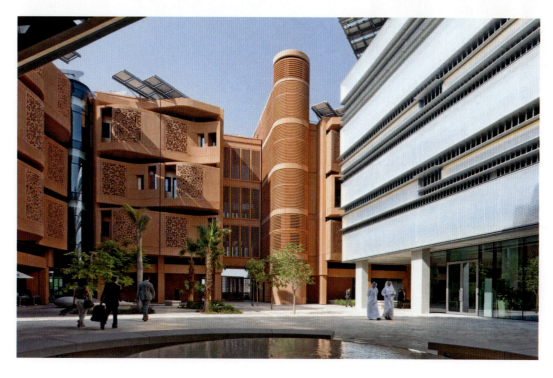

9 Shaded sidewalks and pathways at the Masdar Institute, Masdar City. The Family Square is one of two squares in the first phase of development, Foster + Partners.

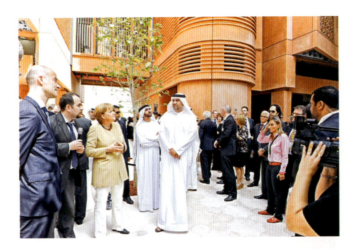

10, 11 Angela Merkel, the Chancellor of Germany, visiting Masdar City, 2010.

in the Middle East, is up and running, providing energy to the Masdar Institute. As well, it is feeding into the Abu Dhabi grid to help offset fossil-fuel energy used during the City's construction process, and in the future it will be one of several renewable energy plants serving the City as a whole.

The idea is that the City, whose first phase is scheduled to be completed by 2013, is an intensely programmed and authentic new piece of city, a showcase for future energy solutions, a research and technology centre, with a cutting edge technological university and science park, peopled by top scientists, students and businesspeople attracted to Abu Dhabi from all over the world, including research and development facilities of multinational companies and new business start-ups in the clean technology field.

The City will be built in phases. The rest of phase one, which includes the Masdar Institute neighbourhood with a campus for MIT and a 45 metre-high wind tower showing community energy use, is complete; the 130,000m² Masdar headquarters (architects Adrian Smith & Gordon Gill), housing the new International Renewable Energy Agency (IRENA), will be completed by 2013, with final completion set for 2021–5. As part of the first completed phase, Foster + Partners have designed a new university, the Masdar Institute, a complex structure with terracotta concrete cladding accommodating classrooms, offices and accommodation for students and professionals in the City. LAVA Architects designed a concept for the city centre, a complex of hotels, retail and entertainment facilities linked by an outdoor space with solar-powered 'sunflower umbrellas', an area of Masdar City as programmatically planned as the Institute neighbourhood.

Foster + Partners' plan, which is not gated, is punctuated by a compact network of steep streets. Here the centuries-old Arabic vernacular architectural concept of tightly planned, compact cities, comes into its own. Shaded walkways – colonnades with retractable patterned screens based on Islamic *mashrabiya* – and an irregular roofscape, are part of the energy-saving strategy including natural cooling. This treatment encourages an experiential quality by bringing deep shadow with angles to bring and filter breezes into streets, and the solidity of the buildings achieves a gradual modulation of temperature.

In traditional areas of cities such as Fez, Shibam and Aleppo, such districts are characterised by narrow shaded streets where

under development. It is conceived as a 6m², 2.8km² city square: a city within a city. Just over a million people live in Abu Dhabi, and Masdar City will only house a small portion of the total population (7000 residents with 12,000 expected to commute from elsewhere in Abu Dhabi). Tens of thousands of commuters will work for companies operating in the district, a renewable energy and clean technology industry cluster with an integrated community of residential properties and workspaces. The 10MW solar power plant, the largest grid-connected solar plant

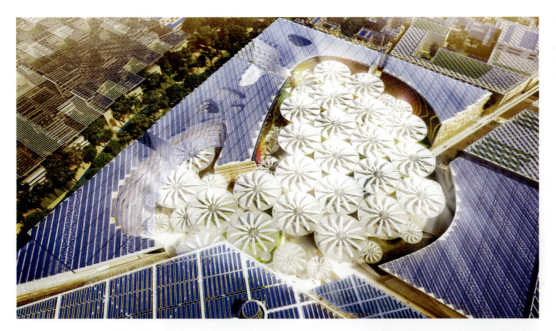

12 Masdar City city centre,
LAVA Architects, aerial view
showing the solar-powered
'sunflower' umbrellas,
rendering.

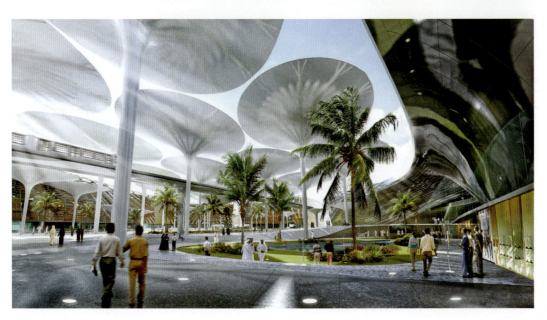

13 Masdar City city centre,
LAVA Architects, solar-
powered 'sunflower'
umbrellas in the outdoor
plaza, rendering.

14 Masdar City, Masdar Institute Personal Rapid Transport Station, where vehicles dock in dedicated glass boxes, Foster + Partners.

people can walk, and courtyard housing was developed to allow natural daylight into houses. In the rectilinear urban blocks of Masdar City, buildings will have no more than five storeys and have ETFE (ethylene tetrafluoroethylene) façades – durable, low maintenance and with a low thermal mass – and public outdoor spaces covered by awnings with photovoltaic cells. ITC systems run by the Institute manage and monitor water and electricity use and wastage.

Transport links will be close at hand, and Masdar City will be linked by roads and a light rail system to surrounding communities, as well as the centre of Abu Dhabi and the international airport. It is also car-free, taking fossil fuel-powered vehicles out of the equation at ground level – with a system of Personal Rapid Transit (PRT) vehicles, four-person, driver-less 'taxis' which arrived on the site in October 2009. Passengers tap in their destination and are whisked away on a non-stop journey at speeds of up to 40km/hour between two PRT stations along its small network near the north end of the site. The Light Rail

Transport, meanwhile, has six stops along a meandering north–south track through the city. To ensure a feasible driver-less future based on smart technology, the team looked at a trial PRT system in the Netherlands as part of their research.

Not only is the car banished from Masdar City, but PRTs will run on a dedicated corridor located in the city's undercroft 7 metres below a high concrete podium. Whether such an arrangement enables the best carbon footprint is under-standably not yet clear, and the system is a pilot for the Masdar Institute neighbourhood so that its feasibility could be assessed for use in the rest of the city.

The plan builds the city fabric as a reconciled, interde-pendent but locally responsive gestalt. The base of the plan is the fine gridwork of streets, and to ensure maximum and balanced shading, Masdar City's urban square is rotated to orient itself 52 degrees against the cardinal grid; spaced corridors capture the winds, also acting as 'green fingers', or lungs of the city. The proposed LRT line is accommodated in

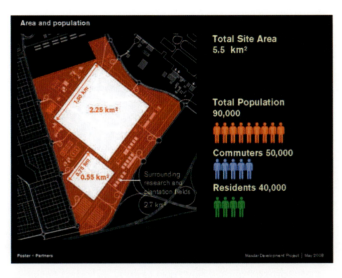

15 Masdar City, proposed population figures to use the site, Foster + Partners.

corridors, with a cross-site development corridor for a Metro line tunnel and station. Gateways are located strategically around the perimeter of the square so that pedestrians can access a primary cross-site network of streets connecting different neighbourhood locations, and civic nodes in the form of squares establish multiple reference points, each with their own individual identity. A fine network of neighbourhood streets complements the primary arterial grid, each being compact, self-shading and pedestrian-friendly. The characteristics of the green fingers and squares are adjusted to respond to climate and other local planning needs.

Abu Dhabi sets great store by its ecological vision: in 2009, at the second annual World Future Energy Summit (WFES), an annual gathering, hosted by Masdar, of academics, politicians, businesses, NGOs and others in the renewable energy and clean-technology industry, Abu Dhabi – which has no immediate need to alter its habits – pledged that 7 per cent of its energy would come from renewable sources by 2020. Masdar City will be powered by a number of solar-powered energy plants, the first of which, the 10MW plant, became operational in 2009. The City's boundary is designed to avoid sprawl, and the 'field' which surrounds it has from the outset been

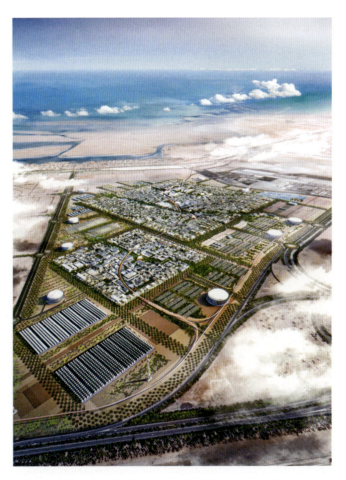

16 Aerial view of Masdar City, masterplan by Foster + Partners, rendering.

conceived as a support space for power, utilities, recreation, productive landscape, among other things. Foster + Partners say the environmentally advanced design proposition is not purely about technical features, but also involves the insulation of the building, the passive systems in the walls, the composition of the façade, all to reduce energy by about 50 per cent.

'It will change people's thinking,' says Gerard Evenden, Senior Partner at Foster + Partners. 'Masterplanning is not about shapes and spaces alone, but thinking about how urban

fabric can create a sustainable environment.'[4] Foster, who is in huge demand as a masterplanner, does not divorce energy use from architecture and urban planning. He claims to favour mixed-use towers, natural ventilation and careful consideration of orientation rather than more expensive options for environmental efficiency such as automatic shading systems or photovoltaics. He regards anonymous architects who are architects of the vernacular among his heroes and Masdar City calls upon traditional compact cities for the advantages of its density and shading. Comments from visitors about the first phase to be completed in 2011 have been generally very favourable, although 'it sometimes feels like a composite of solutions rather than an integrated whole', observed Rowan Moore after a visit in December 2010.[5] However, such issues are relative. Masdar City strives for an integrated vision of place, one that draws on the past as well as the latest design and technology thinking for its qualities: too much spatial integration with such a density of programme would have been oppressive.

This progressive urban plan, evolving as it grows, emanates from a country that set up an Urban Planning Council in 2007, to review every plan within the 2030 masterplan. There are numerous other schemes: those going forward include the 4900-hectare Capital City District, intended to be a second downtown between the International Airport 5km away and Mohammed bin Zayed City. Developed by the Abu Dhabi Urban Planning Council, which was established in 2007 to realise all the Island's new urban environments, it is a key part of the city's forging of an 'authentic sustainable modern Arab capital', embodying *estidama*, the Arabic concept of sustainability, with fruitful relationships between environment, culture and economy.

The 45km² scheme is a revitalisation and expansion of the existing central business district. At the heart of a radial grid on a triangular site are iconic buildings on seven grand boulevards. A Federal Precinct will be the future seat of government for the UAE. Of the five other precincts, the largest is the Emirati Neighbourhood, planned as a low-density area for 3000 Emirati families. Capital City District includes the development of a Surface transport masterplan, an inter-modal network of metro, fast train, trams, buses and taxis. The programming of land uses is based on 'maximising their inherent economic, as well as cultural synergies', with, for example, 'the highest concentration of office use in order to attract commerce and trade oriented towards the global needs of the modern business world'.[6]

Capital District's close collaboration with Masdar and adherence to the common strategies of the World Energy Council, an alliance of 100 countries, will ensure it has 'the comprehensive systems' required for ecological sustainability, says Jody Andrews, Director of the development.[7] Like all of Abu Dhabi's current schemes, it will include affordable housing, and the masterplan has been designed with a sustainable framework, not one bolted on, with rapid transit going in first, not later on, so it should drive cost savings and good business, he explained, emphasising the plan's capacity to flexibly reexamine land use as they go along.

The development is being planned with a mix of stakeholders, with private and quasi-private bodies, and has involved considerable international 'knowledge transfer', as desired by the government, with each piece of the jigsaw being masterplanned by different consultant teams: Federal Precinct by the Canadian firm CIVITAS Urban Design and Planning and Busby, Perkins + Will; City Centre by Soloman Cordwell Buenz from the US in association with Transsolar and US landscape architects Andropogon Associates; the Emirati Neighbourhood by KEO International – responsible for the transportation and infrastructure masterplan – with Dan Weinbach & Partners; the transit network design by Mott MacDonald, UK multidisciplinary management, engineering and development consultants, epitomising one of the kinds of technology transfer specialists Abu Dhabi wants to attract.

A sustainable zero waste urban blueprint has become a holy grail for ambitious urban developments around the world, but it is not yet clear what Masdar City's chances are of achieving

4 Interview with the author, 2009.
5 Rowan Moore, 'Masdar City, Abu Dhabi: the gulf between wisdom and folly', *The Observer*, 19 December 2010.

6 Capital District brochure, 2009.
7 Abu Dhabi Investment Forum presentation, London, 19 October 2009.

Development Concept
City Fabric Development Stages

1.11

1 - Base and Orientation
The compact generic development mass of the city is structured by a fine gridwork of streets, yielding a gridwork of regular development plots. In response to the need to ensure maximised and balanced shading to the overall streetscape the city square is rotated to orient itself 52 degrees against the cardinal grid.

2 - Green Fingers
In order to assure appropriate ventilation access two evenly spaced corridors are cut into the depth of the compact city square development block; oriented to capture the prevalent morning and evening winds. These "Green Fingers", besides acting as the lungs of the city, afford Masdar City's population open space for leisure within easy walking reach from every point of the development.

3 - Transit Corridors
In response to the Abu Dhabi Surface Transport Masterplan (STMP) corridors are provided to incorporate the proposed LRT line at grade level to act as the principal transport access artery of the development and a cross-site development corridor to receive a cut-and-cover Metro Line tunnel and station located centrally to serve Masdar City.

4 - Main Connectors
Masdar City is designed as a pedestrian-friendly urban development, restricting personalised car-based access traffic to the perimeter of the city alone. Gateways are located strategically around the perimeter of the city square in order to provide pedestrian access into a primary cross-site network of streets connecting into, and linking principal city centres and neighbourhood nodes with each other.

Development Concept
City Fabric Development Stages

1.11

5 - Responsive Network
The generic connector street network is made to respond to planning-specific gateway placement considerations, such as actually viable access conditions from the external road network and previously described open space and transport corridors.

6 - City Squares
City nodes resulting from the cross-over of principal public transport corridors with main pedestrian connector street corridors are established spatially as city and neighbourhood squares of corresponding sizes and characteristics. A differentiated network of civic nodes in the guise of neighbourhood squares establishes multiple reference points with individual identities to ease orientation.

7 - Street Network
A fine network of neighbourhood streets complements the primary arterial grid informed by the primary lines of public transportation as well as cross-site connectors. These streets are conceived as a compact, self-shading, pedestrian-friendly neighbourhood street gridwork which makes up the majority component of the streetscape of the city square.

8 - Open Space Differentiation
The spatial characteristics of the open space components such as the green fingers and public squares throughout the city are adjusted in response to climatic and infrastructure specific planning considerations. The generic straight alignment of the green finger corridors are, for example, made to respond to plot and neighbourhood planning specific communal and micro-climatic needs.

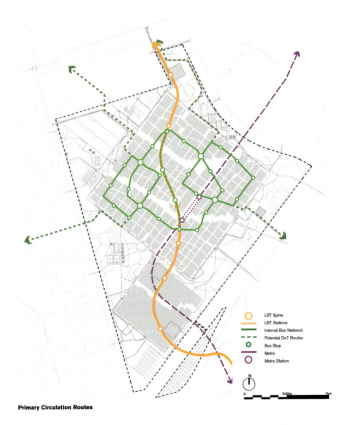

Primary Circulation Routes

LRT Spine
LRT Stations
Internal Bus Network
Potential DoT Routes
Bus Stop
Metro
Metro Station

19 Masdar City, primary circulation routes, masterplan by Foster + Partners.

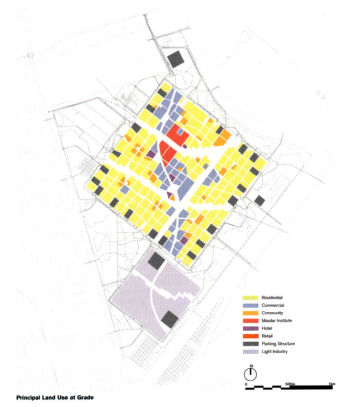

Principal Land Use at Grade

Residential
Commercial
Community
Masdar Institute
Hotel
Retail
Parking Structure
Light Industry

20 Masdar City, principal land use at grade, masterplan by Foster + Partners.

such a goal in such a ferocious desert climate. Abu Dhabi has the funds to invest in making something with greater longevity and significance across the world, and has steered clear of making Masdar City a theme park. While the pilot scheme is intended to facilitate intensive business research development instead of accommodating a wider public, that does not detract from its interest as a masterplan. Inevitably there have been adaptations as the world's clean-tech industries have been adversely affected by the global crisis: there will now not be a second Masdar City, as originally planned; the completion date of 2016 is now set for 2021–5; there will no longer be a \$2.2 billion hydrogen power plant or a solar manufacturing plant and there will be just one floor for the remaining phases, not an

extension of the pedestrian-only platform. 'The masterplan is changing as the world economy changes,' said Dale Rollins, Chief Operating Officer in 2011, explaining that it has been reworked as technology and the market has moved on, in order to give the best result that is cost effective.[8]

The \$1.4 billion cost for this community, plus advances in clean tech, makes it unfeasible to scale up in this format, but, as the first of its size to reach partial completion, with energy use monitoring technologies to help conserve resources a major

8 John Vidal, 'Masdar City – a glimpse of the future in the desert', The Guardian, 26 April 2011.

part of the scheme, it can rightly be regarded as a pioneering experiment. Large in scale, bridging history and the future and geared to more transformational goals than many plans today, Abu Dhabi's new masterplans seem like Pharaonic model endeavours to many. It will take a few years to discern whether they have achieved their aims, but they appear to be critical to Abu Dhabi's vision of the evolution of society.

Montecorvo Eco City, Logroño, Spain

'The most important development is the growing urbanization of the world population,' said Nathalie de Vries, partner in architectural practice MVRDV, in 2010. 'Most people will live in cities in the future, and we need to meet this by creating more capacity. Clever infrastructure, waste management, energy and food production will become a bigger part of architectural projects. At the same time we will see an increase in effectiveness: more reuse of materials and buildings. The future will look strangely familiar.'

But the centres of cities are not the only priority: intelligent treatments for the edges have also become a very high priority, and, as part of the wave of interest in 'eco-cities', the practice recently won the opportunity to crystallise a vision for Montecorvo Eco City, not a city as such, but a 61.1-hectare extension to Logroño, the capital of La Rioja, the smallest of Spain's autonomous communities, south of the Basque Country. Founded by the Romans and today home to nearly 154,000 people, Logroño, the centre of its renowned wine trade, is situated in the northern valley of the province, and nearly half its citizens live there.

Montecorvo was designed to enable 130,000 new inhabitants to settle there, and the plan was given the green light by the government of the Rioja Province and Autonomous Community in September 2008. It has a relatively small plot but

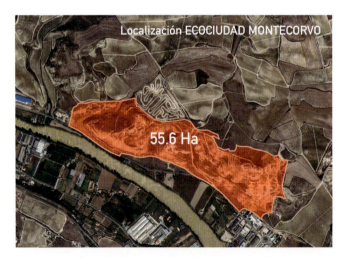

1 Diagram of the Montecorvo site, masterplan, MVRDV.

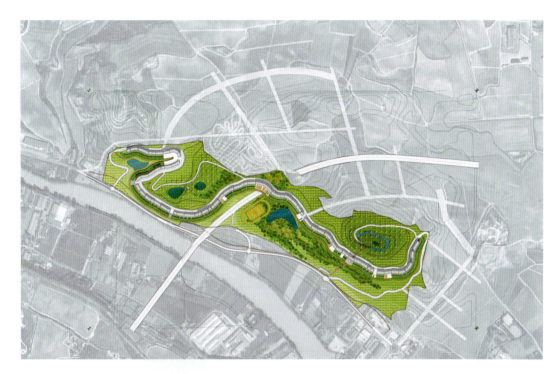

2 Montecorvo masterplan, overview, MVRDV.

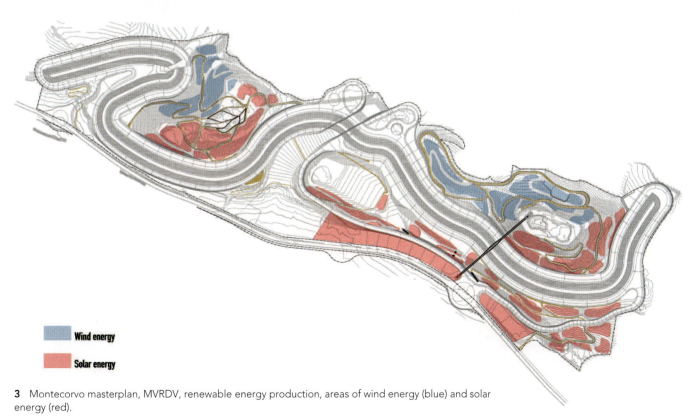

Wind energy

Solar energy

3 Montecorvo masterplan, MVRDV, renewable energy production, areas of wind energy (blue) and solar energy (red).

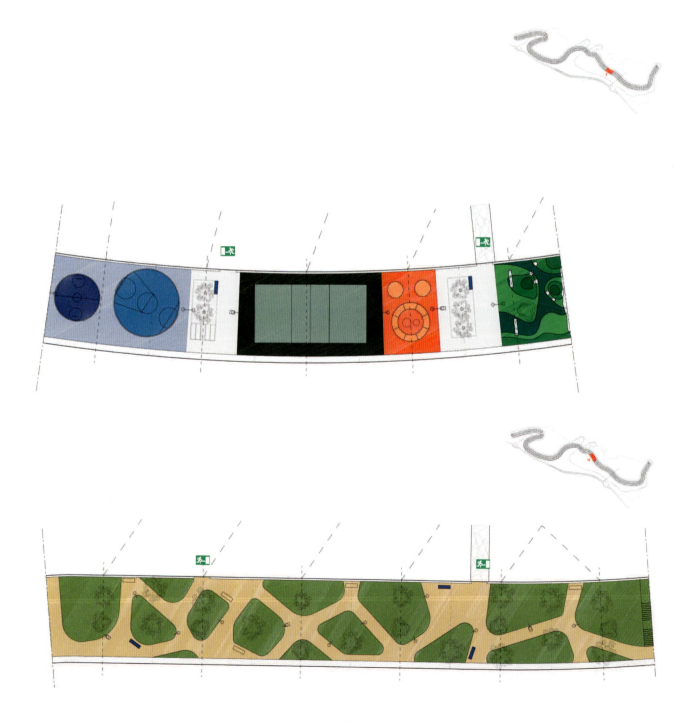

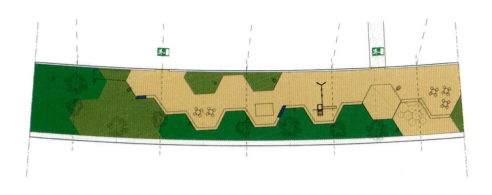

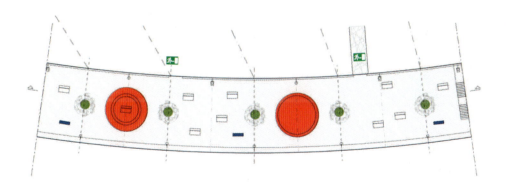

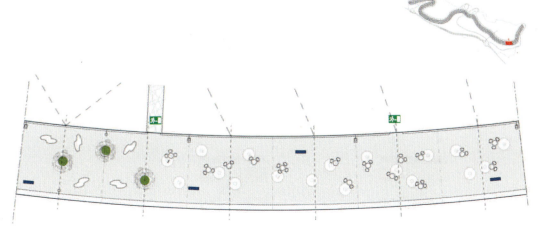

4–8 Montecorvo masterplan, MVRDV, variations in the public space on top of the lower slab.

the scheme is a valuable demonstration that a mixed-use, self-sufficient town is possible. Designed by MVRDV and the Spanish practice GRAS,[1] it will be a new neighbourhood and extension to the city on two small hills of Montecorvo and la Fonsalada, with a CO_2-neutral footprint achieved by producing renewable energy. The budget allocated is 388 million euros, of which 40 million are to be invested in renewable energy technology. Since the announcement to realise this project was made, it has been difficult in the global economic crisis to find enough buyers for the homes being built, which may delay the plan to have the first buildings constructed by 2013.

1 LMB and Grupo Progea will develop the project, which was conceived in collaboration with Arup.

The Ebro River, Spain's most voluminous river, flows through Logroño, and the area is mountainous, ascending to 384 metres in the city. Each of MVRDV's projects works with context but, as partner Jacob van Rijs said, 'We're not critical regionalists: we're critical non-regionalists.' They firmly believe that variety makes cities more attractive and more sustainable because, as well as offering designated mixed use and with the capacity of buildings to adapt, they last longer and work better.

This attitude pervades the team's approach to Montecorvo. Its compact plan is in fact only for 10 per cent of the site, a linear compact urban development that snakes through the landscape, with 3000 housing units – 90 per cent of them for social housing – in apartments that all face the city, with sports facilities, retail, restaurants, infrastructure and public and private gardens along

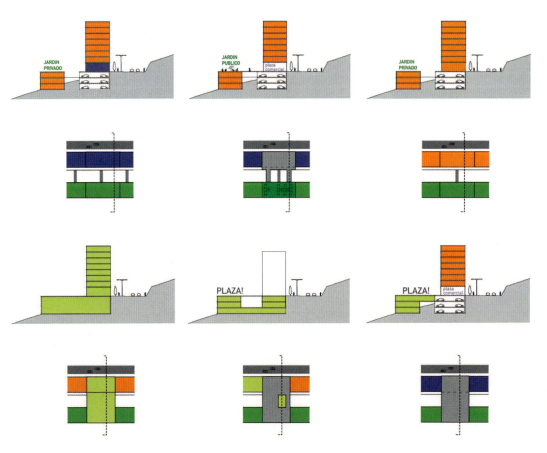

9–10 Montecorvo masterplan, MVRDV, housing programme, public space and parking.

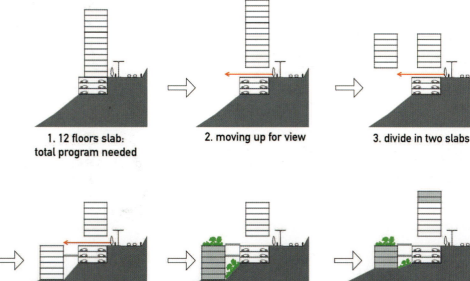

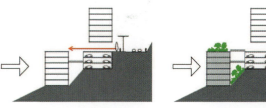
1. 12 floors slab:
total program needed

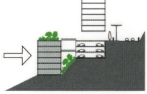
2. moving up for view

3. divide in two slabs

4. push down to give view to
every house

5. bridges make green
roof ccessible

6. section adapts to
topography

11 Montecorvo masterplan, MVRDV, sections showing general concept of the slab.

a serpentine boulevard accommodating traffic, bicycles, landscaping and seating (roads take up 16.5 per cent of the surface area). By building as compactly as possible following the optimum height line of the hill, building costs are reduced. Additionally, by making use of the differences in height through a division into two slabs, upper and lower, every apartment has a great view of the city, while bridges make lower green roofs accessible and offer the possibility to create public space.

The rest of the site (73.2 per cent) will become an eco-park, mixing park and energy production. The new town will enable the rehabilitation of Corvo and Fonsal, areas with abandoned gravel pits and former urban landfills, which will become the 41-hectare park. Topographically the site's strong assets are the two small hills to be clad in a tapestry of PV cells, with windmills on their peaks, with south-facing slopes that easily generate solar energy, offering beautiful views over the city. A funicular runs up to a museum and viewing point hidden at the highest point, housing a research centre for renewable and energy-efficient technology.

A full 100 per cent of the energy demand is generated onsite by a combination of solar and wind energy. The scheme combines density with ecological improvements through its

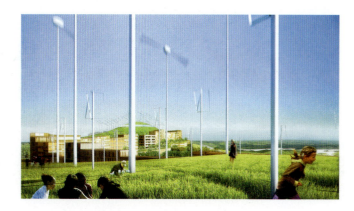

12 Montecorvo masterplan, MVRDV, view from one hill onto another. In-between the eco park meanders over the slopes.

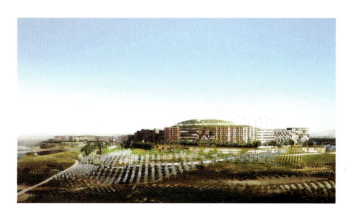

13 Montecorvo masterplan, MVRDV, overview of the site from the south-west with PV cells and windmills.

14 Montecorvo masterplan, MVRDV, view of the garden/public space at the location where the funicular pierces through the structure of the slab.

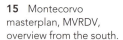

15 Montecorvo masterplan, MVRDV, overview from the south.

greywater circuit and onsite natural water purification, ingredients of a CO_2-neutral footprint and the highest ever Spanish energy efficiency rating. MVRDV say that the onsite production of clean energies and quality of construction will save in excess of 6000 tons of CO_2 emissions annually.

Montecorvo Eco-City was presented at the Shanghai EXPO 2010 by Aránzazu Vallejo, the Vice President and Minister of Tourism, Environment and Regional Policy of La Rioja. 'The theme of this EXPO is "Better city, better life" and what China is trying to teach is how to evolve cities, so we felt almost obligated to show our eco-city project here,' he explained to *El Mundo*.[2] 'Our intention is to show Western cities to which Chinese cities are aspiring,' he added, explaining that plans for Montecorvo, which was conceived as 'a living park', strived for 'standards of quality of life but with less impact on nature, with a different model than we've had so far'.

16 Montecorvo masterplan, MVRDV, public space on top of the lower part of the slab.

2 Montecorvo, El Mundo, 9 July 2010.

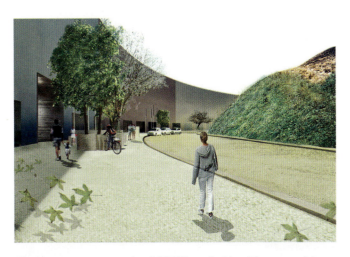

17 Montecorvo masterplan, MVRDV, north side of the upper slab.

Spain has renewed its commitment to eco-towns and other recently completed Spanish demonstration projects include Ecociudad Valdespartera in Zaragoza, a complex of 9687 bioclimatic housing units built on the site of a former barracks, on 243 hectares of land, so four times as big as Montecorvo, which is almost all social housing. While Valdespartera lies within the boundaries of a city of 700,000 inhabitants, both it and Montecorvo aim to address social inclusion and advanced environmental design in an integrated way. Tudela in Navarre, another eco-city development (300,000m^2) in Spain, is supported by the European Commission's Concerto initiative to demonstrate the environmental, economic and social benefits of integrating renewable energy sources through a sustainable energy management systems operated at a community level.

Montecorvo is still at the development stage but its assets are its integrated renewable energy plan, the north–south

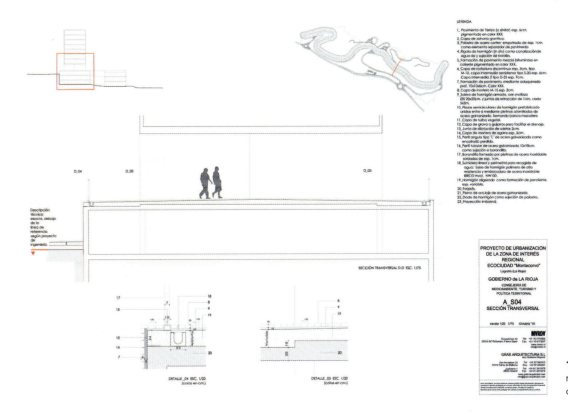

18 Montecorvo masterplan, MVRDV, section of street profiles and details.

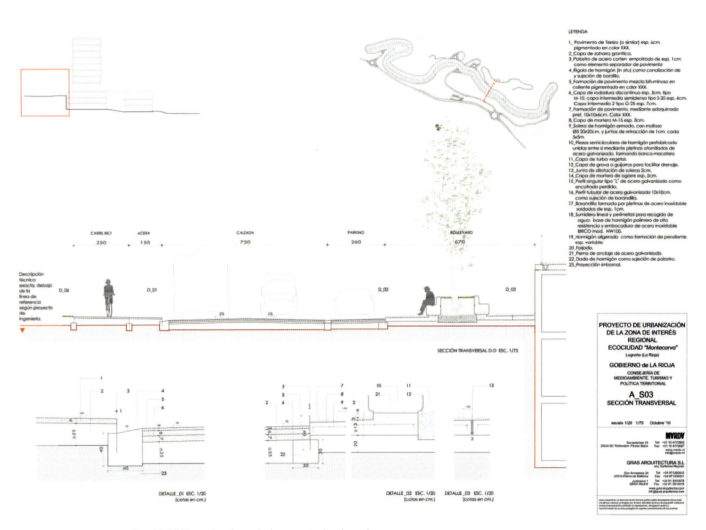

19 Montecorvo masterplan, MVRDV, section through the superior boulevard.

orientation, the quality of green spaces and its responsiveness to the local topography. Rather like Foreign Office Architects' nearby Technological Transfer Centre in Logroño (2005), Montecorvo's buildings can be perceived as a topographical event where nature and technology are intrinsically connected. As a still relatively rare breed of urban development, the scheme can capitalise on its role as an exemplar of solar strategies and environmental awareness, and could easily be replicated in Spain and elsewhere.

Some have cautioned that its location risks marginalisation from the city centre, because if social housing can be centrally located, it saves on transport fuels, and that it is an isolated response to energy use, augmenting rather than replacing facilities in larger urban centres. Others, such as architect Richard Rogers, regard 'the concept of an eco new town' as 'an oxymoron', embodying the tendency of new towns to be far more car-based, while city districts are more likely to have existing jobs, infrastructure and public transport systems.[3]

3 'Rogers rejects call for more garden cities', Building Design, 14 July 2011.

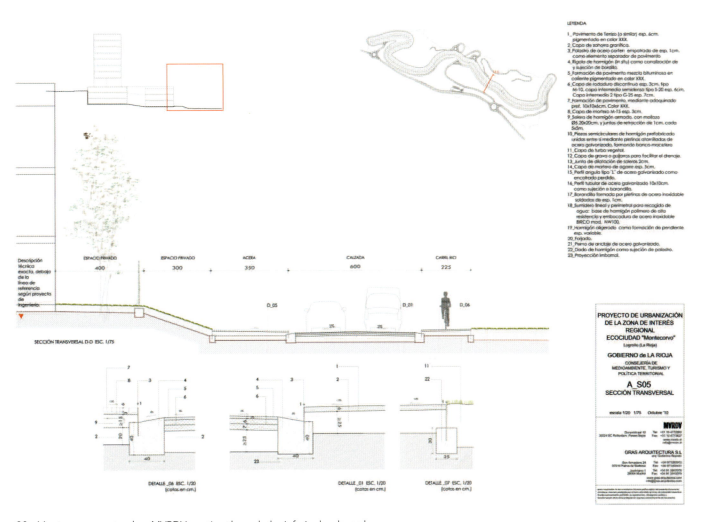

20 Montecorvo masterplan, MVRDV, section through the inferior boulevard.

But mixed-use facilities with business premises, and ideally an eco-energy visitor centre, help to guard against the downside of suburban marginalisation; and the ecological and allied landscape masterplanning strategy serves to enhance rather than degrade territories. A plan of this kind – carbon-neutral, aiming for near self-sufficiency – is always going to open discussions about the corresponding need to retrofit the central areas of the city, and in this sense, Montecorvo will hopefully be a catalyst with a wider knock-on effect on Logroño and other cities considering their future residential accommodation options in an environmentally friendly way.

7

Landscape and
landscape infrastructure-
driven urban plans

Milan Urban Development Plan, Italy

Ongoing changes in the socio-economic structure of the whole metropolitan area of Milan, a city of 3.8 million inhabitants with 1.3m in an area of 182km^2, have been largely due to changes in land use. In the past 20–30 years Milan has experienced a continual loss of population and a radical deindustrialisation with 10 million m^2 of industrial areas closed and manufacturing employees reduced to one-third. In northern Italy – Piedmont, Lombardy, Veneto, Friuli, Emilia Romagna, Liguria and Tuscany, where the most important facilities of the twentieth century were located, the sites have already been redeveloped, but thousands of small and medium industrial areas remain.

The city's core is still very attractive for new innovative, high tech industries, for traditional industries such as leatherwear, jewellery, graphics and publishing, and for commerce and services, banking and insurance. Meanwhile many munici-palities in the hinterland – historically the rural ones in the south and west – have experienced population rise. These changes have shifted mobility patterns within and beyond the metropolitan area from a centripetal to a centrifugal pattern, but have not been supported by an efficient transport system, except for the building of new roads and external ring roads, and public transport until recently was designed according to the historical radial patterns within the metropolitan area.

Milan is a compact city developed on an industrial matrix; introverted with few squares, few open spaces, aggregation spots and places to gather and spend time. In 2000, it was still regulated by the *Variante Generales* plans of 1976/80 which aimed to respond to the crisis of the model of Milan's devel-opment – urban sprawl, the absorption of a new population, the processes of renewal in the central zones and under-utilisation of building stock, the decay of extensive urban areas, the difficulty of adapting the system of infrastructure and publicly provided facilities to the city's metropolitan dynamic.

The 1980 plan was 'the product of a decade of conflict over housing policy and the city's planning policy', according to the Milanese planning expert Corinna Morandi.[1] It aimed to change the way in which residential and industrial areas functioned, curb uncontrolled development in the tertiary

1 Corinna Morandi, *Milan: The Great Urban Transformation* (Venice: Marsilio Editori, 2005).

sector; redirect the provision of built-up spaces to improve living conditions and create badly needed amenities; use existing building stock as a resource for new housing needs, 'defending a mix of functions as the strong point of the city's economy'.[2] Its planning innovations included a 'cautious abandonment of zoning in several areas earmarked for development', some of them large sites, for which goals were established including numbers of inhabitants and employees; and standards for the areas to be redeveloped as services.

Changes in the 1980s included further de-industrialisation in suburban areas, where manufacturing facilities still existed in the 1970s, and in the city itself, and by this time a total of 5–6million m[2] of plant had been abandoned or under-used. The process spread to affect all the established industrial areas of the city, especially along two main axes north-west and north-east into the metropolis, from Bovisa to the Saronnese and from Bicocca to Sesto San Giovanni. It was also pronounced on the east side, because of the closure of factories and plant connected with the Porta Vittoria railway station and to the south of Porta Romana station, and along the south–west axis where factories had originally been set up because of the presence of the canals and the Porta Genova station.

The need to innovate and modernise production technologies was addressed and there was a consequent restructuring of manufacturing and relocation of plant. 'Only the reuse of brownfield sites, physical evidence of the crisis of the industrial city, can supply sufficient resources for a significant functional restructuring,' Morandi pointed out.[3] The city masterplan of that time shifted to favour selective development of certain urban areas, polycentrism and new central poles, transferring important functions like universities and museums to the outer areas. But the plans were inadequate plugs and did not fit into any explicit and shared territorial plan or municipal scale.

Among the instruments of this continual process of revision were some major projects redeveloping certain large-scale areas with obsolete production plant, and housing projects modified the zoning, mainly in the south suburban areas, which had been previously green belt and public amenities. But the

construction of new gateways to the city set on the radials made no reference to any planning scheme. In the mid-1980s, the *Documento Direttore* guidelines for the Passante Ferroviario rail link project proposed more ambitious objectives for territorial strategies leading to the medium-term programme to rescue many vacant lots or brownfield sites including the former gasometers at Bovisa; the old Alfa Romeo works at Portello adjoining the Milan Trade Fair site, the inner city Garibaldi-Piazza Repubblica area and the Porta Vittoria station and sidings. A second *Documento Direttore* gave guidelines for reusing some vacant and underused areas, and in the mid-1990s ten large definite areas of strategic conversion were identified, when the process of conversion of large brownfield sites began to be implemented.

The *Documento di Inquadramento 2000* replaced the vision of the polycentric city with a new general scheme of development, based on the intersection of two lines of force in urban and metropolitan development: the north-west axis to as far as Malpensa and south-west towards Linate (both airport locations) and by the axis running north-east. This aimed to increase supply of spaces for tertiary business functions: high tech research, production and housing. A policy on urban green areas and new city parks (the study, *Nine Parks for Milan*, was carried out in the mid-1990s) was dependent on negotiations between private and public operators.

Milan's *Plan of Services 2004* introduced a method for assessing the ratio between numbers of inhabitants and public and community facilities. However, it failed to set individual projects within a framework that traced a scenario of development for the post-industrial city and gave coherence to the various operations. Not much attention was given to the design of public space and the relationship between new buildings and the urban scene, something Milan had been good at in earlier times during the nineteenth and twentieth centuries.

From 2001 onwards until the credit crisis, there was an acceleration in the development of programmes of urban transformation and a renewed dynamism in Milan's property market, but the halting of the development of the mixed-use Santa Giulia project converting a brownfield site in the south-east (masterplan by Foster + Partners) by developers Risanamento in 2009 due to funding problems, demonstrated the disadvantages of solely market-driven solutions.

2 Ibid.
3 Ibid.

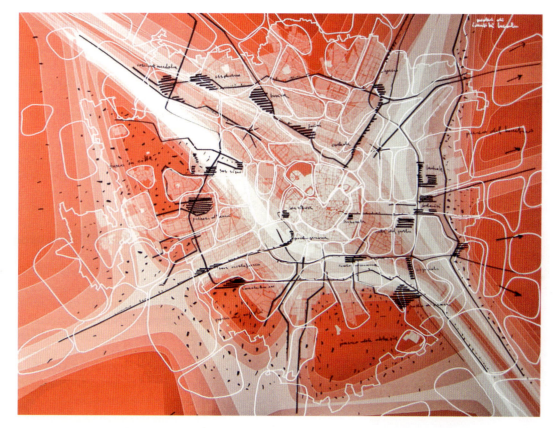

1 Milan UDP: the overall vision, Metrogramma.

In the past few years Carlo Masseroli, until 2011 the Deputy Mayor of Milan, as councillor for land use, has overseen the devising of a unique masterplan for Milan to 2030, a new Urban Development Plan (UDP) known as the Piano di Governo del Territorio following Lombardy's Regional Law number 12 (11 March 2005), adopted on 14 July 2010. He has involved 80 people from ten different disciplines, including 40 from the municipality and five external consultants: architects Metrogramma (Andrea Boschetti and Alberto Francini), to do the structural plan; Id-Lab, headed by architect Stefano Mirti, to design a new model of services delivery for the city; landscape architects LAND (Andreas Kipar and Giovanni Sala), to design the plan for green and other public spaces in a radial fashion; Mediobanca, to design a new subsidiary via a localised 'stock exchange of rights to build' (*perequazione*), working with Professor Michelli,

Giacomo Biraghi, one of the staff of Business Integration Partners, management consultants in charge of the programme management, coordinating the plan to make sure there is coherence, recently explained.[4] The UDP was released as a White Paper for public comments prior to definitive approval, made on 4 February 2011.

In 2009, Masseroli explained that, after some turbulence in its financial past, Milan, in adjusting to a post-industrial era, had converted its many industrial facilities and areas to other uses.[5] The council wanted to make sure any new growth was based on a robust public–private partnership, via a transition from the

4 Interview with the author, 2010.
5 Interview with the author, 2009.

2 Milan UDP. Satellite visualisation representing the Plan's concept of densification to save land, Metrogramma.

recent rise in private development, to a new social contract between powers in the city to overcome the previous lack of collective strategy.

The plan aims to make Milan efficient, attractive and liveable. Moreover, it represents a major paradigm shift in holistic thinking about the city. That means bringing a new economic and ecological sustainability for the metropolis, and also improving liveability via mixed use, a move to compact city density at infrastructure nodes, and connectivity between the

inner core spaces, not simply consuming more land. Three innovative elements in the plan – mixed use, subsidiarity and an open-endedness as a work in progress blueprint – make it a performative rather than a compliant one. 'We didn't want this to be a project set in stone, once and for all, Boschetti and Francini told Nicola Leonardi in an interview in The Plan.[6]

The enabling mechanism of subsidiarity is a vital part of the plan, to be realised through the development of a land stock exchange model to give all landowners the same rights (*péréquation*), and by eradicating zoning and old policy instruments from the past that block the new sustainability system to be nurtured. The new rules also enable the ethos of mixed use, for example, all unsold properties around Milan can in future be put on the market. Under the stock exchange system the municipality stands to gain 20 per cent of the land, and to see the positive results of a compulsory density around metro and railway stations. Densification in these areas would improve entrepreneurial activity, social inclusion and raise municipal funds. The UDP covers a vast territory of 70 million m^2 and has a capital expenditure of more than 18 billion euros. Subsidiarity enables a new supportive and participative model of public–private relationships and of interaction with citizens across the city, to bring projects into being. This process is to be realised with a continuous cycle of consultation of citizens and administration to ensure sufficient information exchange.

To compile the Services Provision Plan (SPP), community-based research was carried out by Id-Lab to investigate, district by district, what is really needed and focus on that in a decentralisation of power, rather than the old blanket approach to provision of services. A service matrix compares demand for services with their actual supply to show where an aggregation of services for macro-functional systems could be effected. The operation is responsive, confronting the reality of local needs, and entails the 'empowerment' of business owners through incentives enabling them to provide the city with a more even balance of services. Focussing on 88 newly defined neighbourhood epicentres, the system can support Milan's international competitiveness, and boost the potential of development

6 Andrea Boschetti and Alberto Francini, Metrogramma, interviewed by Nicola Leonardi, The Plan, Dec. 2010–Jan. 2011.

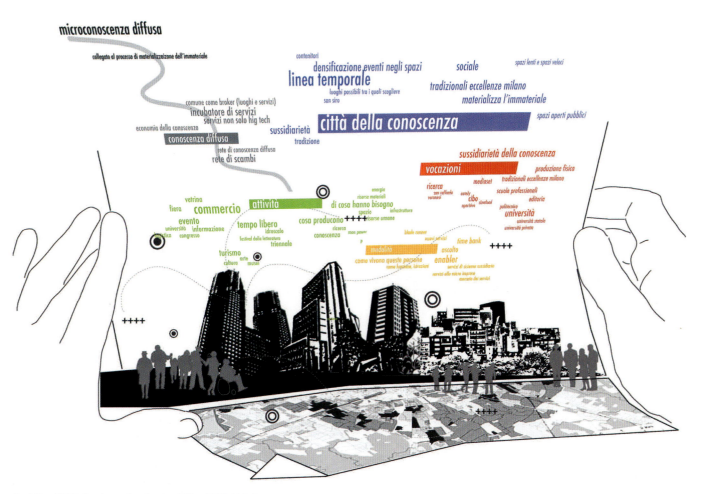

3 Milan UDP. Services plan for the Milan PGT. Id-Lab.

Milano per scelta: © Comune di Milano | 2009 — website e video Interaction Design Lab

4 Milan UDP. Services plan for the Milan PGT, Id-Lab.

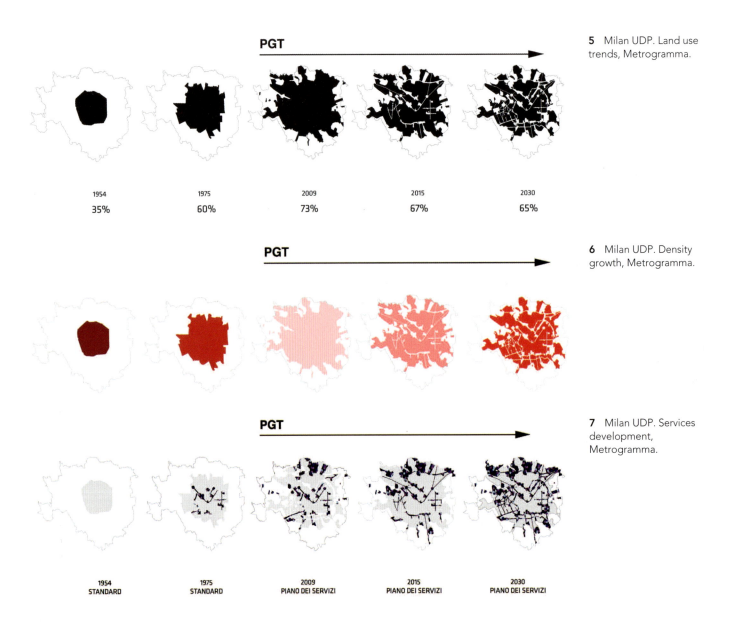

5 Milan UDP. Land use trends, Metrogramma.

PGT

| 1954 | 1975 | 2009 | 2015 | 2030 |
| 35% | 60% | 73% | 67% | 65% |

6 Milan UDP. Density growth, Metrogramma.

PGT

7 Milan UDP. Services development, Metrogramma.

PGT

| 1954 | 1975 | 2009 | 2015 | 2030 |
| STANDARD | STANDARD | PIANO DEI SERVIZI | PIANO DEI SERVIZI | PIANO DEI SERVIZI |

schemes located in specific areas, such as hospitality; commerce and small businesses; design; the university; sports; large events facilities and research and technology. The plan aims to double per capita service standards from 18m^2 to more than 36m^2 for green spaces, kindergartens, schools, libraries, hospitals, individual and collective mobility services, and rebalance the relationship between the historic city centre and outlying areas.

Metrogramma initially provided simulations of potential scenarios for new densities in the city and then took on the role to lead the strategic development of the UDP over four years. They explained that while it follows the usual town planning approach of 'setting out and organising the main public services (green areas, squares, boulevards, mobility)', the UDP's variable elements 'must meet the specific demands of a city undergoing constant development' – through flexibility and being abreast of the times. Its performative nature stems from the fact that it does not distribute building permissions abstractly but does so strategically on the basis of specific projects of relevance, for example in an area with good quality infrastructure and services that can support higher density, rather than in areas of natural beauty. 'Greater density does not mean wholesale indiscriminate increase of urban volumes as was often the case

in traditional land-use plans where density was abstractly allocated,' say Boschetti and Francini. 'Compacting urban fabric at the epicentres identified promotes new ways of living and experiencing a city.'

There is also a principle of sustainability at work, so instead of consuming greenfield sites, Transformation Areas (TAs) of brownfield land, differentiated in three categories – transformation sites, unbuilt or brownfield (5.5 million m^2); general public interest for high profile transformation (5 million m^2) and larger peri-urban areas either unbuilt or largely unoccupied on the outskirts – are prioritised, as Milan has many former industrial sites, railway yards, military areas and dumps, as well as southern areas such as Navigli and Le Abbazie, due for remediation that can be returned for public use.

Despite a lack of demographic change, there is nonetheless demand by existing citizens for land for new houses including social housing, services, community facilities and public green spaces, and by businesses for their developing activities. 'Quality of life and urban density are not opposites,' say Metrogramma. 'A city can be dense and compact, but of excellent quality; urban quality does not necessarily coincide with low density, either. Think of New York. You can get around really easily on foot even if it's a very dense city full of skyscrapers.'[7]

8 Milan UDP. Structuring the void: the model shows the void in the city plan as an extruded architectural volume. Heights have been calculated on the basis of density of the surrounding built volumes. It shows how the development plan can create a permeable network interconnecting the whole city.

The UDP embodies a new, research-based perception of Milan's contemporary urban identity and composite whole, one whose dynamic equilibrium was expressed in a sculpture in the form of a thick contorted pad inscribed with a map of the city by Metrogramma at the 2008 Venice Architectural Biennale. The macro-scalar nature of Milan was initially surveyed, which identified different segments of the city, reflecting its polyphonic, granular quality: the historic city centre within the former Spanish walls and its environs; the eastern linear city of the Navigli between the centre and the southern park along the River Lambro; the area north of Milan up to Lake Como typified as the 'Brianza leaf'; and the transversal city to the north between Malpensa and Bergamo-Orlo al Serio Airports, and the star-shaped city to the west. This counters the pattern of Milan's past development which was solely outwards from the centre to the periphery, and mandates two-way development going from the periphery to the centre.

By collecting data on a dedicated website and through a long series of neighbourhood meetings the team was able to create a map of 88 new Local Identity Nuclei neighbourhoods (LINs; and more than 400 in the metropolitan area as a whole). This information was then used to help define the current service requirements for the Services Provision Plan (SPP) and for an 'area atlas' of each LIN.

Researching the social and cultural identity patterns along with the historic and morphological characteristics of different locations enabled them to highlight their intrinsic qualities and resources and define the LINs as the local-scale aspects of Milan as a multi-centre, 'networked lattice array', parts of which are the outlying areas of the city now perceived as part of the metropolitan network. Farini-Lugano, to the north, for example, a huge derelict railway depot in the heart of the city, cutting it in two, will be a research and technology area; Piazza d'Armi, an old military base to the west, will be a future garden city; Bovisa, in the north-west, is to be a new university area, while Stephenson, further out, will be a new Business Improvement District (BID) with a massive concentration of tall buildings similar to La Défense in Paris.

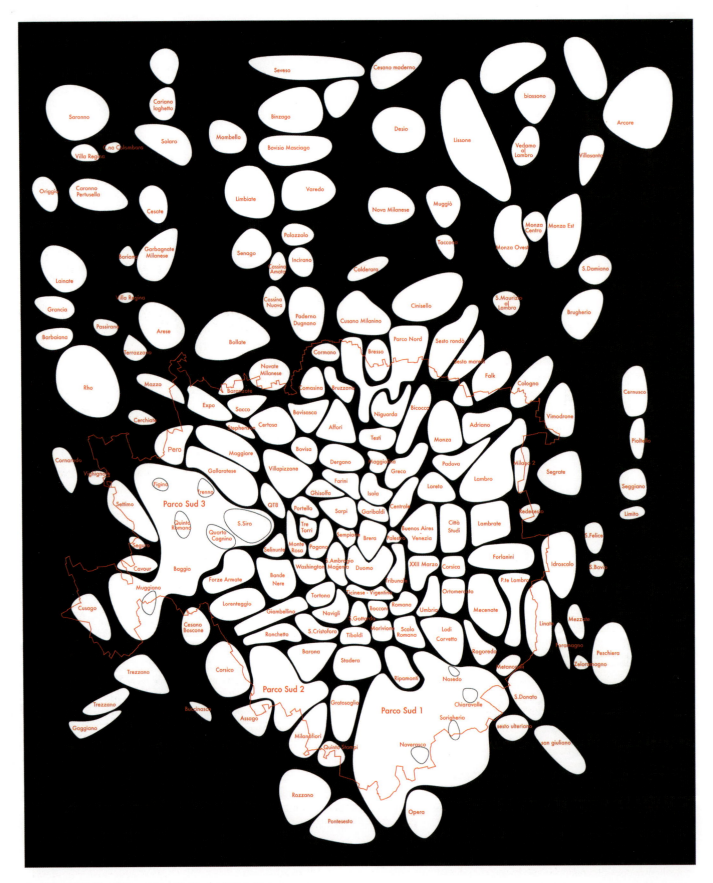

9 Milan UDP. The 88 Local Identity Nuclei (LINs), Metrogramma.

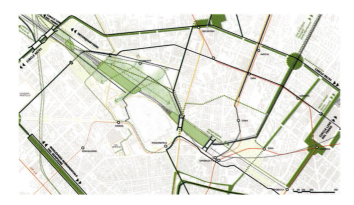

10 Milan UDP. Farini/Lugano: simulation and scenarios in the transformation area, Metrogramma.

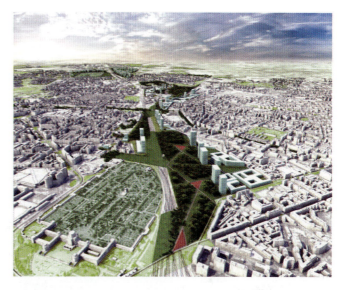

11 Milan UDP. Farini PGT project sheet, Metrogramma.

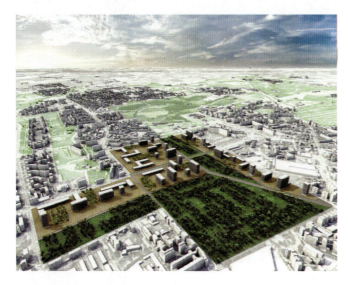

12 Milan UDP. Piazza d'Armi: simulation and scenarios in transformation area, Metrogramma.

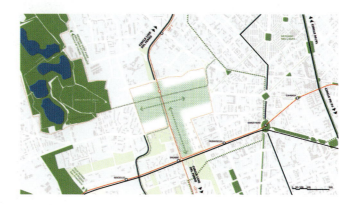

13 Milan UDP. Piazza d'Armi PGT project sheet, Metrogramma.

Accordingly, a heterogeneous mix of industrial districts, parks, waterways, clusters of housing development, commercial units, agricultural land and a confetti of smaller areas become part of a seamless urban fabric. For the neighbourhoods Boschetti uses the metaphor of fruit on the tree of the urban structure. This new concept replaces the traditional 'hub and spoke' city of nine former administrative zones built up over centuries that the team deemed no longer meaningfully reflected local identities. This exercise in emphasising the differentiated nature of the city via nuclei was in part inspired by the thinking behind the Greater London Plan of 1944 prepared by Patrick Abercrombie, the architect and town planner (as a

14 Milan UDP. Bovisa: PGT project sheet, Metrogramma.

16 Milan UDP. Stephenson: simulation and scenario in the transformation area, Metrogramma.

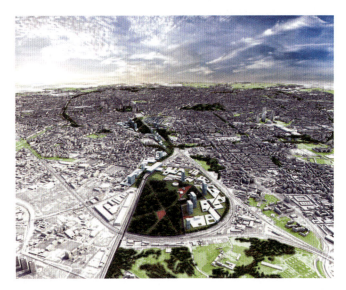

15 Milan UDP. Bovisa, Metrogramma.

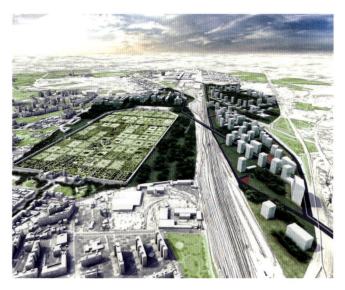

17 Milan UDP. Stephenson PGT project sheet, Metrogramma.

blueprint for the city's post-war reconstruction and development) and the way in which French municipalities operate.

The team also identified a number of urban voids. Rather than continuing the tradition of seeing these as left-over, in-between land of not much value, they conceived of them as a permeable set of spaces representing considerable opportunities, and part of a system of great resource that is part of the

infrastructural backbone of the overall plan. Fifteen large-scale public interest projects were also defined to prompt competition and tender proposals and engage funding sources and generate specific interpretations of the subsidiarity system, ranging from the waterways, historic boulevards, to green bridges and specific parks. 'We propose urban planning to put an end to the deterioration of the territory,' explains

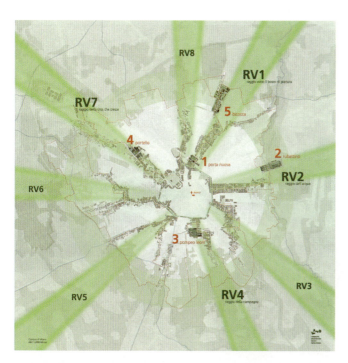

18 Raggi Verdi: a green strategy for the Milanese metropolis 2015, LAND, 2009.

19 A visualisation, Raggi Verdi: a green strategy for the Milanese metropolis 2015, LAND, 2009.

Metrogramma, 'degradation often caused by the prevalence of architecture rules and constraints which too often are circumvented through cunning and speculation.'[8]

Before the UDP was instituted, the landscape architects LAND had already conceived 'A Green Ray for Milan' or 'Raggi Verdi',[9] a proposal for seven rays or environmental corridors connected by 72km of bicycle–pedestrian paths. These new green 'nerves' within the urban tissue of Milan start from the old Spanish walls of the city and connect to the epicentres of the future city. The principle once again is that outlying areas – the southern agricultural land, the Lambro, North and Groane Parks – are not to be marginalised but the rays will enable citizens, wherever they are located, to easily access the urban green belt spaces which link the main parks in the outer ring and all the open spaces in between.

They insert themselves into the wider metropolitan Metrobosco, a plan devised by architect Stefano Boeri's Multiplicity Lab, and exhibited in his exhibition 'BioMilano'.[10] This makes the city's green presence part of a provincial-scale system with a pronounced ecological focus on transitional areas as part of a dynamic hybridity between the urban, the rural and the natural. 'BioMilano' encompasses botanical gardens envisaged for EXPO 2015[11] (for which Boeri was one of the initiating curators), hosted by Milan on a 1.7million m² site at Rho-Pero in the north-west of the city on the theme of sustainable development, including local urban allotments and courtyard farms, and il Bosco Vertical, his scheme of tower blocks in the Isola neighbourhood. 'BioMilano' envisages Milan as a big laboratory in terms of sustainable biological and environmental change. 'Raggi Verdi' was formally included in the new urban plan, and encompasses, among others, Porta Nuova; Bicocca, formerly the Pirelli site and location of the Parco Nord; the eastern site of Rubattino where Maserati-Innocenti once had its site; the south-east Parco Ravizza, and

8 Interview with the author, March 2011.
9 'Raggi Verdi: Green Vision for Milan 2015', LAND Milano, exhibition and catalogue, AedesLand, Berlin, 3 April–18 June 2009.
10 'BioMilano', the British School at Rome, exhibition curated by Stefano Boeri, February 2011.
11 www.en.expo2015.org/.

20 Raggi Verdi bicycle trip arranged by the L'Associazione Interesse Metropolitani (AIM), Milan Triennale garden, May 2007, LAND.

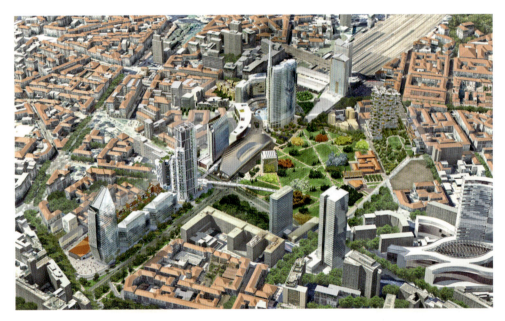

21 Visualisation of the Porta Nuova mixed-use scheme, 2005+, connecting Garibaldi, Varesina and Isola. Pelli Clarke Pelli, masterplan, offices; Boeri Studio, masterplan, residences, Porta Nuova Isola, KPF, masterplan, offices, Porta Nuova Varesine. Green areas and public spaces: LAND; public spaces: Gehl Architects; park: Inside Outside.

Parco Portello, former site of the Alfa Romeo and Lancia factories and Milan's Trade Fair.

Out of LAND's earlier proposals came the Green Plan (Piano del Verde), created by the city with the landscape architects, an environmental strategy, which the EXPO 2015, awarded to Lombardy, is advancing at the Porta Nuova site along the north-west axis of the city, disused after changes in the railway system. Here plans have been afoot since 2000 for three adjacent neighbourhoods, Garibaldi, Varesine and Isola, to be reunited, linked by an 85,000m² park. 'In today's cities so-called "green urban spaces" are no longer set apart in a specific section of town, but places for daily interaction which acquire value only if they become an integral part of the city itself,' says Andreas Kipar of LAND.[12]

The 290,000m² mixed-use Porta Nuova project 1500m north of the Duomo at the city's crossroads adjoining Garibaldi Repubblica Station is a public–private sector initiative and was

12 Andreas Kipar, 'New Landscape Territories in Urban Design', LAND, lecture to the 44th International ISOCARP Congress, Dalian, China, September 2008.

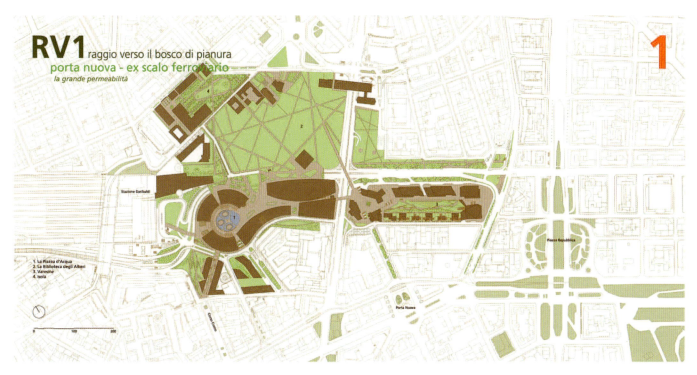

22 Plan of Green Ray area 1, Porta Nuova, the former Garibaldi Station, LAND.

23 Milan UDP. Environmental network, Metrogramma.

24 Milan UDP: the peri-urban parks and green spokes that make up the urban scale green landscape, Metrogramma.

initiated in 2005 when three masterplanners, Pelli Clark Pelli, Boeri Studio and KPF, and a host of architects were commissioned to work on the site. It connects Garibaldi, Varesine and Isola and reunites the territories in the north and south of this whole area. It renovates and improves urban texture,

introducing a new pedestrian system with green areas (by LAND, and with other public spaces by Gehl Architects), piazzas, bridges, as well as a large park designed by Dutch landscape architects Inside Outside, that seamlessly connects the different neighbourhoods efficiently and securely.

25 Milan UDP. From transformation areas to epicentres, Metrogramma.

26 Milan UDP. The epicentres' services, Metrogramma.

Boschetti and Francini describe the future Milan as a city region made up of a series of epicentres within a regional network, so the planning process to determine strategic policies needs to embrace the whole geographic area. They also believe that it must acknowledge truths about the parallel realities of the slow city and the fast city, but also the demand for 'tangential and traverse' mobility. This is a major part of the UDP, and a new Mobility Plan was issued in 2010. New tangential and transverse routes, for example, two new north–south connections, the *interquartiere* and the *ronda* will improve fast traffic connections, taking them away from urban neighbourhoods (which will have new local roads to make them more porous) so their quality of life is improved. The epicentres will be served by new high-capacity transport systems, and a circle line with 18 new local stations is planned.

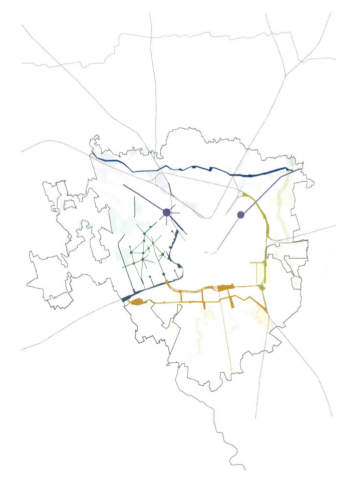

27 Milan UDP. The epicentres' infrastructure network, Metrogramma.

An extension of the underground railway network is also envisaged, and the network of cycle paths and bike sharing points will make the city more liveable.

Metrogramma sum up the guidelines of the UDP as 'zero growth, new parks, collective city, regeneration, densification, district plans, "Circle Line" and new subways'.[13] They used investigative tools – traditional urban mapping and geographic, sociological, historical, economic, statistical, archaeological, architectural and engineering surveys – to build up an overall, complex picture of Milan's different morphological features, scales of reference, pace of development, lifestyles and connectivity between the inner city and the periphery. Of the 3000 public observations, 1000 people asked for more fixed planning with zoning and specific limits to growth, in other words, going back to predetermined rules. In response, Metrogramma comment, 'The need for flexibility in the contemporary world is anything but a vague assumption. Implanting precise rules but within a flexible planning framework means, in fact, respecting the people who live in the city itself and their changing needs over time. The instrument device on which this is based, is emerging as a "vision device", to be activated within a framework of continuous dialogue between citizens and administration.'[14]

In April 2011, Grammatiche Metropolitane, a new association of professionals from different technical and cultural fields, including Metrogramma, and structured as a research-based 'urban observatory on the contemporary city', was founded. Through exhibitions, debates, meetings, it will discuss the future of Milan with citizens. 'Only this step for the future will draw a new "urban grammar" for Milan,' explain Metrogramma, stealing the discussion away from only a technical, and often self-referential level, and foreseeing not utopias, myths or misinformation but 'a more liveable city, disciplined and humane'.[15]

After May 2011 when left-wing lawyer Giuliano Pisapia triumphed in the Mayoral race for Milan, the new administration committed to go back through the comments from the public on the UDP. These were made between the first adoption in July 2010 and the final approval in February 2011, but got caught up in the election campaigns, and it was deemed that the previous administration had not given them sufficient attention. Some changes have been made, but the most innovative aspects of Metrogramma's plan – the mixed use, self-determination of the districts as centres of local identity and the major projects for public services will not be affected. Moreover, now 'a window of a cross-party agreement in the interests of all citizens has finally been opened', said Francini, who sees the final configuration of the UDP coming imminently, and already documented in a post-election publication, PGT Milano: rifare, conservare, correggere (The Milan PGT: redo, preserve, amend)[16], based on the outcome of debates at a public event which took place just after the city government changed.

In the past, Milan was characterised by rules and constraints of reference. The UDP is a radical and comprehensive city-wide plan focusing on strong design ideas and visions, a flexible instrument that reflects a profound understanding of changes in the city. One recurring issue with masterplans is how far they should attempt social engineering. The UDP is the blueprint of a methodological model with a built-in capacity to be updated as new information is taken on board. It is synergistic since the areas undergoing transformation are also nodes of a new infrastructure network and plan for environmental improvement. This integrated vision of restitution has the best chance to drive the revitalisation of the entire urban fabric. While its success will rest on the ability of the city's new administration to govern this instrument, it aims to transform and bring equilibrium to the whole metropolitan area through the cumulative effects of a set of new rules which, according to Boschetti and Francini, will allow 'formerly immoveable taboos to be left behind'.[17]

13 Interview with the author, May 2011.
14 Interview with Metrogramma by the author, March 2011.
15 Ibid.
16 'PGT Milano: rifare, conservare, correggere', ed. Marcello De Carli, Giorgio Fiorese, Federico Oliva and Elena Solero, Maggioli Editore, Milan, 2012.
17 Ibid.

MRIO, Manzanares River, Madrid, Spain

Until recently, the River Manzanares in Madrid had been ignored by urban growth, overshadowed by the two four-lane highways of the city's first ring road, the M30. After gridlock worsened in the south-west of the city, Madrid's Mayor at the time, the progressive Alberto Ruiz-Gallardón, in power since 2003, took action to have the ring road put into an underground tunnel, to be the longest of its kind in Europe. An urban renewal project with nearly 97km (60 miles) of new roadway and a 56km (35 mile) tunnel, costing €3.7 billion in infrastructure investment, kicked off in mid-2004. Citizens were told that would also mean cleaner air and a better quality of life above

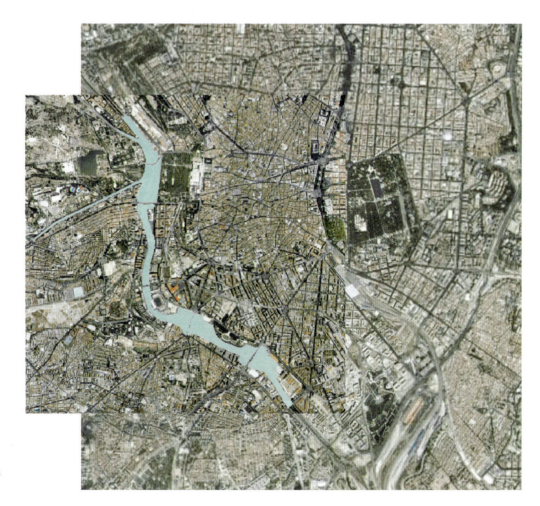

1 Manzanares River, Madrid: map showing location within the context of the city centre, West 8 & MRIO Arquitectos.

ground in an area traditionally regarded as the backside of the city – and Madrid – a city that has been planned since the seventeenth century – would finally have its own 8km-long waterfront and 150 hectares of open space added to its recreational land transforming this neglected western periphery.

Madrid RIO (MRIO), as the project has been termed, answers the critical question: how can we best reconcile infrastructure with the city in the twenty-first century? It also demonstrates how a humanised urban landscape and rethinking of the relationship of river and urban fabric can emerge from a masterplan of a very particular kind. Other examples of redefining the city through placing a highway underground include The Big Dig in Boston, which created more than 300 acres of open land and reconnected downtown Boston to the waterfront, a 24-year project from environmental impact assessment to substantial completion in 2006.

Madrid Calle 30, the international competition staged for the 120-hectare site, was won in 2005 by Dutch landscape architects West 8 and MRIO arquitectos, led by Ginés Garrido Colomero of Burgos & Garrido, whose masterplan proposal included an 'ecological boulevard' with 80 hectares of new public spaces transforming the banks of the Manzanares River, with nine walkways, cycle paths and a beach at the Arganzuela Park to the south. It followed an earlier competition that OMA, Toyo Ito and Herzog & de Meuron had entered, for which no-one seemingly made a comprehensive proposal. Gallardón included the first part of the river zone renewal – 'The Lungs' – and a vital site of mediation in the city in Madrid's 2016 Olympic legacy bid, and the work on the 150-hectare Rio Manzanares valley site was costed at €6 billion in 2006. The municipality did some public consultation, and opened a competition for children in schools near the site to get the views of future citizens – one of whom visualised the beach – later publishing this as a book.

Brandishing the slogan 'Más rio – más Madrid' (More river – more Madrid), the plan aimed to reorient the city towards the river by multiple means, including a park with five illusionistic water streams along a boulevard of 8000 pine trees, Salón de Pinos, that connects almost all the parks in Madrid, creating a new green 'spine' boulevard with a 150,000m^2 pedestrian zone next to the river on both sides. 'It was an opportunity to connect the city with the surrounding landscape,' said West 8 project architect Edzo Bindels.[1]

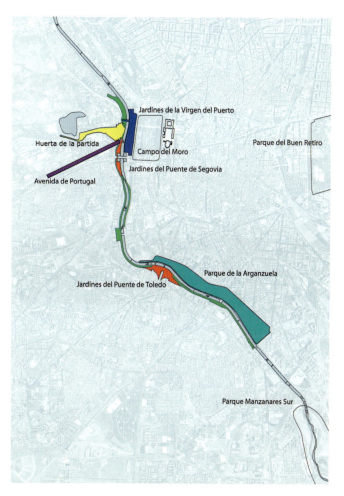

2 Map of the Manzanares River site, Madrid, West 8 & MRIO Arquitectos.

Instead of a single 'grand project' for the reclaimed river banks and new urban area above the M30 highway, the team decided on the idea '3 + 30', cutting the 80-hectare scheme up into three initial strategic projects serving as a foundation for a number of further projects. The three elements are the Salón de Pinós, the connecting space between the historic centre and the

1 Interview with the author, 2009.

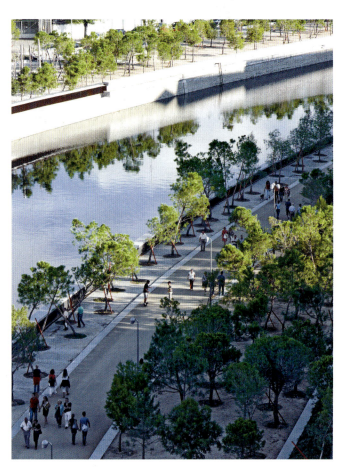

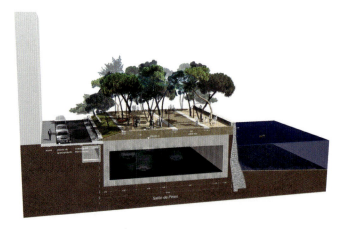

3 Manzanares River, Madrid: Salón de Pinos, section showing relationship between design and technical base, West 8.

5 Manzanares River, Madrid: Salón de Pinos, West 8 & MRIO Arquitectos.

4 Manzanares River, Madrid: Salón de Pinos, West 8 & MRIO Arquitectos.

6 Manzanares River, Madrid: Salón de Pinos, West 8 & MRIO Arquitectos.

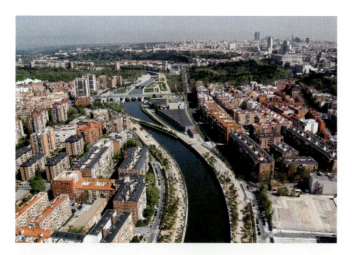

7 Manzanares River, Madrid: Salón de Pinos, Oblique Bridge and Segovia Bridge, West 8 & MRIO Arquitectos.

8 Manzanares River, Madrid: Avenida de Portugal, West 8 & MRIO Arquitectos.

Casa de Campo and the Parque de la Arganzuela. A total of 47 urban and architectonic sub-projects have been developed with a total budget of 280 million euros, the most important being the 6km-long Salón de Pinos boulevard park completed in 2010: the Avenida Portugal, a 2km-long urban boulevard completed in 2007; Huerta de la Partida, a modern interpretation of the orchard; the biggest green space project, the 35-hectare Parque de la Arganzuela; the gardens of the Puente de Segovia and Puente de Toledo; Jardins de la Virgen del Puerto; and two new bridges, Puentes Cascara. These are major interventions that, along with the repair of blocks and improvement of schools, enable the scheme to be an integrated piece of city, so that what was formerly background space in Madrid is now a new, river-facing district.

The work to be done was defined in two stages: first, to repair the site, and then to deliver the park, promenades, garden and bridges. In the 1950s, the Madrileños put dams in the river, a very unsustainable thing to do. Today it looks like a French canal, full of water from September to June, and then dry in the summer, when Madrid is extremely hot, so priority was given to the shade. The first parts of the plan were completed in Spring 2007. The new urban boulevard, Avenida de Portugal, nearly 2km long, introduces cherry trees, elements of the

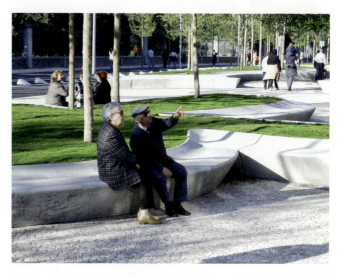

9 Manzanares River, Madrid: Avenida de Portugal, Madriliños on cherry islands, West 8 & MRIO Arquitectos.

landscape situated between Madrid and Portugal, into the city. One of the most important roads into the centre of Madrid, it lies on the boundary of one of the most densely-built residential

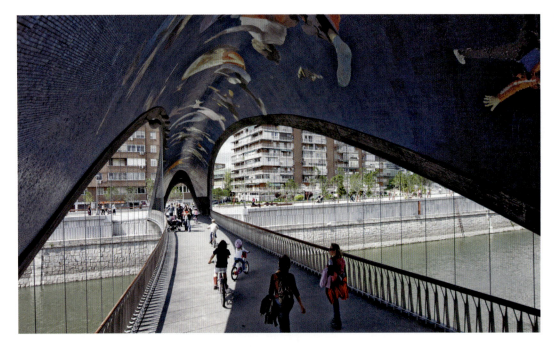

10 Manzanares River,
Madrid: Cascara Bridge,
West 8 & MRIO Arquitectos.

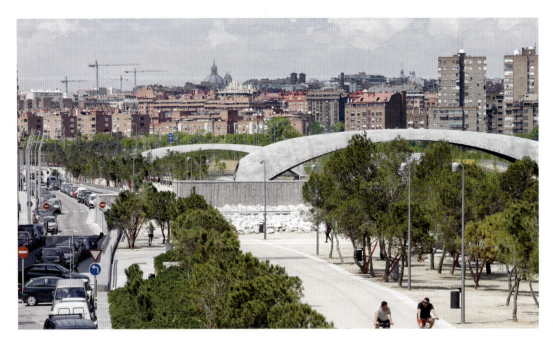

11 Manzanares River,
Madrid: Cascara Bridges,
West 8 & MRIO Arquitectos.

districts and the Casa de Campo, formerly the king's hunting grounds.

On the 6000m-long Salón de Pinos boulevard on the west side of the river, pine trees were planted in a 5km stretch from Casa Campo to the Matadero area, creating a Madrid version of the Ramblas. These now do in fact connect with all other parks in the city, and the trees are being encouraged to grow in free form shapes through diagonal planting angles and wooden stick supports with ends like bulls' horns. With more than 8000 planted, and as a species capable of surviving in barren rocky mountains, the pine tree brings a typical mountain landscape into an urban area. Huerta de la Partida was originally the city palace grounds which were used for hunting and a fruit and vegetable garden. In the 1950s, the orchard became a transportation hub, and West 8 have converted the land back into an orchard, with species symbolising the paradise of the past.

Avenida de Portugal, Huerta de la Partida and part of the Salon de Pinós riverwalk were completed in time for the 2007 elections. However, the design phase of the 47 sub-projects was hit by the global economic crisis, affecting public finances and putting building projects on hold. Through the national Plan E subsidy scheme Gallardón was able to allocate 280 million euros to the remainder of the project, financed by a loan from the municipality and repaid by citizens over 30 years. He consistently avoided building development on the site, but the different schemes had to be divided into smaller sections than previously anticipated to meet the grant criteria.

The Arganzuela Park, a 35-hectare space bordering the river (where it is 2–3 degrees cooler) on the south side, has a thick mesh of trees, little creeks giving the illusion of a delta, a 20-metre-wide track for cycling and running and three trails crossing it, a shaded path, a winding path across soft slopes connecting entrance ways, corridors, kiosks and green areas and a winding path on the dry river bed with thick vegetation. Madrileños typically do not use bicycles to go to work or for shopping, but for recreation. Here a group of former slaughterhouses have been converted into the Matadero Centro del Artes, the largest exhibition hall in the city which opened in 2010. Two new bridges, Puentes Cascaras, dedicated to the people of the Arganzuela and Usera districts long separated by the former M30, opened in September 2010. These are key elements in the River's bridge system, which connect the

historic Royal Garden and the Casa de Campo, the former Royal hunting grounds, now new park areas on either side of the river reintroducing itself as an experiential place for public use. The heavy concrete domes of 'Abattoir' and 'Greenhouse' carry a delicate steel deck on 100 cables like whalebones. As a homage to the local neighbourhoods, artist Daniel Canogar, chosen in competition by the Reina Sofia Museum, created Constelaciones, a mosaic-tiled mural inside each one, depicting some of the residents from either side of the river.

12 Manzanares River, Madrid: Ecological Fountain at Segovia Bridge, West 8 & MRIO Arquitectos.

13 Manzanares River, Madrid: Salon de Pinós, West 8 & MRIO Arquitectos.

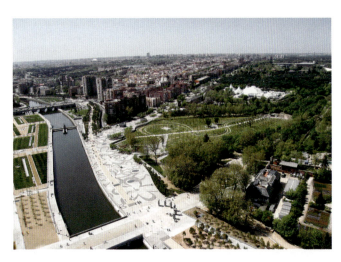

14 Manzanares River, Madrid: Plataforma del Rey, West 8 & MRIO Arquitectos.

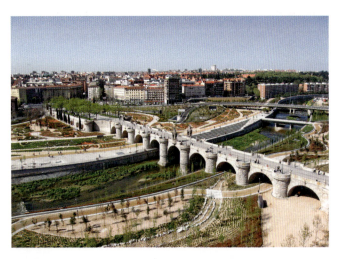

15 Manzanares River, Madrid: River Garden and Toledo Bridge, West 8 & MRIO Arquitectos.

The scheme gives the district a 'new layer', yet uses existing conditions rather than generating a theme park. Two notable features of this landscape architecture-driven scheme are the scope for flexibility: the schematic design was rough, and

contractors were chosen who could help remake the design on site: 'Our profession is much more rough than architecture – we can allow more improvisation,' comments Bindels.[2] The other point concerns what happens too often with an urban planning and architectural approach, he feels, 'is a *view* of the water that is so over-estimated, so it doesn't deal with an interface between that and the public space. You should feel the water in the DNA of the city.'[3]

The final part of the project, the Arganzuela Park, in the south, opened to the public on 15 April 2011. The tunnel is coursing with traffic: the burial of the whole of the M30 highway took less than six years. The sprawling park areas above, stretching from the Arganzuela Park to the vast Casa de Campo, Madrid's main park, in the west, offer respite in a city with searing heat of over 40° C, 42 km of pedestrian paths, 32 km of bicycle paths, 11 new children's playgrounds and spaces for the elderly. The beach, fulfilling a collective dream of citizens, bears a similarity to the one opened on the River Seine in Paris in 2002. People are using the public spaces intensively, including for biking and jogging. Swimming is prohibited but the river will have a new pier with boats for hire, as its flow has been increased from what was a trickle before. Without the traffic knots and complex junctions, the area has gone from being very high density with a lot of noisy roads to being an environment with a mix of uses, connectivity and a symbol of progress – house prices on Avenida de Portugal have doubled. In a rise in biodiversity, bats have even returned to the district. 'It's a wonderful place of tranquillity. All Madrileños can enjoy it,' said one resident. 'There were no play areas before,' said another.

'Madrid's growth never dealt with the river banks as a friendly place; on the contrary, it ignored and defended itself from them,' says Garrido.[4] 'The variety of social and topographic conditions on the banks made the urban approach to the river diverse and chaotic', with clusters of buildings leaving just a narrow strip of land on the right side from the 1950s onwards and green spaces away from the historic city on the left.

2 Interview with the author, 2009.
3 Interview with the author, 2009.
4 Burgos & Garridos arquitectos, 'Creating an artificial landscape: the green network along the Manzanares River banks', unpublished document, 2011.

16 Manzanares River, Madrid: Arganzuela Park, West 8 & MRIO Arquitectos.

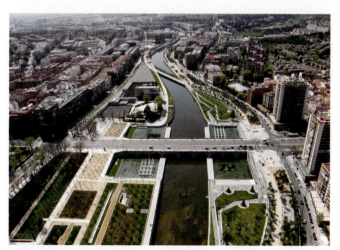

17 Manzanares River, Madrid: Segovia Bridge, West 8 & MRIO Arquitectos.

After the building of the tunnels a wound surfaced; a chain of unoccupied spaces that cherished the latent power to become the nexus of an environmental corridor of nearly 3000 acres within the city.[5] The team were convinced that the river could connect the city, and it now microsurgically incorporates a chain of formulas to integrate the river in the city and vice versa. 'It becomes the door or connection between the urban interior and the territorial exterior,' adds Garrido. In integrating the river as 'an unknown double façade' and creating a chain of green spaces that filtrate to the city, the scheme facilitates a new ground level mobility and accessibility, drawing in and increasing the quality of adjacent neighbourhoods and protecting the heritage of the area.

The completion coincided with campaigning for the 22 May regional and municipal elections, during which the Socialists noted that the project had been partly financed by central government. Gallardón, for the conservative opposition Popular

5 Ibid.

Party as mayor of the city until 2011 attached himself firmly to the project throughout and on its opening called it 'the reference point for a new Madrid'. Many politicians in Spain act on an intuitive sense of the enormous advantages of taking responsibility and delivering on urban schemes. One notable feature of this project was that its planning pre-dated Madrid's 2016 Olympic Games bid, but the failure of the bid did not lead to the project fading away. Also while the council was heavily in debt, a subsidy of eight billion euros of municipal works to stimulate the building industry announced by Spain's former President Zapatero gave the capital city staying power. The economic climate has become much bleaker, and austerity plans make it much harder for major schemes to be funded now. However, the civic-minded gsture helped to enable completion of this ambitious redefinition of public space – a big, brutal metamorphosis establishing a wholly desirable new urban condition everyone can benefit from.

Xochimilco, Mexico City, Mexico

Mexico has many environmental issues, including scarce natural fresh water, serious air pollution, raw sewage and industrial effluents polluting rivers in urban areas, deforestation, widespread erosion, desertification and deteriorating agricultural lands. Major migration from rural to urban centres gives new urgency to the need for new forms of sustainability, not just in the centre, but also in the city's semi-rural settlements where there is fertile ground. In such a context, masterplanning projects addressing these issues and creating a new equilibrium and new families of sustainable patterns are very valuable instruments.

Mexico City itself has an immense physical urban reach. Around the Metropolitan Zone of the Valley of Mexico (ZMVM), a circle of burgeoning small cities (Central Region of Mexico, or RCM) or polycentric regions, contributes to a regional zone of 158 districts and 26.1 million inhabitants. At the 2006 Urban Age conference held in Mexico City,[1] landscape architect Mario Schjetnan, co-founder of Grupo de Diseño Urbano, presented impressive plans to nurture and configure 101 Open Cultural Spaces in the macropolis of the city, a group of open spaces, parks and heritage sites beyond its 'crown jewel' of Chapultepec Park, many of the sites being formerly industrial in nature. An initiative reconciling public and private interests, in a city where malls are too commonly regarded as a place of safety, he called them 'a tool to create a regulated system', a way of promoting democracy and alleviating population density.

The challenge was to discover new centres, i.e. a multi-dimensional, centrical city, added Enrique Norten, founder of TEN, the architectural practice, also a speaker at the conference. He described Mexico City as having been 'born modern', due to the specific geography and vision of its Aztec founders. Their diverse settlements, including the mixed-use Xochimilco, 'provide the basis for the contemporary metropolis' as they grew to overlap and 'produced zones with increasing complexity and networked relationships'.[2]

1 Mexico City, Urban Age, 24 and 25 February 2006, staged by LSE Cities and the Alfred Herrhausen Society, www.urban-age.net.
2 *Urban Age Mexico City Bulletin* 4, LSE Cities & Alfred Herrhausen Society, 2006.

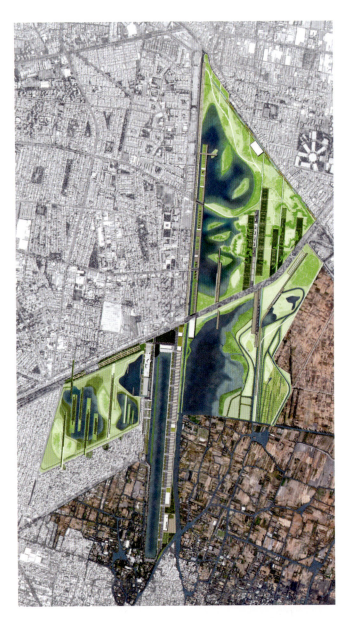

1 Masterplan for the Xochimilco site, Mexico City, Enrique Norten/TEN Arquitectos.

In 2006, the year Urban Age was held, TEN won the competition for the masterplan for the 122km² site of Xochimilco (in Náhuatl dialect, 'place of the flowery orchard'), an area 28km to the south-east of Mexico City that is one of the poorest, and yet fastest growing areas with the youngest population. One of the 16 delegations (and the third largest) within the Mexican Federal District, which by 2000 was 1400km in size, the area was declared a World Heritage site by UNESCO in 1987, and three years later, an urban ecological park.

'It is very important as it is the only remaining part of the lake system of the origins of Mexico City, which was founded on a lake when the Spanish conquistadores came,' explains Norten.[3] The land was covered by lava, so canals were created, today navigated by traditional *trajineras*, flat-bottomed boats, and *chinampas*, artificial agricultural/garden islands dating from pre-Columbian times, employing an ancient Mexican method of agriculture, a sustainable model that feeds and replenishes. They are not only historic artefacts but a model of sustainable agriculture, each island being lined with willow trees to act as natural stabilisers. Some 189 km of canals are the remains of the ancient Xochimilco system of lakes, from which organic debris is dredged to use as fertiliser. There is an archaeological site for the capital of the Aztecs, and each year the area attracts thousands of migratory birds.

Travelling to this location, now in a period of redefinition, visitors take in a sensually exuberant mix of Mariachi bands, colour, and nature, the delights of the famous Cuemanco plant and flower market, the largest of its type in Latin America, its recreational canal system, and the Ecological Park designed by Mario Schetjnan. However, through centuries of conquest and urbanisation, the lakes were neglected and polluted, with both air and water pollution problems, scarce and hazardous waste disposal facilities, and, with the growth of the capital city, the area was under constant threat of losing its distinctiveness. To reverse this deterioration, since 2003 there has been a massive clean-up operation and Grupo de Diseño Urbano, under Schetjnan's leadership,[4] provided the first masterplan through which Xochimilco was transformed.

3 Interview with the author, 2011.
4 Mario Schetjnan, *The Ecological Park of Xochimilco*, Lotus International, 91, 1996.

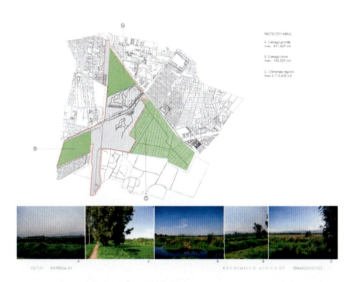

2 Protected areas of the Xochimilco site, Mexico City, masterplan, Enrique Norten/TEN Arquitectos.

3 The different facilities on the Xochimilco site, Mexico City, including relocated sports facilities and flower market, masterplan, TEN Arquitectos.

4 Proposed flower and plants market in its new location on the Xochimilco site, Mexico City, masterplan, Enrique Norten/TEN Arquitectos.

Xochimilco had received little investment, and so Marcelo Ebrard, as the PRD's candidate for Head of Government in the Federal District election in July 2006, who was subsequently voted in, promoted the plan to improve the area. It needed further protection as a lot of encroachment had happened and agriculture had been dying. One aim of the masterplan was to bring back all the public uses, including new entertainment and sports facilities, and boost the identity of this already popular part of the city but not obstruct its cultural amenities.

TEN worked with a team, including Arup (on sustainability), Hargreaves Associates (on landscape architecture), Cosestudi (on water exhibit design), Alonso y Asociados (on structural design), Syska Hennessy (on water exhibit engineering), and designer Bruce Mau, who played a conceptualisation role. One challenge they faced was that Xochimilco had originally been developed in unplanned, disconnected phases, with scattered elements that were hard to reach, and threatened by the area's severe environmental issues.

There are five ecological parks on the site: Vivero Nazahualcoyatl, Tiahuac Forest, San Luis Tlaxiaemalco Forest, Nativatas Forest and Xochimilco Ecological Park, and three

flower markets: Cuemanco, Las flores Madreselva and San Luis Tiaxialtemaco. The masterplan reorganises these elements in a single, vertical aligned rectangular strip of developed land, a central park of a kind closely related to its aquatic surroundings and regional history. It increases the amount of green space by 40 per cent with the creation of the Parque Cienaga Chica, the expansion of the Deportivo Cuemanco and a further green strip down the centre. With Arup's consultancy, it also recovered 30 per cent more water surface through the Humedales, Cienega Chica and Cienega Grande.

Xochimilco already had an Olympic Rowing Track, flower markets, the Cuemanco Sports Park, private sports clubs,

5 Sports facilities, ecological park, Xochimilco masterplan, Mexico City, Enrique Norten/TEN Arquitectos.

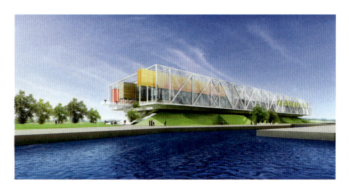

7 Rendering of the CIEAX Centre for the investigation of and education about water, Xochimilco masterplan, Mexico City, Enrique Norten/TEN Arquitectos.

6 Looking across the Xochimilco site, Mexico City, to the water centre, rendering. Masterplan, Enrique Norten/TEN Arquitectos.

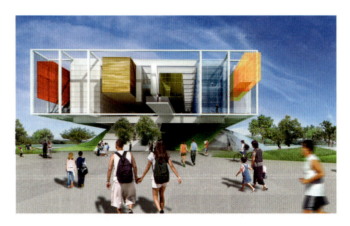

8 The CIEAX Centre for the investigation of and education about water and its plaza, rendering, Xochimilco masterplan, Mexico City, Enrique Norten/TEN Arquitectos.

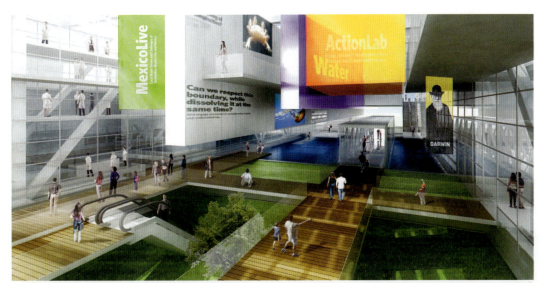

9 Foyer of the CIEAX Centre for the investigation of and education about water, rendering, Xochimilco masterplan, Mexico City, Enrique Norten/TEN Arquitectos.

10 Interior of the CIEAX Centre, rendering, Xochimilco masterplan, Mexico City, Enrique Norten/TEN Arquitectos.

research facilities, regulatory water basins, archaeological sites and parking facilities. The team has proposed additions to the programme and made design concepts for them, including an open amphitheatre to the south-east, a water park/aquarium at the southern tip, a botanical garden, relocating the sports facilities to the north-east part of the site, and a flower market to the south, and adding parking spaces. Many facilities are on the central north–south strip of land, including the new Centro de Investigación y Educación del Agua (CIEAX). This core 'fosters modes of interaction, education and exploration' for

11 One of the lakes on the rendering Xochimilco site, masterplan, Mexico City, Enrique Norten/TEN Arquitectos.

13 A canal on the rendering, Xochimilco, masterplan site, Enrique Norten/TEN Arquitectos.

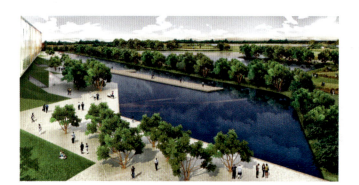

12 Public space next to the water, rendering, Xochimilco masterplan, Mexico City, Enrique Norten/TEN Arquitectos.

14 View of the CIEAX across the lake, rendering, Xochimilco masterplan, Mexico city, Enrique Norten/TEN Arquitectos.

both residents and visitors, and includes a proposal for a new central transport node close to the water park/aquarium.

The masterplan is accompanied by an economic plan to incentivise traders of various kinds to maintain the area's agricultural quality. A new market to sell flowers and vegetables, and a new waterfront market, are tactics to encourage people to carry on producing. Norten explains that there has been resistance to change from the preservationists, but the plan has endured, with many meetings held with all the many interest groups.

The social, environmental and political dynamics of local government efforts to preserve Mexico City's largest remaining green space, the conservation land in the southern periphery of the city, have been complicated by the need to modify local land use regulations, UNESCO site specifications and limitations, as well as make plans for the partial relocations of existing owners, users and residents. Plans are underway to clean the local water supply and make it drinkable. Refurbishing the water basins will also enable the recreational facilities to

function at optimum level for everyone's benefit. The city is also buying bio-mass for the area. Arup is developing ecological solutions for wastewater treatment, water reuse, flood control and stormwater management, and habitat improvement in the wetlands and floodplains is integrated into the design.

'Every plan has a life of its own,' says Norten. 'I'm not even comfortable with the word masterplanning. It's over-used and over-manipulated. Everyone, however, believes in creating a vision.'[5] Planning in the twenty-first century, he believes, needs to stop being a two-dimensional phenomenon, and must show imagination to avoid becoming obsolete. Xochimilco's preservation of resources within a vital settlement of the city, through 'inventing nature' and employing associated remediation strategies, indeed shows that this kind of wider knowledge to sustain such a settlement is a powerful conduit for the creation of new forms of space.

5 Interview with the author, 2011.

Sociópolis, Valencia, Spain

On the southern outskirts of Valencia in Spain at La Torre, on the banks of the new course of the diverted River Turia, is the 350,000m² site of Sociópolis, delimited by motorways and with a degraded urban periphery. The scheme makes a strong case for architecture's ability to create hybrid situations and to work with geography in ways that relate to the complexity of contemporary society. Whereas an older generation focussed on maintaining the traditional morphologies of cities, or their artificiality as environments, almost to the exclusion of other considerations, the architects involved with Sociópolis have perceived the city as a landscape where, as Manuel Gausa, one of the architects involved,[1] says, 'nature equipped with new meanings emerges as one of the goals of current architecture'.

The plan has a central park of 150,000m² surrounded by amenities, with 3000 housing units, both owner-occupied and for rent, on a preserved agricultural landscape with historic irrigation channels. 'This is a revolutionary masterplan,' says Sociópolis's initiator, architect Vicente Guallart, who has worked with agricultural engineer Manuel Colominas. 'After 150 years of urbanism, in this project, the city can grow without destroying the structure of the agriculture. It is a mix of urban and rural, and included social networks in order to allow

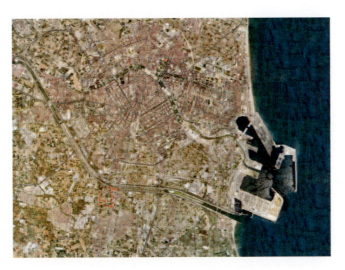

1 Site plan showing La Torre district of Valencia where the neighbourhood of Sociópolis is, Vicente Guallart, María Diaz, Why Art Projects.

1 The full list of collaborators is given at www.sociopolis.net.

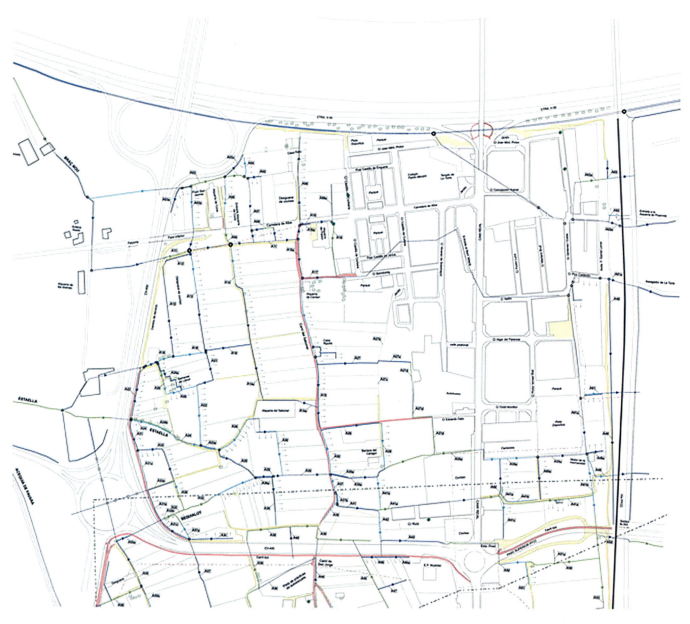

2 Sociópolis, Valencia: diagram of original water channels, Vicente Guallart, María Diaz, Why Art Projects.

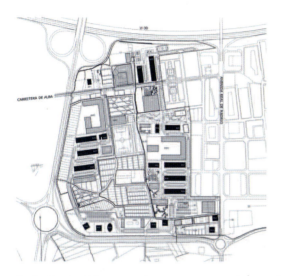

3 Sociópolis, Valencia: implantation strategies, Vicente Guallart, María Diaz, Why Art Projects.

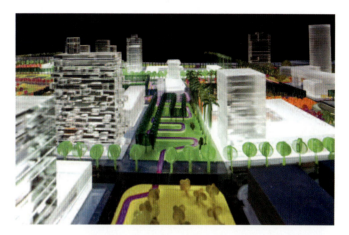

4 Sociópolis, Valencia: model of neighbourhood, Vicente Guallart, María Diaz, Why Art Projects.

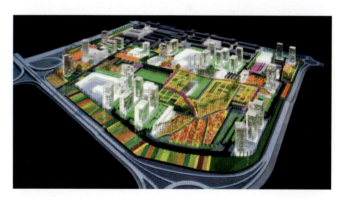

5 Sociópolis, Valencia: model of neighbourhood, María Diaz, Why Art Projects.

agriculture and sports management to intervene in public space.'[2] Construction is currently on hold because of the economic crisis, but the first inhabitants to occupy buildings realised by some private developers, were, at the time of writing, due to move in during July 2011.

The contemporary concept of integrating the countryside into the fabric of the city in order to create a common habitat has been discussed but rarely implemented in Europe. The traditional European urban scenario has been that whenever the city has grown in size, then nature and agriculture have disappeared, as the urban and the rural have become two opposing and ever more entrenched concepts. Sociópolis, an ambitious and rare prototype for an advanced urban development, breaks with the traditional European city–country dichotomy, by combining high urban density with historic agricultural landscape, public with private, and opening the rural condition of the *huerta* to new inhabitation.

The *huerta*, or market garden, with its water channels and agricultural irrigation, is a network system made by the Arabs a

thousand years ago, with urban conditions, found in Valencia and other Mediterranean sites. Shaping the geometry of the land, it became an accessible garden for citizens, cultivated using the technologies of the day that fed the city. From this cultural history, monasteries and the medieval cities evolved the concept of the *hortulus*, or medieval garden residence, in which the house is set within a natural, productive environment. Now no more than seven cities have an agricultural landscape around the city, Valencia being one of them, and Sociópolis proposes a radical revival of its heritage.

2 Interviews with the author, 2006, 2011.

Such a hybridisation into a 'rurban' environment creates ideal conditions for the evolution of urban–rural resources such as the allotment (market garden), not as mass production but as local cooperatives run by people who also live in the *huerta* in new, advanced designs for housing typologies and enjoy facilities with digital networking technologies as an essential part of the mix. 'Sociópolis gives farmers the urban life and the city the *huerta*, which implies garden, sun, space and good food,' as collaborating architect Lourdes García Sogo describes it.[3] There was a growing lack of reasonably priced housing in the city. This hybrid vision, led by Guallart, achieved full political backing in Valencia from the President of the Generalitat, allowing the

project to start construction overseen by the IVVSA (Instituto Valenciano de Vivienda) as developers just three years after it was first presented as an exhibition of proposals at the Valencia Biennale in 2003.

'The 20th century city was organised as an industrial city. We want to make a city at another speed, that of the pre-industrial age, but it should also have a digital speed,' explains Guallart. Instead of divorcing functions, or functionally fragmenting territories as in the American city, Sociópolis strives to 'create a resonance in one place'. While individuality has become such a strong theme in society, there is also a growth in communality that demands an architecture capable of reflecting on connectivity and its spatialisation. In its approach to living environments the scheme recognises the three aspects of social interaction: mental, social and environmental. Philosopher Félix Guattari described them as 'ecologies'. For this reason, José María Torres Nadal, one of the collaborating architects, feels Sociópolis is unique in its treatment of contemporary housing needs.

At Sociópolis, Guallart displaces the concept of housing for the typical nuclear family unit, which now accounts for less than

EQUIPAMIENTOS

LÍMITE DEL SECTOR

6 Sociópolis, Valencia: implantation strategies, Vicente Guallart, María Diaz, Why Art Projects.

7 Sociópolis, Valencia: diagram of sports circuits, Vicente Guallart, María Diaz, Why Art Projects.

3 Actar and the Architekturzentrum Wien, 'Sociopólis, Project for a City of the Future', 2004.

8 Sociópolis, Valencia: planting in the park, Vicente Guallart, María Diaz, Why Art Projects.

50 per cent of households in many regions of Spain, in order to focus its *huerta* environment predominantly around the needs of emerging types of family units, including young people and the elderly, and embracing the notion of the virtual family, in which people who are not biologically related share resources and activities. Both ideas are typified most closely by Abalos and Herreros's Two Communes for each of these groups, designed for the first phase (they designed a solar tower for the site). Living in an environment in which everything is made with recyclable materials, and unified by the mutual elements of *huerta* with its fruit trees, footbridges for harvesting and vegetal walls, 'Nature becomes a device that accommodates the activities, from the most intimate to the most public, of each of its inhabitants, as they describe it. Sociópolis aims to behave as an optimum micro-city, 'recycling its own waste, purifying its own water, generating its own energy, minimising the distances between workplace, housing and services, and engaging in the digital economy, physical work on the land and in clean manufacturing.

This sense of the city or neighbourhood as an artificial ecosystem governed by rules similar to those of natural ecosystems is the opposite strategy to that of Ildefons Cerdà, the Spanish urban planner who designed the Eixample, the nineteenth-century extension of Barcelona, which applied a rational structure to an agricultural territory in the form of a grid system. At Sociópolis, these rules have been changed, and the site has within its bounds 8 kilometres of water channels and a network of roads including a peripheral circuit, with a park at its centre connecting the channels, paths, and 10 hectares of agricultural plots which are the bases for the residential plots. Guallart calls this overall treatment of space 'following the rules of urbanity without urban form'. By creating 'rurban' areas of transition from farmland to city, he feels that the agriculture around cities can be protected.

His polemic is that the *huerta* is threatened not only by uncontrolled growth bringing giant urban blocks but also by rashes of terraced housing developments with fences hiding unproductive private gardens. Hermetic solutions of this kind deny the value of landscape. Instead Sociópolis as a masterplan offers a group of complementary facilities: appropriately scaled housing types in a hybrid agricultural-park setting suitable for single parents and the elderly. These are laid out on the peripheral traffic circuit, with 18 public centres on their own major plots within or next to the inner parkland. 300 smaller allotment plots are present on land that is a mix of plots with higher and lower intensities of vegetable garden and fruit tree cultivation. These types of plots are unusual in Spain, and a real incentive for those moving in, irrespective of age. The existing rural roads run parallel to the water networks that are part of five overlapping layers of different mobility systems, including a path connecting the football field, swimming and basketball facilities. The park itself is not generic, but has functions, for instance, greenhouses for the cultivation of roses.

The housing complexes allow for multiple configurations and enable each one to be as individual as its inhabitants. They also have hybrid functions, with 20 per cent public, 80 per cent private, with each embodying a notion of *huerta*. Guallart's Sharing Tower of 99 small student apartments has communal areas; Ito's home for the elderly has a spa; Manuel Gausa's has a kindergarten; Greg Lynn's has artists' studios and housing for young people; Duncan Lewis's a community centre below housing; Willy Müller's design on the edge of the athletics field is a tower of stacked platforms with housing, a sports centre and stadium; housing blocks by Young Joon Kim include a health centre, while JM Lim's housing has a music centre.

The developments have an intimate and in some cases metaphorical relationship with the *huertas*, which are a

functional social space, 'woven' with housing, as François Roche describes it, creating 'an antidote to info-tech delocalisation' that, instead of being marginalised, can be seen clearly for their own newly enunciated urban form. MVRDV elevates them,

bringing the trees up onto the roof to create a public park of orange trees connected by ramps, staircases and walkways. Toyo Ito's comment speaks for the approach taken by all the architects involved: 'We don't want to create a typical building

9 Sociópolis, Valencia: park, Vicente Guallart, María Diaz, Why Art Projects.

11 Sociópolis, Valencia: orchard gardens, Vicente Guallart, María Diaz, Why Art Projects.

10 Sociópolis, Valencia: sports circuits, Vicente Guallart, María Diaz, Why Art Projects.

12 Sociópolis, Valencia: orchard gardens, Vicente Guallart, María Diaz, Why Art Projects.

type architecture, but something lying in front of the architecture, something that permits an exchange with external space and society.' The creation of an ecosystem stems from Guallart's observation that 'the more different species exists and the more equality there is between them, the more balanced and consistent it will be. This being so, the inter-dependence between the buildings is the key to achieving a greater social interaction that will generate urban cohesion.'

Creating transparency, rather than hiding specific social groups, is a necessary challenge for the architecture of housing for the elderly, which is mostly cut off from society and in very

few cases in any way innovative in design. Ito's design for interconnected, four-storey circular houses surrounding patios with sleeping quarters, a restaurant, pool and public bath, breaks with this convention. It has a radial distribution of functions, and soft radial passages, and a fabric façade blurring interior and exterior, that open like curtains to external terraces. His cue is the garden itself, and especially medieval gardens reflecting universal nature, and the improvised inhabitation of nature, for instance, spaces created by the Japanese *manmaku* curtain temporarily hung from cherry blossom trees during *hanami* parties. At Sociópolis, his garden spaces for sitting and resting are created by carving out wave and crater forms.

The Sociópolis model is ripe for development in other locations. Its design strategy of creating open borders to cities has many implications, including the breaking of the illusion of autonomy. Communality for both the young and the old as a psychological need requires new systems to be developed in order to create relocalised, but not rigid, communities. Responding to changes in Spain's traditional family structure, the plan is designed for the elderly and single people. Based on the intertwining of new spatial concepts with social patterns and resourced by digital technologies, this plan, the first in the country to create an agricultural zone within the fabric of the city, makes the fertility of natural landscape – both as a metaphor of a living environment and as a conceptually reinforcing agricultural context – part of their fabric.

13, 14 Sociópolis, Valencia, under construction, 2011, Vicente Guallart, María Diaz, Why Art Projects.

8

The water city

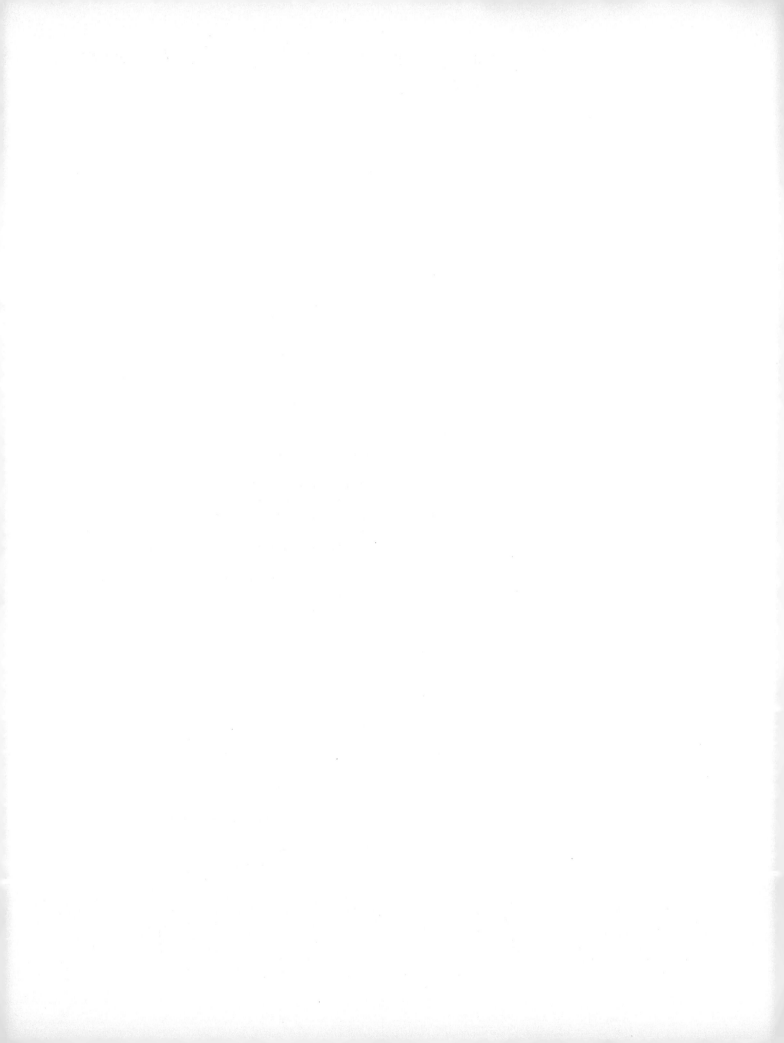

Saemangeum Island City, South Korea

The non-zoned city has huge relevance in the current era of complexity. For urban designers that entails going beyond the lingering global orthodoxy of functional zoning laws, challenging instruments that are rigid, backwards-looking and as a result cannot facilitate layered city structures that are durable and sustainable. Unfortunately the mindset that businesses will not come to a district or a city unless it is zoned also prevails.

A plan for any given context, whether or not it is declining in use, does not have to be ruled by zoning. Instead, its generative strengths lie in a spatial framework whose rationale is for a coexistence of mixed uses and programmes. This must not be an arbitrary cut-and-paste procedure lending genericism, but a *modus operandi* that creates a specific, yet adaptable canvas for city life and spaces with meaningful – and in all senses necessary – connections to the surrounding landscape.

The Saemangeum Island City by Architecture Research Unit (ARU) (Florian Beigel and Philip Christou) is a 400m² land reclamation project on the west coast of the South Korean peninsula, at a scale at which the architects had never

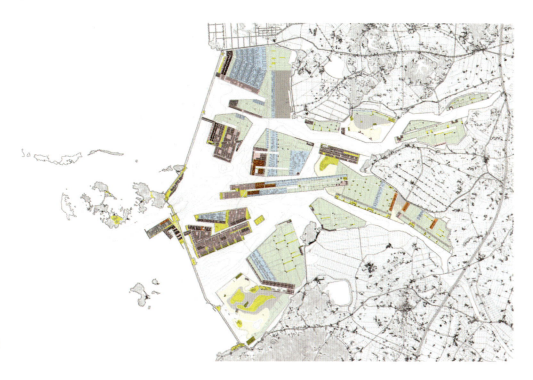

1 Saemangeum Island City, development land-use plan with seven lead programmes indicated in colour coding, drawing, ARU.

previously worked. A 33km-long seawall – the longest in the world – was built between 1991 and 2006 by the national government to enable land reclamation, and the intention is for the site to be developed by 2020 to house a population of approx 680,000 to 1,000,000 living at densities of up to 60 dwellings per hectare near transport hubs, with lower densities along transport lines. ARU's concept is a water city of co-existence and proximity of functions and programmes, to endow it with economic flexibility essential to its future sustainability. It is that immaculate twenty-first-century concept, not a utopian tabula rasa, but a city concept lacking single function zones, going against the grain of conventional Korean practices which refer to the zoning of the modernist city but risk leaving out the critical sense of conviviality that comes from diversity.

2 Saemangeum Island City, synthesis plan. This drawing brings together the ideas of a landscape infrastructure of islands, research about City Structures and the size and spatial relationships between the City Magnets, or Cities within the Island City, drawing, ARU.

3 Saemangeum Island City, initial concept drawing looking west over the Island City towards the horizon of the Yellow Sea, drawing, Bumsuk Chung, ARU.

4 Saemangeum Island City, Landscape Infrastructure design plan of new islands, drawing: ARU.

Saemangeum is at the heart of South Korea's agricultural and food processing province, Jeollabuk Do, but it has unfortunately been in decline. Agricultural and food production research and its future evolution in the region consequently forms a key part of the spatial programme. Analysis of the characteristics of each specific place, has helped to identify areas of potential to help reverse this situation and nurture the food culture the Koreans are, after all, intensely interested in generating. There was not much agricultural or flat space (approx 20% of the land mass of South Korea is used for agriculture) in the South Korean peninsula because of the extensive nature of the mountains.

As a result, Saemangeum is conceived as a global city and centre for tourism, not in a generic way, but harnessed to the concept of a local agri-tourism to combine hospitality to help farms, service industries and international investment. Such a synthesis drives opportunities for coexistence, overlapping activities for what aims to be a major urban centre based on sustainable energy within the Yellow Sea Rim regional network.

The idea to build a sea wall at Saemangeum began in 1971 as part of land reclamation to provide more productive agricultural land, and avoid a predicted food shortage. In 1987, the Saemangeum project was commenced but debates about potential environmental damage and the impact of pressure groups put a halt to reclamation until the Supreme Court ruled that it should restart, and the seawall was finally completed in 2006. After Lee Myung-bak was elected as President of the National Government of South Korea in 2007, he pledged to transform Saemangeum into a global economic free zone. The plans are part of a South Korean National Government policy to decentralise industry and population to other regions of Korea so that Seoul, the capital city, can be relieved of its congestion.

ARU was selected as one of seven international teams, along with those from the Berlage Institute, Rotterdam, Columbia University, N.Y., the European University of Madrid, the Massachusetts Institute of Technology, Cambridge, Mass., the Tokyo Institute of Technology and Yonsei University, Seoul, to participate in an invited design 'workshop competition' intended to encourage the teams. The ARU team visited and met the

Governor of the province to discuss all aspects of the project including which global models he would be keen to simulate in some way; Dubai, Singapore and Los Angeles were deemed to possess the qualities that the Governor was looking for. ARU were well known in South Korea for their role in the Paju Book City project in Seoul, and their experience and ideas about inhabitation and city structures were very well received. This led to them making a portfolio of historic examples for the clients. ARU's eventual proposal was for six new islands – not organically shaped but with long straight edges – to be built within the fresh-water lake that now exists behind the seawall, and located and shaped to take advantage of the existing lakebed topography.

ARU subscribe to Aldo Rossi's sense that urban research needs to avoid being reductively partial, and focus on its broader significance. Because they believe that the city is a social agreement between people to live together, they stress the relational aspect of urban spaces in their designs, relations that can be substantiated via a sense of spatial in-between-ness in which the temporal dimension comes strongly into play. Having worked in Korea for over a decade, predominantly on

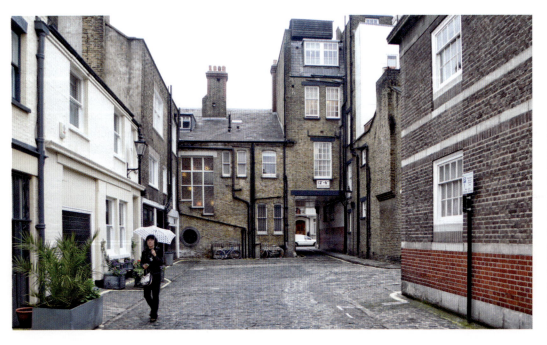

5 Saemangeum Island City: inhabiting the islands with City Structures, Weymouth Mews, originally built (1715–1720), is a typical example of a London mews block with large terraces of 4- or 5-storey houses facing the main streets and 2-storey mews houses inside the city block. The mews houses were originally built as stables for horses and carts, with a small servant's house above. Photo: Philip Christou, ARU.

Scale 1:10000

0 100 200 300 400 500 600 700 800 900 1000 m

6 Saemangeum Island City: inhabiting the islands with City Structures, Quadrangle City Structure, Cambridge University, England, thirteenth to eighteenth centuries. A series of quadrangles sit along the banks of the River Cam in Cambridge. Drawing: Awot Kibrom.

Paju Book City, they are well aware of the Confucian idea of emptiness or *kong-gan* which originated from the Taoist philosopher Lao-Tse, one example being the *madang* courtyard of a traditional Korean house, which is 'a positively charged void', the architects explain.[1] This idea has also to do with the

memory of the ancient landscape of a place, as in this case of Central Park, New York, designed by Frederick Law Olmsted. ARU attribute an organising potential to this urban void as a principle, for voids at the architectural scale and at the urban scale between buildings.

The City Structures ARU chose are 'city pieces' identified from various places around the world, especially Ypenburg in the Netherlands (2006), Dockland City Block in Hamburg (1885–1913) and the Cerdà City Block in Barcelona (1850s) from a total of 12 'gifts to the city' that could be squares, gardens, streetscapes or skylines, made up of buildings of a similar type, flexible in use and densification but not use-specific. 'It is within these urban blocks that the city structures begin to deal with the uncertain future and evolving nature of the city,' say ARU.[2] Some of the islands have two City Structures; others as many as four, chosen from the rest of the 12, Weymouth Mews, London (1715), Barceloneta in Barcelona (1749), Malmö City Block, Sweden (late nineteenth century), Hornbaekhus City Block, Copenhagen (1922–2 3), Oido city block, Gyeonggi-do Province, Korea (early 1990s), Cambridge University quadrangle, UK (thirteenth–eighteenth centuries), Farm and Guesthouse ensemble, France and the Netherlands, Bedford Square in London (1775–83), Place des Vosges, Paris (seventeenth century) and Central Park, New York City (Olmsted, 1857–70).

Five lead programmes to support Saemangeum's economic development up to 2020 were devised to be located within the different City Structures, each complemented by a mix of financial and business support services. These are the city's food industry clusters, which ARU describe as usually subject to 'ad hoc, additive' development, for example, an out-of-town industrial park or an American university campus. The drawback is that this model separates work and living.

Their food cluster facilitates a much more integrated and unique solution, based in part on the university campus model that began in medieval times in Europe. The second lead programme is farming; and then there is the tourist infrastructure, which can also be developed along the lakeside and seaside through agri-tourism; high tech industries; and lastly, urban infrastructure, anticipating an emerging urban region.

1 Florian Beigel and Philip Christou (Architecture Research Unit), *Architecture as City: Saemangeum Island City* (Vienna: Springer-Verlag, 2010).

2 Interview with the author, 2011.

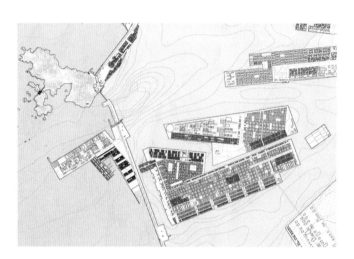

7 Saemangeum Island City: Harbour City Magnet, ARU.

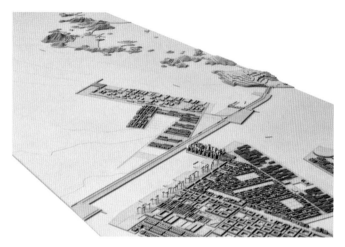

9 Saemangeum Island City, view of the Harbour City towards the New Sea Port and the Gogunsan Archipelago of islands beyond, photo: Philip Christou, ARU.

8 Saemangeum Island City: Harbour City Magnet, ARU.

ARU's idea of City Magnets – combinations of different city structures with special infrastructural significance, each 'a city within a city' – are essentially desirable, designed densifications of the dispersed city. There are seven of them and between each of them are either landscape voids, water bodies, agricultural land or wilderness. Within and between each other they are well connected, and industries are not separate but coexist across the islands, often with several programmes based in the same building.

The most lively magnet is Gogunsan Harbour City, an industrial seaport city with a transit interchange, a Cerdà-style city block structure filled with mixed uses and a quayside lined with Barceloneta-type City Blocks; then there is the financial heart of Saemangeum, Jin-Bong Lagoon City, which engages a Malmö City Block structure, and has a Food Cluster City composed of courtyards and quadrangles similar to those found in university cities such as Oxford and Cambridge in the UK. Farm City along the shores of the Donjin River has clusters of spaces for agri-tourism and farm-stay holidays; Airport City is people's first experience when they arrive here, which has tulip fields similar to those seen around Amsterdam's Schiphol Airport, high tech industries and city structures derived from Hamburg, Barceloneta and Barcelona Cerdà.

Then there is Dongjin Lake City in the south next to the mountains; the seawall, conceived by ARU early on during their visits as the Korean equivalent to the Great Wall of China, which has high density Threshold Cities; and finally Man-Gueong Lake City, an area with the highest density which will be built in the final stages of the development and engages the Hamburg and Malmö City Block structures ARU introduce as urban design exemplars.

10 Saemangeum Island City, Man-Gueong, Lake City Magnet, ARU.

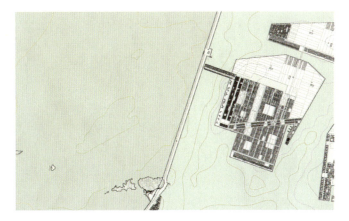

12 Saemangeum Island City, Man-Gueong Lake City, on the eastern edge of Man-Gyeong Lake City, ARU.

11 Saemangeum Island City, Man-Gueong, Lake City Magnet, ARU.

To help engage with realising the local water bodies as public spaces, at Saemangeum, ARU related them to the scale of water bodies they admired and had photographed and scaled for size and viewing distances in Europe – in Barcelona, in Cadiz in southern Spain, the archipelago city of Stockholm in Sweden and the islands within the lagoon of Venice. They did not want to make their islands at Saemangeum too big, feeling that each one should be walked across in 25–40 minutes to give a good experience of being on an island.

One other aspect of this in-between-ness is a lack of urban hierarchy. However, in introducing a grid of the dimensions of Cerdà's Barcelona block, which is non-hierarchical with a lot of variety, ARU juxtapose it with a small grid derived from the London mews block. In instances like this, and also when the grid borders topographical features, a sense of hierarchy inevitably emerges and the ordering principles have to become pliant and open up to facilities such as markets or civic buildings. 'We are looking for a civility of spaces, a space of identity and a sense of time,' says Florian Beigel. 'We can't design, so we collage. What do we have to change, and how does it meet the edges? We are thinking all the time about infrastructural space, about what is shared.'[3]

ARU shy away from masterplanning as a practice because of its 'definitiveness and disregard of the temporal', when, in fact, a plan is inevitably overcome by time and circumstances, and then usually becomes out of date by the time construction begins. ARU's 'vision statement' plan for Saemangeum has 30 years of uses embodied within it, say the architects, but add that it will not look like this in the future. Instead, ARU apply their design tool of a landscape infrastructure. The two words are significant: for ARU the landscape is a collective phenomenon

3 Ibid.

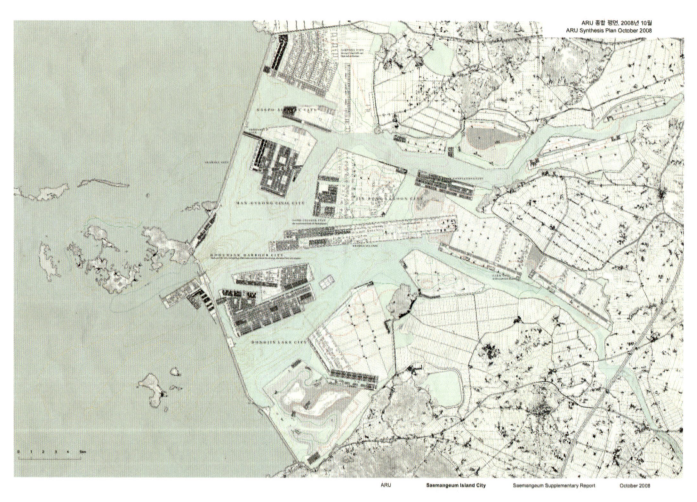

13 Saemangeum Island City, a vision plan for 25–30 years, ARU.

in terms of cultural significance, and infrastructure is about the in-between; putting them together creates the driver. Placing emphasis on landscape prioritises bringing people together in shared space. The concept is a very specific one. Without it, say ARU, 'the islands are in danger of being out-of-place, characterless places.'

Building a satisfying connection with the landscape has been accepted as a recognisably shared goal of the stakeholders at both Paju Book City and at Saemangeum. At Paju Book City, the architects' landscape infrastructure is the river, the mountains, the embankment of the motorway, flood protection, and the wetlands which they took care to keep because of its contribution to the character of the space. The buildings on the site (with a maximum of four storeys) reinforced the quality of that landscape infrastructure. Unfortunately Paju's zoning is industrial, based on old modernist principles, and ARU have had difficulty introducing residential functions there, away from the neighbouring monocultural residential districts being built.

At Saemangeum, as indeed elsewhere with ARU's urban design, they made a reading of the site's history, its geological, agricultural context and urban development which are still visible, so that their proposal could be specific to the location. The architects explain that landscape infrastructure can hold

urban sprawl at bay, but is not actually the development itself, rather the design of the site before the development. The architects also made a plan for water taxis and there is a main train line along the seawall and water and land buses.

14 Looking along the southern portion of the sea wall at Saemangeum with the Gogunsan Archipelago on the distant horizon. Photo: Alex Bank, ARU, April 2005.

16 View of the Saemangeum Island City from the hills of the Byeonsanbando National Park, looking north. Drawing: Thomas Gantner, ARU.

15 Saemangeum is located on the south-west coastline of the Korean peninsula, facing a number of major industrial cities along north-east China, including Shanghai, Qingdao and Bejing.

17 View of Saemangeum from a helicopter, looking towards the new freshwater lake enclosed by the recently completed seawall at Saemangeum. Photo: Philip Christou, Jan 2008, ARU.

The field structure is an important part of ARU's approach, but its intention is not to zone functions, which remain overlapping, as the architects never start with function. One of ARU's first urban projects was the Berlin Lichterfelde project, a 1km x 1km suburban extension of the city, which they knew it would be built in phases over time to designs by different architects and developers across the site. To achieve spatial integrity and identity while allowing for these factors, they laid down a field structure, identifying 'field boundary conditions' of an agricultural scale which referred to the history of how the site had been built and rebuilt in the past. The field menu consisted of eight different housing types, so each neighbourhood could have a distinct architectural identity but at the same time responded to the conditions of its field.

At Saemangeum, one field the architects worked with was based on the urban block structure of Weymouth Mews in London, a five-storey-high setting that internally is like a form of village. They took their Korean clients to see it and the concept was easily understandable. South Korean housing of the past 20–30 years is repetitive and is being built at larger scales. By contrast, Saemangeum has a pleasurable diversity, incorporating urban structural types from London, Barcelona (reinventing Barceloneta's narrow streets and narrow buildings) and Copenhagen.

To organise the project, besides the design team, there was an urban economy team, cost consultants, environment consultants and a renewable energies network, including many specialists from Germany. Apart from a lot of 'old-fashioned research', the team did a lot of sketching and photographing, going to the site over a period of a month with up to ten people. The landscape of the edge of the lake (the former sea coastline) has been altered by land reclamation and farming practices over many decades, and ARU hired a minibus to visit and explore the local topographies and to talk to local people. Their design concepts have been developed in the short term (more specific), the medium and the longer term (more open-ended), so that they can be adjusted to changes that will take place through time. For ARU, this is a procedure of design that is more responsive than more fixed, deterministic master-planning strategies.

ARU's approach, employing a well-judged choice of European urban referents, is potentially relevant to many situations of this kind, to waterfronts globally, new reclamations of land, and new cities. The development is not spread evenly across the ground but exists with open landscapes of farm fields, lakes and mountains. Its urban fabric is concentrated in localities of density, strategically positioned, so people have the opportunity to live where they work in a city of coexistence free of bed towns, business parks and tourist resort enclaves.

9

Urban growth

Almere Structure Vision, 2030, the Netherlands

As central government has withdrawn its influence on and funding of European cities, devolving its powers to the market, the distinction between urban and rural space in the Netherlands has become much more blurred. Not only do the effects of urban development on landscape need to be questioned, but climate change and economic crisis have made it vital to reassess land use and management in relation to housing needs.

This set of profound shifts requires both more flexible and more integrated masterplanning strategies. Plans for Almere, 35km west of Amsterdam, in the fourth polder of the Zuiderzee works, and part of the province of Flevoland, first commenced in 1961, making it more than 40 years old. One of eight New Towns in the Randstad of the Netherlands built from 1965 onwards – Zoetermeer near The Hague and Haarlemmermeer near Amsterdam being two of the others, it was, like them, close to an existing city – Amsterdam – with good transport links, but only to that mother city.

Built on reclaimed land and in part deriving from the intense deconcentration policy of the 1960s to provide a green, spacious place to live for the overflow population of Amsterdam, Almere became a municipality in 1984 after its first house was completed in 1976, and there was a subsequent average growth rate of 5000–6000 inhabitants per year. It is one of the *vinexwijken*, districts for dwelling created after the central government initiative for spatial planning of the early 1990s. The first of these were considered too 'urban' for people leaving the city for suburbia, yet also too suburban for people wanting an urban place to live. Full of suburban family houses, its development is considered to be mono-functional, with little interaction, lacking what researchers at Delft University of Technology, writing in 2007, termed 'an integrating "intranet" of paths and places that facilitates an optimum implementation of both public and private investments'.[1]

1 The Dutch Ministry of Housing, Spatial Planning and the Environment published a supplement to the 4th report on spatial planning, VINEX, or 'Vierde Nota Ruimtelijke Ordening Extra', a policy document stating that 455,000 new homes subsidised by the government needed to be built, 285,000 concentrated in the suburbs, and the rest in city regions, to increase urban density and fortify the urban economic base, and save land, hence the suburbs needed to be compact, as close to existing cities as possible, and to favour public transport and bicycles. National, provincial and local authorities signed an agreement for the VINEX development areas, working to a timetable from 1995–2005. After VINEX, policy shifted away from large-scale urban extensions to emphasise redevelopment of existing urban areas, including former docklands and railway station areas; 40 of the country's most disadvantaged neighbourhoods and small-scale, part urban and part rural developments on the edges of cities. 'To know the path is to rule the system: the discrepancy between serial planning and vital city', Peter de Bois and Karen Buurmans, Delft University of Technology, 12 March 2007.

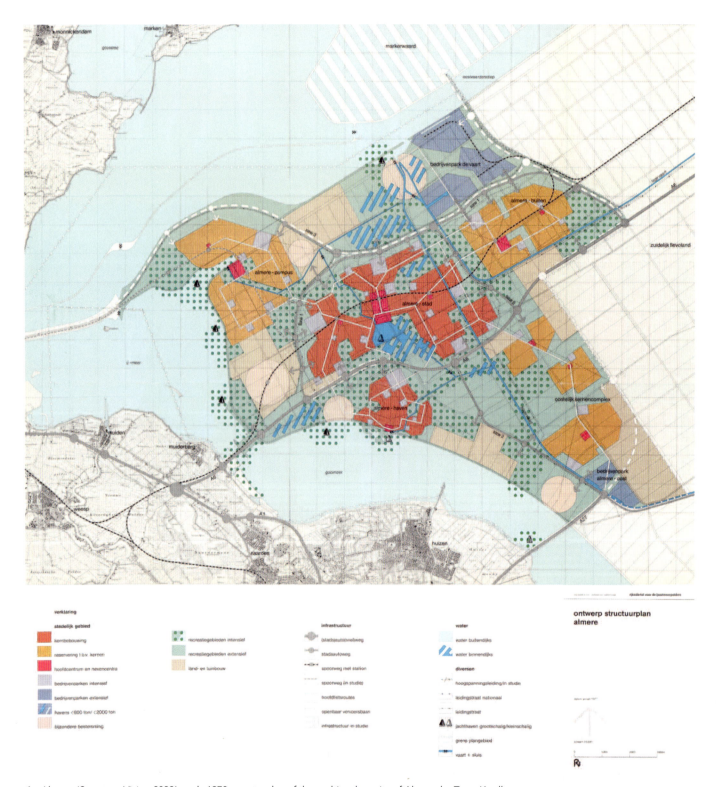

1 Almere 'Structure Vision 2030', early 1970s masterplan of the multinuclear city of Almere by Teun Koolhaas.

Almere, amalgamating polycentricism (yet not sufficiently connected), garden city with green belts and significant nature reserves, has been developed in series, in a top-down fashion, since the 1960s, each time without variation in typological distinction in the different neighbourhoods. It has been highly desirable for some time to look at changing its operative model. At the start of the 1970s, urban designer Teun Koolhaas designed the masterplan of Almere New Town as a multinuclear city, a time that was also the start of a career that included the design in 1988, by TKA, his practice, of the masterplan for the Kop van Zuid waterfront of over one million square metres of mixed-use buildings in Rotterdam. He worked on Almere from within the Lake IJssel Development Authority where he directed the design department.

The Gemeente Almere, the city's municipality, now wants to increase the population from 190,000 to 350,000, creating new districts for this inward-looking polder city. First, they engaged urban geographers to make a 'structuurvisie'. This produced three scenarios: (1) continue development in the existing districts; (2) expand to the west; or (3) expand to the east, adding new transport links between Iberg and Almere. Some 60,000 extra houses and 100,000 new workplaces and related facilities will lead to the city being the fifth largest city in the

3 Almere 'Structure Vision 2030', visualisation of Almere new central station, MVRDV.

2 Almere 'Structure Vision 2030', visualisation of Almere Island, a more upmarket urban area connected to Amsterdam by metro and aimed at more affluent Amsterdammers. Selling the island finances the water improvement through newly created wetlands, MVRDV.

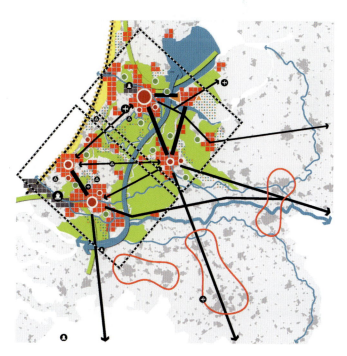

4 Almere 'Structure Vision 2030', Almere in the context of the Randstad urban network, MVRDV.

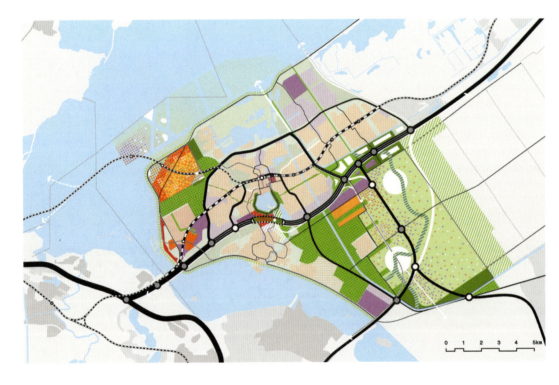

5 Almere 'Structure Vision 2030', overview of the masterplan, divided into four parts, from left to right: Almere Island, Almere Pampus, City Centre and Almere East, MVRDV.

Netherlands, relieving the pressure on Amsterdam. It is vital that Almere serves the Randstad, and 'Almere 2.0', using the Web terminology of a new system breaking with an old model, was accordingly also developed with the city councils of Amsterdam and Utrecht, with all three councils having a vested interest in boosting the Northern Randstad. The cities' three provinces – North Holland, Flevoland and Utrecht – account spatially for around one-third of the Netherlands, and together are the fastest growing area of the country, and its great economic motor.

The overall concept for Almere's 'Structure Vision 2030' commissioned from architects MVRDV (see also p. 000) accommodates this growth in a polynuclear shape. Growth will focus on four areas, each with their own character, identity and logic, but linked by an infrastructural axis connecting the metropolitan area of Amsterdam with Almere. Almere IJland, a new island off the coast in the IJ-lake designed by West 8 (see also p. 000) and William McDonough of McDonough and

Partners, is an economic and cultural connector. The axis leads to Almere Pampus, a neighbourhood overlooking the lake where 20,000 units of experimental housing are envisaged; Almere Centre, an extended city centre surrounding the central lake, and Oosterwold to the east, where a more rural and organic form of urbanism is envisaged, and which will in the future be extended to link up with Utrecht. Investment in infrastructure, public transport and Almere's adjoining green belt including its long coastline will help to connect the city more closely with its surroundings.

Adri Duivesteijn, Almere's Alderman, who originally presented the plan for Almere's sustainable growth in 2008, feels that the Structure Vision exceeds the scope of 'an urban masterplan' or 'blueprint' because 'it describes how the city can develop in economic, cultural and social terms'. It factors in the need to add new qualities that allow it to both 'serve the Randstad' and 'develop into an ecologic, social and economically sustainable city'. These are defined by client and architects

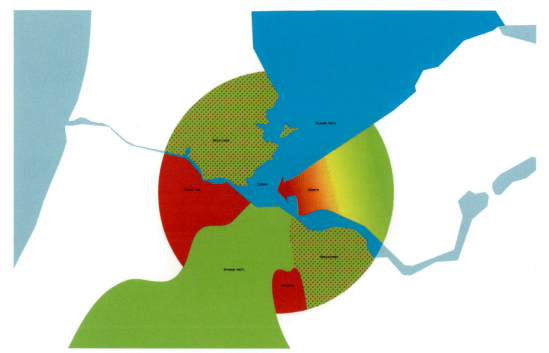

6 Almere 'Structure Vision 2030', showing Almere and its position in the Amsterdam region, with the city's Green Heart (green) and Blue Heart (blue) joining at the Ijmeer, which Almere and Amsterdam flank, MVRDV.

as added 'densities, programmes and characters' not yet existing in the current set-up. Unlike the abandoned plan for eco-towns by the last UK Labour Government, which proposed urban growth with a limited 'town' formula without this mix of characteristics, and lacked perception in its choice of location (too many greenfield sites that the locals were against developing), the areas seem to be far more integrated to ecological needs and transport infrastructure, even though overall large investments in infrastructure are still needed to connect the city and its anticipated total of 350,000 inhabitants to its surroundings and to Amsterdam.

The 'Structure Vision's' holistic approach deserves to be adopted by all masterplans, but whether or not the term is retained and reinvented, 'structure vision' defined in this way is a valuable concept for urban growth that needs to be more widely applied globally. But terminology alone is of no use. Critically, 'It is a flexible development strategy, a framework which can be filled in by the people of the city. By remaining flexible we create possibilities to adjust the plans to future

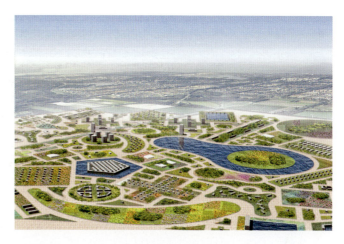

7 Almere 'Structure Vision 2030', visualisation of Almere Oosterwold: a neighbourhood of informal urbanism in which low density and mixed use are combined and provide flexibility for the future, MVRDV.

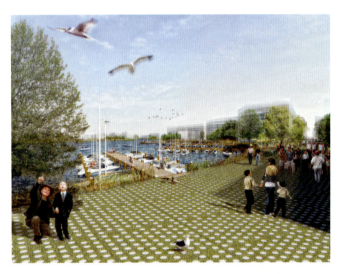

opportunities,' commented Henk Meijer of the Gemeente Almere, project director for the Almere Structure Vision.[2]

However, while flexibility is an essential quality, one that some of local public consider there is not enough of, are the proposed areas of Almere devised in a way that is sufficiently distinct in identity? It seems that their very contexts vary considerably, with Almere Ijland built on a series of urban and nature reserve islands in order to improve water quality in the lake, as is urgently needed, where a new community of up to 10,000 homes will be built, connected to Amsterdam by a new rail link.

Almere Pampus on the lake is envisaged more as a high-density coastal town with 20,000 homes, with streets leading to a lakeside boulevard and a new railway station with a plaza on

8 Almere 'Structure Vision 2030', marina on Almere Island, MVRDV.

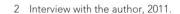

2 Interview with the author, 2011.

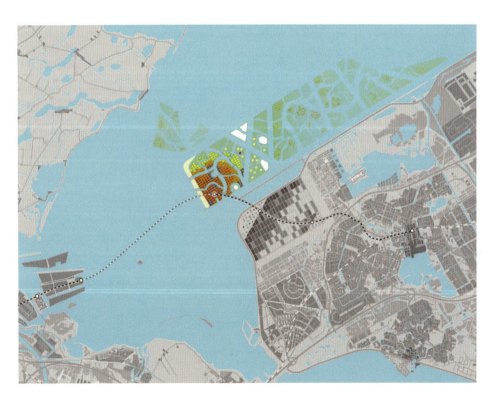

9 Almere 'Structure Vision 2030', Almere Island and Almere Pampus, MVRDV.

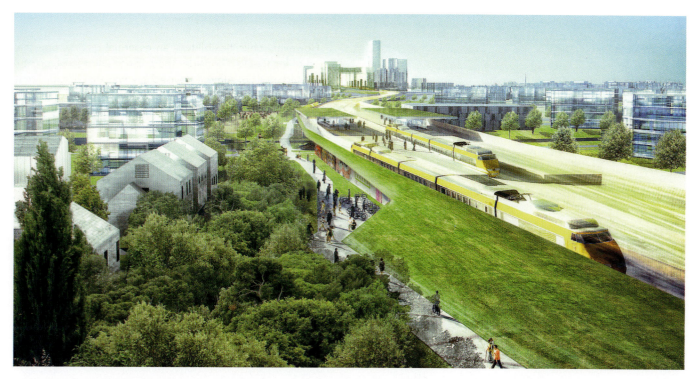

10 Almere 'Structure Vision 2030', Almere line with city centre in the background, MVRDV.

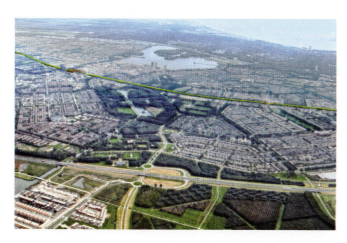

11 Almere 'Structure Vision 2030', Almere train line and new Central Station, MVRDV.

the coastline. The harbour, currently used for maintenance, will be redesigned for leisure uses and to incorporate floating villages, and picks up Winy Maas of MVRDV's earlier study for a neighbourhood of 500 floating dwellings here.

The urban ecology envisioned for Almere Centre is one of growth and extension to the south bank of Weerwater, turning the central lakeside area into a park and, in time, into the cultural and economic heart of the city. As at West 8's MRIO scheme (see p. 202), the motorway (at its junction with the railway line) will be covered, but here it frees up the land for an adjacent development of up to 5000 homes, offices and public amenities. The central station will be developed as a financial hub.

Plans for the large Almere Oosterwold to the east epitomise the adaptive planning ethos of 'Almere 2.0', by no means a conventional predetermined masterplan. They transform an

agricultural area with a mix of individual and collective initiatives of various scales – people can buy land and build houses or create recreational facilities – in a context of natural development, parks and urban agriculture. In such a context, 18,000 new homes and new facilities such as business and retail centres can be accommodated. The 'Almere 2.0' requirement is that all development adheres to its sustainable system and that all stakeholders contribute to the public system. Plans for the large Almere Oosterwold to the east epitomize the adaptive planning ethos of 'Almere 2.0', by no means a conventional predetermined masterplan. They transform an agricultural area with a mix of individual and collective initiatives of various scales – people can buy land and build houses or create recreational facilities – in a context of natural development and parks, with 50% allocated to urban agriculture. In such a context, 18,000 new homes and new facilities such as business and retail centres can be accommodated. The 'Almere 2.0' requirement, through 'Estates for initiatives', the development strategy, is that all development adheres to its sustainable system and that all stakeholders contribute to the public system. As such, the scheme invites organic growth and is innovative in the context of Dutch urban planning, giving the government a facilitative rather than a directive role.

Almere, as architectural historian and critic Bart Lootsma pointed out in 1999,[3] 'is not a city in the traditional sense of the word, an urbanized area, maybe', so the differentiation in densities and programme, flexibility and experimentation in its structure vision is an appropriate means of taking steps towards a more urbanistic identity. This can be seen as an excellent example of a refrain from total planning, with its top-down approach and conventional development logic, in its experiments with self-build, how to regulate or not, and the participants' sustained level of interest in what can be learned from the process.

Also, by appointing different architects to work on individual schemes, such as Homerus Quarter (OMA, MVRDV, Must), the risk of formal uniformity of, for example, the district master-planned by Daniel Libeskind at Ørestad, Copenhagen (see p. 27), is avoided. The innovative idea stimulated by Alderman

Duivestijn is for the development of a city without developers, but instead for individual clients, and he is also prepared to try out what this method demands from all parties. This contrasts with the other end of the spectrum, where a developer owns the land, and works largely without municipal help, for example, Risanamento for the post-industrial, mixed-use district Santa Giulia in Milan, which was halted recently and sold mid-scheme due to lack of revenue, or City Center (masterplan by Gensler; no social housing included) in Las Vegas, for which the mix of architects commissioned lent itself to the image of an architectural zoo but without a corresponding set of facilities extending beyond the idea of a Vegas fun palace to high levels of civic utility.

The decision by Duivesteijn, representing the city council, to collaborate with Stadgenoot, the Amsterdam housing association, and MVRDV, on a masterplan for the Olympiakwartier, a mixed-use urban district with a higher density than other neighbourhoods of 220,000m², which is conceived of as a secondary hub to Almere's centre, one that involves no less than 24 different architectural practices, is a bold way of changing the rules of the conventional master-planning game. Each practice in the mix, from Europe, Japan and the USA, was commissioned to design two buildings, 48 in total. The aim is to achieve 'urban variety, flexibility and high quality of a lively inner city district', as Frank Bijdendijk, Director of Stadgenoot, puts it. The association did not have experience of making entire districts but they are one of the most progressive in the Netherlands, according to van Rijs.

The plan, based on 10 blocks, each with 10 buildings, is 'nothing special but different for Almere and not so common for Dutch housing', says van Rijs.[4] In design development, in the first version involving all the practices' submitted building designs, there were inevitably some clashes, so they 'played a game of chess', eventually producing 'a tool kit of 100 designs – so they can build any neighbourhood'. This tool kit is aimed at introducing 'inner city life to the mostly suburban typology of Almere', with a mix of work space, housing, educational facilities, commercial space, various public spaces and parking space split into 93 volumes, of which MVRDV will design 45. All

3 Archis, *Almere, City of Belonging*, Nov, 1999.

4 Interview with the author, 2010.

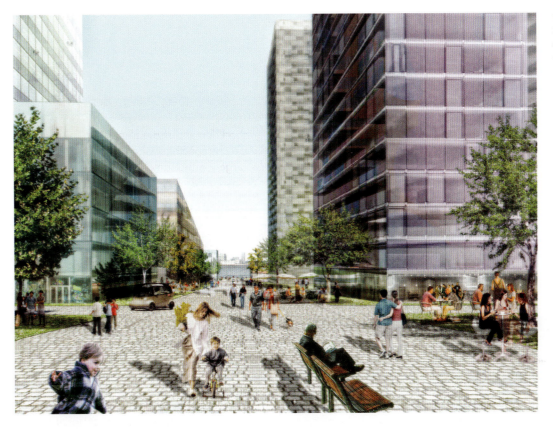

12 Almere 'Structure Vision 2030', Almere Pampus street scene of the coastal community, MVRDV.

ground floors and part of the office and apartment buildings are designed to facilitate future change of use, enabling Stadgenoot to adjust the district to the changing needs of inhabitants. The housing association has temporarily pulled out because of the recession, but this is not of major importance to the overall investment in 'Almere 2.0', because the main costs are for transport infrastructure and the ecological side of the plan.

Giving citizens the freedom to build their own house in Almere is 'a very successful way to deal with the recession', says Meijer. 'It gives a huge diversity at a small scale', and 'is very independent of the large building institutes' which drive 90 per cent of new housing and whose projects are now largely on hold due to an unwillingness to invest in an uncertain climate. This approach is quite new in the Netherlands, he maintains, while it has been common in Belgium for decades. Adding off-grid energy systems to catalyse the plan is also part of this plan. Every city in the Netherlands has had to deal with the recession and councils have been looking at Almere's 'Structure Visie' plan since it began four years ago.

The city has always experimented with different kinds of housing types during its 34-year history. Its separation of different types of traffic and widespread single family neighbourhoods into concentrated suburban settlements lacked high quality urban spaces. Population growth to the current 188,000 inhabitants, making it a medium-sized city, led to the need for 'a quantum leap', OMA argued in 2007, 'from an agglomeration of distinct "equal" centres, each with its own concentration of facilities, to a city with a recognizable hierarchy in the programmatic development'.[5] That new programme was embodied in OMA's 2007 masterplan (in design development

5 This stemmed from the 'Ruimtelijke ontwikkelingsstrategie Almere 2015' (ROSA), Almere, 2006, a development strategy commissioned by the city council by Riek Bakker, which was received well, but then put on hold. Bakker, as Director of Urban Development for the Municipality of Rotterdam, from 1986–1991, headed the elaborate masterplanning process for Kop van Zuid, the industrial area being vacated by the Port on the south side of the river, to combine both sides as a unified CBD.

since 1994), sited between the town hall square and the boulevard alongside Weerwater, and, second, between the station and the planned Nelson Mandela Park. A second pedestrian level and new functions were introduced to create a higher density and new animation underlining Almere's new status, differentiated from the existing, low-density retailers and offices, and giving the low rise, polynuclear Almere the form and identity it needed.

Unlike the 70-hectare masterplan that OMA made for Euralille in Lille, France, a civic and business centre, and central node of Europe's high-speed network, which modernised the existing city, at Almere OMA's layered masterplan opened the door for new mega-blocks, apartment buildings, a theatre, leisure facilities and retail units designed by a mix of local and international architects, including SANAA, Christian de Portzamparc, Gigon Guyer and David Chipperfield. In tandem with this, the 'Gewild Wohnen' (wished living), was a scheme[6] in which individuals commissioned architects, including Laura Weeber and Architekten Cie, to design their future homes, working in unusually close collaboration. This followed the evolution of new neighbourhoods with individual narratives: the Reality, the Fantasy, the Film Quarter, the Eilandenbuurt (Island District), showing that customisation via an urban laboratory of ideas by residents keen to have a hand in thematising their living spaces, had more validity than repetitive suburban density and appearance.

It is therefore part of the DNA of Almere that, as the draft Vision Almere 2.0[7] states, responsible growth is 'primarily created by the people themselves'. Almere is positioned as 'a national demonstration site for the implementation of large-scale sustainable systems', and Almere 2030 will entail a further 'quantum leap', as Meijer from the Gemeente Almere, who has been involved in Almere's development since 1981, put it at the 2009 launch (involving a large exhibition at Almere Port). This will incorporate 'cradle-to-cradle' solutions recognising the interdependence at all scales of the city of ecological, social and economic health, deriving from collaboration with the American sustainability expert William McDonough.

The value of having evolved and clearly expressed principles, as Almere 2.0 defines in a single compact document, is that they serve as continual reminders and an automatic point of reference in any dialogue between citizens and the council. Groups of people can come together to scrutinise a principle, and if it proves lacking, they can take action as well as comfort from knowing that it is prototypical, and not yet legislation. Usually it is part of a wish list. In the public consultation concerning the Almere Principles, one person apparently stated that 'my goal is that people should want to live in this city because of the Principles'.[8] Quite rightly, there was public criticism that too much emphasis was being placed on the spatial aspects of new neighbourhoods and not enough on the social dimension. There were also wishes for the already promised urban agriculture to be developed, as well as for Almere to be a Dutch Silicon Valley for sustainable business, prioritising creative businesses and affordable office space tenancies.

When it comes to the MVRDV masterplan, its huge strength is the distinction made between high, middle and low density. 'There is a lot of middle density in the Netherlands,' says Jacob van Rijs of MVRDV.[9] Almere is one of the few Dutch cities with space, but it has a lot of mono-functional suburban houses. It also has a balance of green and built areas, and will be less dense than the average VINEX development, more of a kind of 'Frank Lloyd Wright prodigal city', adds Rijs, who may have in mind the American architect's 1932 Broadacre City which differentiated housing types to suit all people.

The structure vision was launched in June 2009, after the plans had been germinating in secret for about a year. Since then, there has been much public debate, and in November 2009 the Dutch government decided in favour of the structure vision; not a final decision, but an affirmation, subject to a satisfactory plan for investment currently being worked out. According to Meijer, one of the most appealing aspects of the structure vision to central government is the fact that it is flexible, and can be speeded up or slowed down.[10]

6 An initiative of Arie Willem Bijl, the Alderman before Adri Duivestijn, with project director Hans Laumans.
7 MVRDV and the Municipality of Almere, *Almere 2.0: Structuurvisie,* July 2009.

8 Municipality of Almere, *The Almere Principles,* 2008.
9 Interview with the author, 2010.
10 Interview with the author, 2010.

'It's a reaction to VINEX,' he explains. 'VINEX was quantity-driven, with a lack of diversity.' While Almere was all totally planned – a new area, in a new polder – as a production-driven development, now in the next step to double the city in the long term, it seems that Almere's city council is 'searching for the unplanned', as Meijer puts it. It is one of the first demonstration urban developments in the Netherlands involving a new sustainable logic; Venlo, which has the Floriade, is the other, but Almere is far larger. While other cities have made investments in older systems, Almere has the possibility to grow in a state of the art manner, and – unlike in the past – to benefit from the fact that its backbone of objectives and issues arising were very publicly discussed.

13 Almere Oosterwold: the development strategy anticipates the organic growth of a rich mix of initiatives with a green agricultural character, MVRDV.

13 Almere Oosterwold, mixed use development including plots on which individuals can construct homes, MVRDV.

Longgang, Pearl River Delta, and Qianhai Port City, Shenzhen, China

China aims to build 400 new cities by the year 2020 – the equivalent of 20 cities per week – to accommodate its huge migratory rural population. This has spurred a fast track urbanism producing new cities in the shortest imaginable time, and completely changing the faces of the older towns and urban districts. Performance and functionality have given way to genericism and copycat styles of satellite towns[1] in this unprecedented wave of project development. There may be 5000 years of Chinese history but demolition has additionally

1 For example, Thames Town, one of the nine new towns Shanghai's urban planners have created to resettle 500,000 people in the suburbs, with reproduction half-timbered Tudor houses, an Italian town with canals based on Venice or a German town designed by Albert Speer.

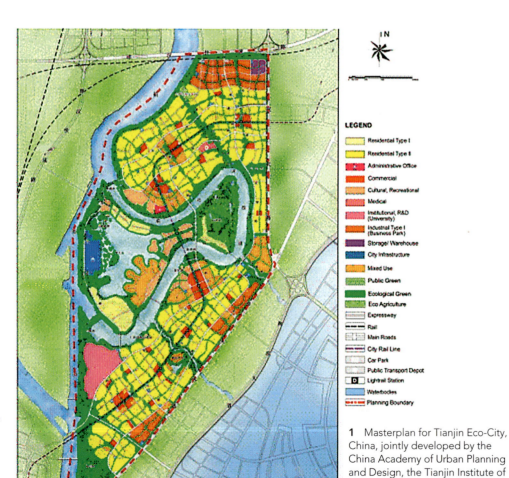

The Master Plan of the Eco-city

LEGEND

- Residental Type I
- Residental Type II
- Administrative Office
- Commercial
- Cultural, Recreational
- Medical
- Institutional, R&D (University)
- Industrial Type I (Business Park)
- Storage/ Warehouse
- City Infrastructure
- Mixed Use
- Public Green
- Ecological Green
- Eco Agriculture
- Expressway
- Rail
- Main Roads
- City Rail Line
- Car Park
- Public Transport Depot
- Lightrail Station
- Waterbodies
- Planning Boundary

1 Masterplan for Tianjin Eco-City, China, jointly developed by the China Academy of Urban Planning and Design, the Tianjin Institute of Urban Planning and Design, and the planning team of Singapore Urban Redevelopment Authority.

created a physical and spiritual loss: in existing cities, Beijing, for example, the last remaining high-density heritage districts with their traditional lane houses have been demolished to make way for new developments.

But after more than a decade of often reckless urbanisation, a new five-year plan is placing more emphasis on sustainability, with eco-cities at the heart of future development, and many planned, for example, the Sino-Singapore Tianjin Eco-City, 40 km from Tianjin, which broke ground in September 2008, whose mixed-use masterplan, jointly developed by the China Academy of Urban Planning and Design, the Tianjin Institute of Urban Planning and Design, and the planning team of Singapore Urban Redevelopment Authority, is based on a 400m × 400m modular grid of 'eco-cells' and an 'eco-valley', and aims to strike a responsible balance between environmental protection and economic development.

This makes huge sense because, as one of the world's largest economies and the second largest energy consumer, China is where half the world's buildings will be constructed by 2015,[2] and building-related energy consumption accounts for 40 per cent of the country's total energy use. As a result, green building is paramount in China's 11th Five-Year Plan. The Pearl River Delta strategic plan, formulated by Guangdong Province in 2008, was one of the first to address sustainability. When it comes to 'eco-cities' in China, the planned Dongtan Eco City scheme (masterplan by Arup) for a beautiful unspoilt wetlands habitat outside Shanghai was cancelled a few years ago by Shanghai Industrial Investment Corporation, or SIIC, a state-owned developer, after the land use term expired before permissions were achieved. But creating sustainable urbanisation to meet the needs of existing and future inhabitants with a minimal ecological footprint remains a pressing issue, and the World Wide Fund for Nature (WWF) launched low carbon development projects in Shanghai and Baoding in 2008. Numerous research laboratories and design studios interrogating China's rapid urbanisation and proposing design solutions exist, for example, the China Lab at the Graduate School of Architecture, Planning and Preservation, Columbia University,[3] or architect and founder of the Beijing-based Dynamic City Foundation (DCF), Neville Mars' BURB.TV collaborative research wiki on The Chinese Dream (the goal to create 400 new cities).

'Today's eco cities are designed on a framework of regulations that effectively prevent the most basic sustainable concepts – like the pedestrian-friendly city – from ever happening,' says Mars,[4] an approach that fails to take the leap of faith needed to achieve genuine sustainability. His concept of evolutionary planning has, with the input of five Dutch and five Chinese practices: Urbanus, MAD, Rocksteady, Powerhouse, MVRDV, BAU, Tsinghua School of Architecture, Urban China, ZUS and MARS Architects, led to a long-term growth strategy for Caofeidian in Tangshan, designed in relay, with each team adding to the previous proposal in three-year cycles by proposing an urban expansion of 100,000 people to achieve a city of 1 million by 2040. This, argues Mars, creates a city 'as the product of an accumulation of evolving ideas, able to emulate the complexity and organic logic of a slowly maturing city'. For each cycle, the Development Cooperation Forum (DCF) of the United Nations has indicated hazards which can affect the urbanisation process, from rising sea levels to changing wind conditions. The argument is that existing regulations need to be changed if even good planning is to break away from inefficiency, congestion and pollution and adopt new sustainable habits. The Caofeidian development plan includes the use of a range of renewable energy sources, such as wind, solar, tidal and thermal.

Applying an organic metaphor for urban growth is not part of masterplanning as it is traditionally understood in China, but hopefully the work currently being done in these areas will spur a new perception of its huge value when harnessed to the scientific, incisive approach and the very specific methodologies masterplanning needs to hold onto. Also, masterplanning involving social and economic research is still weak, and the process of public participation is not rigorous, claim authors Gu Chaolin, Yuan Xianhui and Guo Jing, in 'China's Masterplanning System in Transition', part of an ongoing research project on

2 Estimate source: the World Bank.

3 http://china-lab.org/.
4 Dynamic City Foundation, 'From Generic to Genetic: A Case Study in Evolutionary Planning', 2010.

China's urbanisation.[5] Seen in general terms, masterplanning since 2000 has certainly supported China's global vision for urban development, focussing on economic development, large-scale infrastructure, global economic networks and the development of the tertiary industries. Three new towns in the suburb of Beijing, for example, with manufacturing and high tech development bases, are planned to grow into cities with 700,000–900,000 people by 2020, a scale much in excess of that of typical American edge cities. But in terms of positive factors, since 2004, revisions to the National Constitution have brought in a wider range of legal rights for individuals, and urban planning cannot be undertaken without considering the opinions of various interest groups. Moreover, the new Regulating Plan of 2004–2020 calls for humanistic cities to include ecological and habitable qualities, rather than building new urban entities seen superficially as *grand projets*: the intention is for 'a micro, internal and intensified urbanity at a human and walkable scale'.[6]

Chaolin, Xiahui and Jing rightly also underline that urban planning, as a management science of the artificial and natural environments in transition, necessitates policy and project implementation, coordination between different interest groups, the ability to evaluate creative solutions, as well as discernment in matters of politics and morality. As Chinese cities aspire to be planned metropolises and urban competitiveness becomes vitally important, and the 'eco-city' model needs testing and evaluation, they wisely advocate adaptive planning modifying the usual methodologies – including in these challengingly complex areas – in order to facilitate environmental transformation as well as present meaningful responses to global economic demands.

GroundLab, an urban design practice based in London and Beijing, led by partners Eva Castro, Holger Kehne, Alfredo Ramirez, Eduardo Rico and Sarah Majid, takes an inherently multidisciplinary approach, seeing 'the cities and the landscapes in between as natural processes that constantly change and evolve', which therefore 'require flexible and adaptable mechanisms and designs to emerge, to configure and to reconfigure the existing and future urban environments'. Their work fulfils the adaptable planning model that China needs to avoid the disadvantages of fast track development-driven practices, and the team has been based in Beijing for a few years. Its members are working in various locations, including at Xi'an on the impressive International Horticultural Expo 2011, which opened in May 2011 (following Plasma Studio and GroundLab's competition win in 2009). They are also active in the Xisi Bei district, one of the 25 protected *hutong* zones in Central Beijing, subject to such development pressure that its historic *siheyuan* typology (like a quadrangle surrounded by four buildings) is threatened with extinction and traditional urban life reduced and in certain cases destroyed completely.

At Xi'an, the Expo was sited on a restored sandpit in the historic city and produced for its context a sustainable urbanism with 37 hectares of Flowing Gardens, with a reversal of the traditional relationship between ground and landscape into a symbiotic experience. At Xisi Bei, GroundLab aim to use the district's traditional system of urban organisation as a basis and starting point. Their project aims at the reinterpretation and growth of the Xisi Bei area by building a catalogue of a generative typology of four combined gardens to help 'breed' a broad domain of modular arrangements in the block of Xisi Bei. Their design demonstrates the versatility of adaptable design modelling techniques as part of masterplanning to create different options in an urban configuration, but applied in tandem with a set of cultural principles about the village as an identifiable and robust urban domain.

Deep Ground was GroundLab's winning entry for the international design competition for Longgang Centre and Longcheng Square. The project aims to regenerate 11.8 km² of the urban fabric in the centre of Longgang, north-east of Shenzhen in the Pearl River Delta, with an estimated population of 350,000 and 9,000,000m² of new development. A fast-growing district, the masterplan for the business district for Longgang City Centre, Shenzhen, by Dutch architects Mecanoo created the basis for a 24/7 mixed-use district. Currently in detailed development, Deep Ground radically expands the

5 Gul Chaolin, Yuan Xiaohui and Guo Jing, 'China's Masterplanning System in Transition: Case Study on Beijing', 46th ISOCARP Congress, 2010, part of a research project on China's urbanisation conducted by the National Natural Science Foundation (NNSF), China.

6 Ibid.

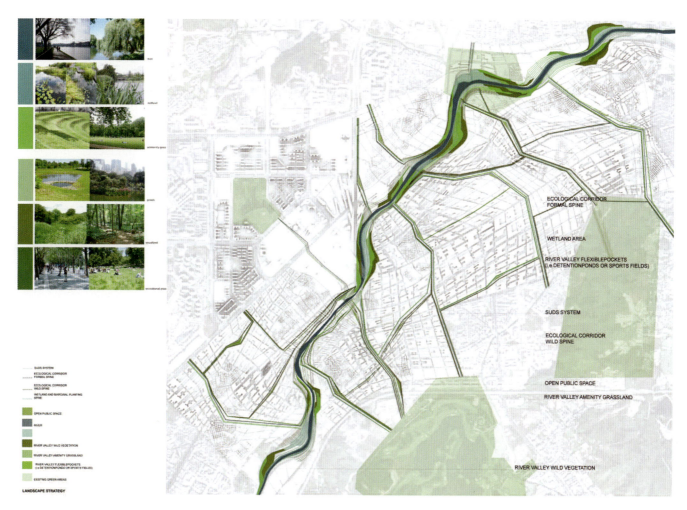

2 Deep Ground, Longgang, Pearl River Delta, China infrastructure landscape masterplan, GroundLab and Plasma Studio.

scope of urbanism in order to deal with the contemporary challenges of modern China. The partners explain that they do that through the concept of 'thickened ground' – multiple ground datums fused to foster intuitive orientation and connectivity. As a result, the polluted and neglected river will become an ecological corridor, while the existing urban villages are retained to form nucleuses to lend identity, vitality and human scale to the new development.

The proposal for the project is a practical deployment of the methodology currently used in the Landscape Urbanism Master's programme of the Architectural Association, London, which deploys multi-scalar strategies, bottom-up design, mapping of information and indexing territories, as well as relational urban models. The spatial strategy used for the implementation of the underground development in conjunction with public space design and the river crossing is based

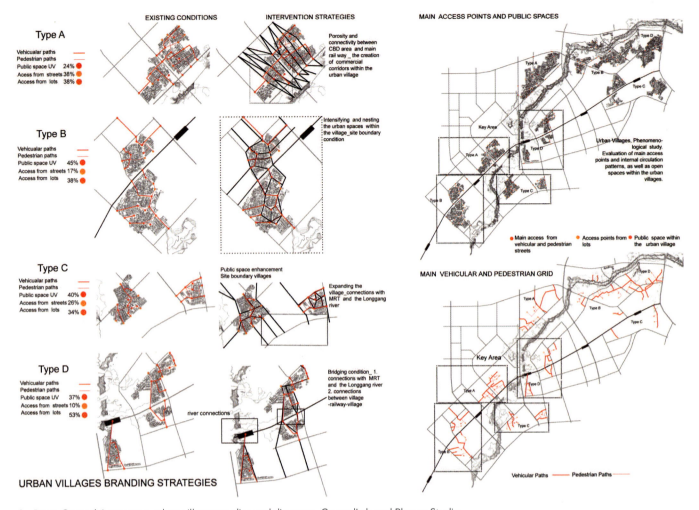

EXISTING CONDITIONS

INTERVENTION STRATEGIES

MAIN ACCESS POINTS AND PUBLIC SPACES

Type A

Vehicular paths
Pedestrian paths
Public space UV 24%
Access from streets 38%
Access from lots 38%

Porosity and connectivity between CBD area and main rail way _ the creation of commercial corridors within the urban village

Type B

Vehicular paths
Pedestrian paths
Public space UV 45%
Access from streets 17%
Access from lots 38%

Intensifying and nesting the urban spaces within the village_site boundary condition

Urban Villages, Phenomeno-logical study. Evaluation of main access points and internal circulation patterns, as well as open spaces within the urban villages.

● Main access from vehicular and pedestrian streets ● Access points from lots ● Public space within the urban village

Type C

Vehicualar paths
Pedestrian paths
Public space UV 40%
Access from streets 26%
Access from lots 34%

Public space enhancement
Site boundary villages

Expanding the village_connections with MRT and the Longgang river

MAIN VEHICULAR AND PEDESTRIAN GRID

Type D

Vehicular paths
Pedestrian paths
Public space UV 37%
Access from streets 10%
Access from lots 53%

river connections

Bridging condition_ 1. connections with MRT and the Longgang river 2. connections between village -railway-village

URBAN VILLAGES BRANDING STRATEGIES

Vehicular Paths Pedestrian Paths

3 Deep Ground, Longgang, urban villages studies and diagrams, GroundLab and Plasma Studio.

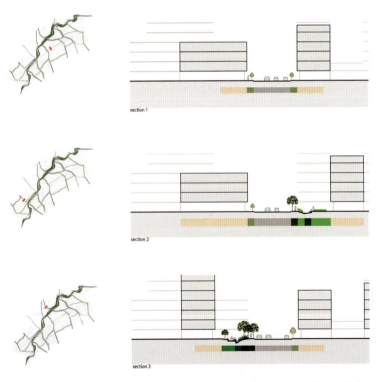

section 1

section 2

section 3

4 Deep Ground, Longgang, infrastructure landscape key sections, GroundLab and Plasma Studio.

on the notion of the ground 'as a surface which acquires thickness and spatial complexity as the different programmes and land uses start to combine', explain Castro and Kehn.

In this way, the thickened ground aims for a mixture of programmes rather than compartmentalisation of functions, working towards 'an open-ended spatial result which combines good quality open space with otherwise isolated infrastructural elements'. Here, the thickened ground emerges out of the bridge over the Longgang River, crossing north to Longcheng Square, then becoming a folded surface containing both public pro-grammes, underground access and parking for the CBD. It embodies a whole strategy to challenge the traditional opposition of building versus landscape, managing to introduce a 'surprisingly high density programme' into areas which are currently under-used, increasing the overall value, open space usage and intensity of life at the street level.

Longgang River is located at the heart of Longgang city but is radically separated from it, with no interaction or relation apart from being used as a back yard and wastewater sewer. The infrastructural landscape project worked from this contradictory urban condition, com-

5 Deep Ground, thickened ground, top view, CGI visualisation, GroundLab and Plasma Studio.

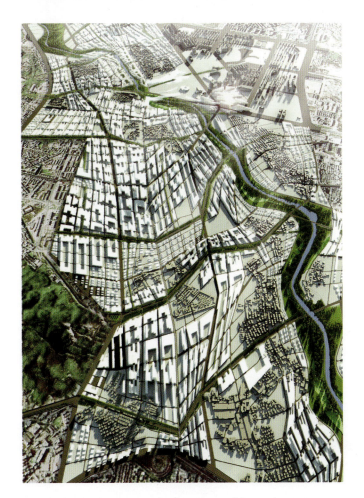

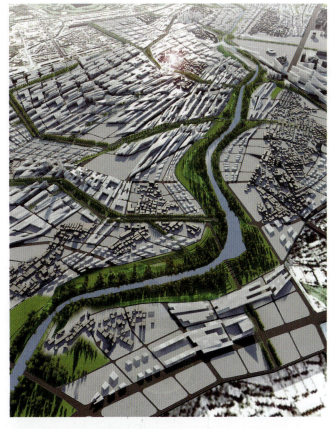

7 Deep Ground, Longgang, bird's eye view, CGI visualisation, GroundLab and Plasma Studio.

6 Deep Ground, Longgang, bird's eye view, CGI visualisation, GroundLab and Plasma Studio.

monly found the developing world over, to propose the recovery of the river, triggering revitalisation not just of its banks and surrounding areas but of the whole city, enabling the landscape, its greenery and the river to be one interactive and interconnected system.

The design for the infrastructural landscape incorporates river and waterscapes, ecological corridors, river valleys, considering aspects of biodiversity, connectivity, use and activity and character combined to produce an inspiring, accessible, safe, sustainable and contemporary environment. The infrastructure along the river is designed to serve as an anchor point to deploy cleansing strategies, rainwater collection and flooding defence while creating green areas, ecological corridors, public open spaces, sports fields and leisure areas. 'The landscape network creates a major framework to articulate the urban fabric, the public areas and the infrastructural equipment of the city and will be able to generate a great

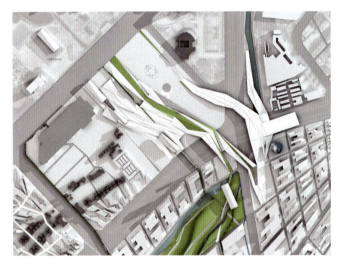

8 Deep Ground, Longgang, thickened ground, top view, CGI visualisation, GroundLab and Plasma Studio.

9 Deep Ground, Longgang, thickened ground, eye-level view, CGI visualisation, GroundLab and Plasma Studio.

10 Deep Ground, Longgang, thickened ground, eye-level view, CGI visualisation, GroundLab and Plasma Studio.

256

variety of programmes which do not exist or are in poor condition, linking the river to the neighbourhoods and with the city,' explain Castro and Kehn, underlining the fact that this will highlight the presence of the river in the city, not just as an aesthetic element but as a strategic, active and vital asset for its future viability. Making the best of the natural assets that already exist but need remediation and reconnection is something to which masterplanning today urgently needs to give consistent priority.

The key to the project is the concept of the urban village. The architects regard this as an urban typology which clearly defines the character and history of many cities in China, and Longgang in particular. They identified a set of urban villages as potentially interesting to preserve, and the project proposes

using these areas as part of a strategy for the generation of various urban identities across the site, providing certain characteristics and a sense of differentiation to help advance the city as a whole.

Urban villages worldwide tend to have a distinct character which attracts visitors, and the Dafan Oil Painting Village, also in Shenzhen is where an industry of production of painting replicas has generated an unprecedented interest from tourists, which in turn has sparked the arrival of different kinds of artists and creative professionals. Villages possess different characteristics, such as the presence of a market or prominent historical buildings, which make them unique, and GroundLab regards these as key in the management strategy of urban villages, as a way to anchor the urban life around them.

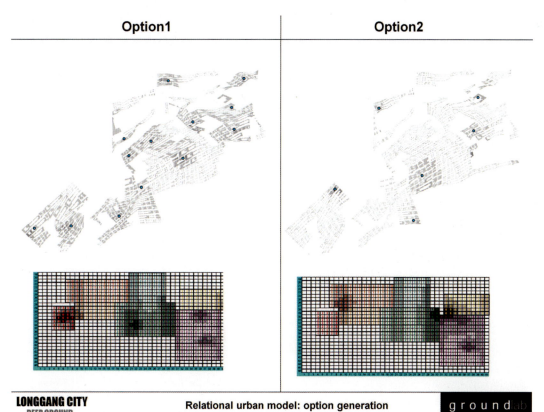

Option1　　　　**Option2**

LONGGANG CITY
DEEP GROUND　　　　　　Relational urban model: option generation　　　　**ground**lab

11 Deep Ground, Longgang, parametric model potential scenarios, GroundLab and Plasma Studio.

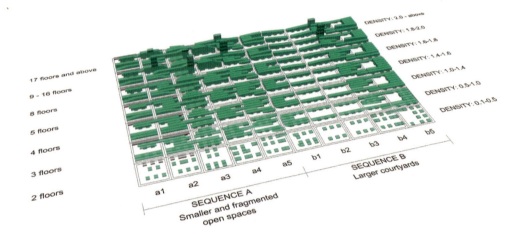

12 Deep Ground, Longgang, parametric model typology chart, GroundLab.

LONGGANG CITY
DEEP GROUND

Relational urban model: Typology definition

groundlab

The architects created a relational urban model which can simultaneously control built mass quantities as well as a 3-D model of the built fabric, based in sets of urban relationships. This enables different options to be generated quite easily, 'as most of the drawing gets automatically produced, while there is potentially the chance to evaluate the overall built volume before the volume is even generated'. It also enables the combination of variables related to density with variables related to typology, explain the architects. This can be used to produce varied and diverse urban patterns with simple controls. The volumetry of the proposed built fabric shown in the final drawing and renderings was modelled to suit the quantity of land use calculated in the Transport Chapter (around 9,000,000 m²).

As a result, a series of options allow GroundLab to study simultaneously the effects of different massing options in terms of GFA (m²) and spatial arrangement. The model allows different iterations, evaluating options in which the centre of

intensity of the model as well as the overall quantity of buildings are modified in order to produce a totally different, yet related, urban configuration. As a result, adaptable design as a concept can be made integral to the Longgang masterplan, with changes in different variables, for example, location and number of density nodes, particularities in building catalogue, and so on, can be added into the design almost in real time so that further discussion on the urban fabric and architectural qualities can be put forward during the decision-making process. Through these tactics, the obvious typological and historical references can be omitted while a contemporary, authentic expression of place and China's current and future ambitions can emerge.

Architects and masterplanners OMA recently prepared a masterplan for Qianhai Port City in Shenzhen, an 1804-hectare, former port site at the threshold of Hong Kong and mainland China. The city is strategically important in the Pearl River Delta, with planned intensification of transport through it assisting its

emergence as a new centre. The design regards Qianhai not merely as peripheral to Shenzhen but instead as a new centre. 'The question is not whether Qianhai will develop, but how? If successful, a new city centre could fulfil Shenzhen's coastal ambitions and establish a node for interaction between various components of the Pearl River Delta,' say the OMA team, as 'a platform for strategic and economic cooperation' between Hong Kong and Shenzhen. The existing port is a hub of infrastructure, transportation and logistics and these operations define much of the quality of the site and adjacent areas. A crucial point for OMA is that these conditions should not be suppressed or insulated from new development, but regarded as latent elements which can be used to form the identity of the new city.

The masterplan for Qianhai, as outlined in a 98-page document for the clients Shenzhen Urban Planning and Land Resources Committee, dated 10 June 2010, has three closely related programmatic anchors: logistics, education and healthcare. Their interrelationship by means of innovation and research enables Hong Kong and Shenzhen in their economic cooperation. The programme also extends to five other activities accommodated spatially: residential, offices, culture, retail and hotels. Instead of keeping these eight overall programme types separate, the distribution formulated by the plan overlaps them to generate a diverse mix comparable to neighbouring

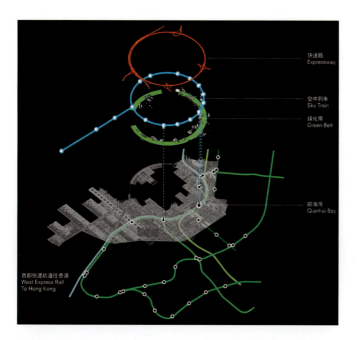

13 Exploded view of the transport loop of the Qianhai Port City masterplan, OMA.

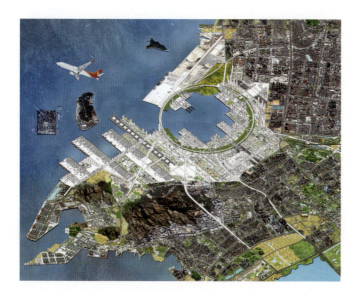

14 Concept of masterplan for Qianhai Port City, OMA.

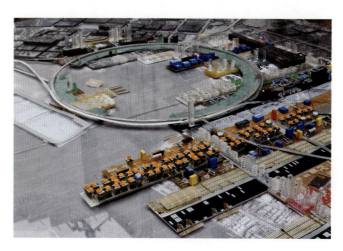

15 The port, model of the Qianhai Port City masterplan, OMA.

16 Port and logistics area, model of the Qianhai Port City masterplan, OMA.

17 The port, model of the Qianhai Port City masterplan, OMA.

regions in the Pearl River Delta and other developments in Asia and the world, so that 'every programmatic typology finds its most appropriate locations and retains an efficient coherence with the whole', states OMA.

The plan is one of OMA's most beautiful, and most elegantly visually documented for an entire city, with the site arranged in a series of parallel bands running east–west, and the irregular extension of these layers into the Qianhai Bay and Pearl River Estuary creates piers and brings the city closer to the water. The layers constitute a stack of varieties of types of juxtaposed spaces, each with their own architectural typologies, density and landscape condition. On top of the layers is a loop, a distinctive element that consolidates infrastructure, transportation and circulation, delimiting the Qianhai Bay and relating the context to Shenzhen's other centre, as well as redirecting the major expressways and carrying the Skytrain. At 3.4km in diameter, and 250km wide, Qianhai contains a huge continuous park and other public elements adjoining this natural habitat. New north–south trajectories transect the layers in a perpendicular fashion and enable the bands to work together while keeping their separate identities, for example, the area to the south of the site is connected by a spine for freight, but which also creates programmatic overlaps across the layers.

The parallel bands constitute Qianhai's 'hardscape', but also – in addition to the green band – part of its green 'softscape', with botanical gardens, nurseries, herb gardens, sports fields, bamboo groves, an orchid park, a wetland park and meadows. Transport planning is based on providing accessibility rather than fast mobility for minimum negative environmental impact. Several expressways are planned to cross the sea combined into a circular layout, with a clear rationale underlying numbers of lanes, distribution roads and junctions. The complementary infrastructure of a suspended monorail, underground Metro lines, a PRT network, pedestrian and cycle routes is also dealt with in the masterplan document, along with coastal environment and water quality plans and scope for port and marina facilities as part of the potential expansion provided for. The strategy calls for some behavioural changes, including reduced demand for transport through increased home working and local group working, encourages cycling, walking and public transport to minimise car usage and dependency and encourage car sharing, and Intelligent Transport Systems (ITS) to minimise the length

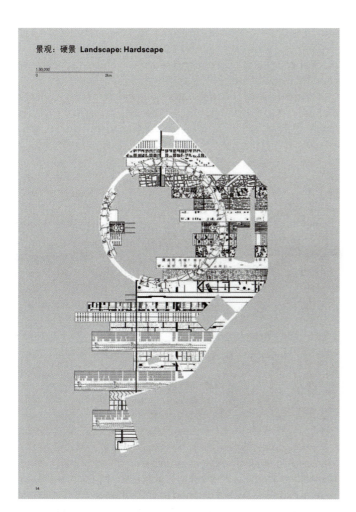

景观：硬景 Landscape: Hardscape

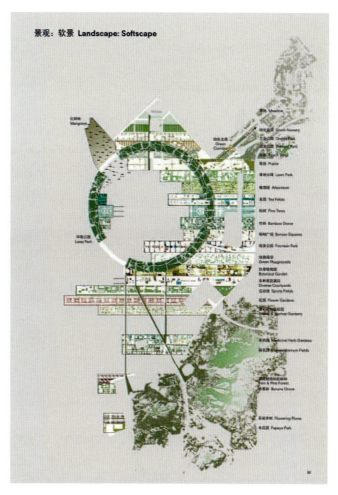

景观：软景 Landscape: Softscape

18 Qianhai Port City: the city's 'hardscape' in bands with different typologies at various densities, OMA.

19 Qianhai Port City: the city's 'softscape' facilities which are largely but not entirely arranged on the bands of different typologies, OMA.

and number of trips, congestion and environmental impact. Precincts are planned to create energy, water, nutrients and life benefits. The Qianhai coastal area is on mostly reclaimed land that is generally flat or at an elevation of 4–6km with abundant wind energy, and the plan will introduce environmentally responsive design, offshore wind farms and turbines.

Qianhai is envisioned as the first port of education in China, a newly generated education hub accommodating institutes

from Asia, Europe and the USA, as well as campuses of those from universities in Hong Kong which lack land on which to expand, a focus that will catalyse the growth of the other programme anchors and industries. Additionally, a large-scale specialist healthcare facility will make up for the lack of facilities in Shenzhen.

The phasing plan is a critical part of the concept, planned as a long-term development strategy over 15 years, with three

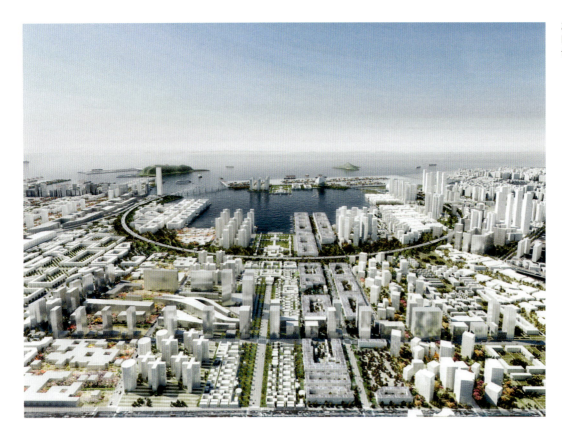

20 Visualisation of Qianhai Port City, looking towards the transport loop, OMA.

phases of five years each carried out at two distinct scales: city and neighbourhood. The scale of the city aims to produce the overall identity of Qianhai with 'large, deliberate and strategically planned gestures', while the scale of the neighbourhood attempts to refine the city's urban character in a free and idiosyncratic way. During the course of the three phases, low-density logistics are gradually replaced by high-density urban programmes 'to establish its centres and thresholds and mature and strengthen its internal structures' as spatial demands increase from all the anchors and their supporting programme.

OMA's sustainable masterplanning projects include Zeekracht, a plan of offshore wind farms in the North Sea, completed in 2008, and Roadmap 2050, a masterplan for an integrated European power grid based on renewable energy, both overseen by OMA partner Reinier de Graaf. For the

execution of their proposed masterplan for Skolkovo, Russia's Silicon Valley 20km outside Moscow, OMA offered its expertise in masterplanning with a body of work in sustainable design and large-scale renewable energy planning by its AMO arm, which advances a range of agendas. In order to ensure maximum innovation also at an urban level, the plan will also serve as a test bed for technologies developed, seeking the participation of resident companies in the development of innovative solutions for energy saving, recycling, transport and communications systems envisaged as exportable to other parts of the world, including China.

The series of studies that Rem Koolhaas, OMA's co-founder, oversaw at Harvard University (Graduate School of Design) during the late 1990s and early 2000 under the title of 'The Project on the City' included volumes on the unprecedented

hyper-urbanisation of the Pearl River Delta in China, which he has described as a 'dispassionate' focus on 'empirical givens' to help dislodge the discourses of the day which were more about architecture's critical autonomy.[7] He maintains a desire for architecture to 'regain its instrumentality as a vehicle of modernization'. Masterplanning – seen as a prime integrative and reconciliatory conceptual urban mechanism for the evolution of the natural and artificial environment – is shown in the Qianhai masterplan as an intelligent, advanced mode of thinking – neither hermetic nor single track – about a direct engagement with the identity of a port, and how it could usefully and stimulatingly be reshaped in relation to future needs.

It is also a connective concept. 'In the current 5 year plan, the new approach to improve urban competitiveness is city agglomeration',[8] said Chen Xiaohui, Deputy Chief Planner, Jiangsu Institute of Urban Planning and Design, in 2012.

'This is what is fascinating with China, whatever its faults: that it's still an effort to apply design at an unimaginably ambitious scale,' said Reinier de Graaf in 2008.[9] In an urban context in which building is the first impulse of developers, it is moreover the hybridised mindsets characterising such a masterplan that are fascinating, and lead the city into a new direction, an intense virtual architectural speculation about the real that is embedded in an evolutionary, rather than a fantastic, sense of the world.

7 Interview with Rem Koolhaas and Reinier de Graaf by David Cunningham and John Goodbun, Radical Philosophy, 30 October 2008.
8 At the New Cities summit, Paris, May 2012, staged by the New Cities Foundation.
9 Ibid.

Smart Cities: Rethinking the City Centre, Brisbane, Queensland, Australia

Brisbane, Australia's third city, long regarded by locals as a 'big country town', is the country's growth epicentre, recording a weekly influx of 1800 people.[1] While historically from the 1970s onwards, the city grew outwards like a pancake, now the expansion is in density, height and texture in key locations. For the first time in the city's history, interrelated strategies from the macro to the micro level are emerging – from the SE Queensland Regional Plan to the new City Plan, the River City Blueprint and the Neighbourhood Plan.

Since the original historical layout of the city in 1859 when it became the capital of Queensland, there had not been any masterplan for it, even though the World Expo in 1988 brought new facilities, strengthened its identity and left citizens feeling more relaxed about public space. At the time of its founding, there was a feeling by the city fathers that Brisbane only needed narrow streets as it would never be more than a colonial outpost and therefore did not warrant the grand boulevards of Sydney and Melbourne. Around the inner grid was even an outer grid called Boundary Street where 'undesirables' were not allowed, a reference to the aboriginal people, and the off-putting street name still exists.

1 Figures from HEAT, a Queensland Government Initiative by the Creative Industries Unit, Department of Employment, Economic Development and Innovation.

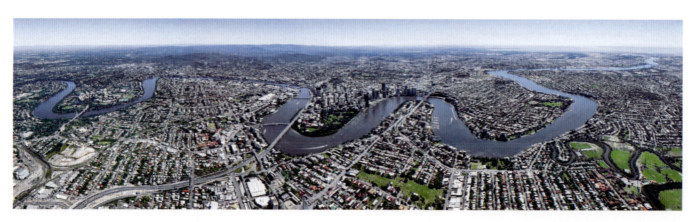

1 View of the Brisbane City Centre looking north. Brisbane City Centre consists of a series of peninsulas defined by the serpentine course of the river.

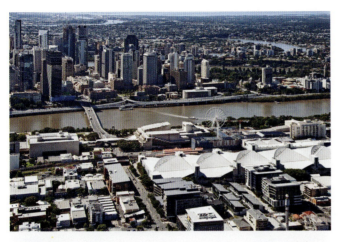

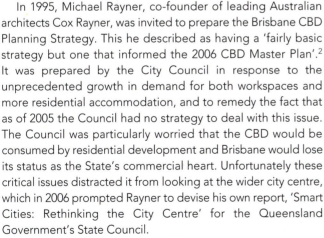

2 Brisbane, view of Brisbane CBD from South Brisbane: the freeway-lined waterfront on the CBD side is proposed to be revitalised as an under-freeway precinct.

3 Brisbane, view of Brisbane CBD from South Brisbane. The city centre comprises a series of 'peninsulas' defined by the serpentine course of the Brisbane River.

In 1995, Michael Rayner, co-founder of leading Australian architects Cox Rayner, was invited to prepare the Brisbane CBD Planning Strategy. This he described as having a 'fairly basic strategy but one that informed the 2006 CBD Master Plan'.[2] It was prepared by the City Council in response to the unprecedented growth in demand for both workspaces and more residential accommodation, and to remedy the fact that as of 2005 the Council had no strategy to deal with this issue. The Council was particularly worried that the CBD would be consumed by residential development and Brisbane would lose its status as the State's commercial heart. Unfortunately these critical issues distracted it from looking at the wider city centre, which in 2006 prompted Rayner to devise his own report, 'Smart Cities: Rethinking the City Centre' for the Queensland Government's State Council.

Only looking at the CBD peninsula was myopic and missed potential in seeing it as part of a wider city centre. The Brisbane CBD Plan calls this wider area the City Frame but, apart from nominating 19 districts, it did not seek to understand the strategic distribution of commerce and living space over this

wider area. Had this been done, Raynor feels that other conclusions might have been forthcoming, rather than the need to declare unlimited heights in the CBD. 'The Council identified 19 or so urban village precincts to try and deal with the development surge but this worried me as they were seen as neat, independent parcels, not as part of a wider, better integrated urban environment.' Also, developers were actively looking at options in the wider city centre as much as those at CBD, but there was no strategy to deal with that.

Apart from the creation of the 19 districts, the CBD masterplan aimed at shedding Brisbane's residual 'big country town' image through compactness and accessibility, including a new mass transit system. It did not consider impacts and opportunities for precincts further out, such as Woolloongabba, actually only 1km from the CBD, now undergoing a similar rejuvenation to that of the inner city Fortitude Valley district ('the Valley') north-east of the CBD, known as one of the city's nightlife hubs. 'Smart Cities' mapped 30 or so precincts across the city, concluding that 'nearly every major urban renewal precinct abutted a significant health, cultural development or other "knowledge" precinct'. However, Rayner points out that his own Smart Cities Plan adopted a 5km 'ring' as the city centre and did not look beyond that. His reasoning was that the 'ring'

2 Interview with the author, 2010 and 2011.

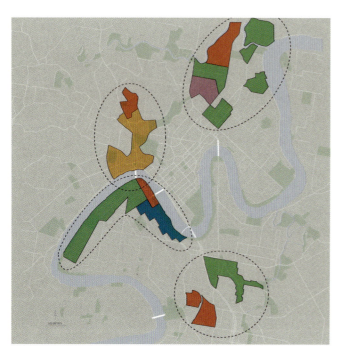

4 Brisbane: Prior to the Smart Cities strategy, urban renewal encompassed nearly 30 different districts largely due to different jurisdictions. This meant fragmented planning, and each was conceived as a so-called 'urban village', isolated rather than considered as integral to a cohesive future. Green = City Council; Dark Green = Statutory Authority; Red = State Government; Orange = Joint Council/State Government; Purple = Not for Profit Organisation, Cox Rayner Architects.

5 Brisbane: 'Smart Cities' Report, Cox Rayner Architects. Cox Rayner proposed recasting the districts into four clusters, each collocating major urban growth with knowledge and research precincts. This structure simplified planning, enabling each cluster's team to consider the whole plan and consult with the others. Orange = City North (Bowen Hills, Royal Brisbane Hospital, City Showgrounds); Green = City West (Kelvin Grove, QUT Campus, Auchenflower); Blue = South Brisbane Riverside (Kurilpa Precinct, City Cultural Precinct); Purple = City South (Woolloongabba, Princess Alexandra Hospital, Ecosciences Precinct, linked to University of Queensland).

comprised the great majority of future developable, and/or redundant industrial land, over all the major health and knowledge precincts, as far as the team was able to examine.

Rayner's sense of the lack of plan prompted the architect to embark on creating his own Smart Cities Plan. 'My worry was that the Queensland Government had developed a South East Queensland Regional Plan for its rapid growth – Australia's fastest – and the only other plan was the Council's for the CBD. Nothing in between.'

His own notion of a valuable masterplan is one which 'predicates and describes a series of actionable projects, having

undertaken the studies – environmental, social/inclusive, economic, physical, demographic – which generate those projects'. The measure of value accruing is, first, when the projects are actually undertaken and, second, whether people embrace them. He accepts that the tendency has been for most masterplans to become rapidly obsolete. 'A sceptic can rightly point out that few cities or precincts bear resemblance to their masterplan, and if they do, they tend to have only adopted their two-dimensional planning, for example, in cities in China, with little qualitative aspect nor diversity,' says Rayner. 'We all know the towns and cities we most adore are unplanned and accreted

6 Brisbane: 'Smart Cities' Report, Cox Rayner Architects diagram illustrating the positions of the city's major education, research and cultural precincts, noting that they form a distinct 'corridor'. Until this point, it was not recognised that the major urban growth of Brisbane closely relates to this corridor.

7 Brisbane: 'Smart Cities' Report, Cox Rayner Architects. 2006 diagram by KPMG showing the zones where major urban density was forecast to occur (orange), irrespective of planning intervention.

over time', which presents most masterplans with a constant challenge.

As to the decisions about what is to be built where, the Smart Cities Plan – like most commissioned plans – embodies decisions based on an identified need and a piece of land found for that purpose. Rayner mapped public and redundant land together with private 'redevelopable' land, knowing that this was where 'the growth must occur', and prepared a reasonably flexible series of use scenarios. He argues that it is difficult to post-install public transport and pedestrian link infrastructure, so the smartness in the plan comes from identifying where they can most readily – and at least in terms of social/environmental impact – be installed, and then see what land adjoins these corridors, and what uses can be positioned along them. This represents the reverse of locating uses –

residential, office, shopping centre, research, hospital, cultural – and then struggling to connect them.

Rayner's Smart Cities Plan stimulated Brisbane City Council to prepare the new wider City Plan (draft Strategic Plan, a broad vision for future growth and development for the next 20 years) and the current River City Blueprint (the Council's replacement name for the Smart Cities Plan), on which Rayner is currently assisting as an advisor. Within these are a whole raft of so-called Neighbourhood Plans (precinct plans), which are well coordinated, an advance from 2007.

The Council has assessed on a ratio basis that for the 138,000 new dwellings Brisbane will build over the next decade, a specific amount of recreational open space has been marked on a map of the main growth areas. Rayner personally favours a different approach: to instead develop an actual open space

8 Brisbane: 'Smart Cities' Report, Cox Rayner Architects. This diagram corresponds to the major urban growth precincts as they are now planned with the primary research and tertiary education precincts already existing and expanding.

9 Brisbane: 'Smart Cities' Report, Cox Rayner Architects. Diagram illustrating a series of primary pedestrian corridors (purple) to connect the urban growth precincts across the city's serpentine river requiring a number of new bridges.

plan which studies the existing open spaces, and sees what is lacking, for example, what connections and new parks, which together will add up to more than an area/ratio approach. This strategy, he feels, is especially valuable, for it considers also the accompanying issue of where land for open space is actually available or not, in ensuring certain areas are not developed but are retained for open space.

'Smart Cities' underlined how important it was to recognise the ways in which each precinct was different. Some, like the Coopers Plains Food Sciences Precinct, are purely for research and industry; some are for commercial, residential and retail purposes, like the Newstead River Park and Hamilton North Shore. Others mix research and living, for example, Kelvin Grove Urban Village, a 17-hectare site 2 km from the CBD, dubbed 'Australia's first fully integrated inner-city masterplanned community'. Others are health-focused, like the

Princess Alexandra Hospital precinct, which encompasses the Translational Research Institute and the Mater/Queensland Children's Hospital precinct.

The Smart Cities strategy sought to identify how the knowledge-based precincts could form an interconnected network by proposing new physical and operational linkages. It also studied how the precincts could be collocated with new population growth areas into 'clusters', so that the precincts were involved with the life of the city rather than being set apart in 'ivory towers'.

Rayner feels one of the most promising clusters to date is the '109 Central' cluster on the north side of the city centre, which links Queensland University and the Kelvin Grove Urban Village with the Royal Brisbane Hospital/University of Queensland Health precinct, and with the RNA Showgrounds and Bowen Hills urban renewal precincts. Nearby is the proposed high-

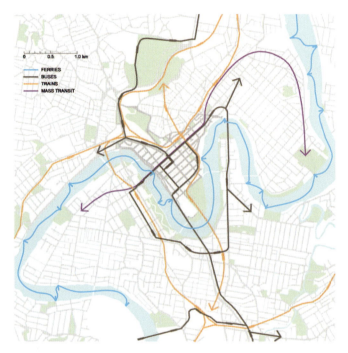

10 Brisbane: 'Smart Cities' Report, Cox Rayner Architects. Diagram illustrating a variety of options for light rail loops and lines, corresponding with the city's rapid ferry (Citycat) system. Subsequently the Queensland Government announced a new heavy rail corridor to run north–south through the city centre, with stations located in each urban growth precinct.

density mixed use Newstead River Park, on the 17-hectare site of a former gasworks. 'These clusters have the potential to "brand" Brisbane as a genuinely integrated "New World" city for the knowledge economy,' says Rayner, suggesting they be named either SynchroCity North or South.

Another cluster example is a trio of urban villages of living and working populations related to the Busway Station. Here the Nathan ovals to the south 9 km from the CBD are being redeveloped as the new innovation park linking this campus with the QEII Hospital/Coopers Plain Foods Sciences precinct, which becomes the University's sports centre. 'Taking what exists and seeing the greater potentials, rather than imposing some form of new order, is, to my mind, what will underpin the "New World" city Brisbane is seeking to be,' says Rayner.

11 SW1 Precinct, Brisbane, masterplan, Cox Rayner Architects.

12 SW1 Precinct, Brisbane, masterplan, Cox Rayner Architects.

13 James Street Market, Brisbane, Cox Rayner Architects.

15 Brisbane, the SW1 precinct was masterplanned by Cox Rayner Architects and sits opposite the practice's Brisbane Convention and Exhibition Centre (1996). The SW1 site was originally intended for Exhibition Centre expansion but was reclaimed in 2006 for mixed use urban renewal.

16 Brisbane, urban renewal of South Brisbane has begun – this precinct SW1 won the 2011 Australia Award for Urban Design, Cox Rayner Architects.

14 Brisbane, James Street Market, Cox Rayner Architects, part of the revitalisation of Fortitude Valley in the Brisbane North Precinct.

In the past decade, the city has enhanced its assets hugely, creating the cosmopolitan Emporium/James Street precinct in 'The Valley' designed by Cox Rayner, the Oxford Street Bulima, Baroona Street Rosalie, and other destination precincts to add to what before solely consisted of the CBD and Park Road at Milton, none of which are dependent on the river.

Meanwhile the riverside precincts have also dramatically improved, most notably among them South Bank, expanded and revitalised – in a city that lacks architectural icons – to include two well-designed buildings, the Gallery of Modern Art (designed by Architectus), and the redeveloped State Library of Queensland (by Donovan Hill), and also the upgrading of

17 Kurilpa Bridge, Brisbane, Cox Rayner Architects.

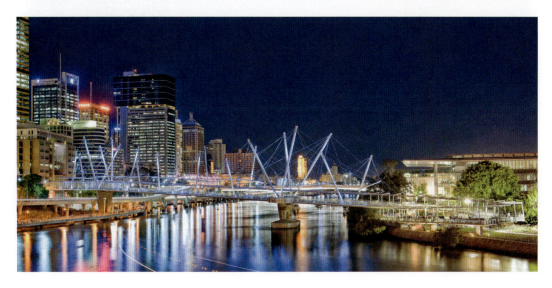

18 Kurilpa Bridge, Brisbane, Cox Rayner Architects.

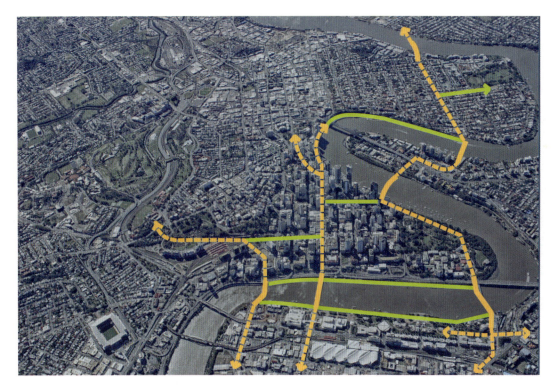

19 Brisbane: 'Smart Cities' Report, Cox Rayner Architects. Diagram promoting three main pedestrian corridors through the city centre, each requiring new pedestrian bridges. Two of these – the Goodwill Bridge and the Kurilpa Bridge – have already been constructed.

QPAC. Small-scale urban realm upgrades have included the Vibrant Laneways programme alongside investment in transport infrastructure, roads, hospital and education facilities.

Connectivity is as important an aspect of 'Smart Cities' as place-making since they feed each other. Rayner approves of projects such as the Council's linking of Russell Street to South Bank to West End's Boundary Street, and advocates the interconnection of pedestrian, cycle and ferry through a cohesive series of pedestrian and cycle bridges. Cox Rayner, with Arup, designed and built the Kurilpa Bridge (2009; a rare tensegrity structure) and Goodwill Bridge crossing the city's serpentine river, which have introduced pedestrian corridors of great potential to the legibility of the city centre, where densities of living are also connected with those of workplaces. These connections are significant in an era when Brisbane has started to celebrate its river after 200 years of neglect, and developers are now building a broad range of accommodation

focusing on the riverside benefits of amenity, views, ventilation and natural light, as well as getting its CityCat boats running between the University of Queensland in the south-west and Apollo Road in the north-east.

New facilities like QUT's Creative Industries Precinct at Kelvin Grove, a creative hub including facilities for start-up firms, play a role in boosting inner city cultural life. Gentrified districts such as Teneriffe with its industrial heritage of Woolstore warehouses converted into apartments or New Farm, where conversions of Queenslander houses are common, 'the Valley', in which apartments predominate, or Balmoral, just 4 km from the CBD, typify what Australian urban historian[3] Bernard Salt calls the shift from suburbia to a more European 'apartmentaria' lifestyle, reflecting also a growing diversity in groups to be catered for.

3 See http://www.bernardsalt.com.au/.

20 Brisbane: Knowledge Precinct Network, Cox Rayner Architects. The planning for a series of interconnected urban renewal and 'knowledge precincts' has been expanded to encompass all of South East Queensland from the Gold Coast to the Sunshine Coast. This diagram identifies a network of existing and proposed knowledge clusters.

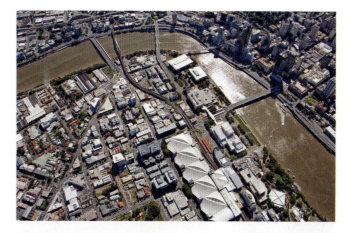

21 Brisbane: the aerial view of the South Brisbane precint which is now planned to become the city's second CBD across the river from and linked by new bridges to the existing CBD.

Architects are exploring how higher densities of housing, with flexibly designed spaces, can meet needs, as people embrace the sub-tropical city and its social fabric.

The first corridor extends from South Bank/South Brisbane through the CBD to Kangaroo Point, New Farm and Bulimba, via the Southpoint TOD (Transit Oriented Development), the Botanic Gardens and QUT Gardens Point, Kangaroo Point residential area, New Farm Park and the Brisbane Powerhouse. It interconnects with the CBD's 'golden triangle', and on the New Farm Peninsular with Brunswick Street and James Street. A second corridor links the proposed high-density South Brisbane Riverside Neighbourhood Precinct, a mini-CBD, to the revitalising main CBD North, to Roma Street Station and Parklands and onto QUT/Kelvin Grove Urban Village. A third

corridor links West End via Melbourne Street through Queens Street to the Valley and Newstead.

A lot of these plans now lie in the framework of the upcoming River City Blueprint, an overarching plan for Brisbane's inner city development which brings together Brisbane City Council and the Queensland Government in a coordinated initiative, as it also informs the core of a new, wider City Plan integrated with the South East Queensland Regional Plan. It will look at how inner Brisbane should develop over the next 20 to 50 years, and investigate the recommendations of the 'Smart Cities' report, along with other new ideas from the Council and the community.[4] There was a four-month period of public consultation with residents to share ideas, with 'Bright Ideas' forums held at various locations throughout the city. Rayner regards the River City Blueprint as 'the seminal strategy to generate a truly comprehensive framework of implementable actions for the inner Brisbane ring'. Its great asset is the extensive amount of preparatory work carried out to inform its structure with the

4 The River City Blueprint, a joint project of Brisbane City Council and Queensland Government's Department of Local Government and Planning. The project will be a non-statutory document that will inform the ongoing development of government policy and various city projects: http://brisbane.qld.gov.au.

goals of sustainability, prosperity, liveability, connectivity and inclusivity.

Triggered by the recent floods in the city, which was built on a flood plain, the City Council released a Flood Review Action Plan,[5] making reviews of standards for rebuilding an additional priority, especially in those suburban areas that were most severely hit. The enquiry conducted will empower the River City Blueprint team with knowledge about how large-scale flooding affects the city, and this will be incorporated into future planning, according to the Council. An agile, adaptive planning ethos is vital in such a scenario. Right across the board a lot of progress has been made since Rayner began formulating his 'Smart Cities' report. Plans for cities 'are only as good as their implementability and execution', adds Rayner, describing Brisbane's coming of age as one 'where how we design is what differentiates our city from the rest.'

5 24 May 2011.

Epilogue

This book is a meditation, among many other things, on the relative value of some viable modes of urban planning in the twenty-first century against a backdrop of reductivist practices. Each is geared to the challenges of an individual context, and, as a group chosen from across the globe, they inform and support each other.

In my study of these urbanist road maps for adaptive planning – since that is what Masterplanning Futures entails – I have been acutely aware that my own city of London has generated a huge range of plans from top-down to micro plans evolved by communities. Yet it seems that the guiding principles of The London Plan, an overall strategic plan for the city published in 2009[1] are the ones that the majority of people continue to refer to and be influenced by The Plan, now set to be updated by a new masterplan in 2012 under mayor Boris Johnson, with talk of a public digital display of cross-sectional data about the city. It embraces the diversity of the city and focuses on key areas for London's development over the next two decades against a background of a growing city: economic development, tackling climate change and other environmental issues, housing and transport. Revisiting these themes three years on, there will undoubtedly be changes.

Principles entail instrumentality and some people subscribe to scenario planning's compelling discussions of imagined polarised outcomes to help clarify options. Architect Rem Koolhaas, co-founder of OMA, is one architect who believes that the term poses a problem, because 'scenario planning implies plurals'.[2] He cites what is happening in The Netherlands in urban planning, particularly regarding the lost Green Heart of the Randstadt. 'It's difficult to have a single strong conviction; it's not make or break.' Scenario planning can be 'interesting speculation, but a weak form of decision making'.

Going back in time to a radical plan by way of direction, as this book has done selectively in order to help illuminate issues, the premise applied to the masterplan for Melun-Sénart (1987), the last of the Villes Nouvelles around Paris, for a beautiful, forested, 5000-hectare site, was to 'take urbanism's position of weakness as its premise'. Focusing on landscape 'islands', its

1 *The Mayor's London Plan,* published in October 2009, available at: http://www.london.gov.uk/shaping-london/.
2 Interview with the author, October 2011.

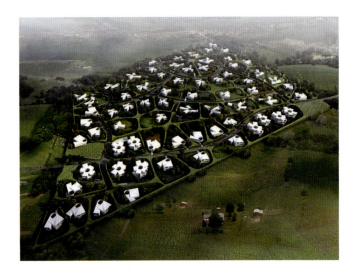

1, 2 Bohácky residential masterplan, Bratislava, Slovakia, Serie Architects. Rethinking infrastructure via natural hedge boundaries that promote a typological grammar of spatial difference.

The hedges as a singular and complete artefact acts as an enabling 'infrastructure' that allows each plot to be an autonomous site for the enactment of villas by other architects

resistance enabled the original 'void' (where not to build) space of nature with existing farmland and roads to predominate, with the built environment of residential, workplace and social infrastructure assembled in relation to these. While the multiplicity of global sites brings huge differentials in terms of conditions as well as needs, the notion of voids, or spaces of resistance, remains a potent one.

The sea of options that blurs scenario planning's agency in the minds of clients is quite distinct from the design potentials offered by parametric modelling tools, identifying a small number of options based on real-time data collection and analysis, so long as the practitioners remain conscious of and responsible to their conceptual role and commitment to an engaged process of interpretation of 'empirical givens'. This is another phrase used by Koolhaas which remains vital in a climate in which citizens are exposed to the vagaries of the market and the public sector's input is on the whole a desire to improve curtailed by slashed budgets.

Toyo Ito, writing in the aftermath of 2010's disaster in Japan, declared that 'our task now is to rethink how we "assume" design conditions, rather than reviewing the conditions'. We need to start by questioning the way we relate to nature,

avoiding reductive approaches. Adaptive planning entails drawing out the latent qualities of nature, biodiversity and its patterns of behaviour – however they were suppressed in the past or the present by trauma – through the infinitely reinventive capacities of architecture and urban design.

A currently discussed scenario for future masterplans is 'post-future', renouncing growth for a shared economic model. Whatever models are adopted in the future, they are likely to be hybrid, with progressive pockets or transversal features.

Today's socio-economic and cultural dynamics, ecological crises and conditions of complexity necessitate the agency of conceptual masterplanning – otherwise known as adaptive planning, if you like. A rose by any other name smells just as sweet, or it tries to. This is not a requirement for adaptive planning as a one-off event, or a rare luxury, but as a continuous flow of action. It is not about the rigid blueprints of old – but integrated, loose-fit frameworks designed as evolutionary, generative systems, possessing adaptive capacities for intelligent differentiation of place, and advanced in a way that is consistent with, or integrated with, community plans.

In this way, agency and framework can mutually inform each other and be genuinely adaptive and beneficially

interdependent, not weak and dysfunctional. This process is predicated on social equity and calls for a transparency with full regard to community needs for inclusive housing, jobs, work-spaces and local amenities, including high quality, accessible green spaces and overall environmental and economically sustainable strategies of benefit to all.

Certain principles can be justified on practical grounds:

1. Intelligent, responsible use of land.
2. A good conceptual masterplan is an adaptable, living instrument, born of sensing places in multiple ways, and through which greater potential can be drawn out through a network of local initiatives rather instead by the impo-sition of an all-encompassing blueprint for a whole new order.
3. The market is now end-user focused and public consul-tation is part of what helps give the masterplan life. 'Build it and they will come' is an unsustainable approach.
4. Adaptable growth boundaries based on the notion of collective rights. Breaking down the regulatory regime could be a better way to fight the impact of the global economic crisis and introduce new dynamism.
5. Permeable boundaries and thresholds.
6. Correlation of systems in intensity rather than seen purely as density alone, e.g. hybridised facilities – reconceptu-alising housing in new ways, such as live-work mixed tenures, to renew neighbourhoods and communities. Nodes of mixed-use transport infrastructure – more effi-cient and less wasteful in terms of use of energy and resources.
7. Contexts and sites, conditions and synergies, natural systems and the performative aspects of nature are key drivers of twenty-first-century adaptive planning.
8. Meaningful synergies of top-down and bottom-up dynamics in terms of participants, i.e. no longer just the state, not just the market, but a new DNA of alliances based on partnership and networks of agents, for example, social entrepreneurs committed to social equity and sustainable outcomes.
9. Self-reflexivity born of multidisciplinary research – environ-mental, social/inclusive, economic, physical, demographic – not solely market research-driven practices, combined and analysed in updatable systems for which huge capacity now exists. This is a mix of analogue and virtual strategies, in which architectural and planning, scientific, sociological and anthropological approaches develop urbanist team research.
10. The city has a metabolism: feedback loops from seed projects and from smart city dashboards to help create new more organic principles for urban evolution.
11. Urban plans developed from fresh readings of individual places based on history, culture and geography, local standards and metrics, as part of baseline studies.
12. Facilitators of equity for city dwellers through new dynamics is a fundamental goal.
13. Cultivate ecological consciousness and strategies in synergy with goals of economic sustainability, prototyped through public events to encourage community involve-ment and acceptance at a sufficiently early stage of framework plans. Cultivate biodiversity: it's eco-logical. 14. A good urban plan is not 2d or static but its strategies and designs grow durably through the extended process of engaging civil society stakeholders. These are not doomed performances but involve individuals in interactive activities which help build a deeper or different sense of meaning about place, their own place in the world, and their 'buy-in'.
15. Evaluate the 'eco-city' models. The single mitigation plan must be bespoke for its city or region.
16. Coherent differentiation in urban patterns rather than replicas to ensure responsiveness to specific cultural, social and economic aspects of locations and a unique character and sense of order, including at metropolitan scales of 15 million people and upwards.
17. Polycentric urbanism gives new agency to different aggre-gations of places.
18. Make sure buildings within masterplans respond to their ethos; they will anyway, by counterpoint; but at least make them respond.
19. Custom-designed, situational, maybe loose fit but not cut-and-paste or generic urbanism.
20. A rigorous and creative adaptive approach to a series of typologies.
21. Retrofit, remodel, reuse rather than raze – along with

removal of structures delimiting districts widely deemed anachronistic, especially relating to transport.

22. Transcend the generalized area/ratio approach and embrace needs for more green spaces (why not 50% park land), more urban farms and interconnected networks across differentiated districts.

23. Well-considered urban intensity patterns promoting cultural, social and economic transactions, in tandem with revised, distributed energy systems and reinvented waste disposal systems.

24. Parametric spatial simulation modelling in architecture, because this way responsive options can be evolved from a wide range of synergised data, and further analysed in light of a range of cultural and social equity issues, supporting the evolution of sustainable urbanism.

25. Infrastructural urbanism promoting light systems, e.g. BRT, Metro cable cars.

26. No more construction of nugatory infrastructure. We have quite enough non-places going nowhere already.

27. Further investigation of the phenomenological physics of the city, not to create hermetic scientific laboratories but by this broad cultural means to further explore issues such as how to intervene and work with diverse memories of historic contexts and continue applying the creative benefits of Geographic Information Systems.

28. Regular hard and soft updates of masterplan frameworks within urban areas so that community plans can be consistent.

29. Regular infrastructure monitoring and mitigation programmes.

30. An adaptive plan may be fast and engage past, present and future realities.

31. The benefits from using design codes, used for centuries, can assist the quality of urban design, but their value needs to be judged in relation to a specific context and design objective, since codes can be written in different ways and are best evolved as a set of principles. It has to be considered whether their implementation also serves to undermine the creation of socially diverse neighbourhoods.

32. Incremental implementation to assist economic sustainability. Robust mechanisms to deal with issues of practical viability and management of rapid change.

33. Adaptive plans democratically debated and benefitting from crowd sourcing exercises and other new mechanisms can provide the basis of open source policy instruments and smart systems (of networked information) that reflect present-day demographics, social patterns and needs.

34. More charrettes and workshops for a synergistic learning-development framework; take part in as many study tours as possible before getting involved in adaptive planning, and take notes – talk to everybody you meet about what they know.

35. Judge the best balance of the planned and the organic in relation to the specific circumstances of a context.

36. Think and do. Test and do. Design the means and the way as part of the plan. Make it relationship-based. If you fail along the way, fail better (as Samuel Beckett proposed). How we move to determine the future is about how we respond to and influence conditions through our actions.

My adaptive plan: a final page left free for your generative thoughts.

Illustration Credit Information

Cover

Deep Ground Plan, Longgang, Pearl River Delta, China, bird's eye view, CGI visualisation, GroundLab and Plasma Studio.
© Groundlab and Plasma Studio.

Introduction, page 1

1 HafenCity, Hamburg, masterplan by KCAP. Dancing on Magellan Terrace at Sandtor Quay.
© Elbe & Flut, Hans Joachim Hettchen.

2 Milan Urban Development Plan: Services plan for the Milan PGT (architects Metrogramma), Id-Lab.
© Id-Lab.

3 Masterplan for Algae Farm for the Swedish Municipality of Simrishamn, EcoLogicStudio, demonstrates the interactive potentials for algae-related urban activities via a 'co-action' plan map with six prototypes sited in a devised network.
© EcoLogicStudio.

4 Aerial view of Masdar City, Abu Dhabi, masterplan by Foster + Partners, rendering.
© Foster + Partners.

5, 6, 7 Loop City masterplan concept to revitalize Copenhagen's suburbs linked to the cross border region between Sweden and Denmark, renderings, BIG/Glessner Group.
© BIG/Glessner Group.

8, 9 Angela Merkel, the Chancellor of Germany, visiting Masdar City, Abu Dhabi, 2010. Masterplan and buildings by Foster + Partners.
© Masdar.

10 Medellín, Colombia, Parque Explora, inauguration, Alejandro Echeverri, Alcaldía de Medellín.
© Alcaldía de Medellín.

11 Manzanares River, Madrid: River Garden and Toledo Bridge. Masterplan by West 8 & MRIO Arquitectos.
© Municipality Madrid.

12 MRIO, Manzanares River, Madrid: Avenida de Portugal, Madrileños on cherry islands. Masterplan West 8 & MRIO Arquitectos.
© West 8.

13 Concept of masterplan for Qianhai Port City in Shenzhen, China, OMA.
© OMA.

14 D-38 Zona Franca office complex, Barcelona, masterplan, Foreign Office Architects & Arata Isozaki Architects, 2009. With buildings capable of hosting a variety of workspace types, FOA realised building 2 in the first phase, diagram.
© AZPA/FOA.

15 D-38 Zona Franca office complex, Barcelona, masterplan, Foreign Office Architects & Arata Isozaki Architects, sections.
© AZPA/FOA.

16, 17 D-38 Zona Franca office complex, Barcelona, masterplan, Foreign Office Architects & Arata Isozaki Architects, plans.
© AZPA/FOA.

18, 19 D-38 Zona Franca office complex, Barcelona, masterplan, Foreign Office Architects & Arata Isozaki Architects.
© Javier Arpa.

20 Constitución, Chile, PRES sustainable reconstruction masterplan by Elemental, public space and public buildings plan, riverside, coastal and downtown plans.
© Elemental.

21 Constitución, Chile: PRES sustainable reconstruction masterplan by Elemental. Community workshop in progress at the PRES Open House.
© Elemental.

22 Constitución, Chile: day of the popular vote for the mitigation park and other projects. Elemental's PRES sustainable reconstruction masterplan got 92 per cent approval.
© Elemental.

23 Xochimilco masterplan, Mexico City, TEN Arquitectos. The different facilities on the site including relocated sports facilities and flower market.
© Enrique Norten/TEN Arquitectos.

24 Plan for Kartel-Pendik mixed-use masterplan by Zaha Hadid Architects on the Asian side of Istanbul.
© Zaha Hadid Architects.

Ørestad, Carlsberg, Loop City, Nordhavnen, Copenhagen, Denmark, page 27

1 Nordhavnen masterplan, Copenhagen, COBE, Sleth and Rambøll, CPH City & Port Development.
© COBE.

2 Nordhavnen, masterplan, Copenhagen, COBE, Sleth and Rambøll, CPH City & Port Development.
© COBE.

3 Carlsberg masterplan, Copenhagen: map showing listed buildings, gardens, basements and buildings on the Carlsberg site, to be demolished (in grey), Entasis.
© Entasis.

4 The Carlsberg site in the context of Copenhagen, Entasis.
© Entasis.

5 The Carlsberg masterplan, Copenhagen, showing the separate building 'sections'. The numbers originally represented a chronology, number 1 being the first. However, the order has changed as the planning of the first building section stopped two years ago due to the financial crisis, and number 8 by the station seems to be the first one to be planned, with a couple of competitions taking place there, Entasis.
© Entasis.

6 Chart of the existing Carlsberg site in Copenhagen, showing what is presently going on in the buildings, Entasis.
© Carlsberg A/S Ejendomme.

7 Masterplan by Entasis of the future Carlsberg site, Copenhagen, the basis for the local plan, Entasis.
© Entasis.

8 Photocollage made by Carlsberg showing the different existing buildings on its site in Copenhagen, Entasis.
© Carlsberg A/S Ejendomme.

9 Aerial view of the Carlsberg site, Copenhagen, as it is today, Entasis.
© Carlsberg A/S Ejendomme.

10 Aerial view of the Carlsberg site, Copenhagen, a visualisation of the masterplan, Entasis.
© Entasis.

11 View of the future station at the Carlsberg site, Copenhagen. The roof of the platform is a giant cardiogram. The station project is not shown on the masterplan as it was not yet politically approved at this point (May 2011), Entasis.
© Entasis.

12 Visualisation of 'the basement square' at the Carlsberg site, Copenhagen: a small square is planned around an existing listed basement, originally used for storing beer, Entasis.
© Entasis.

13 Visualisation of a shopping colonnade at the Carlsberg site, Copenhagen, showing views of the existing former power plant in the background, Entasis.
© Entasis.

14 Visualisation of the future plaza behind the listed brewery with the buildings at the Carlsberg site, Copenhagen [en] Frederiksberg and Søndermarken [en] in the background. Most of the new buildings have green roofs, Entasis.
© Entasis.

15 Ørestad, the 1995 masterplan diagram of the light rail systems in red, with the station catchment areas within a radius of 600m. Station 5 is Ørestad Station with an interchange to the railway to the airport and to Sweden.
© CPH City & Port Development.

16 Ørestad, the 1995 masterplan presented by the Ørestad Development Corporation follows the general concept of the Finnish first prize entry in the ideas competition. It shows catchment areas for the Metro stations by 600m circles: Islands Brygge, University District, Sundby, Bella Center, Ørestad and Vestamager. The schematically drawn up building patterns were used as a guideline in the first competitions until the masterplan was revised as a result of these.
© CPH City & Port Development.

17 Ørestad, the water element (lake, preserved wetlands and canal) in blue.
© CPH City & Port Development.

18 Aerial photo of Ørestad in its context south of Copenhagen.
© CPH City & Port Development.

19 Ørestad, aerial photo of Ørestad North with the KUA educational and research campus in the foreground. Photo: Ole Malling, CPH City & Port Development.
© CPH City & Port Development.

20 Ørestad, Ørestad City, with VM Houses by PLOT (completed in 2005) in the background. Photo: Lena Skytthe, CPH City & Port Development.

21 Ørestad, aerial visualisation of Ørestad South with the mixed-use 8 House (completed in 2010) by BIG on the outer edge of the development overlooking the common. CPH City & Port Development.
© CPH City & Port Development.

22 Ørestad, aerial view of VM Houses (completed by PLOT in 2005) and the mixed used MTN (completed in 2008) at Ørestad City. Photo: Ole Malling/By & Havn I/S.
© CPH City & Port Development.

23 Ørestad, housing by Vilhelm Lauritze at Ørestad South with views over western Amager. Photo: Lene Skytthe/CPH City & Port Development.
© CPH City & Port Development.

24 and 25 Ørestad, housing development bordering the canal running down the spine of the district. Photo: Lene Skytthe/By & Havn.
© CPH City & Port Development.

26 Ørestad, DR Byen at Ørestad North. Photo: Lene Skytthe/By & Havn.
© CPH City & Port Development.

27 Ørestad, the mixed use Bjerget MTN development at Ørestad City completed in 2008 by BIG. Photo: Lene Skytthe/By & Havn.
© CPH City & Port Development.

28 Ørestad, the tiled portrait of BIG's client Per Høpfner at one of the entrances to VM House, PLOT, Ørestad City.
© Lucy Bullivant.

29 Ørestad, the VM Houses (PLOT) and MTN development, BIG, seen from the common on the west side of the district.
Photo: Lene Skytthe/By & Havn.
© CPH City & Port Development.

30 Loop City masterplan concept to revitalise Copenhagen's suburbs linked to the cross-border region between Sweden and Denmark, BIG and Kollision.
© BIG/Glessner Group.

HafenCity, Hamburg, Germany, page 45

1 Aerial view of HafenCity, Hamburg, masterplan, KCAP.
© Elbe & Flut.

2 Aerial view of HafenCity, masterplan, KCAP.
© Elbe & Flut.

3 HafenCity, Hamburg, KCAP: render overview.
© Schiebel.

4 Masterplanning competition model of HafenCity, Hamburg, KCAP.
© KCAP.

5 HafenCity, Hamburg, KCAP: Bird's eye view of the Magellan Terrace at Sandtor Quay with ship dock.
© Elbe & Flut, M.Korol.

6 HafenCity, Hamburg, KCAP: Bay at Sandtor Quay.
© KCAP.

7 HafenCity, Hamburg, KCAP: Boardwalk at Sandtor Quay.
© KCAP.

8 HafenCity, Hamburg, KCAP: Boardwalk at Sandtor Quay.
© KCAP.

9 HafenCity, Hamburg, KCAP: Marco Polo Terrace at Sandtor Quay.
© Elbe & Flut.

10 HafenCity Hamburg, KCAP: Magellan Terrace at Sandtor Quay.
© Elbe & Flut, Hans Joachim Hettchen.

11 HafenCity, Hamburg, KCAP: Dancing on Magellan Terrace at Sandtor Quay.
© Elbe & Flut, Hans Joachim Hettchen.

12 HafenCity, Hamburg, KCAP: Lunch terrace and basketball courts on the Vasco Da Gama Square at Dalmann Quay.
© Elbe & Flut.

13 HafenCity, Hamburg, KCAP: Water view from tourist boat of Sandtor Quay.
© Elbe & Flut, Hans Joachim Hettchen.

14 HafenCity, Hamburg, KCAP: Dalmann Quay boardwalk.
© Elbe & Flut.

15 HafenCity, Hamburg, KCAP: Small concert on the Magellan Terrace at Sandtor Quay.
© Elbe & Flut.

16 HafenCity, Hamburg, KCAP: Marco Polo square at Sandtor Quay.
© KCAP.

17 HafenCity, Hamburg, KCAP: Bird's eye view of Osaka Street at Überseequartier with proposed new buildings.
© Elbe & Flut/

18 HafenCity, Hamburg, KCAP: Boulevard along Grasbrookhafen at Dalmann Quay.
© Daniel Bartmann.

19 HafenCity, Hamburg, KCAP: massing principles of the masterplan.
© Astoc.

20 HafenCity, Hamburg, KCAP: diagram showing spatial relations.
© Astoc.

21 HafenCity, Hamburg, KCAP: diagram showing mass vs void.
.© Astoc.

22 HafenCity, Hamburg, KCA: diagram showing pinnacles triangle.
© Astoc.

23 Diagram of historical area of Hamburg with HafenCity extension, KCAP.
© Astoc.

Musheireb, Doha, Qatar, page 59

1 Musheireb, rendering of aerial view at night showing Musheireb in the context of Doha, with the commercial district, West Bay, in the background.
© Msheireb Properties.

2 Aerial view, Musheireb, Doha.
© Msheireb Properties.

3 Musheireb, Doha, aerial view in 1959.
© Msheireb Properties.

4 Musheireb, Doha, aerial view in 1973.
© Msheireb Properties.

5 Musheireb, Doha, Al Barahat arcade and colonnade, rendering mossessian & partners.
© mossessian & partners.

6 Musheireb, Doha, Sikkat Al Nouq looking towards Al Barahat, rendering, mossessian & partners.
© mossessian & partners.

7 Musheireb, Doha, Barahat Al-naseem Square as an 'urban *majlis'*, rendering, mossessian & partners.
© mossessian & partners.

8 Musheireb, Doha, Office building on the corner of Abdullah Bin Thani and New Ukaz Street rendering, mossessian & partners.
© mossessian & partners.

9 Musheireb, Doha. Mixed use development around Al Barahat, Musheireb, looking east, rendering, mossessian & partners.
© mossessian & partners.

10 Musheireb, Doha. Reemas Street Arcade, rendering, mossessian & partners.
© mossessian & partners.

11 Musheireb, Doha. Adjaye Associates, commercial, office and residential buildings, rendering.
© Adjaye Associates.

12 Musheireb, Doha. Adjaye Associates, commercial, office and residential buildings, rendering.
© Adjaye Associates.

13 Musheireb, Doha. Masterplan diagrams showing the incorporation of a diverse mix of uses and character areas, AECOM.
© AECOM.

14 Musheireb, Doha. Diagram of the different character areas of the masterplan, AECOM.
© AECOM.

15 Musheireb, Doha. Masterplan diagrams, from left to right: historic urban grain and the *wadi* route as a reference framework for the masterplan; the lattice creates intimate *sikkats*; the street grid captures north/south winds and caters for road traffic, AECOM.
© AECOM.

Waterfront Seattle, USA, page 69

1 The Bay Ring: recentring Seattle around the Bay, james corner field operations.
© james corner field operations.

2 Overlook Fold, connecting Victor Steinbrueck Park and Pike Place Market to the Aquarium, Pier 62/63 and the waterfront; view looking east, james corner field operations.
© james corner field operations.

3 Seattle connects to a new green waterfront, looking east from the Bay, james corner field operations.
© james corner field operations.

4 Colman Dock Gallery, looking north, james corner field operations.
© james corner field operations.

5 Festivals, events and concerts at Pier 48, looking south towards the Port of Seattle, james corner field operations.
© james corner field operations.

6 The Beach at Pioneer Square, looking north, james corner field operations.
© james corner field operations.

7 The Urban Framework Plan: connecting the city to its waterfront, james corner field operations.
© james corner field operations.

8 Aerial overview of conceptual ideas for the new waterfront, looking north, james corner field operations.
© james corner field operations.

9 Public thermal pools at Pier 62/63, looking west, james corner field operations.
© james corner field operations.

10 Rooftop sun lawn at Colman Dock Ferry Park, looking west, james corner field operations.
© james corner field operations.

one-north Singapore, page 83

1 Site plan of the various Xchange districts of one-north Singapore, Zaha Hadid Architects.
© Zaha Hadid Architects.

2 Phasing of organic growth diagram, one-north Singapore, Zaha Hadid Architects.
© Zaha Hadid Architects.

3 Diagram, one-north Singapore, Zaha Hadid Architects.
© Zaha Hadid Architects.

4 Final district programme, one-north Singapore, Zaha Hadid Architects.
© Zaha Hadid Architects.

5 Buildings at Biopolis, one-north Singapore.
© Zaha Hadid Architects.

6 Matrix building, one-north Singapore.
© Zaha Hadid Architects.

7 Diagram of heritage areas at one-north Singapore, Zaha Hadid Architects.
© Zaha Hadid Architects.

8 Diagram of main roads at one-north Singapore, Zaha Hadid Architects.
© Zaha Hadid Architects.

9 Axonometrics of the programmes, one-north Singapore, Zaha Hadid Architects.
© Zaha Hadid Architects.

10, 11 Bird's eye visualisations of one-north Singapore, Zaha Hadid Architects.
© Zaha Hadid Architects.

12 Painting of one-north Singapore, Zaha Hadid Architects.
© Zaha Hadid Architects.

13 Bird's eye visualisations of one-north Singapore, Zaha Hadid Architects.
© Zaha Hadid Architects.

PRES Sustainable Reconstruction Plan, Constitución, Chile, page 93

1 Constitución, PRES sustainable reconstruction masterplan Elemental, pink shows tsunami damage, red, earthquake damage.
© Elemental.

2 Constitución, aerial view of the PRES sustainable reconstruction masterplan with the location of the park to mitigate the effects of the tsunami, Elemental.
© Elemental.

3 Constitución, PRES sustainable reconstruction masterplan project chart showing coordinated lines of development, Elemental.
© Elemental.

4 Constitución, PRES sustainable reconstruction masterplan, Elemental.
housing plan for different contexts,
© Elemental.

5 Constitución, riverside after the tsunami.
© Elemental.

6, 7 Constitución, PRES sustainable reconstruction masterplan, Elemental, proposal for riverside construction after the tsunami, with trees and mitigation hills.
© Elemental.

8 Constitución, PRES sustainable reconstruction master-plan,Elemental. proposal for the riverside, with new docks and a new pedestrian bridge.
© Elemental.

9 Constitución, riverside after the tsunami.
© Elemental.

10 Constitución, PRES sustainable reconstruction masterplan, Elemental, proposal for the reconstruction, mitigation park and new buildings.
© Elemental.

11 Constitución after the tsunami.
© Elemental.

12 Constitución, PRES sustainable reconstruction masterplan, Elemental.
proposal for the reconstruction of the coastline.
© Elemental.

13 Constitución, PRES sustainable reconstruction masterplan, Elemental,.riverside mitigation park.
© Elemental.

14, 15 Constitución, PRES sustainable reconstruction master-plan, Elemental, proposal for the Enrique Donn Primary School and the current site.
© Elemental.

16 Constitución, day of the popular vote for the mitigation park and other projects. PRES got 92 per cent approval.
© Elemental.

17 Constitución, community workshop in progress at the PRES Open House.
© Elemental.

18 Constitución, earthquake damage in the downtown area
© Elemental.

19 Constitución, PRES sustainable reconstruction masterplan, Elemental.
public space and public buildings plan, riverside, coastal and downtown plans.
© Elemental.

Make It Right, New Orleans, USA, page 104

1 Plan for the 21st Century: New Orleans 2030, New Orleans City Planning Commission's citywide Masterplan, by consultant team led by Goody Clancy and other local and national experts.
© New Orleans City Planning Commission

2 Aerial view of the Make It Right site before building, Lower 9th Ward, New Orleans, April 2008.
© Make It Right.

3, 4 The Pink Project, 450 recyclable pink tented structures installed in on the Make It Right site in the Lower 9th Ward, New Orleans, by Graft architects, 2008. Photo: Charlie Varley.
© Make It Right.

5 Make It Right site breaks ground on plans to build 150 houses, March 2008, former US President Bill Clinton, Make It Right founder Brad Pitt and residents, Lower 9th Ward, New Orleans.
© Make It Right.

6, 10 Make It Right, Lower 9th Ward, New Orleans, children playing in front of the house designed by Trey Trahan.Photo: Charlie Varley.
© Make It Right.

7 Make It Right, Lower 9th Ward, New Orleans, resident Gloria Guy and her grandchildren.
© Make It Right.

8 Make It Right, Lower 9th Ward, New Orleans, FLOAT House designed to float securely with rising water levels, by Morphosis in association with UCLA Architecture and Urban Design, 2009.
© Make It Right.

9, 11 Make It Right, Lower 9th Ward, New Orleans, Concordia House, one of the largest, single family houses on the site, built

in the first round of houses, with two storeys and indoor and outdoor spaces, shown with resident Gloria Guy, 2008.
© Make It Right.

10 Make It Right, Lower 9th Ward, New Orleans, house by Trahan Architects.
Photo: Charlie Varley.
© Make It Right.

12 Make It Right, Lower 9th Ward, New Orleans, pre-fabricated house with a shallow pitched roof designed by Graft.
© Make It Right.

13 Make It Right, Lower 9th Ward, New Orleans, Kieran Timberlake's house design, a flexible system based on customised options, 2008.
© Make It Right.

Medellín, Columbia, page 117

1 Medellín, Map from 2004 showing areas of greatest poverty identified in light green with more affluent areas in darker shades of green. The plan intends to bring the poorest areas up to the level of the rest, Alejandro Echeverri/Empresa de Desarrollo Urbano EDU.
© EDU.

2 Medellín, masterplan showing the 30 interventions made in the city, Alejandro EcheverriEmpresa de Desarrollo/EDU.
© EDU.

3 Medellín's Metro Cable car, line K, Valle de Aburrá transport system, Metro de Medellín, Empresa de Desarrollo Urbano (EDU).
© EDU.

4 Medellín in 2004 with the brand new Metro Cable car, Valle de Aburrá transport system, Metro de Medellín, Empresa de Desarrollo Urbano (EDU).
© EDU.

5 Medellín's Metro Cable car runs above the street connecting barrios for the first time, Valle de Aburrá transport system, Metro de Medellín, Empresa de Desarrollo Urbano (EDU).
© EDU.

6 Medellín's Metro Cable car above Paseo Calle 107, Valle de Aburrá transport system, Metro de Medellín, Empresa de Desarrollo Urbano (EDU).
© EDU.

7 Medellín, Parque Biblioteca España, Giancarlo Mazzanti, on top of the Santo Domingo barrio, Empresa de Desarrollo Urbano (EDU).
© EDU.

8 Medellín, one of the PUIs (projectos urbanos integrals) in the Santo Domingo barrio, Alejandro Echeverri, Empresa de Desarrollo Urbano (EDU).
© EDU.

9 Medellín, school behind the Parque Biblioteca España, Giancarlo Mazzanti, on top of the Santo Domingo barrio.
© EDU.

10 Medellín, Parque Biblioteca España, Giancarlo Mazzanti, on top of the Santo Domingo barrio.
© EDU.

11 Medellín, new library parks planned, Alejandro Echeverri/EDU.
© EDU.

12 Medellín, new schools of quality planned, Empresa de Desarrollo Urbano (EDU).
© EDU.

13 Medellín, locations of the 'projectos urbanos integrals' (PUIs) to combat social exclusion in the poorest three barrios, Alejandro Echeverri/EDU.
© EDU.

14 Medellín, Parque Explora, inauguration, Alejandro Echeverri, Alcaldía de Medellín.
© EDU.

15 Medellín, Granizal sports centre, Empresa de Desarrollo (EDU).
© EDU.

16 Medellín, total investment in the regeneration of the city, EDU.
© EDU.

Lion Park Urban Design Framewor, extension to Cosmo City, Johannesburg, South Africa, page 129

1 Lion Park, Cosmo City Ext 17, Johannesburg, design framework for an integrated mixed-use housing development, Michael Hart Architects and Urban Designers.
© Michael Hart Architects and Urban Designers.

2 Location of Lion Park to the north-west of Johannesburg.
© Michael Hart Architects and Urban Designers.

3-7 The existing settlement at Lion Park.
© Michael Hart Architects and Urban Designers.

8 Urban Design Criteria: green networks structuring elements, Lion Park, Cosmo City Ext 17, Johannesburg, design framework for an integrated mixed-use housing development, Michael Hart Architects and Urban Designers.
© Michael Hart Architects and Urban Designers.

9 Urban Design Criteria: road hierarchy structuring elements, Lion Park, Cosmo City Ext 17, Johannesburg, design framework for an integrated mixed-use housing development, Michael Hart Architects and Urban Designers.
© Michael Hart Architects and Urban Designers.

10 Urban Design Criteria: land use layout, Lion Park, Cosmo City Ext 17, Johannesburg, design framework for an integrated mixed-use housing development, Michael Hart Architects and Urban Designers.
© Michael Hart Architects and Urban Designers.

11 Urban Design Criteria: activity nodes and spines structuring elements, Lion Park, Cosmo City Ext 17, Johannesburg, design framework for an integrated mixed-use housing development, Michael Hart Architects and Urban Designers.
© Michael Hart Architects and Urban Designers.

12 Diagrammatic representation of solar collector hot water system, Lion Park, Cosmo City Ext 17, Johannesburg, design framework for an integrated mixed-use housing development, Michael Hart Architects and Urban Designers.
© Michael Hart Architects and Urban Designers.

13 Diagrammatic representation of grey water and storm water recycling, Lion Park, Cosmo City Ext 17, Johannesburg, design framework for an integrated mixed-use housing development, Michael Hart Architects and Urban Designers.
© Michael Hart Architects and Urban Designers.

14, 15, Civic node defines place making and making of centres; civic, municipal, transportation, public square and mixed uses, Lion Park, Cosmo City Ext 17, Johannesburg, design framework for an integrated mixed-use housing development, Michael Hart Architects and Urban Designers.
© Michael Hart Architects and Urban Designers.

16 Urban Structure: key strategic objectives: diagram of public transport nodes and activity spine, Lion Park, Cosmo City Ext 17, Johannesburg, design framework for an integrated mixed-use housing development, Michael Hart Architects and Urban Designers.
© Michael Hart Architects and Urban Designers.

17, 18 Open courts accessible from pedestrian streets allow for social activity and parking; 7-metre-wide roads promote walkability and access to facilities, Lion Park, Cosmo City Ext 17, Johannesburg, design framework for an integrated mixed-use housing development, Michael Hart Architects and Urban Designers.
© Michael Hart Architects and Urban Designers.

Urban Think Tank, an interview page 141

1 Metro Cable, Caracas, Venezuela, view of Homos de Cal Station, Urban Think Tank.
© Urban Think Tank.

2 Metro Cable, Caracas, view of La Ceiba Station with the Plug-in of the Vertical Gym and Community Centre, Urban Think Tank.
©: Urban Think Tank.

3 Metro Cable, Caracas, Parque Central Station, Urban Think Tank.
© Urban Think Tank.

4 Metro Cable, Caracas, life around Homos de Cal Station, Urban Think Tank.
© Urban Think Tank.

5 Metro Cable, Caracas, Metro Cable System plan, Urban Think Tank.
Source: Urban Think Tank.

6 Metro Cable, Caracas, Vertical Gym prototype, Urban Think Tank.
© Urban Think Tank.

7 Metro Cable, Caracas, Growing House for replacement housing, Urban Think Tank
© Urban Think Tank.

8 Metro Cable, Caracas, Urban Catalysts, Urban Think Tank.
© Urban Think Tank.

9 Metro Cable, Caracas, toolbox or icons of the prototypes that will be plugged into the system, Urban Think Tank.
Source: Urban Think Tank.

10 Grotão favela, São Paulo, the project is embedded in the challenging situation of a high risk zone, Urban Think Tank.
© Urban Think Tank.

11 Grotão favela, project catalysts, Urban Think Tank.
© Urban Think Tank.

12 Grotão favela, São Paulo, site plan showing high risk zones, Urban Think Tank.
© Urban Think Tank.

13 Grotão favela, water systems and reuse, Urban Think Tank.
© Urban Think Tank.

14 Grotão favela, building systems diagram, Urban Think Tank.
© Urban Think Tank.

15 Grotão favela, landscape diagram of elements, Urban Think Tank.
© Urban Think Tank.

16 Hoograven, the Netherlands, ArtSpot provides a new art and cultural campus for the neighbourhood, Urban Think Tank.
© Urban Think Tank.

17 Hoograven, map of the ArtSpot, Urban Think Tank.
© Urban Think Tank.

Masdar City, Abu Dhabi, UAE, page 159

1 Saadiyat Island Cultural District masterplan, aerial rendering, AECOM.
© AECOM/TIC.

2 Saadiyat Island Cultural District masterplan, aerial rendering, AECOM/TIC.
© AECOM.

3 Guggenheim Abu Dhabi and Saadiyat Island Cultural District, Gehry Partners, LLP, rendering.
© Saadiyat Island Cultural District/TIC.

4 Guggenheim Abu Dhabi and Saadiyat Island Cultural District on coastline, Gehry Partners, LLP, rendering.
© Saadiyat Island Cultural District/TIC.

5 View of the Masdar Institute building at Masdar City, Masdar Institute: laboratory building with roof-mounted photovoltaic panels, Foster + Partners.
Photo: © Nigel Young/Foster + Partners.

6 Masdar City, Masdar Institute: street view with laboratory building on the left and student residences on the right, Foster + Partners.
Photo: © Nigel Young/Foster + Partners.

7 Masdar City, colonnades with retractable patterned screens based on Islamic mashrabiya, Foster + Partners.
Photo: © Nigel Young/Foster + Partners.

8 Masdar City, The Oasis, one of two squares in the first phase of development, with the 45-metre high wind tower in the centre showing citizens' levels of energy consumption, laboratory building to the left and student residences to the right, Foster + Partners.
Photo: © Nigel Young/Foster + Partners.

9 Shaded sidewalks and pathways at the Masdar Institute, Masdar City. The Family Square is one of two squares in the first phase of development, Foster + Partners.
© Nigel Young/Foster + Partners.

10, 11 Angela Merkel, the Chancellor of Germany, visiting Masdar City, 2010.
© Masdar City.

12 Masdar City city centre, LAVA Architects, aerial view showing the solar-powered 'sunflower' umbrellas.
© LAVA Architects.

13 Masdar City city centre, LAVA Architects, solar-powered 'sunflower' umbrellas in the outdoor plaza, rendering.
© LAVA Architects.

14 Masdar City, Masdar Institute Personal Rapid Transport Station, where vehicles dock in dedicated glass boxes, Foster + Partners.
Photo: © Nigel Young/Foster + Partners.

15 Masdar City, proposed population figures to use the site, Foster + Partners.
Photo: © Foster + Partners.

16 Aerial view of Masdar City, masterplan by Foster + Partners, rendering.
Photo: © Foster + Partners.

17 Masdar City, city fabric development stages 1-4, masterplan by Foster + Partners.
Photo: © Foster + Partners.

18 Masdar City, city fabric development stages 5–8, masterplan by Foster + Partners.

19 Masdar City, primary circulation routes, masterplan by Foster + Partners.
Photo: © Foster + Partners.

20 Masdar City, principal land use at grade, masterplan by Foster + Partners.
Photo: © Foster + Partners.

Montecorvo Eco City, Logroño, Spain, page 174

1 Diagram of the Montecorvo site, masterplan, MVRDV.
© MVRDV.

2 Montecorvo masterplan, overview, MVRDV.
© MVRDV.

3 Montecorvo masterplan, MVRDV, renewable energy production, areas of wind energy (blue) and solar energy (red).
© MVRDV.

4-8 Montecorvo masterplan, MVRDV, variations in the public space on top of the lower slab.
© MVRDV.

9-10 Montecorvo masterplan, MVRDV, housing programme, public space and parking.
© MVRDV.

11 Montecorvo masterplan, MVRDV, sections showing general concept of the slab.
© MVRDV.

12 Montecorvo masterplan, MVRDV, view from one hill onto another. In-between the eco park meanders over the slopes.
© MVRDV.

13 Montecorvo masterplan, MVRDV, overview of the site from the south-west with PV cells and windmills.
© MVRDV.

14 Montecorvo masterplan, MVRDV, view of the garden/public space at the location where the funicular pierces through the structure of the slab.
© MVRDV.

15 Montecorvo masterplan, MVRDV, overview from the south.
© MVRDV.

16 Montecorvo masterplan, MVRDV, public space on top of the lower part of the slab.
© MVRDV.

17 Montecorvo masterplan, MVRDV, north side of the upper slab.
© MVRDV.

18 Montecorvo masterplan, MVRDV, section of street profiles and details.
© MVRDV.

19 Montecorvo masterplan, MVRDV, section through the superior boulevard.
© MVRDV.

20 Montecorvo masterplan, MVRDV, section through the inferior boulevard.
© MVRDV.

Milan Urban Development Plan, Milan, Italy, page 187

1 Milan UDP (Piano di Governo del Territorio/PGT): the overall vision, Metrogramma.
© Metrogramma.

2 Milan UDP. Satellite visualisation representing the Plan's concept of densification to save land, Metrogramma,
© Metrogramma.

3 Milan UDP. Services plan for the Milan PGT. Id-Lab (Stefano Mirti, Simone Quadri with Francesca Abbiati, Walter Aprile, Luca Buttafava, Massimiliano Bortoluz, Lorenzo Caddeo, Davide Ciuffi, Eyal Fried, Giorgia Lupi, Viola Merici, Stefano Mirti, Simone Muscolino, Simone Quadri, Henrik Runshaung; with Dario Buzzini).
© Id-Lab.

4 Milan UDP. Services plan for the Milan PGT, Id-Lab (Stefano Mirti, Simone Quadri with Francesca Abbiati, Walter Aprile, Luca Buttafava, Massimiliano Bortoluz, Lorenzo Caddeo, Davide Ciuffi, Eyal Fried, Giorgia Lupi, Viola Merici, Stefano Mirti, Simone Muscolino, Simone Quadri, Henrik Runshaung with Dario Buzzini).
© iD-Lab.

5 Milan UDP. Land use trends, Metrogramma.
© Metrogramma.

6 Milan UDP. Density growth, Metrogramma,
© Metrogramma.

7 Milan UDP. Services development, Metrogramma,
© Metrogramma.

8 Milan UDP. Structuring the void: the model shows the void in the city plan as an extruded architectural volume. Heights have been calculated on the basis of density of the surrounding built volumes. It shows how the development plan can create a permeable network interconnecting the whole city,
© Metrogramma.

9 Milan UDP. The 88 Local Identity Nuclei (LINs), Metrogramma,
© Nicola Russi.

10 Milan UDP. Farini/Lugano: simulation and scenarios in the transformation area, Metrogramma,
© Metrogramma.

11 Milan UDP. Farini PGT project sheet, Metrogramma,
© Metrogramma/images:Attustudio.

12 Milan UDP. Piazza d'Armi: simulation and scenarios in transformation area, Metrogramma,
© Metrogramma/images: Attustudio.

13 Milan UDP. Piazza d'Armi PGT project sheet, Metrogramma.
© Metrogramma.

14 Milan UDP. Bovisa: PGT project sheet, Metrogramma.
© Metrogramma.

15 Milan UDP. Bovisa, Metrogramma.
© Metrogramma/images: Attustudio.

16 Milan UDP. Stephenson: simulation and scenario in the transformation area, Metrogramma.
© Metrogramma.

17 Milan UDP. Stephenson PGT project sheet, Metrogramma.
© Metrogramma/images: Attustudio.

18 Raggi Verdi: a green strategy for the Milanese metropolis 2015, LAND, 2009.
© LAND.

19 A visualisation, Raggi Verdi: a green strategy for the Milanese metropolis 2015, LAND, 2009.
© LAND.

20 Raggi Verdi bicycle trip arranged by the L'Associazione Interesse Metropolitani (AIM), Milan Triennale garden, May 2007, LAND.
© LAND.

21 Visualisation of the Porta Nuova mixed used scheme, 2005+, connecting Garibaldi, Varesina and Isola. Pelli Clarke Pelli, masterplan, offices; Boeri Studio, masterplan, residences, Porta Nuova Isola, KPF, masterplan, offices, Porta Nuova Varesine. Green areas and public spaces: LAND; public spaces: Gehl Architects; park: Inside Outside.
© LAND.

22 Plan of Green Ray area 1, Porta Nuova, the former Garibaldi Station, LAND.
© LAND.

23 Milan UDP. Environmental network, Metrogramma,
© Metrogramma.

24 Milan UDP. the peri-urban parks and green spokes that make up the urban scale green landscape, Metrogramma,
© Metrogramma.

25 Milan UDP. From transformation areas to epicentres, Metrogramma,
© Metrogramma.

26 Milan UDP. The epicentres' services, Metrogramma,
© Metrogramma.

27 Milan UDP. The epicentres' infrastructure network, Metrogramma.
© Metrogramma.

MRIO, Manzanares River, Madrid, Spain, page 202

1 Manzanares River, Madrid: map showing location within the context of the city centre, West 8 & MRIO Arquitectos.
© West 8.

2 Map of the Manzanares River site, Madrid, West 8 & MRIO Arquitectos.
© West 8.

3 Manzanares River, Madrid: Salón de Pinos, section showing relationship between design and technical base, West 8.
© West 8.

4 Manzanares River, Madrid: Salón de Pinos, West 8 & MRIO Arquitectos.
© Jeroen Musch.

5 Manzanares River, Madrid: Salón de Pinos, West 8 & MRIO Arquitectos.
© Jeroen Musch.

6 Manzanares River, Madrid: Salón de Pinos, West 8 & MRIO Arquitectos.
© Jeroen Musch.

7 Manzanares River, Madrid: Salón de Pinos, Oblique Bridge and Segovia Bridge, West 8 & MRIO Arquitectos.
© Municipality Madrid.

8 Manzanares River, Madrid: Avenida de Portugal, West 8 & MRIO Arquitectos.

9 Manzanares River, Madrid: Avenida de Portugal, Madriliños on cherry islands, West 8 & MRIO Arquitectos.
© West 8.

10 Manzanares River, Madrid: Cascara Bridge, West 8 & MRIO Arquitectos.
© Jeroen Musch.

11 Manzanares River, Madrid: Cascara Bridges, West 8 & MRIO Arquitectos.
© Jeroen Musch.

12 Manzanares River, Madrid: Ecological Fountain at Segovia Bridge, West 8 & MRIO Arquitectos
© Jeroen Musch.

13 Manzanares River, Madrid: Salon de Pinós, West 8 & MRIO Arquitectos.
© Jeroen Musch.

14 Manzanares River, Madrid: Plataforma del Rey, West 8 & MRIO Arquitectos.
© Municipality Madrid.

15 Manzanares River, Madrid: River Garden and Toledo Bridge, West 8 & MRIO Arquitectos.
© Municipality Madrid.

16 Manzanares River, Madrid: Arganzuela Park, West 8 & MRIO Arquitectos.
© Jeroen Musch.

17 Manzanares River, Madrid: Segovia Bridge, West 8 & MRIO Arquitectos.
© Municipality Madrid.

Xochimilco, Mexico City, Mexico, page 211

1 Masterplan for the Xochimilco site, Mexico City, Enrique Norten/TEN Arquitectos.
© Enrique Norten/TEN Arquitectos.

2 Protected areas of the Xochimilco site, Mexico City, masterplan, Enrique Norten/TEN Arquitectos.
© Enrique Norten/TEN Arquitectos.

3 The different facilities on the Xochimilco site, Mexico City, including relocated sports facilities and flower market, masterplan, TEN Arquitectos.
© Enrique Norten/TEN Arquitectos.

4 Proposed flower and plants market in its new location on the Xochimilco site, Mexico City, masterplan, Enrique Norten/TEN Arquitectos.
© Enrique Norten/TEN Arquitectos.

5 Sports facilities, ecological park, Xochimilco masterplan, Mexico City, Enrique Norten/TEN Arquitectos.
© Enrique Norten/TEN Arquitectos.

6 Looking across the Xochimilco site, Mexico City, to the water centre, rendering. Masterplan, Enrique Norten/TEN Arquitectos.
© Enrique Norten/TEN Arquitectos.

7 Rendering of the CIEAX Centre for the investigation of and education about water, Xochimilco masterplan, Mexico City, Enrique Norten/TEN Arquitectos.
© Enrique Norten/TEN Arquitectos.

8 The CIEAX Centre for the investigation of and education about water and its plaza, rendering, Xochimilco masterplan, Mexico City, Enrique Norten/TEN Arquitectos.
© Enrique Norten/TEN Arquitectos.

9 Foyer of the CIEAX Centre for the investigation of and education about water, rendering, Xochimilco masterplan, Mexico City, Enrique Norten/TEN Arquitectos.
© Enrique Norten/TEN Arquitectos.

10 Interior of the CIEAX Centre, rendering, Xochimilco masterplan, Mexico City, Enrique Norten/TEN Arquitectos.
© Enrique Norten/TEN Arquitectos.

11 One of the lakes on the Xochimilco masterplan site, rendering, Mexico City, Enrique Norten/TEN Arquitectos.
© Enrique Norten/TEN Arquitectos.

12 Public space next to the water, rendering, Xochimilco masterplan, Mexico City, Enrique Norten/TEN Arquitectos.
© Enrique Norten/TEN Arquitectos.

13 A canal on the Xochimilco masterplan site, rendering, Enrique Norten/TEN Arquitectos.
© Enrique Norten/TEN Arquitectos.

Sociópolis, Valencia, Spain, page 217

1 Site plan showing La Torre district of Valencia where the neighbourhood of Sociópolis is, Vicente Guallart, María Diaz, Why Art Projects.
© Sociópolis.

2 Sociópolis, Valencia: diagram of original water channels, Vicente Guallart, María Diaz, Why Art Projects.
© Sociópolis.

3 Sociópolis, Valencia: implantation strategies, Vicente Guallart, María Diaz, Why Art Projects.
© Sociópolis.

4 Sociópolis, Valencia: model of neighbourhood, Vicente Guallart, María Diaz, Why Art Projects.
© Sociópolis.

5 Sociópolis, Valencia, model of neighbourhood, María Diaz, Why Art Projects, © Sociópolis

6 Sociópolis, Valencia: implantation strategies, Vicente Guallart, María Diaz, Why Art Projects.
© Sociópolis.

7 Sociópolis, Valencia: diagram of sports circuits, Vicente Guallart, María Diaz, Why Art Projects.
© Sociópolis.

8 Sociópolis, Valencia: planting in the park, Vicente Guallart, María Diaz, Why Art Projects.
© Sociópolis.

9 Sociópolis, Valencia: park, Vicente Guallart, María Diaz, Why Art Projects.
© Sociópolis.

10 Sociópolis, Valencia: sports circuits, Vicente Guallart, María Diaz, Why Art Projects.
© Sociópolis.

11 Sociópolis, Valencia: orchard gardens, Vicente Guallart, María Diaz, Why Art Projects.
© Sociópolis.

12 Sociópolis, Valencia: orchard gardens, Vicente Guallart, María Diaz, Why Art Projects.
© Sociópolis.

13, 14 Sociópolis, Valencia, under construction, 2011, Vicente Guallart, María Diaz, Why Art Projects.
© Sociópolis.

Saemangeum Island City, South Korea, page 227

1 Saemangeum Island City, development land-use plan with seven lead programmes indicated in colour coding, drawing, ARU.
© ARU.

2 Saemangeum Island City, synthesis plan. This drawing brings together the ideas of a landscape infrastructure of islands, research about City Structures and the size and spatial relationships between the City Magnets, or Cities within the Island City, drawing, ARU.
© ARU.

3 Saemangeum Island City, initial concept drawing looking west over the Island City towards the horizon of the Yellow Sea, drawing, Bumsuk Chung, ARU.
© ARU.

4 Saemangeum Island City, Landscape Infrastructure design plan of new islands, drawing: ARU.
© ARU.

5 Saemangeum Island City: inhabiting the islands with City Structures, Weymouth Mews, originally built (1715-1720), is a

typical example of a London mews block with large terraces of 4- or 5-storey houses facing the main streets and 2-storey mews houses inside the city block. The mews houses were originally built as stables for horses and carts, with a small servant's house above.
Photo: © Philip Christou, ARU.

6 Saemangeum Island City: inhabiting the islands with City Structures, a Quadrangle City Structure, Cambridge University, England, thirteenth to eighteenth centuries. A series of quadrangles sit along the banks of the River Cam in Cambridge.
Drawing: Awot Kibrom.
© ARU.

7 Saemangeum Island City: Harbour City Magnet, ARU.
© ARU.

8 Saemangeum Island city: Harbour City Magnet, ARU.
© ARU.

9 Saemangeum Island City, view of the Harbour City towards the New Sea Port and the Gogunsan Archipelago of islands beyond, photo: Philip Christou, ARU.
© ARU.

10 Saemangeum Island City, Man-Gueong, Lake City Magnet key, ARU.
© ARU.

11 Saemangeum Island City, Man-Gueong, Lake City Magnet, ARU.
© ARU.

12 Saemangeum Island City, Man-Gueong Lake City, on the eastern edge of Man-Gyeong Lake City, ARU.
© ARU.

13 Saemangeum Island City, a vision plan for 25-30 years, ARU.
© ARU.

14 Looking along the southern portion of the sea wall at Saemangeum with the Gogunsan Archipelago on the distant horizon. Photo: Alex Bank, ARU, April 2005.
© ARU.

15 Saemangeum is located on the south-west coastline of the Korean peninsula, facing a number of major industrial cities

along north-east China, including Shanghai, Qingdao and Bejing.
© ARU.

16 View of the Saemangeum Island City from the hills of the Byeonsanbando National Park, looking north. Drawing: Thomas Gantner, ARU.
© ARU.

17 View of Saemangeum from a helicopter, looking towards the new freshwater lake enclosed by the recently completed seawall at Saemangeum. Photo: Philip Christou, Jan 2008, ARU.
© ARU.

Almere Structure Vision, Almere, The Netherlands, page 239

1 Almere 'Structure Vision 2030', early masterplan of the multinuclear city of Almere by Teun Koolhaas.
© MVRDV.

2 Almere 'Structure Vision 2030', visualisation of Almere Island, a more upmarket urban area connected to Amsterdam by metro and aimed at more affluent Amsterdammers. Selling the island finances the water improvement through newly created wetlands, MVRDV.
© MVRDV.

3 Almere 'Structure Vision 2030', visualisation of Almere new central station, MVRDV.
© MVRDV.

4 Almere 'Structure Vision 2030', Almere in the context of the Randstad urban network, MVRDV.
© MVRDV.

5 Almere 'Structure Vision 2030', overview of the masterplan, divided into four parts, from left to right: Almere Island, Almere Pampus, City Centre and Almere East, MVRDV.
© MVRDV.

6 Almere 'Structure Vision 2030', showing Almere and its position in the Amsterdam region, with the city's Green Heart (green) and Blue Heart (blue) joining at the Ijmeer, which Almere and Amsterdam flank, MVRDV.
© MVRDV.

7 Almere 'Structure Vision 2030', visualisation of Almere Oosterwold: a neighbourhood of informal urbanism in which low density and mixed use are combined and provide flexibility for the future, MVRDV.
© MVRDV.

8 Almere 'Structure Vision 2030', marina on Almere Island, MVRDV.
© MVRDV.

9 Almere 'Structure Vision 2030', Almere Island and Almere Pampus, MVRDV.
© MVRDV.

10 Almere 'Structure Vision 2030', Almere line with city centre in the background, MVRDV.
© MVRDV.

11 Almere 'Structure Vision 2030', Almere train line and new Central Station, MVRDV.
© MVRDV.

12 Almere 'Structure Vision 2030', Almere Pampus street scene of the coastal community, MVRDV.
© MVRDV.

13 Almere Oosterwold: the development strategy anticipates the organic growth of a rich mix of initiatives with a green agricultural character, MVRDV.
© MVRDV.

14 Almere Oosterwold, mixed use development including plots on which individuals can construct homes, MVRDV.
© MVRDV.

Longgang, Pearl River Delta and Qianhai Port City, Shenzhen, China, page 250

1 Masterplan for Tianjin Eco-City, China, jointly developed by the China Academy of Urban Planning and Design, the Tianjin Institute of Urban Planning and Design, and the planning team of Singapore Urban Redevelopment Authority.

© Sino-Singapore Tianjin Eco-City Investment and Development Co., Ltd.

2 Deep Ground, Longgang, infrastructure landscape masterplan, GroundLab and Plasma Studio.
© GroundLab and Plasma Studio.

3 Deep Ground, Longgang, urban villages studies and diagrams, GroundLab and Plasma Studio.
© GroundLab and Plasma Studio.

4 Deep Ground, Longgang, infrastructure landscape key sections, GroundLab and Plasma Studio.
© GroundLab and Plasma Studio.

5 Deep Ground, thickened ground, top view, CGI visualisation, GroundLab and Plasma Studio.
© GroundLab and Plasma Studio.

6 Deep Ground, Longgang, bird's eye view, CGI visualisation, GroundLab and Plasma Studio.
© GroundLab and Plasma Studio.

7 Deep Ground, Longgang, bird's eye view, CGI visualisation, GroundLab and Plasma Studio.
© GroundLab and Plasma Studio.

8 Deep Ground, Longgang, thickened ground, top view, CGI visualisation, GroundLab and Plasma Studio.
© GroundLab and Plasma Studio.

9 Deep Ground, Longgang, thickened ground, eye-level view, CGI visualisation, GroundLab and Plasma Studio.
© GroundLab and Plasma Studio.

10 Deep Ground, Longgang, thickened ground, eye-level view, CGI visualisation, GroundLab and Plasma Studio.
© GroundLab and Plasma Studio.

11 Deep Ground, Longgang, parametric model potential scenarios, GroundLab and Plasma Studio.
© GroundLab and Plasma Studio.

12 Deep Ground, Longgang, parametric model typology chart, GroundLab and Plasma Studio.
© GroundLab and Plasma Studio.

13 Exploded view of the transport loop of the Qianhai Port City masterplan, OMA.
© OMA.

14 Concept of masterplan for Qianhai Port City, OMA.
© OMA.

15 The port, model of the Qianhai Port City masterplan, OMA.
© OMA.

16 Port and logistics area, model of the Qianhai Port City masterplan, OMA.
© OMA.

17 The port, model of the Qianhai Port City masterplan, OMA.
© OMA.

18 Qianhai Port City: the city's 'hardscape' in bands with different typologies at various densities, OMA.
© OMA.

19 Qianhai Port City: the city's 'softscape' facilities which are largely but not entirely arranged on the bands of different typologies, OMA.
© OMA.

20 Visualisation of Qianhai Port City, looking towards the transport loop, OMA.
© OMA.

Smart Cities: Rethinking the City Centre, Brisbane, Queensland, Australia, page 264

1 View of the Brisbane City Centre looking north. Brisbane City Centre consists of a series of peninsulas defined by the serpentine course of the river.
© Stefan Jannides.

2 Brisbane, view of Brisbane CBD from South Brisbane [en] the freeway-lined waterfront on the CBD side is proposed to be revitalised as an under-freeway precinct.
© Ethan Roholff.

3 Brisbane, view of Brisbane CBD from South Brisbane. The city centre comprises a series of 'peninsulas' defined by the serpentine course of the Brisbane River.
© Ethan Roholff.

4 Brisbane: Prior to the Smart Cities strategy, urban renewal encompassed nearly 30 different districts largely due to different jurisdictions. This meant fragmented planning, and each was conceived as a so-called 'urban village', isolated rather than considered as integral to a cohesive future. Green = City Council; Dark Green = Statutory Authority; Red = State Government; Orange = Joint Council/State Government; Purple = Not for Profit Organisation, Cox Rayner Architects.
© Cox Rayner Architects.

5 Brisbane: 'Smart Cities' Report, Cox Rayner Architects. Cox Rayner proposed recasting the districts into four clusters, each collocating major urban growth with knowledge and research precincts. This structure simplified planning, enabling each cluster's team to consider the whole plan and consult with the others. Orange = City North (Bowen Hills, Royal Brisbane Hospital, City Showgrounds); Green = City West (Kelvin Grove, QUT Campus, Auchenflower); Blue = South Brisbane Riverside (Kurilpa Precinct, City Cultural Precinct); Purple = City South (Woolloongabba, Princess Alexandra Hospital, Ecosciences Precinct, linked to University of Queensland).
© Cox Rayner Architects.

6 Brisbane: 'Smart Cities' Report, Cox Rayner Architects diagram illustrating the positions of the city's major education, research and cultural precincts, noting that they form a distinct 'corridor'. Until this point, it was not recognised that the major urban growth of Brisbane closely relates to this corridor.
© Cox Rayner Architects.

7 Brisbane: 'Smart Cities' Report, Cox Rayner Architects. 2006 diagram by KPMG showing the zones where major urban density was forecast to occur (orange), irrespective of planning intervention.
© Cox Rayner Architects.

8 Brisbane: 'Smart Cities' Report, Cox Rayner Architects. This diagram corresponds to the major urban growth precincts as they are now planned with the primary research and tertiary education precincts already existing and expanding.
© Cox Rayner Architects.

9 Brisbane: 'Smart Cities' Report, Cox Rayner Architects. Diagram illustrating a series of primary pedestrian corridors (purple) to connect the urban growth precincts across the city's serpentine river requiring a number of new bridges.
© Cox Rayner Architects.

10 Brisbane: 'Smart Cities' Report, Cox Rayner Architects. Diagram illustrating a variety of options for light rail loops and lines, corresponding with the city's rapid ferry (Citycat) system. Subsequently the Queensland Government announced a new heavy rail corridor to run north[en]south through the city centre, with stations located in each urban growth precinct.
© Cox Rayner Architects.

11 SW1 Precinct, Brisbane, masterplan, Cox Rayner Architects.
© Christopher Frederick Jones.

12 SW1 Precinct, Brisbane, masterplan, Cox Rayner Architects.
© Christopher Frederick Jones.

13 James Street Market, Brisbane, Cox Rayner Architects.
© Christopher Frederick Jones.

14 Brisbane, James Street Market, Cox Rayner Architects, part of the revitalisation of Fortitude Valley in the Brisbane North Precinct.
© Christopher Frederick Jones.

15 Brisbane, the SW1 precinct was masterplanned by Cox Rayner Architects and sits opposite the practice's Brisbane Convention and Exhibition Centre (1996). The SW1 site was originally intended for Exhibition Centre expansion but was reclaimed in 2006 for mixed use urban renewal.
© Ethan Roholff.

16 Brisbane, urban renewal of South Brisbane has begun – this precinct SW1 won the 2011 Australia Award for Urban Design, Cox Rayner Architects.
© Angus Martin.

17 Kurilpa Bridge, Brisbane, Cox Rayner Architects.
© Christopher Frederick Jones.

18 Kurilpa Bridge, Brisbane, Cox Rayner Architects.
© Christopher Frederick Jones.

19 Brisbane: 'Smart Cities' Report, Cox Rayner Architects. Diagram promoting three main pedestrian corridors through the city centre, each requiring new pedestrian bridges. Two of these – the Goodwill Bridge and the Kurilpa Bridge – have already been constructed.
© Cox Rayner Architects

20 Brisbane: Knowledge Precinct Network, Cox Rayner Architects. The planning for a series of interconnected urban renewal and 'knowledge precincts' has been expanded to encompass all of South East Queensland from the Gold Coast to the Sunshine Coast. This diagram identifies a network of existing and proposed knowledge clusters.
© Cox Rayner Architects.

21 Brisbane, aerial view of the South Brisbane precinct which is now planned to become the city's second CBD across the river from and linked by new bridges to the existing CBD.
© Ethan Roholff.

EPILOGUE

1, 2 Bohácky residential masterplan, Bratislava, Slovakia, Serie Architects. Rethinking infrastructure via natural hedge boundaries that promote a typological grammar of spatial difference.
© Serie Architects.

Index

Abe, Hitoshi, Atelier, 109
Abercrombie, Patrick, 9, 195–6
Abalos and Herreros, 221
Abu Dhabi, UAE: Grand Prix, 161; Masdar City, xvii, 6, 68, 159–173
access, by citizens, 197
acupuncture, urban, 123, 142, 147
activist architecture, 153
adaptive planning, 275, 276
Adjaye, David, Adjaye Associates, 64, 68, 109, 110
administration, city. See government, local.
adobe, courtyard houses, 59, 93
AECOM, 64, 160, 162
aerial photography in landscape architecture, 130
Africa, 131; South Africa, 129–140
agent-based modelling, 22
agriculture: context, 235; deteriorating land, 211; engineer, 217; future evolution, research into, 229; islands, 212; irrigation, 219; land, 197, 217, 219, 232; park, 221; sustainable, 212; urban, 113, 138, 152, 195, 213, 219, 221, 236, 246, 248; zones, 223, 245
agri-tourism, 229, 231, 232
aggregation spots, 182
airports, 42, 138, 168, 170, 188, 193, 232; expansion, 164
Al Barahat Square, Doha, 64
Alberto Franchini and Andrea Boschetti, Metrogramma, 187–201
Alejandro Aravena, Elemental, 95, 96, 101, 103
Alejandro Zaera-Polo, AZPA, 1, 15–17
Aleppo, Syria, 166
Alfred Herrhausen Society, 211
Allies & Morrison Architects, 64, 68
allotments, urban, 38, 197, 219, 220, 221
Almere, The Netherlands: Almere Structure Vision 2030 (MVRDV), 239–249
Al Nahyan, Sheikh Zayed bin Sultan, 161, 164
Alonso y Asociados, 213
Amager Common, Copenhagen, 33, 35
Amsterdam, the Netherlands, 239, 243, 244
amphitheatre, 215
Amsterdam: Eastern Docklands,
AMO (see also OMA), 14, 262

Ando, Tadao, 162
Andrea Boschetti and Alberto Franchini, Metrogramma, 187–201
Andreas Kipar and Giovanni Sala, LAND, 14, 189, 197, 198, 199
Andrews, Jody (Director of Capital City District, Abu Dhabi), 170
Andropogon Associates, 170
anthropological research, 277
Antonio Derka School (Carlos Pardo/Obranegra), 124
Arabian Gulf, the, 162
Arabic architecture, 59; terms, 60; *estidama*, 159; *huerta*, 219; *mashrabiya*, 162; *masdar*, 164; vernacular, 166
Aravena, Alejandro, Elemental, 95, 96, 101, 103
Arauco, 94, 96, 101
Architectural Association, London, 253
architecture: activist, 153; story teller, architect as, 154
Architectus, 270
Architekten Cie, 248
area atlases, 23, 193
archaeological sites, 212, 215
Archis Foundation, Amsterdam, 11
Archis Interventions, 11
Architecture for Humanity, 19
Arganzuela Park, Madrid, 203, 207, 208, 209
Arkki, 356
art installations, 76
artists, 12, 67, 72, 79, 207, 257; studios, 162, 221
ARU (Florian Beigel and Philip Christou), 10, 227–235
Arup, 64, 95, 178, 213, 214, 216, 272
Asia, 7, 11, 14, 83, 84, 141, 142, 143, 180, 227–235, 250–263
ASTOC, 45
Atlantic Yards, Brooklyn, 10
Auroville, India, 11
Australia, 21, 264–274
authenticity, 11, 258
autonomous communities, 174
Avenida de Portugal, Madrid, 205, 207
awards, 126

awnings, 168
Ayala, Clarissa (Ministerial Regional Secretary for Housing and Urban Development, Chile), 101
AZPA, 15–17

Bachelet, Michelle (President of Chile), 93
Balmoral, Brisbane, 272
Baltic States, Sea, 42, 45
Bakker, Riek (Director of Urban Development, Municipality of Rotterdam, 1986–1991), 247
Ban, Shigeru, 109, 110
Baoding, China, 251
bars, 162
Bara Link, 130
Barahat Al-Naseem Square, Doha, 67
Barcelona, 15, 83, 231, 233, 236; Barceloneta, 231, 232; 1992 Olympics, 121; Urbanizacíon marginal programme, 121
Barefoot Plaza, Medellín, 123
barrios, 8, 121, 123, 124, 125, 128, 141, 144, 147, 148
Baron Haussmann, xvii
barracks, former, 181
Barth, Larry, 85, 87
Basil Reed Developments, 140
Basque Country, the, Spain, 174
Battle for Brooklyn, 10
Bay Ring, 76
BAU, 251
Bauschner, Joshua, 8
beaches, urban, 164, 203, 208
bed towns, 236
Behnisch + Partner, 47
Beigel, Florian and Christou, Philip, ARU, 10, 227–235
Beijing, 251, 252
Belgium, 247
benchmark projects, 55, 87, 140
Berger Partnership, the, 72
Berlage Institute, Rotterdam, 230
Berlin: Lichterfelde, 236; Wall, 45
bespoke design, 64
Bhabha, Homi (*The Third Space*), 10
Bicocca, Milan, 188, 197

bicycles: 198, 239; bridges for, 272; paths, 197, 201, 203, 208, 260; schemes, 21, 23; sharing schemes, 201; track, 207; as a form of travel, 28
BID (Business Improvement District), 193
BIG, 6, 38; 40–41
Big Dig, The, Boston, 203
Bijdendijk, Frank (Director, Stadgenoot), 246
Bilbao, 20, 90; Bilbao effect, the, 9
Bild, 109
Billes, 109
Bindels, Edzo, West 8, 203, 208
bio: -climatic housing, 181; diversity, 42, 79, 208, 256, 276, 277; -mass, 216; reports, 135
biomedical research, 83, 86
'Biomilano', 197
Biopolis, 83, 86
Bjarke Ingels, BIG, 11, 40
Bjerget MTN, Ørestad City (BIG), 40
blocks, urban, 231
blog comments by the public, 72
blueprints, 141, 242
BNIM, 109
Boeri, Stefano, Multiplicity Lab, 197, 198, 199
Bogóta, Colombia, 12, 117, 128
Boháčky residential masterlan, Bratislava, Slovakia (Serie Architects), 276
Boschetti, Andrea and Franchini, Alberto, Metrogramma, 187–201
Boston, 105
botanical gardens, 197, 215, 260
bottom up: design, 253; urban planning, 12; processes, 147, 277
boulevards, 170, 179, 182, 192, 196, 203, 207, 247; lakeside, 244; -park, 205. See also streets.
boundaries, 169
Bovisa, Milan, 188, 193, 196
Brasilia, 8
brands, cultural, 162
Branzi, Andrea (Weak and Diffused Modernity), 10
Brazil, 12, 17, 141, 142, 148–52
Braungart, Michael, 108
Bratislava, Slovakia, 276

bridges, 51, 121, 124, 161, 205, 206, 268, 270, 272; foot, 221; green, 196; Puente: de Segovia, Toledo, 208, 209; Puentes Cascara, Madrid, 205, 206, 207
Brillembourg, Alfredo, Urban Think Tank, 17–18, 22, 141–155
Brinkley, Douglas, 107
Brisbane, Queensland, Australia: CBD Planning Strategy and Masterplan, 265; Powerhouse, 273; Smart Cities: Rethinking the City Centre, 6, 264–74
Broadacre City (Frank Lloyd Wright), 248
Brooklyn, 10; Brooklyn Bridge Park, 75
Brown, Marshall and James, Letitia, The Yards Development Workshop, 10
brownfield development, 55; reuse of sites, 188, 193
BRT, 278
Bruns-Berentelg, Jürgen (HafenCity Hamburg GmbH), 45, 52, 53, 55
buildCollective, 138
buildings: capacity to adapt, 178; civic, 233; correspondence with streets, 135; heights, 30, 265; iconic, 170; networks of, 155; along a promenade, 163; permissions, 192; in a masterplan, 246, 258, 277; relationship between new and the urban scene, 188; storeys, 168; systems, 151; responsiveness to topography, 182, 234; stock, underutilisation of, 182; tall, 30, 193; v. landscape opposition, challenging the, 254
buildingstudio, 109
bureaucratic hurdles, 85, 103
Buona Vista Park, one-north, Singapore, 88
budgets for masterplans, 178
BURB.TV (Neville Mars), 251
Burgos & Garrido, 203
Busan, South Korea, 51
Busby, Perkins + Will, 170
buses, 78; BRT/Bus Rapid Transit systems, 133
Bush, George, 105
business: centre, 248; districts, 252; facilities, 138, 183, 193; industry clusters, 83–90; 159–73; owners, 190; parks, 9, 236; research and development, 172; sector, 47, 51;

small, 126, 192; start-ups, 166; sustainable, 248; trading, 71; zones, 130, 227
Business Integration Partners, 189
By & Havn, 27, 35

cable car transport system, 122–3, 144–7, 155
Cadiz, Spain, 233
Cambridge: 232; quadrangles, 231
Campanella, Richard, 113
campuses, 11, 61, 153, 166, 231, 261
Canada, 170
canals, 36, 153, 162, 188, 212, 216; canal city, Dutch, 35, 42
Canary Wharf, London, 10
Canogar, Daniel, 207
Caofeidian, Tangshan, 251
Capital City District, Abu Dhabi, 170
Caracas, Venezuela, 17, 141, 144–5, 147, 148, 153
carbon: footprint, 168; monoxide emissions, 28; -neutral, 183
Carlsberg, Copenhagen, 28–34
car: -based eco new towns, 182; -free, 168; cars v. pedestrians, 12–13, 135; dependency, 105; v. domination by, 126; focussed planning, 131, 135;. public spaces, 65; use, 59, 260
Casa de Campo, Madrid, 205, 207, 208
catalysts, plans as, 183
census information, 144
central: business districts (CBDs), 106, 133, 247, 265, 266, 268, 269, 270, 272, 273; Central Park, New York, 231; of the city, relationship with outlying areas, 192
Central Market, Abu Dhabi, 164
Centre for Advanced Spatial Analysis (CASA), University College London, 23
Cerdà: Ildefons, 221, 231, 232, 233; Juan Ignacio, 101, 103
Chandigarh, 8–9; Update Chandigarh (TU Berlin), 9
Chang Mai, Thailand, 162
change of use, 246
Chan Krieger Sieniewicz, 106
Chaolin, Gu, Xianhui, Yuan and Jing, Guo, 251, 252

Chapultepec Park, Mexico City, 211
charrettes, 15, 20, 277; visioning, 71
Chengdu, 83
Chennai, India, 11
Cherokee Gives Back Foundation, 108
Chicago (Millennium Park), 20, 80
children; 55, 126, 130, 144; children's play
 spaces/grounds, 53, 79, 101, 135, 208;
 competition for, 203; Early Childhood
 Development Centre, 140
Chile, 18–19, 93–103
China, 7, 14, 83, 84, 141, 142, 143, 180,
 250–263, 266; China Lab, Columbia
 University, 251
chinampas, 212
Chipperfield, David, 248
Christiania, Copenhagen, 30
Christiansen, Jan, 28
Christiaanse, Kees, KCAP, 5–56
Christou, Philip and Beigel, Florian, ARU, 10,
 227–235
Chuan, Yeoh Keat, 84
churches, 101, 130, 135
CIEAX Centre, Xochimilco, Mexico City, 214,
 215, 216
cinemas, 162
circulation routes, primary, 172
citizens. See public
city: waterfront neighbourhoods, 27–44,
 45–56, 59–68, 69–80, 93–103, 202–10,
 211–16, 227–35, 239–49, 250–63, 264–74;
 city blocks, 71; CityCat boats, 272; City
 Center, Las Vegas, 246; -City Magnets;
 Structures, 231, 232, 233; and country
 dichotomy, 219; edges, 174; extension to,
 178; medinas, 153; new, 236
civic meeting place, 67; gatherings, 148; utility,
 246
CIVITAS Urban Design and Planning, 170
climate: 169; change, 12, 15, 109–110, 239,
 275; climatic design, 63; engineers, 164
Clinton, Bill (former US President), 108
Clos, Joan (UN Habitat), 15
cluster: policies, 51, 86; strategies, 268, 269
coalitions, 11; consultation, 10, 20; -driven
 planning principles, 143; facilities, 135, 193;

forum, 131; integrated, 166; oversight
 committee, 11; living, 63; meetings, 72,
 144, 146; participation, 95, 148; sense of
 ownership, 11; spirit, 59; well-being, 12;
 workshops, 101.
coastal: areas, 261; cities, 109, 159–173, 244;
 coastline, 235, 242, 245, 247
COBE, 27
codes, 9, 30
Codevco, 130
cohesion, urban, 223
Cold, Christian and Signe, Entasis, 28
Collage City (Colin Rowe and Fred Koetter), 10
collaging, 10, 233
collective: city concept, 201; identity, 63, 68;
 ethos, 65; landscape, 233
collective rights, 277
Colombia, 12, 117–128
colonnades, 64
Columbia University, 230
commerce, attracting, 170
commercial: buildings, 161; firms, 28;
 precincts, 268; units, 195, 246
communal: 223; gardens, 63; networks, 136;
 growth in communality, 220
community: amenities, 163; autonomy of, 126;
 centres, 51, 118, 221; close-knit, 61;
 involvement, 277; plans, 276, 277
compact: cities, 28, 64, 170, 182, 190, 265;
 spatial planning, 140
compartmentalisation, 52
competitions, 20, 28, 30, 32, 33, 35, 45, 85, 108,
 118, 123, 128, 164, 196, 203, 207, 212, 252;
 workshop, 230
concentric plan, 60
Concerto initiative (EU), 181
Concordia, 109, 111, 114
Congress for the New Urbanism, 105
connectivity: 253, 256, 272, 274; new road, 200;
 social, 12, 60, 87; and its spatialisation, 220
conservation land, 216
Constitución, Chile, 18–19, 93–103
construction standards, 138
cooperatives, business and social, 153, 220
COP15 United Nationals Climate Change
 conference, 2009, 27

Copenhagen, Denmark: Carlsberg; Ørestad;
 Loop City; Nordhavnen, 27–44;
 Hombaekhus, 231, 246
Cornell University, Sustainable Design (CUSD)
 group, 138
Corner, James, james corner field operations,
 13
corniche, 60
corridors: environmental, 197; growth, 267
Cosestudi, 213
Cosmo City, Johannesburg, South Africa,
 129–140
costs: consultants, 236; of masterplan
 implementation, 172. See also budgets
CO2 neutral: districts, 30; footprints, 178,
 180
countryside, 219
Cox Rayner Architects, 264–74
creative: hub, 272; industries, 162
critical regionalism, 178
crowdsourcing, 21, 277
councils, local, 71
courtyards, 63, 67
Cradle to Cradle thinking, 108, 109, 248
crime, violent, 126
Crane, David, 129
Cruz, Teddy, estudio teddy cruz, 18
Ctrl G, 128
cultural: destination, 159–62; facilities, 259;
 local readings, 277; precincts, 265, 266,
 267
Curry Stone Design Prize, 2009, 126
customisation, 248
cut-and-paste urbanism, 227
cycle paths: see bicycle; cyclist friendly
 schemes, 39

Dafan Oil Painting Village, Shenzhen, 257
Danish Architecture Centre (DAC), 27, 44
Darden, Tom (Executive Director, Make It
 Right), 110
data, 23, 144, 146; collection, 193; 3D data
 bank, 147
David Adjaye, Adjaye Associates, 64, 68, 109,
 110
Davis, Mike (City of Slums), 12

day care centres, 42, 51
debates, 201
de Graaf, Reinier, OMA, 1, 14, 262
de Vries, Nathalie, MVRDV, 174
decay, urban, 182
decentralisation, 64
Deep Ground (GroundLab), 252–258
deforestation, 211
deindustrialisation, 9, 187, 187
Delft University of Technology (The Why
 Factory), 239
delocalisation, antidote to, 222
democracy: process for democratic cities, 13,
 154; promoting, 211
democratic society, 33; processes, 142;
 participative democracy, 143
demographic: change, lack of, 193; research,
 7, 135, 138
demonstration: projects, 181; national
 demonstration sites, 248
Demos, 21
Denmark, 6, 27–44, 231
density: 12, 28, 133, 142, 162, 164, 170, 179,
 190, 192, 232, 236, 243, 260, 272, 276;
 alleviating, 211; compulsory, 190;
 densification, 190. 201; differentiation in,
 246, 248, 261; distributed, 10; growth,
 192, 264; high, 36, 135, 161, 192, 208, 219,
 227, 244, 246, 247, 251, 254, 262, 273;
 increasing, 239; low, 9, 20, 135, 170, 227,
 243, 248, 262; medium; 84; nodes, 248; of
 programme, 170; variables related to
 density and typology, 258
Department of Planning and Development,
 Seattle, 71
de Portzamparc, Christian, 248
Desert: Island, Abu Dhabi, 161; desertification,
 211
design: codes, 278; concepts, adjustable,
 236; modelling techniques, 252;
 multidisciplinary, 153; research-led, 138;
 social, 148; studios, 151; urban, 129–30
developers, 11, 12, 141, 219, 220, 236, 246,
 265, 272; multiple, 10; -led urban planning,
 105; -led housing schemes 140
development: 235; effect on landscape, 239;

fast track, 252; pace of, 201; new, 259;
 strategies: long-term, 84, 261; private, 190
Development Cooperation Forum (DCF),
 United Nations, 251
developing world, the, i, 2, 142
differentiation: in urban identities, 257, 276,
 277
digital: economy, 221; technologies, 21, 23,
 223
Dion, Mark, 72, 79
Dijon, France, 162
Disney, Walt, 22
districts, 37, 90, 162, 207, 208, 211, 265, 266;
 Mexican Federal District (Distrito
 Federal/D.F.), 212; new, 241; plans, 201;
 river-facing, 205
disurbanism, 19
Diwan Amiri Quarter, 65
D-38 Zona Franca office complex, Barcelona
 (FOA; Arata Isozaki), 15
Doha, Qatar: Musheireb, 59–68
Dockland City Block, Hamburg, 231
docks, 69, 239
Dongtan Eco City, China (Arup), 251
Donovan Hill, 270
dormitory towns, 42. See also bed towns.
downtown, 38, 64, 69, 73, 123, 126, 203
driverless PRT systems, 168
Dubai, 60, 159, 230; -land, 159; Healthcare
 City, 159; Media City, 159; Internet City,
 159
Duggan, Tim (Make It Right), 111
Duivesteijn, Adri (Alderman of Almere), 242,
 246
Dynamic City Foundation, Beijing, 251

earthquakes, 93, 142
East River waterfront, New York City, 75
Eastern Docklands, Amsterdam, 52
Ebrard, Marcelo, 213
Echeverri, Alejandro, 117, 126, 128
Ecociudad Valdespartera, Zaragoza, 181
eco: -cells, 251; cities, 13, 15, 157–183, 251,
 252, 277; -energy visitor centres, 183; -label
 (HafenCity), 47; new towns, 182, 243; parks,
 179; -systems, 11, 71, 162; -valley, 251

ecology: 72, 109; boulevard, 203; crises, 276;
 footprint, 251; functions, 71; ecological
 corridor, 253, 256; ecological performance,
 13; health, 248; improvements, 180; needs,
 243; park, 212; plan, 246; prototypes, 153;
 qualities, 252; solutions, 216; strategies, 79,
 277; sustainability, 190; territorial ecologies,
 154; three (Félix Guattari), 220; transitional
 areas, 197; urban, 245
ecoLogic Studio (Algae Farm, Sweden), 5
economy: knowledge-based, 61; new
 industries, 83; post-oil and gas, 61; urban
 team, 236
Economic Development Board of Singapore,
 84
economic: activity, local, 99; crisis, global, 12,
 20, 159, 178, 188, 207, 219, 239;
 cooperation, 259; demands, 252;
 development, 231, 251, 252, 275; digital
 economy, 221; diversification, 161, 163;
 flexibility, 228; growth, 35, 143; health, 248;
 motor, 242; networks, global, 252; plan,
 216; sustainability, 113, 190, 277
economists, urban, 135, 155,
ecosystem, artificial, 221, 223
Eden Park, Chennai, India, 1
edge cities, 252
EDU (Empresa de Desarrollo Urbano).
 Medellín, Colombia, 117
education, 214–5, 259; campus, 35;
 environmental, 153; facilities, 272; hubs,
 261; precincts, 267, 268; Education Africa,
 138; Education City, Doha, 61
Eisenhower, Dwight D., 105
Eixample, Barcelona, 221
electricity connection, 133
Elbphilharmonie concert hall, HafenCity,
 Hamburg, 49
Elbro River, Spain, 178
elderly: housing the, 221; spaces for, 208
Elemental, 19, 95, 101, 93–103, 109
Elliott Bay, Seattle, 70, 72, 76
EMBT, 49
emergency shelters, 103
eminent domain, 10
Emirates, the United Arab, 142

EMP, 124

energy: alternative means of, 140; availability of, 131 climate, 164; consumption levels, 165, 251; distributed, 277; efficiency, 20, 134; efficiency ratings, 180; in *favelas*, 153; generated onsite, 179, 221; off-the-grid solutions, 110; use, 23; hub for renewable, 164; management, sustainable, 181; network, renewable energies, 236; production, 174, 179; provision, 15; saving, 180, 277; specialists, renewable energy, 164, 166, 169, 175, 178, 181; research centres 179; solar, 166, 169, 175, 179; summit, 169; sustainable, 229; use monitoring technologies, 172

engineers, 78, 142, 213; engineering services, 135, 170

Enrique Norten, TEN Arquitectos, 106, 211–216

Entasis, 28

entertainment facilities, 166, 213

entrepreneurial activity, 190

envelopes, virtual, 15; solar, 22

environmental: capital, 138; change, 197; consultants, 236; corridors, 197; damage, 230; design, 181, 261; environmental conservation area, 130; and housing, 27; impact assessment, 203, 261; impact, 267; improvement, 201; management and technology, 22; networks, 199; protection, 251; problems, 211, 213; science, 155; transformation, 252

epicentres, 190, 197, 200

EPCOT (Experimental Prototype Community of Tomorrow), 22

erosion, 148

Eskew+Dumez+Ripple, 106, 109

estidama, 159, 170

ETA, 164

ETH, Zurich (Department of Urban Design), 17, 141, 148

ethnic groups, global, 161

ethnography, urban, research, 53

Euralille, 248

Europe, 142, 219, 246, 248, 261; cities, 141; 239, Commission, 181; Enlightenment,

163; lifestyles, 272; power grid, 262; University of Madrid, 230; university campus model, 231

evaluating 'eco cities', 252

Evenden, Gerard (Foster + Partners), 169

evolutionary planning, 251, 276

exhibitions, 45, 197, 201, 213, 214, 248; hall, 207

exemplars, 232

experimentation in plans, 246

facades: ETFE, 168

Facebook, 72

factories, 198

family: structures, 223; units, emerging, 221; virtual, 221

farms: 229, 231; fields, 236

fast city, the, 200

Fathy, Hassan, 68

Fajardo, Sergio (former Mayor of Medellín, Colombia), 117, 123, 126, 127, 128

Farini-Lugano, Milan, 193, 195

farms, urban, 197; Farm City, 232

Fauria, Vaughan (Claiborne Corridor Improvement Coalition), 105

favelas, 17, 141, 148–50, 153

Favela Barrio programme, Brazil, 121

federal: governments, 8; precincts, 170

ferry: system, 269, 272; terminal, 69

festivals, 79

Fez, Morocco, 166

51-1 Architects, 128

field structure, 236

films on urban developments and urbanism, 10, 103

financing, projects, 72, 103, 209; financial heart, 232

Finger Plan, Copenhagen (Steen Eiler Rasmussen), 6, 42

fireejs (neighbourhoods), 63, 64

First World, 142

Fishermans Wharf, San Francisco, 75

flagship projects, 61

flexibility, in plans, 45, 239, 244, 246, 248; development strategy, 243

floating: dwellings, 245; villages, 245

flooding, 12, 142; control, 216; defence, 256; plains, 216; protection, 45, 99, 106, 234; records, 109; review action plan, 274; flood-prone areas, 111

Floriade, the, the Netherlands, 249

Florian Beigel and Philip Christou, ARU, 10, 227–235

folded surface, 254

food: culture, 229; industry clusters, 231, 232; production, 174

Forbidden City, The, Beijing, 30

Foreign Office Architects (2003–2011), 15–17, 182

Forest City Ratner, 10

formal city, 126; formal and informal spatial practices, 138

Fortitude Valley, Brisbane, 265, 270, 272

Foster + Partners, 68, 159–173, 188

framework: mixed use, 227; sustainable, 170; plans, urban design, 12, 53, 69, 70–1, 243, 276; urban scale, 76, workable, 153

France, 21, 162, 193, 196, 231

Franchini, Alberto and Boschetti, Andrea, Metrogramma, 187–201

Fredericia, Copenhagen, 30

free zone, global economic, 230

Fresh Kills Landfill, Staten Island, NYC (james corner field operations), 72

Friedman, Yona, 20

Fujimoto, Sou

Fundación Chile, 95

funding: sources, 196; fundraising, 108

funicular, 179, 180

furniture, street, 179

Fusionopolis, 83, 86

future: post-, 276

Galì, Beth, 51

Gallardón, Alberto Ruiz- (former Mayor of Madrid), 202, 207, 210

Galinsky, Michael and Hawley, Suki (*Battle for Brooklyn*), 10

galleries and museums, 52; Abu Dhabi, 161–163, 270

García Sogo, Lourdes, 220

Garden City, 9; English, 129; contemporary, 193, 241; Movement, 22;

garden: botanical, 197, 260; market, 219; public, 153, 205, 231, 252; and private, 178, 223

Garibaldi, Milan, 198, 199

Garrido Colomero, Ginés, Burgos Garrido, 203, 209

gated communities, 11, 140

gateways to the city, 188

Gausa, Manuel, 217, 221

Gehl Architects, 30, 32, 198, 199

Gehry Partners, 109, 161

genericism, 250

Gensler, 246

gentrification, 10, 12

Geographic Information Systems (GIS), 22, 147, 278

geography, 217; geographers, 113, 241; geographical richness, 123

geological context, 235

Gerkan, Marg und Partner, 47

Germany, 15, 45–56, 231, 232, 236

'Gewild Wohnen', 248

ghettos, 56

Gigon Guyer, 248

Giovanni Sala and Andreas Kipar, LAND, 14, 189, 197, 198, 199

global, anti-, 63

Global Green USA, 108

Global North, 141; South, 141–3, 154

globalisation, adverse effects of, 63; challenges of, 67

global migration, 1

Good Work Network, 110

Goody Clancy, 104, 105

Google Earth, 23

Gordeev, Sergey, 3

governments: departments, 105; local, 123, 126, 130, 131, 135, 189, 201, 207, 210, 216, 241, 243, 246, 247, 249, 251, 265, 267, 273; elections, 209; local municipal and national, 20, 142, 144, 146, 153, 157–173, 220, 228, 239, 248; legislation, 252; Ministries, 95; national/Federal, 140, 170; national, funds, 96; provincial, 174; regional, 273; settlement, 129; subsidies, 105, 207

GPS (Global Positioning System), 142

Graft architects, 107, 108, 109, 110, 112

'Grand Paris' competition, 6, 7

Grammatiche Metropolitane, 201

graphics, 79

GRAS, 174–183

grassroots process, 105

green: belt, 188, 197, 241, 242; bridges, 196; building, 251; -field sites, 37, 55, 193, 243; spaces, 182, 192, 193, 198, 277; spine boulevard, 203; buildings, 106; fingers, 168, 169; growth and welfare, 44; loop, 28; lungs, 51, 168; networks, 134; revolution, 42; roofs, 34, 179; spaces, 42, 189, 209, 214, 277

Green Map systems, 23; ring, 76

Greenpeace, 51

greywater circuits, 180

grids, 64, 68, 73, 142, 161, 168, 170, 233; arterial, 169; deformed, 87; off-grid energy system, 247; renewable energy, 262; system, 221

Gross.Max, 9

ground datums, 253

Growing House (Urban Think Tank), 146

growth: anti-, 276; capital, 129: organic, 164; based on public-private partnership, 189; limits to, 201; precincts, 268; rapid, 266; responsible, 248; sustainable, 242; urban, 83, 142, 202, 208, 212, 237–274; zero, 201

Grotão favela, São Paulo, Brazil, 148–52, 154–5

GroundLab (Eva Castro, Holger Kehne, Alfredo Ramirez, Eduardo Rico and Sarah Majid), 14; Longgang, Pearl River Delta, China, 250–263

Grupo: de Diseño Urbano, 211, 212; Progea, 178

Guallart, Vicente, 217–23

Guangzhou Science City, 83

Guattari, Félix, 220

Guggenheim Abu Dhabi (Gehry Partners), 161, 162

Gulf Region, 63

guidelines, urban, 90

Guiyang City, China, 7

Gurgaon, India, 11

Gustafson Porter, 164

gymnasium, 42; vertical, 153

Haarlemmermeer, the Netherlands, 239

habitations, xvii

Hadid Architects, Zaha, 13, 14, 20, 83–90, 162

HafenCity, Hamburg (KCAP), 45–56; University, 53

Haiti, 23

Hamad Bin Khalifa Al Thani, His Highness Sheikh, Qatar, 61

Hamburg, Germany: HafenCity, 45–56, 231, 232

harbour, 49, 245

Hargreaves Associates, 106

Harlem, New York, 107

Hart Architects and Urban Designers, Michael, 129–140

Hartford, USA, 162

Harvard Graduate School of Design: 262; Department of Landscape Architecture, 22

Harvey, David, 13

Hawaii, 96

health: -care, 259, 261; centre, 221; precincts, 265, 266, 268

HEAT, 264

heights, consistent, 48

heritage: districts, 251; local, 64, 88, 209, 219; plan, 159; quarter, 65, 89; sites, 211

Herzog & de Meuron, 49, 203

heterogenous design languages, 110

High Line, NYC (james corner field operations), 72, 74

high: rises, 133; risk zones, 149–50; speed network, 248; tech development bases, 252; -ways, 202, 203

hills, 178, 179

Hiranandani, 11

HIS (Institute for Housing Studies and Urban Development Studies, Erasmus University, Rotterdam, xviii

historic: agriculture, 219; boulevards, 196; buildings, 257; centre, 203; city centres, 193, 252; examples, 230; irrigation channels, 217; layout of the city, 264; mapping of, 277; references, 248; urban

form, 11, 28–30, 38–9, 45, 193; of a site, 235, 236; structures, 93

historians, 113, 272

holistic approach to plans, 243

home working, 260

Hoograven Vision (Urban Think Tank), Utrecht, the Netherlands, 153

Holy Cross, New Orleans, 106; affordable housing project, 108; School site, 113

hortulus, 219

hospices, 21

hospitals, 37, 192, 267, 268, 269, 272

hotels, 39, 49, 59, 63, 166, 259

Homerus Quarter, Almere (OMA), 246

Hong Kong, 258, 259

housing: 40, 89, 99, 130, 131, 133, 141, 188, 195, 236, 239, 259, 267; adobe courtyard houses, 59, 246; affordable, 107, 130, 170; apartments, 47, 246, 248, 272; association, 246; authorities, 148; awards, 111; bioclimatic housing, 181; buyers, finding, 178; clustering typologies, 135; conversion, 272; courtyard, 168; customised, 112; demand for, 265; demolishing, 153; destroyed, 106; developer-led, 140; diversity of, 28, 37; emergency, 96; estates, 9; experimental, 242; floating, 245; high-rise, 39; hybrid function, 221; lane, 251; LEED Platinum, 111; live/work, 162; luxury, 162; luxury penthouses, 52, 56; in *medinas*, 153; mews, 230; mixed-scale, 163; mixed-use, 113; models, 221; needs, contemporary, 220, 267; new, 28, 118, 193, 241, 244; policy, inclusive for, 11; portable, 113; precincts, 268; prefabricated, 110; prices, 208; quality, 68 removal of damaged, 148; retrofitting, 153; row, 135; social, 13, 136, 96, 124, 178, 181, 182, 193, 246; student, 221; subsidy, 133; suburban, 239; sustainable, 30, 130; tenure, mixed, 56; townhouses, 63, 68; traditional housing types, 109; types, 247; units, 178, 217; upgrading, 135; working class, 34.

Howard, Ebenezer, 22

Huaxi masterplan, Guiyang City, China, 7

hubs, 153, 261

huerta (market garden), 219, 220, 221

Hudson River Trust Authority, 11; Park, 73

Huerta de la Partida, Madrid, 205, 207

human scale: of new developments, 253

Hurricane Katrina, 104, 105, 106, 108

hutong zones, Beijing, 252

hybridity, 67; facilities, 277; between the urban, rural and the natural, 197

hyper-urbanisation, 262

Iberg, the Netherlands, 241

Id-Lab, 189, 190, 191

identity: distinct areas, 201, 244; local nuclei, 193–4; national, 132–33; new developments, 253, 259; social and cultural identity patterns, 193; urban, 128, 135, 193, 236, 264

industrial areas, 188, 193

Il Bosco Vertical, Isola (Multiplicity Lab), 197

Illinois Science + Technology Park, 83

improvisation, 208

income, per capita, 159

inclusion, social, 181, 190, 274

incremental: upgrading, 136, development, 143, 278

India, 11, 13, 141, 142

industrial: areas/districts, 42, 70, 182, 187, 195, 268; buildings, 106; clean-tech industries, 172; crisis of the industrial city, 188; food, 231; v. the formal economy, 138; v. formal spatial practices, 138, 147; former industrial sites, 211; high-tech, 182; identity, 220; informal settlements, 17, 126, 130, 133, 142; integrated, 87; land, 266; nodes, 138; parks, 130, 231; plots, 28; post-, 246; warehouses, conversion of, 272

informal urbanism, 243

infrastructure: 148, 174, 178, 196, 203, 234, 246, 259, 260; decentralised; good quality, 192; investment in, 202, 242; landscape project, 254, 256; large scale, 252; monitoring and mitigation plans, 277; multilayered, 147; network, 200, 201; new, 153; service, 229; solutions, 142; social, 148, 153; sustainable, specialists, 164; adapting systems, 182; top-down, linked to bottom-up community

development, 144; by the river, 256; transport, 243; and transportation masterplan, 170

Ingels, Bjarke (BIG), 11, 40

inner city and periphery, connectivity between, 201

innovation, 87, 109, 259; and energy saving, 262; park, 269; technology transfer, 95

Inside Outside, 198, 199

integrated livelihoods, 138

Intelligent Transport Systems (ITS), 260

intensification, urban, 83, 88, 90, 258, 277

Internet, the, 153

investment, private, 107, 161

IRENA (International Renewable Energy Agency), 166

Iron Curtain, 45

Isola, Milan, 197, 198, 199

Isozaki Architects, Arata, 15, 61

Islamic street patterns, 65

islands, 230, 233, 234, 244

Istanbul, 87

IT: hub, 11; industries, 83, 86

Italy, 4, 6, 7, 10, 14, 187–201, 233

Ito, Toyo, 203, 221, 222, 223, 276

intranet, 239

investment, catalyst for new, 89

IVVSA (Instituto Valenciano de Viviena), Valencia, 220

Jacobs, Jane, 7

James corner field operations, 69–80

James, Letitia and Brown, Marshall, Yards Development Workshop, 10

Japan, 86, 96, 103, 142, 146–7, 246, 276

Jardins de la Virgen del Puento, Madrid, 205

Jensen, Frank (Mayor of Copenhagen), 44

Jiangsu Institute of Urban Planning and Design, China, 263

Johannesburg, South Africa, 129–140

John McAslan & Partners, 68

JTC Corporation, 83, 85

Justesen, Rita (By & Havn), 35, 42

Kabul, 10

Kahn, Louis, 8

KCAP, 45–56
Kappe Architects/Planners, 109
Kartal-Pendik, Istanbul, 6, 20, 87, 90
Kelvin Grove Urban Village, Brisbane, 268, 272, 273
KEO International, 170
KHR Architects, 37
Kieran Timberlake Associates, 109, 110, 112
Kim, Young Joon, 221
kindergartens, 153, 192
Kirinda, Sri Lanka, 19
Kipar, Andreas and Sala, Giovanni, LAND, 14, 189, 197, 198, 199
Klumpner, Hubert, Urban Think Tank, 17–18, 22, 141–155
knowledge: -based economy, 61; precincts, 265, 266, 268, 273; transfer, 170
Kødbyen, 27
Kohler, Martin, 53
kong-gan, 231
Koolhaas: Rem (OMA), 262, 275, 276; Teun, 240, 241
Kop van Zuid, Rotterdam (TKA), 48, 241, 247
Korea, South, 142, 227–236
KPF, 198, 199
Kurilpa Bridge, Brisbane (Cox Rayner Architects), 271, 272
Kurokawa, Kisho, 86

L'Associazione Interesse Metropolitani (AIM), 198
Lahoud, Adrian, 21
lake: -side boulevard, 244; new, 235; -side, 231, 236, 242, 244, 245; system, 212, 216
LA Neighbours United community organisation, 11
LAND (Andreas Kipar and Giovanni Sala), 14, 189, 197, 199
Landrieu, Mitch (Mayor of New Orleans), 105
land: changes in, 187, 192; conservation, 216; -fill sites, 179; isolated, 60; lack of, 261; mixed, 87, 105; for open space, 268; reclamation projects, 227, 236; traditional

land-use plans, 192; use, 13, 90, 134, 138, 172, 251, 254, 258; value, 35
landscape, 9, 217; architects, 130, 135, 170, 189, 198, 199, 211 (see also james corner field operations, West 8, LAND, Inside Outside, Mario Schjetnan); architecture, 140; aerial photography for, 130; condition, 260; consultants, 164; and ground relationship, 252; as one interconnected system, 256; islands, 275; landscape urbanism, 13, 72; landscaped walkways, 126; mapping, 267; rexamination of, 170; shared space, 234; and urban agriculture, 152; urban development, effects of, 239; urban plans, landscape and landscape infrastructure-driven urban plans, 75; 185–223; 227–236; use, 277; Landscape Urbanism Master's programme, Architectural Association, London, 253; land use regulations, 216; voids, 232
language, architectural, 67
La Défense, Paris, 193
Lao-Tse, 231
La Rioja, Spain, 174
Larsen, Henning, 37, 47
Las Vegas, 246
Latin America, 117–128, 141, 211–16
LAVA Architects, 166, 167
leadership, 128
Le Abbazie, 193
Le Corbusier, 8–9, 40
LEED Platinum homes, 108, 111
legal frameworks, 142
legislation, planning, 10; government, housing, 138
leisure: areas, 256; destination, 162; facilities, 248; uses, 245
Lenasia, 130
Leth, Soren (SLETH Modernism), 28
levees, 105, 114
Lewis, Duncan, 221
Libeskind, Daniel, 38, 246
libraries, 101, 118, 153, 192, 270; library squares/parks, 121, 123, 124, 128
lifestyles, 138, 146, 201
light rail systems, 35, 168

Lim, JM, 221
Lin, Dillon (ZHA), 85, 90
Lion, Yves, 6
Lion Park Urban Design Framework, Johannesburg, South Africa, 129–140
listed buildings, 31
liveable city, 44, 201; increasing liveability, 190, 274
live-work environments, 43, 135, 162, 277
living roofs, 64
Lloyd Wright, Frank, 8
LMB, 178
local authorities, 15
Local Identity Nuclei (LINs), 193–4
Logroño, Spain: Montecorvo Eco City, 174–183
Lombardy East, 130
London: 275; Docklands, 56; Greater London Plan, The (1944), 195; mews block, 230, 231, 233, 236; 2012 Olympic Park and legacy masterplan, 15, 47; The London Plan (2009), 275
Longgang, Pearl River Delta, China (Groundlab), 14, 250–263
Loong, Lee Hsien (Prime Minister of Singapore), 86
Loop City (BIG), 6, 42–3; 44
Lootsma, Bart, 246
Los Angeles, 230
low carbon development projects, 251
Lower 9th Ward, New Orleans, 104–114
Louvre Abu Dhabi ((Jean Nouvel), 162, 163
LSE Cities, 211
Lundgaard and Tranberg, 37
Lynch, Kevin, 129
Lynn, Greg, 221

Maas, Winy, MVRDV, 245
MAD, 251
madang (courtyard), 231
Madrid, Spain, 202–10
majlis (carpeted social spaces), 67
Malibu Town, Gurgaon, India, 11
Malmö, Sweden, 231, 232
Make It Right, 104–114
Makover, Professor Tim (Allies & Morrison Architects), 65

Malaysia, 86

Malmö, Sweden, 42

management consultants, 189

Mangera Yvars, 68

Manzanares River, Madrid (MRIO plan), 14, 202–10

manufacturing: clean, 221; restructuring of, 188

maps, 23, 193; mapping: 201, 267; methods, 147, 253

marginalisation, of schemes from city centre, 182; guarding against, 183

marinas, 69, 162, 163, 244, 260

Maritime Museum, Abu Dhabi (Tadao Ando), 162

market: -driven solutions, 188; forces, 9; markets, 101, 239, 257; partnership with the state, 277; plants and flower, 212, 213, 214, 215, 216, 233; research-driven practices, 277; user-focused, 277

Mars, Neville, 251

Masdar City, Abu Dhabi, xvii, 7, 68, 143, 159–173; Institute, 165, 166

mashrabiya, 162, 164, 166

Massachusetts Institute of Technology, 230

Masseroli, Carlo (Deputy Mayor of Milan to 2011), 189

massing principles (KCAP), 54

masterplanning, the old model of, 153

Matadero Centro del Artes, Madrid, 207

Matte, Magdalena (Housing Minister, Chile), 103

Mauchos (directed by Sebastian Moreno), 103

Mayer, Albert and Novicki, Mathew, 8

Mayne, Thom (Morphosis), 109

Mayors, 72, 80, 117, 126, 127, 142, 202, 201

Mazzanti, Giancarlo, 121, 127

Mau, Bruce, 213

McAslan, John + Partners, 64, 68

McDonough, William + Partner, 108, 109, 242, 248

Mecanoo, 252

Medellín, Colombia, 8, 20, 117–128; Museum of Modern Art, 128

Media City, 49

Mediapolis, 83

mediation, urban design, 144

medical clinics, 130, 135

medieval city, 38–9

medinas, 153, 163

Mediobanca, 189

Mediterranean sites, 219; see Barcelona

mega: -blocks, 248; cities, 84

Meier, Richard, 51

Meijer, Henk (Gemeete Almere), 244, 246, 248, 249

Melbourne, Australia, 264

Melun-Sénart (OMA masterplan), Paris, 9, 275

Menzl, Dr Marcus (HafenCity Hamburg GmbH), 48, 52

Merkel, Angela (Chancellor of Germany), 7, 166

Metabolism, 7

Metro, 28, 34–6, 42–44, 118, 123, 201, 241, 260; stations, 169, 190. See also underground

Metrobosco, 197

Metrocable Project, Caracas, 118–21, 144, 145, 146–7, 148, 155; cable cars, 277

Metrogramma (Andrea Boschetti and Alberto Franchini), 187–201

metropolises, 90

Metropolitan Directives of Territorial Planning (MDTP), 118

Mexico City, Mexico: Xochimilco, 211

Microrayons, 10

Middle East, the, 59–68, 141, 159–173

Mies van der Rohe, Ludwig, 8

migration, global, 1; in the Global South, 154; from rural to urban areas, 211, 250

Milan, Italy: EXPO 2015, 197, 198; Urban Development Plan, 4, 6, 7, 10, 14, 187–201

Miletus, xvii

military, former: base, 193; training area, 35

Millennium Park, Chicago, 20, 80

Milwaukee, 105

Mina Zayed district, Abu Dhabi, 161

Minsk, 10

Mirti, Stefano (Id-Lab), 189, 191

MIT, 166

Mithun, 72

mitigation plans, bespoke, 277

mixed use, 13, 31, 48, 49, 63, 64, 67, 68, 86, 87, 105, 129, 130, 153, 162, 164, 188, 190, 198, 201, 211, 241, 243, 246, 251, 252, 268, 270; facilities, 183; housing, 113; nodes, 135; tenure, 277; towers, 170; towns, 178

mobility: 200, 209; patterns, 187; services, 192; systems, 221

Mobility Plan, 200

models: development, 182; methodological, 201; sustainable urban, 76; 153

Modernism, 42; Modernist planning, 12; approaches, 87, 146, 234; blueprints, 141; city, 228

Mohali, India, 9

Montecorvo Eco City, Logroño, Spain (MVRDV and GRAS), 174–183

Morandi, Corinna (*The Great Urban Transformation*), 182

morphological characteristics of sites, 193, 201

Moroccan cities, 153

Moreno, Sebastian, 103

morphologies, 217

Morphosis, 109, 110

Mossessian, Michel (mossessian & partners), 19–20, 60–8

Mott Macdonald, 170

mountains: 234; -ous regions, 117–128, 178

MRIO plan, Manzanares River, Madrid (West 8 and MRIO Arquitectos), 14, 202–210, 245

MRIO Arquitectos, 202–10

Msheireb Properties, 60

Mulgan, Geoff, 21

Müller, Willy, 221

multi: -dimensional, 211; -disciplinary: 189, 252; design, 153; management, engineering and development consultants, 170; -nuclear city, 240

multi: -modal: access strategies, 77; transport, 86; -scalar strategies, 253

multinationals, 30

Multiplicity (Stefano Boeri), 197, 198, 199

municipal: funding, 190, 207; operations, 196; scale plans, 188; services, 190; see also government

Munyai, Thabo, 130

museums, 179; 161–3; siting of, 188

Musheireb, Doha, 19–20; 59–68
music: centre, 221; school, 148
Mutopia, Copenhagen, 27
MVRDV, 23, 109, 174–183, 222, 239–249, 251
Myung-bak, Lee (President of South Korea), 230

National Natural Science Foundation, China (NNSF), 252
nature; 216, 217, 219, 221, 276; natural cooling, 166; relationship with technology, 182; reserves, 244
Navigli, Milan, 193
NCC Property Development, 27, 38
NESTA (National Endowment for Science Technology and the Arts), 21
Newark, 113
New Cities Foundation, 263
New Farm, Brisbane, 273
New Orleans, USA: Make It Right, 104–114
neighbourhoods, 9, 10, 14, 46, 51, 60, 63, 113, 163, 166, 193, 199, 219, 236, 242, 247, 248, 262, 277; adjacent, impact on, 208; as artificial ecosystem, 221; barriers between, 70, 73; different characteristics of, 128; disadvantaged, 239; drawing sessions, 144; divided, 105; linked, 124; new, 164, 178, 248; meetings, 193; plans, 267; renewal, 108
Netherlands, the, 23, 35, 135, 153, 168, 231, 239–249, 252, 275
networks: cycle paths, 201; environmental, 199; infrastructure, 201; inter-modal transport, 170; lattice, 193; permeable, 193; railway, new, 201; regional, 200; relationships, 211, 277; renewable energies, 236; of precincts, 268; social, 217; strategic, 123, 128; system, 219; transit design, 170
new economy industries, 83
New Farm, Brisbane, 272
New Gourna town, Egypt, 68
New Orleans, 104–114
New Urbanism, 13, 18, 129, 148
New Towns, 142, 239; eco-, 179, 182; English, 33

New York City: 10, 193; Central Park, 231; grid, 161; Sheridan Expressway, Bronx, 106;
NGOs, 117, 138, 169
Niemayer, Oscar, 8
nightlife hubs, 265
NOBC, 106
Nordhavnen masterplan, Copenhagen, 27–28, 44
'No Town', 9
Norten, Enrique, TEN Arquitectos, 106, 211–216
North Delaware Riverfront Masterplan, Philadelphia (james corner field operations), 72
Nottingham, University of (Institute of Architecture), 140
Nouvel, Jean, 6
Nowak, Henrik, 28
nurseries, 140

office: affordable space, 248; buildings, 31, 63, 68, 248; space, 162, 259, 265, 267; use, 170
Oido, Gyeonggi-do Province, South Korea, 231
oil and gas economy, post- 61
Olmsted II, Frederick Law, 22, 231
Olympiakwartier, Almere, 246
Olympic: Games bid (2016), 203, 210; Sculpture Park, Seattle, 69, 73
OMA, 14, 49, 203, 247, 248, 275; Qianhai Port City, Shenzhen, China: 15, 250–263, Melan Sénart, France, 9, 275
Oman: heritage plan, 159
one-north Singapore (ZHA), 6, 13, 14, 83–90
On Hold, British School at Rome exhibition (2011), 1, 10
open source networks, 19
Open House, Constitución, 101
options, urban planning, 71
oral history, 146
orchards, 205, 207, 212, 222
organic: growth, 83, 246, 277; logic, 251; planning, 114; urbanism, 242
Ørestad, Copenhagen, 27, 33, 34–42, 49, 246
Øresund coast, 28, 42

Orquideorama, Medellín (Plan:B Architects, J Paul and Camilo Restrepo), 126
oversight, 123
ownership, sense of, 11; information, 147
Oxford, UK, 162

Pacific Rim, 73
Paisajes Emergentes, 127
Paju Book City, Seoul, 230–1, 234
parametric: design, scripting, 22; urbanism, 85
parametricism, 13, 87; parametric modelling tools, 276; spatial simulation modelling, 277
Parco Nord, Bicocca, Milan, 197
Parque: de la Arganzuela, Madrid, 205; Explora, Medellín, 126
Paris, 9, 193, 208, 275; density of, 162; 'Grand Paris', 6; Place de Vosges, 231; 'Paris plus petit' (MVRDV), 23
Parco: Portello, 198; Ravizza, Milan, 197
parks: boulevard-, 205; ecological, 179, 212, 213; public, 51, 69, 73, 76, 77, 78, 88, 96, 106, 124, 126, 130, 135, 140, 148, 153, 188, 195, 196, 197, 198, 201, 203, 208, 211, 215, 217, 222, 245, 246, 260, 268, 269
parking space, 59, 178, 215, 246; underground, 64
Parque Biblioteca España (Giancarlo Mazzanti), Medellín, 121, 122
participative design, 144; community participation, 148
passive energy strategies, 67
patterns: centrifugal, 182; historic radial, 182; social and cultural identity, 193; sustainable, new patterns of, 211
Pearl River Delta: Longgang, 250–263; strategic plan, 251; Estuary, 260; hyper-urbanisation of, 262–3
pedestrian: access, 74; bridges, 71, 272; connections, 10, 13; corridors, 268, 272; flows, 20, 77; -friendly environments, 39, 76, 135, 251; link infrastructure, 267; paths, 197, 208; platform, 172; routes, 106, 260; system, new, 199; walkways, 153; zones, 203
Pelli Clarke Pelli, 198, 199

Peñalosa, Enrique (former Mayor of Bogota, Columbia), 12, 117

Pérez Jaramillo, Jorge (Dean, University of Medellín), 123

Pérez Jiménez dictatorship, Venezuela, 8

Performing Arts Centre, Abu Dhabi (Zaha Hadid Architects), 162

peri-urban areas, 193, 199

periphery, urban, 55, 193, 217

Perm, Russia, 10

permeability, 12, 71

Petersen, Lars Holten (Carlsburg), 30

PGT (Piano di Governo del Territorio), Milan, 189

phenomenological considerations, 9

phased development, 83, 166; 172, 261

Philip Christou and Florian Beigel, ARU, 10, 227–235

Piano, Renzo, 9

Piano del Verde (Green Plan), 198

Piazza d'Armi, Milan, 193, 195

piers, 74, 79, 208, 260

pilot projects, 111, 172; transport, 168

Pink Project, New Orleans, 108

Pisapia, Giuliano (Mayor of Milan, 2011–), 201

Pitt, Brad (Co-founder, Make It Right), 107, 108

place making, 137

Plan Abu Dhabi 2030, 164

Plan:B Architects, 126, 127

plans: concentric, 60; compact, 178

planners: urban, 113, 117, 134; urban planning institutes, 117

planning, British, 132; ecological, 154, see also 'eco cities', 157–183; micro, 154; model, adaptable, 242; sustainable, 155; total, 246

PlaNYC 2030, xvii, 11

Plan for the 21st Century: New Orleans 2030, 104, 105

Plan de Ordenamiento (POT), 117

planting, 161

Plasma Studio: see GroundLab

Plataforma del Rey, Madrid, 208

playgrounds, 52; areas for play, 208

plazas, 126, 167, 244

PLOT (Bjarke Ingels and Julien De Smedt, 2001–6), 40

plots, 161, 174

polder: 248; city, 241

policy: 273; housing and planning, conflict over, 182; instruments, 21, 277

pollution: abatement, 13, 251; air and water, 134, 211, 212; non-polluting firms, 86;

poly: centric, 72, 188, 241, 277; -nuclear, 242, 248; regions, 211; river, 253

population: growth, xvii, 23, 28, 129, 161, 239, 247, 251, 252, 264, 268; loss, 187; planned, 162, 169, 227; profiles, 42, 45, 59; rise, 182; young, 212

Porta Nuova, Milan, 197, 198

Portello, Milan, 188

Portland, Oregon, 105

ports, 45, 69, 74, 159, 247, 258, 259, 260, 261, 262; seaport, 232

post-apartheid system, 129

post-disaster urban regeneration, 23, 28, 91–114; -Fordism, xvii, 13; -future shared economic models, 276; -industrial urban regeneration, 12, 27–44; -traumatic urbanism/reconstruction, 12, 21, -zoning model, 4

Potsdamer Platz, Berlin, 9

Poulsen, Lone, 140

poverty, urban, 117–8, 126, 129, 140

power plant, 34

Powerhouse, 251

precincts, 135, 261, 265, 266, 267, 267, 268, 269, 270

preservationists, 216

PRES sustainable reconstruction masterplan, Constitución, Chile, 93–103

Pretoria, 131, 133

PRIMED programme, Medellín, 121

PRT (Personal Rapid Transport) network, 133, 168, 170, 260

private sector, 20, 135–6, 188

privatisation of public space, 12, 105

process-oriented urbanism, 11

programmes, 75, 243, 246; intense, 166; mixed, 254; typologies, 260

Project Russia magazine, Moscow, 10

property: market, 188; values, 10; taxes, 126

prosperity, 59

Proto/e/cologics, Rovinj, Croatia, 90

prototyping, 21; prototypes, 109, 140, 219, 248; ecological, 153

psychologists, 11

public consultation, xvii, 101, 248, 273

public: art strategy, 71; blurring boundaries between public and private, 148; comments, 189; consultation, 203, 277; criticism, 37; debates, 201; demands, 193; dialogue between and administration, 201; events, 71, 277; feedback, 80; forums, 32, 101, 273; good, 56 integrated, 123; meetings, 75, 193, 201, 216; observation, 201; public-private alliances, 95, 103, 130, 189, 198, 211, 239; -private mixes, 219; realm, absence of, 59; realm, strengthening the, 77; sector, 20, 128, 135, 188; space, 13, 19–20, 30, 47, 68, 69, 70, 72, 126, 135, 148, 176–7, 178, 179, 188, 198, 207, 208, 246, 253, 256, 264; space by water; space renovation plans, 117; spending, 105; squares, 133; taxes, 207; transport, 28, 182, 239; transport nodes, 138; uses, reviving, 213; views, 244

Puente: de Segovia, Toledo, 208, 209; Puentes Cascara, Madrid, 205, 206, 207

Puget Sound, 73

Pugh + Scarpa, 109

PUI (Integral Urban Project), Medellín, Colombia, 121, 122, 124, 125

Qatar, 59–68

Qatar Foundation, 60, 61; Science and Technology Park, Doha, 61; University, 65

Qianhai Port City, Shenzhen, China (OMA), 15, 250–263

Queensland: State of, Australia, 264–74; University, 268

Quitana Park and library, Medellín (Ricardo Caballero), 121

'Raggi Verdi', 197, 199

rail: -way line, 245; light loops and lines, 269; link projects, 188, 244; system, new, 118; -way stations, 190, 239, 241, 244

rainwater collection, 256

Rambøll, 28
Ramblas, the, Barcelona, 207
Randstad, the, the Netherlands, 239, 241, 242, 275
Rasmussen, Steen Eiler (Finger Plan), 6, 42
Rayner, Michael, Cox Rayner Architects, 265
RCM (Central Region of Mexico), 211
Reagan, Ronald, 105
reclaimed land, 261
recreational: activities, 75, 148; areas, 130; canal system, 212; facilities, 216, 245; land, 203; space, 153, 267; use, 207
recycling: 262; of materials, 111, 134, 221
redevelopment, ways of stimulating, 75
regeneration, urban, 64, 201
regional zones, 211
regulations: 251; frameworks, 7; preventing sustainable concepts, 251
zoning regulations, 138
Reina Sofia Museum, Madrid, 207
relational: aspects of urban spaces, 230; urban models, 253, 257, 258
relocation of residents, 216
remediation strategies, 216, 257
retail units, 248
renewable energy: planning, 262; sources, 251; specialists, 164; technology, 178
research: business, 172, 259; centres for renewable energy, 179; cross-disciplinary, 86; and development facilities, 69–80; 159–173;, 192, 193; groups, 123; laboratories, 251; -led design, 138; lab, 148; multidisciplinary, 277; precincts, 268; urban, 52, 64, 143, 230, 236
residential: areas: functioning of, 182; resident, populations, 71; depictions of, 207; monocultural, 234; resident wishes, 52, 248
resorts, 163
responsible growth, 12
restaurants and cafes, 63, 69, 86, 89, 126, 162, 178
results-based methodology, 55
retail – see shops
retrofitting, urban, 17, 20, 142, 147, 183, 277
reuse of buidings and materials, 174, 177
Rho-Pero, Milan, 197

rhizomatic upgrading, 147
Risanamento, 188, 246
river: banks, 48, 93–103, 106, 203, 205, 207, 234, 247, 253, 268, 270, 272; City Blueprint, 267, 273, 274; crossing, 253; definition of urban space, 264–5; interface with public space, 208, 209; link with neighbourhoods, 257; recovery of, 256; valleys, 256; walk, 207
River: Ebro, Logroño, 178; Longgang, 254; Maule, Constitucíon, 193; Seine, Paris, 208; Toria, Valencia, 217
roads: 205; connectivity, new, 200; new, 121, 144, 168, 182; hierarchies, 134; networks, 135; Roadmap 2050 masterplan (OMA), 262; ring, 202
Roche, François, 222
Rocksteady, 251
Rogers, Richard, 182
Roosevelt, Franklin D., 104
Rossi, Aldo, 230
Rotterdam, the Netherlands, 48, 241
row houses, 101
Rowe, Colin and Koetter, Fred (Collage City), 10
Rubattino, Milan, 197
rules, 201
running tracks, 207, 208
'rurban' environments, 220
rural: 219, 250; -semi settlements of a city, 211; distinction between urban and rural space, 239
Russia, 83

S+A Arquitectos, 126
Saadiyat Island Cultural District, Abu Dhabi, 159–60, 161, 162
Saemangeum Island City, South Korea (ARU), 10, 227–235
Safdie, Moshe, 156
sahan (courtyard), 63
Sala, Giovanni and Kipar, Andreas, LAND, 14, 189, 197, 198, 199
Salazar, Alonso (Mayor of Medellín), 127
Salón de Pinos, Madrid, 203–5, 207
Salt, Bernard, 272
SANAA, 248

San Agustin, Caracas, 144, 147, 148
San Diego/Tijuana border, 18–19
San Domingo, Medellín, 121
San Francisco, 105, 113
Santa Giulia project, Milan, 188, 246
Santiago, 93
São Paulo, Brazil, 12, 17, 141, 148–52
Sarkozy, Nicolas, 6, 23
satellite: towns, 11, 250; imagery, 144
scaleable prototypes, 109
scale, integrated, 10; of reference, 201
Scandinavia, 28; architecture, 33
scenario planning, 275
Schetjnan, Mario, 211, 212
Schumacher, Patrik, ZHA, 13, 20, 87
science and technology districts and parks, 35, 61, 81–90, 159–173; Dubai Healthcare, Media and Internet Cities, 159
Science Hub Development Group (SHDG), 83
schools, 35, 51, 53, 55, 68, 100, 108, 118, 121, 122, 123, 124, 125, 130, 142, 153, 192, 203, 205
Scott-Brown, Denise, 9
seawall, 230, 232, 235
Seattle, USA: 105, Waterfront Seattle, 13, 69–80
Second World War, 59
security, 11, 79
seed projects, 277
SEEDE (Social, Economic, Environmental, Design and Engineering) criteria, 135
See-Network, 11–12
segregation, racial, 129; strategies, 140
SEHAB (the City of São Paulo Housing Authority), 148
self: -build, 246; -determination, 201; -sufficient towns and cities, 178, 183
Sennett, Richard, 20
serial planning, 239, 241
Serie Architects, 276
Sert, José Luis and Weiner, Paul Lester, 117, 126
services: 200; delivery: 189, 190; development, 192; provision plan, 193
sewage, 133

shading, 170
Shanghai, China: 251; EXPO 2010, 180
sharing resources, 221
Shenzhen, China, 250–263; Urban Planning and Land Resources Committee, 259
Sheridan Expressway, Bronx, 106
shops: 42, 51, 89, 166, 178; shopping centre, 38; malls, 68, 105, 211, 267; precincts, 268, 269–70
Sheikh Moza Bint Nasser Al Missned, Her Highness, 61, 68
SHoP Architects, 72
shortlists, 72
Skolkovo Centre for Innovation, Russia, 83, 262
Shibam, Yemen, 166
siheyuan typology, 252
SIIC, 251
sikkats, 67
Simrishamn, Sweden (Algae Farm), 5
Sinclair, Cameron, 19
Singapore: 230; one-north, Singapore (Zaha Hadid Architects), 6, 13, 14, 83–90
Sisulu, Lindiwe (Minister for Housing, South Africa), 130
site: characteristics, 148; photography, 236; plan in relation to site, 178; readings of history, 235, 236
SITES Pilot Programme, 111
'sites and services', 142
Skåne, Sweden, 42
skateparks, 153
skyscrapers, 30, 193
SLETH Modernism, 28
slopes, south-facing, 179
Slovakia, 276
slow city, the, 200
slums, 126, 141, 146, 147
'Smart Cities: Rethinking the City Centre' (Cox Rayner Architects), 6, 264–274; smart grid, 42
Smith, Adrian & Gordon Gill (Masdar headquarters), 166
Smithson, Alison, 3
society: evolution of, 173; unified, 63
social: activism, 63; cohesion, 130; cleansing, 12; and cultural histories of a city, 109;

design, 148; and economic research, 251
engineering, 201; entrepreneurs, 277;
exclusion, 124, 138; impact, 267; equity, 12,
115–155, 276, 277; groups, 223; housing,
136; inclusion, 20, 181, 190, 276;
infrastructure, 148; interaction, 223;
networks, 217; patterns, 223; sustainability,
28; urbanism, 123; workers, 135
sociologists, 20, 12, 52, 277
Sociópolis, Valencia, Spain (Vicente Guallart), 217–23
Soho City, Beijing, 20, 90
solar envelopes, 22; cells, 153, 155; energy, 175, 179; power, 167; power plant, 166; strategies, 182; tower, 221
Soloman Cordwell Buenz, 170
Sondermarken, Copenhagen, 30, 33
souks, 60, 68, 153, 164
South Africa, 129–140
South Korea, 10, 227–235
Soviet urban planning model, 143
Soweto, 129, 130
Spain, 174–183, 202–10, 217–23, 233
space: green, 182; spatio-temporal spread models; hierarchies, 67
Speer, Albert, 250
sports grounds, 38, 101, 131, 135, 215, 220, 222, 256, 260; centres, 127; facilities, 148, 178, 192, 213, 214, 221; hubs, 153
sprawl: avoidance of, 169; urban, 12, 43, 60, 129, 182, 235; suburban, 105
squares, urban, 63, 121, 165, 169, 182, 231; town hall, 247
Sri Lanka, 19
stadia, 69
stakeholders, 11, 20, 21, 142, 144, 234, 246; committees, 113; groups, 72; mix of, 170
Stamen, 23
standardisation, 128, 129, 147
stations, railway, 200, 245
Stefano Boeri, Multiplicity Lab, 197
Stephenson, Milan, 193, 196
Stockholm, Sweden, 233
stormwater management, 77, 112
streets: 36; arcades, 63; congested, 63

connectivity, better, 77; furniture, 53, 179;
landscaped, 179; narrow shaded, 166;
network, 169; new, 101, 113, 121, 130, 138;
pedestrian-friendly, 169; profiles, 181; safer,
124; -scapes, 231; street life, 44, 89. See
also boulevards
structuurvisie (Structure Vision), 241, 242, 243, 244
S333, 87
students of urban design and planning, 155
sub-tropical city, 273
suburbs, 28, 33, 40, 42, 135, 141, 239, 248, 272, 274, 183; deindustrialisation, 188; density, 248; expansion of, 59, 105, 130; suburban, 46, 85, 110, 236; patterns, Islamic, 65; new, 71; settlements, 247; sprawl, 105; typology, 246
subsidiarity (*péréquation*), 189, 190, 196
subsidies, government, 207, 210
subways. See Metro, underground.
superblocks, 8
supermarkets, 9
supra-regional networks, 12
surface transport masterplan, 170
surveys: geographic, sociological, historical, economic, statistical, archaeological, architectural and engineering, 201; social, 136; ground, 144
sustainable: 155, 193, 251, 274; agriculture, 212; business, 248; catalysts, 76; cities, 178; claims for sustainability, 55, 246; city, 242; through culture-based tourism, 162: definition, 154; design, 262; development, 197; economic, 113; environment, 170, 213, 256; *estidama*, 159; framework, 170; growth, 242; housing, 109; infrastructure and development, 44; logic, 249; measuring, 155; new forms of, 211; planning and development, 12, 140, 155; reconstruction, 93–103; systems, 248; urbanisation, 251; urbanism, 277; urban models, 153, 164
Sweden, 34, 231, 233
Sydney, Australia, 264
Syska Hennessy, 213
systems, water, 150; building, 151

22@Barcelona, 83
TABO, 8
Tadao Ando, 162
Tainan Science Park, Taiwan, 83
Taiwan, 83, 142
Talca, University of, 95
Tange, Kenzo, 7
TDIC (Tourism Develoment and Investment Company), Abu Dhabi, 161
Team 10 Primer (Alison Smithson), 3
Technological Transfer Centre, Logroño (Foreign Office Architects), 182
technologies: clean technology field, 166; relationship with nature, 182; research, 188; state-of-the-art, 153; technology transfer specialists, 170
TEN Arquitectos, 106, 211–216
templates, replicable, 111
Teneriffe, Brisbane, 272
tensegrity structure, 272
tenure, housing, 56, 140
terraced landscape, 148
tertiary sector, uncontrolled development in, 187–8
Thailand, 162
Thames Town, Shanghai, 250
theatres, 162, 248
theme parks, 172, 208
'thickened ground, the', 252–8
think-and-do-tank:Archis Foundation, 11; Elemental, 95
Third Space, The (Homi Bhabha), 10
Third World, 13
Tianfu Life Science Park, Chengdu, 83
Tianjin Eco-City, China, 250, 251
TIGER II Infrastructure Grant, 106
Tillería, Hugo (Mayor of Constitucíon), 95
time-based urban morphologies, 22
Tironi Asociados, 101
toilets (restrooms), public, 153
Tokman, Marcelo, 95
Tokyo, 7, 146–7; Institute of Technology, 230
Tomato, 72, 79
top-down masterplanning, 12, 128, 143, 277; mandates, 113; infrastructure, 144

topographical: assets, 179; conditions, 208; design adapting to topography, 179, 182; diagrams, 77; features, 233; lakebed, 230; local, 236; measures, 71, 74;
Torres Nadal, María, 220
towers, 59, 89
townships, 11, 129, 140; kasi (township) registers, 130
touristic: activity, 70, 74, 101, 148; agri-tourism, 229; resort enclaves, 236; tourist destinations, 161, 162, 229, 257; infrastructure, 231
traffic, 78, 208; calming, 135
trams (streetcars), 78, 133
transit: network design, 170; mass transit system, new, 265
Trahan Architects, 109
TransMilenio (Bogotá, Colombia)
transport: BRT, 278; high-capacity, 200; hubs, in proximity to business hubs, 138; inter-modal networks, 170; infrastructure, 243, 246, 267, 272, 277; interstate highways, 105; light systems, 278; links, 241; loop, 258–9, 260, 262; masterplan, 170; monorail, 260; nodes, 138; public, 53, 147, 182, 242; savings in fuel costs, 182; Skytrain, 260; systems, 133, 182, 262
Transsolar, 164, 170
Treme, 105
Tsinghua School of Architecture, 251
tsunamis, 93; measures to protect against, 96
23 de Enero, Caracas (Carlos Raul Villanueva), 8
TU Berlin (Update Chandigarh), 9
Tudela, Navarre, 181
Twitter, 72
typologies: 48–9, 138, 260, 261; distinctions between neighbourhoods, 241; grammar, 276

UAE, 59–68, 159–173
UCLA Architecture and Urban Design, 109
UDP (Milan), 187–201
UK, 162, 230–1
underground: Metro, 28, 34–6, 42–44, 118, 123, 201; stations, 169, 190. See also Metro.

parking, 30; roads, 30; tunnels, 70; tube system, 133
unemployment, 35
UNESCO, 216
Unified New Orleans Plan (UNOP), 105
universities: 52, 166, 192, 193, 261; collaborative role of, 140; siting of, 188; Nottingham, 140; Medellín, 123; Queensland, 268; Talca, 95; Technology, Sydney (Urban Design), 21
UN-Habitat, 15
UNITY Plan, Brooklyn, 10
Update Chandigarh, 9
Urbam Center of Urban and Environmental Studies, EAFIT University, Medellín, 128
urbanisation, 153, 174, 212, 251, 252; hyper-, 262
urban: acupuncture, 142; agriculture, 113, 138, 152; design, 129; ethnography, 53; expansion, 251; farms, 21; framework, 76; growth, xvii, 28, 42, 142, 202; guidelines, 90; -ism, 217; photography, 53; planning as a management science, 252; renewal projects, 202, 266, 268, 270; sprawl, 12; squares, 63; and rural mix, 217; and rural as opposing concepts, 219; 'urban generator', 153; web, 88
urbanism: fast track, 250; informal, 243
Urban Age, The (LSE Cities and Alfred Herrhausen Society), 211, 212
Urban China, 251
Urban Design, chair of Architecture and, ETH, Zurich, 141
Urban Design Framework, Lion Park, Johannesburg, South Africa, 129–140
Urban Planning Council, 170
Urban Room, The, 19
Urban Think Tank (Alfredo Brillembourg and Hubert Klumpner), 17–18, 22, 141–155
Urbanus, 251
USA, 13, 20, 103, 104–114, 141, 142, 162, 246, 252, 261
US Green Building Council, 111
utopia/s, utopian, 9, 10, 20, 201, 228
Utrecht, the Netherlands, 153; 241, 242

Valby (Carlsberg site), Copenhagen, 28–31, 33
Valencia, Spain: Sociopólis, 217–23
Vallejo, Aránzazu (Vice President and Minister of Tourism, Environment and Regional Policy, La Rioja), 180
vandalism, and neglected open spaces, 130
van Egeraat, Erick, 51
van Ettinger, Jan, xviii
van Rijs, Jacob (Partner, MVRDV), 246, 248
Vanderbilt Yards, Brooklyn, 10
vantage points, 106
Varesine, Milan, 198, 199
Variante Generales plans (1976/80), 182
'Velaerdsstatens Arkitektur' (welfare architecture), 33
Venezuela, 17, 18, 141, 144–5
Venice, 142, 233; Architecture Biennale, 193
Venlo, the Netherlands, 249
ventilation, natural, 170
vernacular: building types, 65; brick, 128; planning, 166, 170
Vesterbro, Copenhagen, 30, 33
viaducts, 70, 72
views: of the city, 179; viewing points, 179
villages, urban, 143, 253–8, 266, 269; cultural principles about, 252; floating, 245; precincts, 265
Villanueva, Colombia, 128
Villes Nouvelles, 9
vinexwijken: 239; VINEX developments, 239, 248
vision: 216; 'vision device', 201; plan, 234; statement, 233
visitor centres, 183
Vista Xchange, one-north Singapore, 83, 86
VM Houses, Copenhagen, 38, 40, 41
voids, urban, 193, 196, 231, 275–6
Volume magazine, 11
voting, 71, 101

wadi, 60, 67
Wageningen University, the Netherlands (Urban Environmental Management), 22
Waggoner & Ball, 109
Wagner, Marlene (Technical University of Vienna), 138

Waldheim, Charles, 22
walkable neighbourhoods, 64, 252
Walking Papers, 23
walkways, 166, 203; riverside, 207
warehouses, 47, 49
War on Cars, 12
waste: disposal systems, 212, 277; to energy businesses, 138; management, 174
water: availability of, 131; basins, 215; bodies, 232; channels, 218, 219; cities, 225–235; education about, 214, 215; -front, 265; improvement, 241; park, 215; pollution, 134; proximity of, 260; purification, 180, 221; quality, 244, 260; redistribution, 96; rising levels, 109; shortages, 43; storm, recycling, 136, 153, 216; systems, 150; supply, 216; taxis, 235; -ways, 195, 196; wastewater sewer, 254; waterscapes, 256
waterfronts, 28, 51, 69–80, 118, 153, 162, 203, 216, 236, 241
Waterfront Seattle, 69–80
Weak and Diffuse Modernity (Andrea Branzi), 10
web, urban, 88
web, the, 242
websites, 72, 193
Weeber, Laura, 248
Weinbach & Partners, Dan, 170
Weiner, Paul Lester and Sert, José Luis, 117, 126
Wessex Estate, 83
West 8, 14, 202–10, 242, 245
Western cultures, 67
wetlands, 36, 106, 113, 162, 216, 234, 241, 251, 260; assessments, 135
White Paper, 189
Why Factory, The, Delft University of Technology, the Netherlands, 23
Why Not Projects (Vicente Guallart and María Diaz), 217
Wilheim, Jorge, 12
Williams, Richard (The Anxious City), 9
Williams, John C., 113
wind: energy, 175, 179, 261; farms, offshore, 261, 262; -mills, 180; tower, 166
Winy Maas, MVRDV, 245
World Wide Fund for Nature (WWF), 251

Woolloongabba, Brisbane, 265, 266
Woonerf (living street), 135
World: Architecture Festival, 40; Energy Council, 170; Health Organisation, 96; Heritage Site, 212; -mappers, 23
workplaces, 241
workspaces (integrated with housing), 166
Works Projects Administration (WPA), 104
workshops, 15, 72, 123, 135, 277; competition, 230
Wright, Frank Lloyd, 248

Xi'an Horticultural Expo (GroundLab), 2011, 252
Xiaohui, Chen, 263
Xochimilco masterplan, Mexico City (Enrique Norten/TEN Arquitectos), 211–216

Yards Development Workshop, The (Marshall Brown and Letitia James), 10
Yas Island, Abu Dhabi, 161
Yonsei University, 230
younger generation, 63–4
Yeang, Ken, 86
young people, 221
Ypenberg, the Netherlands, 231

Zaera-Polo, Alejandro, AZPA, 1, 15–17
Zaha Hadid Architects, ZHA, 6, 13, 14, 20, 83–90, 162
Zapatero, José Luis Rodríguez, (President of Spain), 210
Zaragoza, Spain, 181
Zayed National Museum, Abu Dhabi (Foster + Partners), 162
Zeekracht plan, North Sea (OMA), 262
zero growth, 201
ZMVM (Metropolitan Zone of the Valley of Mexico), 211
zoning: 20, 105, 141, 201, 234, 236; administrative zones, 195; eradication of, 188, 190; laws, 227; modification, of, 188; non-, 227; regulations, 138
Zoetermeer, the Netherlands, 239
Zorrozaurre, 90
ZUS, 251